COMMUNICATION THEORIES
IN A MULTICULTURAL WORLD

Intersections in Communications and Culture

Global Approaches and Transdisciplinary Perspectives

Cameron McCarthy and Angharad N. Valdivia
General Editors

Vol. 31

The Intersections in Communications and Culture series is part
of the Peter Lang Media and Communication list.
Every volume is peer reviewed and meets
the highest quality standards for content and production.

PETER LANG
New York • Washington, D.C./Baltimore • Bern
Frankfurt • Berlin • Brussels • Vienna • Oxford

COMMUNICATION THEORIES
IN A MULTICULTURAL WORLD

Edited by Clifford Christians & Kaarle Nordenstreng

PETER LANG
New York • Washington, D.C./Baltimore • Bern
Frankfurt • Berlin • Brussels • Vienna • Oxford

Library of Congress Cataloging-in-Publication Data

Communication theories in a multicultural world /
edited by Clifford Christians, Kaarle Nordenstreng.
pages cm. — (Intersections in communications and culture:
global approaches and transdisciplinary perspectives; vol. 31)
Includes bibliographical references and index.
1. Intercultural communication—Cross-cultural studies.
2. Communication and culture. 3. Communication—Cross-cultural studies.
I. Christians, Clifford. II. Nordenstreng, Kaarle.
HM1211.C6496 302.2—dc23 2013038193
ISBN 978-1-4331-2306-1 (hardcover)
ISBN 978-1-4331-2305-4 (paperback)
ISBN 978-1-4539-1212-6 (e-book)
ISSN 1528-610X

Bibliographic information published by Die Deutsche Nationalbibliothek.
Die Deutsche Nationalbibliothek lists this publication in the "Deutsche
Nationalbibliografie"; detailed bibliographic data is available
on the Internet at http://dnb.d-nb.de/.

The paper in this book meets the guidelines for permanence and durability
of the Committee on Production Guidelines for Book Longevity
of the Council of Library Resources.

© 2014 Peter Lang Publishing, Inc., New York
29 Broadway, 18th floor, New York, NY 10006
www.peterlang.com

Printed in the United States of America

*The editors dedicate this book
to their colleague,
Robert A. White*

CONTENTS

Part Three: Thematic Approaches

Toward a Better World

KAARLE NORDENSTRENG

The intellectual history of this book has two roots: one general and one particular. The general leads us to view the field of communication research on a global scale and critically assess the Western domination of academic traditions (see Curran & Park, 2000; Thussu, 2009). The particular leads us to see individual scholars as carriers and change agents of research traditions. The two roots meet in the life story of Robert A. White, to whom this volume is dedicated.

Unlike usual Festschrifts, this book is done with active cooperation of the person in question. Bob's chapter 1 provides a self-made profile of the "son of Kansas populism" whose life journey took him through the international Jesuit community to academic centers of formative importance. Moreover, his chapter provides an overview of the book's essays that not only present communication theories in a multicultural world but also tell about life stories of several landmark scholars of the field. Accordingly, subjective narratives of individual scholars make a fascinating mix with objective development of communication research.

The general rationale of this volume takes us back to the reflections that followed the radical shift of research priorities in the 1970s (see Nordenstreng, 2004). A strategic element of these reflections was the question of textbooks used in the rapidly expanding field of journalism and mass communication. And a significant attempt to tackle this question was the textbook project of the International Association for Mass Communication Research (IAMCR), which serves as an essential background for this book. The following passage gives an account

of the project based on an earlier report by the present author and the late Michael Traber, at the time research director of the World Association for Christian Communication (WACC) and editor of its journal *Development Communication* (Nordenstreng & Traber, 1991).

Journalism and mass communication is a relatively young area of study with a rapidly evolving body of knowledge (see Nordenstreng, 2011). The literature of the field is far from established, especially in languages other than English. The predominance of English language literature reflects the fact that the field was first introduced and is quantitatively most developed in the United States. Accordingly, in light of the general state of the art, it is obvious that Anglo-Saxon textbooks dominate. Likewise, it is obvious that part and parcel of the promotion of this field in any country is to bring about textbooks rooted in the national and regional realities.

In this respect the question of textbooks in communication education can be seen as an issue of cultural emancipation as understood in the debate around the New World Information and Communication Order (NWICO; see Nordenstreng, 2013). At the same time the textbook problem represents another element of this new order: the need for a better awareness of the cultural and socio-political diversity of the world, whereby communicators should be educated not only to share a national perspective but to pay due attention also to other peoples and ultimately to the international community at large. Thus, national and universal interests complement each other.

The first international forum that raised the issue of communication textbooks in such a global context was the IAMCR, which, at its meeting in Paris in 1982, drew attention to the lack of adequate textbooks for journalism education in Africa and other parts of the developing world. It was an open call for communication educators throughout the world to review various traditions and doctrines of professionalism and to promote textbook materials in line with the aspirations of NWICO. Actually soon after that, UNESCO held a meeting of experts on cooperation among regional communication training institutions and recommended that textbooks relevant to regional and national needs be produced and published, and "where such textbooks and manuals are already in existence, efforts should be made to disseminate them to other regions with a view to adapting these publications to suit local needs."

These initiatives led to a workshop on the textbook problem by the IAMCR Professional Education Section in Prague in 1984 and two years later to a UNESCO-supported project on the promotion of textbooks for the training of journalists in Anglophone Africa, with extension to the Caribbean and Asia. This was followed by the African Council for Communication Education (ACCE), with support of the Swedish International Development Authority (SIDA), to prepare and evaluate a number of trial adaptations and new materials.

By the late 1980s there was a growing recognition of the need for more systematic interregional contact and cooperation—in communication education in general and textbook promotion in particular. To this effect the IAMCR prepared in 1988 an interregional project for the funding from UNESCO's International Programme for the Development of Communication (IPDC). Those involved in the deliberations about the new project were relevant regional organizations in Africa (ACCE), Asia (AMIC), and Latin America (FELAFACS), as well as two European-based world associations: WACC and the International Organization of Journalists (IOJ).

Thus, the project proceeded to Phase II as a joint venture between several non-governmental organizations and institutions, with the IAMCR playing the role of catalyst and coordinator. Three distinguished professors were appointed by the IAMCR to serve as the project's monitoring committee: Josiane Jouët (Paris), Manuel Parés i Maicas (Barcelona), and Robert White (Rome).

The motivation and objectives of the textbook project were summarized in its final report as follows:

> While it was common knowledge that journalism and mass communication were fields with American domination, we wanted to know in detail how this domination manifested itself in different regions and across various topics. In other words, the disease was known, but there was a need for a proper diagnosis in order to identify the effective treatment. Thus from the beginning our textbook study was an action-orientated project to bring about change.
>
> Specifically, we wanted to identify where and how to promote more socio-economically and culturally relevant educational materials, particularly textbooks in each region. Moreover, we wanted to promote South-South cooperation and to see whether something could be done by putting existing textbooks from other regions at the disposal of those who were under Western and Northern dominance. And this drive for Third World emancipation was far from a uniform, "totalitarian" approach painted by the opponents of NWICO in their propaganda in the 1980s. It was rather an ecumenical drive towards pluralism and global diversity in the sense of the MacBride Report. (Nordenstreng, Brown, & Traber, 1998)

The project was completed in 1998—after further funding from the Finnish Development Assistance Agency (FINNIDA)—with extensive regional surveys and several reports. Its central conclusions were as follows:

> It is clear from the survey that the need to publish local textbooks with a regional orientation is very strong. While textbooks rooted in the local context are very important, the aim should not be to exclude all foreign books completely. It should be recognized that some communication approaches are universal and cannot be pinned down to any particular region. There will, therefore, be a need to have certain inter-regional textbooks. But for those materials that need localizing, some of which this study has identified, every effort should be made to encourage the writing and publishing of local textbooks.

Finally, this survey shows the urgency of theoretical work in the area of communication and culture. What are the paradigms of basic models of communication processes in, say, the Arab world or Africa or Asia? A critical mass needs to be developed, consisting of interdisciplinary studies, particularly from the field of anthropology, social psychology and culturally relevant epistemology. It is only on the basis of new theoretical insights on the relationship between culture and communication that significant progress in educational materials for communication studies can be made.

However, a start has been made, and the process so far has been very encouraging. It not only created awareness of the situation, in most cases dismal, but actually prompted institutions and individual researchers to develop plans for the creation of new manuscripts. In addition, it has brought together communication educators and researchers from most regions of the South. These contacts have laid the foundation for South-South cooperation in what have been, hitherto, uncharted waters.

After completing Phase II of the project, and gaining seven years of additional experience, we recognize that all this and more still needs to be done. However, the project has helped to make a start. We can proudly point to the fact that a new cross-cultural text, *Communication Ethics and Universal Values* (Christians & Traber, 1997), resulted from regional seminars organized by WACC, and as a response to the textbook project. We can also refer to *two global textbooks* which were initiated by the project and which will soon be completed—one on environmental reporting and another on multicultural theories. . . .

However, despite these examples and many optimistic plans, the main problems have not yet been solved. One may even say that on a global scale there has not been real follow-up nor implementations—though the diagnosis is complete, the patient still awaits treatment. Such a gloomy conclusion is inescapable considering the enormous growth of media research and publishing in Europe and the USA, especially on the information society and other policy issues of the North. (Nordenstreng, Brown, & Traber, 1998)

Accordingly, the first blueprint for the present book grew out of the textbook project in the mid-1990s, and it was expected to be edited by Aggrey Brown (for Latin America and the Caribbean), Anura Goonasekera (for Asia), and Michael Traber (for Africa). However, the materialization was slow and was finally suspended by the demise of the editors.

Meanwhile, the rationale did not fade away. On the contrary, globalization in the new millennium made it ever more topical. In 2009 Cliff Christians, Bob White, and the present author discussed the matter under a tree at St. Augustine University of Tanzania and decided to move ahead with the added impetus of honoring Bob's lifelong contribution to the cause of communication theories in a multicultural world. The title is born out of the realization that most original and significant theoretical development is stimulated by attempts to challenge the structures of power, injustice, and de-humanization. Though not a textbook as envisioned by the IAMCR, this volume fulfills its goal of advancing the field by cultivating theory on a worldwide scale.

While the book draws on an understanding of communication theory as a product of its socio-political and cultural context, and the challenges posed by

that context, it also highlights each author's lifetime effort to both critique the existing trends in communication theory and bring out the very best in each cultural context. The selection of authors and their angles can naturally provide just a small sample of multiculturalism. Thus, the book demonstrates the richness of variety in terms of regions and topics rather than a full panorama of the world. In this respect it joins the row of contemporary contributions, such as *De-Westernizing Communication Research*, put together by Georgette Wang (2011).

On the other hand, the book does not suggest multiculturalism to be an easy solution to get rid of the ethnocentric burdens of the past. As Raka Shome (2012) has pointed out, the multiple drives away from modernities in Asia and elsewhere are vulnerable to superficial scholarship—also in cultural studies. Therefore, multiculturalism is invited to build on the solid grounds of the postcolonial tradition. In this sense the book has a humble approach to the way we study the world. At the same time it has a straight normative approach in that it wishes to promote a better world.

Bibliography

Christians, C., & M. Traber. (Eds.). (1997). *Communication Ethics and Universal Values*. Thousand Oaks/London/Delhi: Sage.

Curran, J., & M.-J. Park. (Eds.). (2000). *De-Westernizing Media Studies*. London: Routledge.

Nordenstreng, K. (2004). "Ferment in the Field of Communication Studies." *Javnost—The Public*, 11(3), 5–18. Available at http://javnost-thepublic.org/article/pdf/2004/3/1/

Nordenstreng, K. (2011). "Lost in Abundance? Reflections on Disciplinarity." In B. Zelizer (Ed.), *Making the University Matter* (pp. 194–205). Milton Park, UK, & New York: Routledge.

Nordenstreng, K. (2013). "The New World Information and Communication Order: An Idea That Refuses to Die." In J. Nerone (Ed.), *Media History and the Foundations of Media Studies*. (pp. 477–99). Chichester, West Sussex, UK: Wiley-Blackwell. Vol. 1, *The International Encyclopedia of Media Studies*.

Nordenstreng, K., A. Brown, & M. Traber. (1998). "Overview." In K. Nordenstreng (Ed.), *Inventory of Textbooks in Communication Studies Around the World*. Tampere, Finland: University of Tampere, Department of Journalism and Mass Communication, Reports C 26/1998. Online http://www.uta.fi/cmt/textbooks/ Also in *Javnost—The Public*, 5(1), 79–89. Available at http://javnost-thepublic.org/article/pdf/1998/1/5/

Nordenstreng, K., & M. Traber. (Eds.). (1991). *Promotion of Educational Materials for Communication Studies: Report of Phase I of a UNESCO/IPDC Interregional Project by IAMCR/AIERI*. Tampere, Finland: University of Tampere, Department of Journalism and Mass Communication, Reports B 34/1991. Available at http://www.uta.fi/cmt/textbooks/

Shome, R. (2012). "Mapping the Limits of Multiculturalism in the Context of Globalization." *International Journal of Communication*, 6, 144–165. Available at http://www.ijoc.org/

Thussu, D. (Ed.). (2009). *Internationalizing Media Studies*. New York: Routledge.

Wang, G. (Ed.). (2011). *De-Westernizing Communication Research. Altering Questions and Changing Frameworks*. London & New York: Routledge.

PART ONE

Overview

Keeping the Public Sphere(s) Public

ROBERT A. WHITE

Virtually all of the contributors to this volume, in presenting a theoretical stance, have also told something of their personal life journey. At some point all have taken a strong value stand. I have always been grateful for the events that took me out of the functionalist sociology of the 1950s and into an area of the field of communication that demanded a value stand. The sociology of the 1940s, 1950s, and into the 1960s was struggling to get legitimacy in universities and had to declare its allegiance to the value-free objective scientific orthodoxy of the time. Talcott Parson's functionalism, presenting social systems as self-adapting with no human or social intervention, seemed to fit the demands of a value-free, naturalistic science. This theoretical stance, I am increasingly convinced, isolated functionalist sociology from professional and societal significance—even from a social engineering perspective. It took a new generation of social theorists, such as Anthony Giddens, to open sociological theory to the objectives of societal construction.

Communication sciences, on the other hand, grew out of the realization that newspapers and public speaking were important for giving the public more control over elected political leaders and to provide the upwardly mobile working and middle classes the information they needed about socio-economic opportunities (Dicken-Garcia, 1989; Marzolf, 1991). Denis McQuail, in his essay in this volume, sums up the centrality of the normative in the field of communication, with telling insight: "It is tempting to suppose that what has saved the 'field' from

evolutionary extinction has been precisely its openness to reliance on normative impulses of a compelling kind." The chapter by McQuail is a notable analysis of the role of the normative in the development of the field of communication. Historically, the contrast of the demands placed on the press and the continued irresponsibility of the press led the Pulitzers and other reformers to look for ways to build social responsibility into the media. The solution that began in America and then spread around the world was to provide professional training for journalists and other communication roles. The goal of pioneers such as Walter Williams, who founded the first journalism school at the University of Missouri, was to build into job-oriented training the ideal of opening and expanding the democratic public sphere (Marzolf, 1991, pp. 55–56). As universities around the world have introduced professional communication degree programs, the theory-building process has also grown with advanced degrees, academic associations, research programs, and publications. With this has come a progressively clearer idea of the relation of how the media contribute to building and strengthening the public sphere.

Ironically and interestingly, the theoretical perspectives that have developed in the global south—Latin America, Africa, and Asia—and in the post–World War II social movements in Europe have returned to the United States to help restore the sense of the public in American media. This, the contributors to this volume, speaking from their own cultural experiences, have pointed out well.

The central idea of the public sphere, I would argue, is precisely that it is public. It is (1) open to all to speak their opinion, information, objections, and rhetorical arguments regardless of their social status, education, communication skills, rightness or wrongness, or any other form of communicative power. This is the significance of the thinking of authors such as Clemencia Rodriguez (2001, 2011) in affirming the importance of citizen media, the direct entry into the public sphere to exercise the right to communicate. (2) No part of the public sphere can be private property excluding the views of others. Private media must be subordinate to the public good (Curran, 1991). The rules that govern the public sphere must be set and applied by participatory, democratic processes that allow all the citizenry to govern the public sphere. The democratization of communication means precisely that all citizens participate in its governance. (3) It is dialogical in that it is constituted by interchange in which all are listening to what pertains to them, are challenged, and must respond (Cissna & Anderson, 1994). (4) The language of the public sphere is understandable to all who are part of the culture. Specialist languages at some point must be put into the popular culture language. (5) The public sphere must be based on a common normative discourse and common theoretical discourse of democratic governance. The powerful and the powerless must share a common language and set of values, otherwise there can be no basis for debate about power allocation. (6) The public sphere is con-

testable with every proposal being challenged, in terms of its validity, to the rest of the public. The public sphere, as Habermas would argue, must withstand the test of "rationality," namely, that the proposal supports the common good.

But why is keeping the public sphere public so important? Every reader could think of a reason. I would start with the defense of our humanity. We are born with the capacity for humanity, but it is only through communication with those around us that we become human, and the richer the communication environment the more our humanity is likely to develop. We are communitarian in that we cannot survive outside of community. The dialogical dimension brings in a communication that enables every person to take possession of one's identity and become truly creative in building our human cultures. The public-ness challenges each person to open our identities to social and physical environments to build a deeper integrating relationship with the environment. The life of the public sphere cultivates a respect and reverence for the community as a whole, in the lives of all members of the community and in the universe of existence of which we are a part.

Keeping the public sphere public is, of course, a struggle. The old distinction between administrative and critical research is one pointer to this fact. But underlying this is the perception that the tendency toward the concentration of power in the public sphere is continual and continually fabricates its own ideological reasons as to why monopoly is the best way to achieve the common good. The contributors to this volume have a wide variety of interests, but I would suggest that a common denominator is that each has invented or developed an insight into the public sphere that, on the one hand, reveals the falsity of the monopoly argument and, on the other hand, invents a new way of understanding and defending how to keep the public sphere public.

When the editors proposed that this collection of essays might be in some way a recognition of my own efforts, my immediate response was to protest the thinness of my own bibliographical record, as Michael Real notes with congeniality in his essay. My second thought was that this is a "we" book. That is, these chapters represent a common effort toward an ideal, and I would like to argue that this common effort is best summed up as "keeping the public sphere truly public." My own efforts have been more as "convener," "editor," "facilitator," and "moderator." Some of the contributors have been part of a broader school of thought, but all, individually or as part of a larger group, have made significant contributions to our contemporary thinking on how to keep the public sphere public. I see my own description of the public sphere above as only an opener. What I would like to do in this chapter is to reflect on the contribution of each of the authors to the way we can think of the role of communication in defending the public-ness of the public sphere.

Let me begin with a bit of my own story that explains how the vision of each is refracted in this account.

A Son of Kansas Populism

When Seymour Lipset set out to write his PhD thesis on where in the United States socialism had become a significant socio-political and cultural force, it was not in the garment district of New York but on the high plains of North America, stretching from Oklahoma north to Saskatchewan in Canada. In the background was the crisis of a one-crop wheat economy, the exploitation of the Eastern bankers and the railroads, the strong communitarian structure of settlements set up by the Land Grant Act, and the influence of many immigrant groups from a Europe that already had some acquaintance with the communitarian vision of socialist-inclined movements. The Land Grant Act required that the community establish and maintain a community school, a community-based road system, community cooperation in virtually all farmstead improvements and community cooperation in many aspects of farming.

Into this communitarian vision of life came some elements of the socialist political strategy as a solution to the economic exploitation Great Plains farmers experienced in the late 1800s and early 1900s. At one point significant parts of the Populist Party followed Eugene Debs into the Socialist Party, and the Socialist Party controlled one-third of the vote of Oklahoma (Lipset, 1950–1971, p. 27). The people of South Dakota went so far as introducing a series of state-owned enterprises: a state-owned farm marketing system, state-owned flour mills and meat packing plants, and a state-owned cement plant, which has long supported the South Dakota school system! The movement in North Dakota established a state bank, a state-operated loan system, and a series of other state collectively owned services (Lipset, pp. 23–28).

These political party movements in the United States lost force because of splits in the socialist movement, but in Saskatchewan the socialist political movement remained strong into the mid-twentieth century. Many of the proposals that were crucial in U.S. collectivist rural development and legislation had their origins in the populist movement. What remained influential in the United States even up to today has been a movement for cooperative grain and cattle marketing, a cooperative farm supply system, a government-supported cooperative system of rural electrification, a state-maintained support for market prices, and other forms of security and rural life improvement. Legislation incorporating many of the proposals supporting the farm economy and quality of life was introduced in the 1930s during the Roosevelt administration.

My own introduction to the ideals of the public sphere was largely in the context of a family culture that was part of broader "populist" culture, especially my father's deep involvement in the Kansas farm cooperative movement. He was a

"dirt farmer," but he worked for years to build up the system of collectively owned cooperatives as president of one of the largest farm marketing and supply cooperatives in Kansas, as an officer of the local rural electrification cooperative, and as the chairman of the board of a community bank. One of his youthful memories was standing in a city park listening to the oratory of William Jennings Bryan. My father also argued eloquently for the alliance of movements of farmers and labor unions. In the background was the communitarian life of community-run schools and churches, a party-line telephone system, community harvesting, and much other community cooperation. Births, weddings, funerals, and celebrations of successful sons and daughters were community affairs. As a family, we wrote for the community newspaper and discussed what other members of the community wrote. At the age of sixteen when I entered one of many essay or speaking contests to pick up a little extra cash, the theme was, after some family consultation, "Why cooperatives are important." I found full support for this collectivist vision during my youthful involvement in the Catholic rural life movement.

When I opted to express these family values as a Jesuit (somewhat to my father's discomfort!), I entered a community that had its best and brightest active in the major social movements in the United States at the time: writing, doing research, and becoming advocates in the labor movement, racial integration, and other major social U.S. legislation. Fr. Leo Brown, SJ, was for years the president of the American Academy of Labor Arbitrators. As young Jesuits we formed our own discussion groups on the social, collectivist vision of the Church, the so-called social encyclicals. As students we played cards with Walt Ong and others just as passionate about their scholarship.

Ruth and Keyan Tomaselli comment that I was much influenced by the Second Vatican Council. It is true that I welcomed the theological and social development ideas coming out of Vatican II. But in fact we relished it because our lecturers in theology had been writing books about the future of the Church for twenty or thirty years before the Council. The social development values coming out of family, Jesuit social action work, and our activist social context pushed us toward the vision of Vatican II.

I was one of many young Jesuits invited to get a degree in the social sciences, and I volunteered to work with a team to establish a center for social action and research in Honduras. Experiences in Latin America led to a PhD in the Sociology of Development at Cornell University and close work with Henry Landsberger on peasant movements in Latin America. My interest in rural development Latin America introduced me to years of research and cooperation with the radio school movement working to educate and organize peasant farmers in Latin America. The research experience with radio schools brought an invitation to an appointment as research director at the Jesuit Center for the Study of Communication and Culture (CSCC) in London.

The international Jesuit community had voted as its priority, "Faith that does Justice." That became the policy priority of the CSCC, leading me into dialogue with most of the contributors to this volume. The CSCC had a special link with Jim Halloran at the Center of Communication Research at Leicester University, and eventually with Graham Murdoch and Peter Golding.

It was during the years at the CSCC that I met and began working with some of the founders of communication research and policy action such as Paul Ansah in Ghana, Frank Ugboajah in Nigeria, and Francis Kasoma in Zambia. This commitment continued during the seventeen years of teaching in the Faculty of Social Science at the Gregorian University in Rome. The experience of supervising scores of MA and PhD students from Africa carried my heart into that continent. In all of my years of research and teaching in Africa, one of my closest reference points has been the political economy perspective of Keyan and Ruth Teer Tomaselli. Clearly, the Tomasellis and many of their former students and close colleagues have been among the major defenders of the public sphere in Africa.

For more than twenty years, one of my closest colleagues was Michael Traber, editor of *Media Development* of the World Association of Christian Communication. With Mike Traber (a co-author of books with the editors of this book), we were able to do research and become advocates of major issues in defending the openness of the public sphere. In all of these efforts we assumed without question that we were part of a long, global process of democratization and humanization such as has been described by Karl Polanyi (1944–2007) in *The Great Transformation*, by Raymond Williams (1961–2011) in *The Long Revolution*, or any of a number of other attempts to trace a historic process of democratization in human history.

It was at the CSCC in London that my own concern for defending an open, egalitarian, democratic public sphere began to focus more on research and policy in the area of communication and cooperation with many of those writing in this volume. Each essay in this book has brought out some aspect of the participatory, interactive public sphere and forms part of a more integral vision of the public sphere.

The Cultural Studies Approach in Britain and the United States

I will begin this exploration of concepts of the public sphere with the essays of Roger Bromley and of Michael Real and David Black that analyze the "career" of cultural studies past and present in Britain, America, and elsewhere. The ritual, dialogical perspective of James Carey, but also the more critical wing represented by Larry Grossberg, have been crucial in defining the identity of my own theoretical perspective not only in communication but also in development studies, religious studies, and now in peace studies.

James Carey's challenging of the weaknesses of the dominant American transmission model of communication and his validation of a ritual, cultural model consolidated my own lifelong identification with questioning dominant paradigms. I had long doubted the validity of the linear model of imposing effects as found in the modernizing, strong-state models of development. This may have something to do with my origins in Kansas populism and years of research among the Native American Lakota people in South Dakota. Systematically challenging dominant paradigms that are so often part of a hegemonic socio-political formation has been a link with many colleagues writing in this volume. Pradip Thomas's essay is a good example of this, as is the systematic theoretical work of Brenda Dervin and Peter Shields in their chapter.

Influential for me is Carey's (1977) approach to cultures as a "text," the conscious, reflexive analysis of culture as a particular interpretation of a situation for a particular group that can then become the basis of dialogue with other groups in other valleys casting up their interpretations of reality (pp. 422–23). The public sphere thus becomes not a linear imposition of the meanings of one hegemonic alliance but dialogue among many interpretations of the situations. Here I adopt Arnett's definition of dialogue as openness to the contrasting difference and strangeness of the other (Cissna & Anderson, 1994). This is reflected in Carey's (and my own) identification with Midwest American communitarians such as John Dewey. I see this dialogical interpretation of the public sphere in the thinking of many in this volume, especially that of Cliff Christians, long a close colleague of Carey.

A third area of cultural studies helpful for my thinking has been the analysis of distorting ideologies that defend hegemonic cultural formations. The unmasking of hegemonic ideologies, especially the method of Stuart Hall (1977), has been extremely important in the study of post-colonial control systems in Latin America, Africa and elsewhere in the global south. The commitment to the political, theological, communication and literary vision of liberation movements depends so much on this analysis.

Hall's concepts of decoding and the landmark *Nationwide* studies (Morley & Bronsdon, 1999), carried out by the Center for Contemporary Culture in Birmingham, UK, opened audience analysis to the capacity of publics to make their own interpretation of media texts and resist, from the perspective of the social identities of audiences, the hegemonic ideological dominant code. The discovery that subaltern groups do read the media from their own resisting perspectives— especially when they are part of a protesting movement—has pointed our research toward studying the capacity of the popular classes to generate their own interpretations of the dominant culture. The recognition of the tendency of oppressed groups to identify with the sufferings of the oppressed in the media (Ang, 1985) has been important in understanding the use of people's radio and community

radio and other popular media genres to refashion the symbols to reinforce countercultural identities (Jenkins, 2012). This points to the fact that the media do not establish the public sphere but rather that people interpret the media.

I am also indebted to the openness of cultural studies to the Marxist methods of political economic analysis that sees culture and the public sphere as narrowed and constrained by those who control the material conditions of a society. Janet Wasko synthesizes well the present state of this analysis, with Peter Golding and Karen Williamson linking this to the current neoliberal impositions in Britain.

Real and Black's analysis of the crisis of cultural studies research as the cultural studies approach becomes absorbed into contemporary tenure-track and bottom-line university cultures is a welcome warning. The home of cultural studies is not academia but in the newly emerging minority cultures attempting to explain the value and validity of these cultures so that they can be brought into the dialogue of the public sphere. This is what the cultural studies emphasis did so well in Britain, France (with Bourdieu and Foucault), and elsewhere in the socio-cultural transformation of Europe in the post–World War II years.

One of the major contributions of the critical cultural studies tradition are the analytic tools for the struggle to bring excluded cultural minorities into the dialogue of cultures that constitute the public sphere. Always it was clear that cultural empowerment is closely allied with political-economic empowerment. Theorists such as E. P. Thompson and Richard Hoggart were important in providing methods of analysis that could be placed in the hands of lower status groups in Britain and other parts of Europe to break down the cultural barriers of feudalistic and bourgeois hegemonic formations. Stuart Hall extended this to the struggle of immigrants from former colonies. Bromley's chapter shows particularly well that with globalization the struggle is widened to a host of cultural minorities in Asia, Africa, and elsewhere in the world. With this broadening of the scope of cultural studies has come many new methods of liberating analysis.

People Must Shape the Flow of Information in the Public Sphere

The public sphere is a conversation, a debate, a dialogue, a flow of information, but, as Pradip Thomas insists, it is not really public unless the poor (in information and all other resources) and the marginalized can define the themes of the debate and what information is actually made available. The critique of the modernization model has been precisely that the elites in developing nations decide when and what information to supply and on their terms. The public hearing institution in India is another way of stating that anyone—but especially the poor and the marginal—have the right to demand that information be made available on the terms of the poor.

Thomas's introduction of the theory of four distinct levels of the process of communication and development-social change emphasizes the importance of opening the public sphere to the marginalized. The first dimension, the theory of knowledge, is another way of saying that the presently excluded must define the language and process of communication. The second dimension, the structure of interventions, also opens the lines of access of the public sphere to the participation of the poor and excluded. If health or agricultural information is to be made available, the people must define what information will be given, the form of the information, and how it will be applied. The third dimension, the specific understanding of the practice of participation, demands that the people define the practices of decision-making. In the fourth dimension, the people involved must make sure that the response to their request for technical information and financial support must fit in with the people's tradition, culture, norms, social divisions, and processes of information distribution. What Thomas and others in this collection make clear is that the public sphere is not public unless the less powerful are fully present and setting the terms of the dialogue by their united action.

The Public in Development: Not the State But Indigenous Grassroots Initiatives

Thomas Tufte's chapter reinforces Thomas's argument that social development can happen only if the more marginal, especially rural people, are allowed to become the protagonists. Early development theory and practice made the state planning and extension of technology from the global north the "engine of development." State bureaucracies were defined as the public. This failed because it excluded the farmers and communities who would actually take development initiatives. Tufte points out a growing consensus that development be based on initiatives of the local people and operate under local organizational control. Such initiatives will more likely be based on the indigenous knowledge and organization of the people, will be more sustainable, and will generate benefits for the local people. What is asked for in these cases is that government agencies and nongovernmental organizations (NGOs) respond to the initiatives and requests of local organizations with technical assistance and other support.

Supporting these local efforts are spontaneous movements that emerge in moments of local crisis under local leadership. A second trend is the growth of independent civil society organizations that provide advocacy, build networks and coalitions, and link grassroots initiatives and government officials. A third trend is the importance of small media in development: mobile phones, Internet, video.

Tufte is right to be cautious in placing full confidence in all of these trends being able to generate development based on grassroots initiatives without a sufficient power base to force the bureaucratic elite to provide the resources to support peasant farmers, the millions in the informal economy, or other popular move-

ments. There are many grassroots initiatives for solving problems, but lower status groups in developing countries have relatively little mass organizational capacity and may not yet be a significant public. As they themselves imply, the arguments of Thomas and Tufte need to be grounded in a more macro-political economy analysis and program of action.

The Political Economy Perspective

The field of communication tends to emphasize that new media technologies are opening access to information and the sphere of public debate to more and more people. But as Janet Wasco makes clear in her chapter, echoed by Golding and Williamson: "The studies of ownership and control (in which) political economists document and analyze relations of power, class systems *and other structural inequalities* (emphasis added) show that new technology is actually restricting access to information." This analysis calls our attention to the fact that in the world of media there is a progressive commodification of public communication; that is, putting a price on information according to market demand that automatically excludes those with fewer monetary resources. Information is power and the information rich are tending to increase their monopoly power. Much of the original national legislation around the world placed great emphasis on information being a public good, available to all regardless of the capacity to pay. Nevertheless, progressively there has been increasing concentration of economic control of the media and increasing introduction of legislation to permit making information a marketable commodity.

A second important contribution of the political economy perspective is the study of how specific corporations limit availability of information by increasing the price of that which has greater key importance and demand. This restricts the creativity of the public because key information is not available except at exorbitant costs. This also restricts diversity, equal access to information, and the ability for democratic participation in the public sphere. Of increasing importance is exposure of the growing digital divide causing the increase of access to Internet to those who have greater financial resources.

Political economy research has been particularly important for revealing the continued neocolonial dominance of the global north over the global south. From independence, the nations of Africa, Asia, and Latin America realized that their political independence meant nothing without economic independence, cultural independence, and finally communication independence. This set the stage for debates over the New World Information and Communication Order. The dominance of film, music, news and Internet information, and the cultural sphere by industries in the countries of the north continues in new ways. However, as Jésus Martin-Barbero (1993) documents in the case of Latin America, and I. E. Uwah (2008) with regard to the Nollywood film industry in Africa, the culture indus-

tries of the south are reaffirming their national cultural identities and creating a more open public sphere in those countries.

Much of the research perspective that Janet Wasko describes paints a pessimistic view of increasingly concentrated economic power over the national and global public spheres. Peter Golding cites studies that show that the poor and the working classes have less access to information that would enable them to know more about collective movements to improve their education, health, and other services and information about improved skills and incomes. However, Janet Wasko does point to shifts in the focus of political-economic studies from macroeconomic to micro-social movements that may deal with economic issues but also touch on respect for the freedom and dignity of the people involved. As Clemencia Rodriguez argues (2001), the era of theories of overarching, epoch-changing social processes may be a thing of the past in this postmodern time. More important is the study of the little movements that create a space for freedom, dialogue, and debate built around local cultural symbols of identity and involving very local sorts of media expression. Today, more than ever, it may be appropriate to speak of public spheres in the plural.

The Public Sphere as the Space of Autonomy for Affirming Identity

Stewart Hoover points out that what has been perceived as secularization is, in fact, a decline in the clerical and doctrinal *authority* of religion. Religion has become one more area of personal seeking or questing to affirm and craft one's personal identity. Giddens has argued that a major social trend is a reflexive and autonomous practice of the self, collapsing identity not in large social formations but to the individual and to the local. As Henry Jenkins (2012) has revealed in his studies of fandom, the media are a major source of cultural resources to build one's own identity. The individual can look over a great variety of definitions of identity and pick elements to fashion one's own unique identity. Religion becomes an important source for identity formation because it is already symbolic and identity oriented. As Hoover points out, contemporary religion seeks its reproduction in the media because religion is often the foundation of the meaning of a particular culture, and both the religious leaders and other leaders want to maintain its validity as the frame of meaning of its culture. But the "mediatization" of religion loosens the control of religious leaders and makes it more *publicly* available for individual uses to affirm personal identity.

A second way mediatization emphasizes the public nature of religion is the fact that religion always materializes itself by borrowing symbols and narratives from the culture, which are part of the media culture within a society. A religious leader or innovator faces the difficulty of making his or her interior experiences

understandable to others and takes familiar symbols, stories, or paradigmatic events as means of expressing the interior experience.

A third way the media make religion more publicly available, according to Hoover, is that the media *are* a religion in that the media present stories about our cultural reality as a framed narrative, a whole cultural reality far more organized and coherent than our culture really is. In this sense the media narratives present an ideal world (a liminal world as Victor Turner would put it) that we can enter into, try out, and adopt as our own. The media are a liminal ritual experience that takes us out of the real, everyday life and projects a mythic, ideal reality that a culture is trying to create and invites the public to rise above their differences to find a unifying dialogue in the mythic ideal community the public would like to create.

A fourth way the media contribute to the formation of the public is the analysis of the way media experiences—often not in themselves "religious" in terms of denominational, doctrinal definitions—produce constructions of meaning that people consider sacred and religious. The research of Hoover and his associates finds that the digital media experience is particularly productive of these "religious constructions." For those who discover and construct these meanings, which often have little relation to conventional religion, the meanings are religious because they are in some way transcendent.

This emphasis on the public as the space of autonomy and freedom introduces a very non-instrumental dimension of the media experience quite different from the increasing economic control of the public that the political economy research is emphasizing. Although the economic controllers of the media attempt to control identity formation through advertising of material goods, the research of Hoover and others following the theoretical orientation of Giddens may discover a different locus of the public. Our work world may become less significant than our leisure world. Our leisure world permits far more personal freedom than the work world, which is so dominated by the political-economic order.

The Ecological Interrelatedness of Our Mediated Cultural Environment

Part of the problem of affirming the sense of interdependence that constitutes the public sphere is the tendency since the Western Middle Ages to emphasize the *analytic*, the essential separateness of all aspects of our reality. The public is seen only as a collection of juxtaposed individuals, each in isolated creativity. The self-determined freedom of the person defines the human, not our capacity for intercommunication. We have lost the Greco-Roman vision of our destiny in universal harmony, and now only the power of the state forces us into reluctant contractual harmony.

Paul Soukup's bringing in the media ecology mode of thought is a much welcome response to the overemphasis on the analytic, the essential separateness

of the human. Media ecology sees the human as interrelated, interdependent, and interacting, but without losing the authenticity of the personal. It is significant that so many of the major thinkers in the cultural ecology tradition find their roots in the sense of community and human connectedness of the American progressive era or in the intellectual tradition of the nineteenth- and early twentieth-century romanticist movement, especially in the way that it thought of the new social movements of the nineteenth and twentieth centuries.

Clifford Christians and his close colleagues, Mark Fackler and John Ferré, have brought the logic of communicative interrelatedness of the media ecology perspective into media ethics by challenging the argument that the foundation of media ethics is our individual freedom. Rather, they argue in their communitarian perspective that the root paradigm of media ethics is one of mutual interdependence and dialogue toward a public common good.

Joseph Faniran, with his explanation of communalism as it is found in Africa, takes the empirical emphasis of Carey and media ecology to the more ontological level and sees our existence in community as a normative imperative. In many ways, the recognition of the primacy of the community and the fact that the community is the ground of our existence adds a very important existential dimension to our understanding of the public. Although Faniran introduces the communalistic communication in terms of the African cultural perception, there is much of the universalistic notion of the primacy of the community.

Faniran has made clear that the struggle of Africans to maintain their communalistic, egalitarian values in the face of the colonial societal imposition should be more central to communication theory in postcolonial societies. In Africa and elsewhere in the global south, the construction of a public sphere has been made much more difficult by the persistence of social divisions, grades of superiority, and other divisions that the colonial occupation imposed.

Keval Kumar brings out the essential relatedness of persons in Indian cultures and how this led to a conception of the public as discussion, interchange of insights to bring to fruition or essential relatedness. One of the great advantages of the multicultural emphases of this book is that it brings many conceptions of the public sphere to enrich the rather narrow Western tradition.

Reforming the Bankrupt Political Philosophy and Communication Ethics of Special Interest Democracy

Faniran's argument that a philosophy of communalism is the only way out of the continued dominance of the colonial model of society is valid not only for Africa and other postcolonial societies but is also relevant for finding a way out of the social fragmentation of liberal democracies. The essay of Christians provides a devastating critique of this. The trustee journalism that evolved in the nineteenth and twentieth centuries presumed that democratic progressive society aimed to do

little more than enable every single interest to succeed in its individual goals. The social responsibility role of the media is summed up in telling the public what is transpiring in the public sphere as objectively, accurately, without bias, and completely as possible, and let every interest group use this information to further its own goals. Throughout the world, the poor, the marginalized, those without resources of education and expertise, the minorities are seen as simply incompetent among competing interest groups.

What this democracy of competing interests and trustee journalism has produced, where it is allowed to progress unchecked, is increasing injustice throughout the world, in large part because the weak do not have the communication competence to get and use the information they need. The communitarian ethics of Christians is based on an ethics of compassion and service built around genuine dialogue in the public sphere. Christians' conception of a dialogical ethics emphasizing empathy, caring, awareness of the lived experienced of others, the duty of nurturance, compassion, and cultural diversity is essential to a dialogical public sphere. Communitarian ethics prioritizes a journalism that fosters our sense of interdependence, community bonds, and awareness of the needs of others, especially awareness of how to empower others so that the whole community is better served. A dialogical communication emphasizes listening to others, constructing the meaning of a situation together, openness to the strange and disturbing realities of other cultures and lifestyles, and especially a love of others as they really are constituted. A dialogical communication prizes the capacity to deliberate together so that the interests and needs of all, especially minorities, are recognized and respected.

Theodore Glasser and Isabel Awad introduce the notion that cultural identity is central to our dialogue. A communitarian ethics assumes that all individuals and groups in society are *interdependent* and that the weakness or strength of one party influences the well-being of all. To have a truly universal well-being depends on an operative system of contributive justice in which all contribute to the common good according to their capacity, and distributive justice in which the common good is distributed to all parties according to their individual need and need in terms of contributing to the whole society. For all to realize that the weakness of one is a weakness of all demands a continual education process, precisely through the media.

The essay of Cees Hamelink reinforces and complements well the arguments of Christians and of Glasser and Awad with his insistence on the equal right of all persons to communicate in the public sphere. The human rights movement, which insists on the real equality of communication opportunities in the public sphere and real equality in access to information, has continually clashed with the neoliberal view that a person has the right to use property as one wishes. The insistence that the fruit of one's entrepreneurial efforts has social obligations, and

must accept the equality to communicate and gain access to information, clashes with the neoliberal political-economy institutions of the world.

Hamelink points out particularly well the difficulties of keeping the public sphere public at the macro-national and international level. Hamelink also clarifies that all of us tend to define the public from our own tribal interests and perspectives. As soon as other tribes begin to shout, we question their right to do so. He suggests that the efforts to vindicate the right to communicate, the key issues of equality, security, and freedom of communication, are more successful in very local contexts where the protests and uprisings are under the radar of the major concentrations of political-economic power.

Alliance of Communication Researchers with Popular Classes Widens the Public Sphere

Martin-Barbero, in his essay, has documented well how communication researchers in Latin America developed a theoretical orientation that explained and promoted the movements toward political, economic, and cultural independence. Latin America is a postcolonial society that has been able to affirm its own independent identity—to its great political and economic benefit—and the leaders in the communication sciences made a significant contribution to this. They refused the attractions to join the upwardly mobile into the oppressing classes—as is happening among many in universities in Africa and elsewhere in the global south—and they were important in making the elite-controlled public sphere of Latin American more public.

Many of the leaders in this intellectual movement, as young people, were involved in student protest or more direct cooperation with peasant farmers and labor unions. They were much exposed, at a practical level, to dependency theory, liberation theology, and theories of social transformation. Often, the control of major institutions by the moneyed classes blocked their access to positions in the universities. Instead, they moved into institutions for advocacy research and began to formulate the vision of a new communication order in Latin America. Martin-Barbero himself went into exile from Colombia and had years to do an outstanding Ph.D. thesis in France. The members of this movement were fortunate that much financial support for research and for meeting in conferences to share ideas was coming from the Nordic countries and the United States. They had time to do research, write, and publish.

Their academic work was often linked up with imaginative movements in popular radio, group communication, the adaptation of the Freirean method to radio and television, and the use of media by peasant and urban worker movements. Their cooperation with these movements encouraged an exchange of ideas for organizing the poor, political reform, and how to work consciousness-raising into radio and television programming. All this freed them from the petty poli-

tics of university departments and put them in contact with the broader issues of research and theory. Many were brought into meetings or did commissioned research regarding the New World Information and Communication (NWICO) debate for UNESCO or other organizations. Many also became involved with the International Association for Communication and Media Research (IACMR) and met many of the international figures concerned with a more liberating perspective in communication research.

Out of all this came a theoretical framework showing with much more clarity the forces for cultural, political, and economic independence in the media industry and public policy. Some of the most important books came from Martin-Barbero, but Néstor García Canclini and others influenced what is being taught in universities, government policies, and even the economic strategies of the media industry. For years the future of communication scholars in Latin America seemed bleak because they were excluded from the universities, but this turned out to be a blessing in disguise. Unfortunately, being re-admitted to the universities has not stimulated the creativity of younger scholars. Does this say something about the role of the university programs in communication in making the public sphere more public?

Making Communication Theory a Dialogue

I see Brenda Dervin and Peter Shields as responding to the central question of this essay: what kind of public sphere do we want and what kind of practice of the public sphere in the area of communication research and theory do we want? The authors have chosen to analyze the ongoing debate between critical and administrative researchers and argue that the inability to develop a ground for dialogue will produce no theoretical benefit and a great loss for the field of communication if the two camps cannot work together. When that distinction was set up some sixty years ago, the critical school expected the public sphere to become a more widely accepted set of overarching common democratic values. The media and all other institutions were expected to cultivate and sustain these values—social responsibility theory.

The U.S. media, and increasingly in other parts of the world, defended the value of freedom of media expressed in the United States and other constitutions as the foundation of liberal democracy. The profit motive was, foremost, justified in terms of the value of freedom. The media industry respected the right of the audience to select its media menu or simply not use the public media.

As the contributors to this volume have argued, in fact, the public tends to have fewer choices in the major public channels, but media research and the administrative school contend that with the enormous proliferation of channels and the Internet, the public does have a great variety of choice. Some of the critical school insist that, in fact, the poor do not have access to all these channels.

Dervin and Shields argue that, yes, individuals have a huge variety of media sources to choose from and this has cultivated an attitude of pick and choose according to one's tastes. The emphasis in cultural values today, as Hoover and so many others in this book have noted, is to make choices in response to one's personal identity, an identity that has been created by a life history of interactions—including media interactions.

Dervin and Shields argue that critical theory audience analysis has come much closer to administrative theory and that they are in a position to begin to dialogue to build bridges or at least link the areas of theory with common policy and practice. Critical theory sees audiences as ready to accept, negotiate (perhaps even transform), or reject media offerings according to personal and cultural identities. In this view we need to leave the media unfettered—which the administrative ethos and theory have argued all along. Not all critical theorists would accept this, but the authors would urge the two groups to try dialogue.

What the public sphere becomes in this new view of critical theory is a response to the active seeking of meaning and a dialogue both at the theoretical level and at the practical interpersonal level. Virtually all the contributors have found this trend of seeking and dialogue in their research and practice.

Summing Up: Keeping the Public Sphere Public

All of the contributors propose a public sphere based on a conception of human and social interdependence so that if one prospers this redounds to the prosperity of all. The public is a sphere of ecological consciousness in which all mediation is open and interacting. The public is not seen as simply the collection of individual entrepreneurs seeking individual advantages for communication and through contractual agreements. Rather, the primary goal of all communication endeavors is a culture of the common good that gives primacy to fostering an equality of opportunity to communicate and gain access to information throughout the life course of every person in the society. This conception of the public sphere prizes a communicative relation of care, concern, and nurture, especially of the less powerful and marginalized. This is a system of cultural values that esteems contributive justice in communication (all contribute to the common good according to capacity) and distributive justice (all receive in order to enhance their contribution). It is a public sphere of multicultural dialogue in which all open themselves to the challenging claims of communication justice posed by different cultures with a readiness to adapt to the justice of these challenges.

The contributors here tend to think of the public not as one large communicative arena, but as a multiplicity of public spheres emerging from new movements, the defense of local communities, continually redistributing the power of a feudalistic or imperial past, strong advocacy communication that seeks to make identities explicit, fostering cultural creativity. The conception of the public is

characterized by awareness of the continual harmful tendencies toward concentration of communication power, especially in the realm of the material political-economic order, but also an openness to movements to challenge ideologies and encourage dissent in the face of false unity in the name of harmony.

The contributors seek an academic public sphere that emphasizes a normative science, emphasizing grounded action research anchored in cultural communities supporting advocacy movements for communication justice. In that sense, all of the contributions respond in some way to my opening question: why is keeping the public sphere public so important? All insist on the public sphere as essential for our human and social creativity. They point to the fact that this form of mutual interrelatedness brings for all a sense of well-being and harmony that makes our human existence a social delight.

And now with a concluding thought: It is said that most scholarly careers begin with close adherence to proving a proposition with value-free, positivistic number crunching empirical data. The careers move to surveys of the theory of the field and then to the author's own comprehensive theoretical formulation. From there the career enters the area of research and broader policy formulation as a foundation for the next step, the discussion of the cultural significance of the author's theory for the society. Following this comes the book of poetry or a novel from the author's theoretical perspective, then a biographical reflection on the experience. The final life reflection looking back on this theoretical journey is a doxology, a religious contemplation giving glory to the source of Life in all this experience.

Many of the essays in this volume have a bit of the doxology about them. McQuail is most explicit when he seemingly sums up his career with a quote from the eleventh-century Norman English contemplative and theologian St. Anselm, "*fides quaerens intellectum*" [faith seeking understanding] or perhaps "reconciling faith and reason."

I would have to finish my own essay with my own doxology taken from the Jesuit poet Gerard Manley Hopkins:

Glory be to God for dappled things . . .
All things counter, original, spare, strange:
Whatever is fickle, freckled (who knows how?)
With swift, slow, sweet sour; adazzle dim.
He fathers-forth whose beauty is past change.
Praise him.

Bibliography

Ang, I. (1985). *Watching Dallas: Soap Opera and the Melodramatic Imagination*. London: Routledge.

Carey, J. (1977). "Mass Communication Research and Cultural Studies: An American View." In J. Curran, M. Gurevitch, & J. Woollacott (Eds.), *Mass Communication and Society* (pp. 409–426). London: Edward Arnold.

Cissna, K., & R. Anderson. (1994). "Communication and the Ground of Dialogue." In R. Anderson, K. N. Cissna, & R. C. Arnett (Eds.), *The Reach of Dialogue: Confirmation, Voice and Community* (pp. 9–33). Cresskill, NJ: Hampton.

Curran, J. (1991). "Rethinking the Media as a Public Sphere." In P. Dahlgren & C. Sparks (Eds.), *Communication and Citizenship: Journalism and the Public Sphere* (pp. 1–24). London: Routledge.

Dicken-Garcia, H. (1989). *Journalistic Standards in Nineteenth-Century America.* Madison: University of Wisconsin Press.

Hall, S. (1977). "Culture, the Media and the 'Ideological Effect.'" In J. Curran, M. Gurevitch, & J. Woollacott (Eds.), *Mass Communication and Society* (pp. 315–348). London: Edward Arnold.

Jenkins, H. (2012). *Textual Poachers: Television Fans and Participatory Culture.* London: Routledge.

Lipset, S. M. (1950–1971). *Agrarian Socialism: The Cooperative Commonwealth Federation in Saskatchewan.* Berkeley: University of California Press.

Martin-Barbero, J. (1993). *Communication, Culture and Hegemony: From the Media to the Mediations.* London: Sage.

Marzolf, M. T. (1991). *Civilizing Voices: American Press Criticism 1880–1950.* New York: Longman.

Morley, D. & Bronsdon, C. (1999). *The Nationwide Television Studies.* London: Routledge.

Polanyi, K. (1944–2007). *The Great Transformation: The Political and Economic Origins of Our Time.* Foreword by J. E. Stiglitz. Boston: Beacon.

Rodriguez, C. (2001). *Fissure in the Mediascape: An International Study of Citizen Media.* Cresskill, NJ: Hampton.

Rodriguez, C. (2011). *Citizen's Media Against Armed Conflict: Disrupting Violence in Colombia.* Minneapolis: University of Minnesota Press.

Uwah, I. E. (2008). "Nollywood Films as a Site for Constructing Contemporary African Identities: The Significance of Village Ritual Scenes in Igbo Films." *African Communication Research*, 1, 87–112.

Williams, R. (1961–2011). *The Long Revolution.* Foreword by A. Barnett. London: Parthian.

General Theoretical Conditions

Talking Communicatively About Mass Communication in Communication Theories

Beyond Multiplicity, Toward Communicating*

BRENDA DERVIN AND PETER SHIELDS

The purpose of this book implies an acceptance of two central ideas: (1) there exists a multiplicity of mass communication theories; and (2) proponents of each have rights of presentation—to speak of their theories—where they came from and why; what they aim to accomplish with what struggles and successes; and where their agendas now stand. These are noble and noteworthy ideas. They imply a kind of desirable journalistic neutrality—each viewpoint is offered its own uncontested platform. There is no mandate for the theories to cohere.

This acceptance of multiplicity has its own tensions. On the one hand, it is acknowledged that theories emerge and grow in struggle as developers aim to include ideas that were missing from, overlooked, or even rejected by prior theories. Yet, at the same time because it seems impossible to proceed otherwise, each of the theories emerges with its own independent existence—premises, vocabulary, and explanations. To even trained observers, results look like a supermarket of theories for which we must establish brand preferences for the theories that best suit our circumstances.

In this chapter, we accept this situation as given while at the same time proposing that our communicating about our communication theorizing needs to be itself an object of communication. In short, we call for implementing systematic

* This chapter is drawn from a paper presented at the Philosophy of Communication Division, International Communication Association. The text of the original was three times this chapter's length, including some 640 references compared to the 66 included here. Necessarily, citations below can only exemplify. Readers who wish a copy of the original paper may contact the authors at dervin1@osu.edu or pshields@ewu.edu. The authors thank Mei Song, graduate student at Ohio State University who assisted with literature reviews and analyses of specific theories.

procedures for dialogue across communication theories, not to homogenize them but to enable enrichment and growth. This seems an especially fitting purpose for honoring Robert White who has spent much of his academic life encouraging appreciation for communication theory multiplicities.

An important point to make is this. The change we are calling for—moving to a communicative way of communicating about communication theories—is not simply opening the door for more spontaneous sharing. It is rather a call for adding a disciplined communicative procedural layer inside normal scholarly routines. We do indeed now have many modes of sharing scholarship—conferences, journals, books, list servers, websites. Many of these call for what is labeled *dialogue*. The argument we present is that communicative ways of communicating must happen routinely by design if we are to make better sense from our communication theory supermarket.

Mass Communication Theories: In the Beginning

Our focus is mass communication theories. As hard as it is to imagine, there was a time when mass communication theories were infants—before the proliferation of electronic media and before what is now routinely accepted as the digital age in which media are no longer tools (for better or for worse) but rather structures that potentially define life (e.g., Silverstone, 2007).

While problems of communication have concerned human beings since antiquity, it is only recently that communication has become an object of systematic academic study. Propelled by the early spread of newspapers, magazines, film, radio, and television, mass communication–oriented units emerged all over the world with the aim of putting communication on the academic map. Communication was their business in structures that for the most part ignored communication. Ironically, this is no longer so, for communication has, with the explosion of digital media, become everyone's business. We find today a proliferation of mass communication theories impelled by both internal and external multiplicities.

To cut through this bewildering array we return to the theoretical "infants" of mass communication—theories developed in the 1960s through the 1980s. This allows us to zero in more cleanly on comparisons. In particular, it allows us to zero in on the one comparison that most dominated talk about mass communication theories as they emerged. It is also the single comparison—the divide—that still marches through communication texts albeit now in numerous disguises.

More Than Misunderstanding, Less Than War: "Critical" Versus "Administrative" Theories

The divide that most dominated talk of mass communication theories in the 1960s through the 1980s was that of whether a theory was "critical" or "administrative." At first the divide bubbled below surfaces, reaching a crescendo in the 1980s.

Depending on how one writes history, the debates began in the 1940s between Paul Lazarsfeld and Theodor Adorno (Rogers, 1982); were set off by Ithiel de Sola Pool and Herbert Schiller (1981) at a meeting of the International Association for Media and Communication Research in 1980; or were documented for history in a Summer 1983 special issue, edited by George Gerbner, of the *Journal of Communication* focusing on "ferment in the field."

A more antiseptic shorthand account is represented by Denis McQuail's (1985) division of mass communication theories into media-centered versus society-centered although McQuail's later compilations challenged that simplicity. Others did as well, pointing out how the debates involved more than the stereotyped divide, but also scientific-humanist, quantitative-qualitative, and political-cultural (e.g., Valdivia, 2003).

The aftermath of the debates is itself contested. Some have concluded that the two camps will always be polarized (Ito, 1989). Others suggest that such tensions are an inherent dialectic important to any viable field of scholarship (Craig, 1999) and necessary for impelling paradigm growth (Valdivia, 2003).

Most observers of scholarship agree that growth comes in part from an interchange of different ideas. In practice, however, the most frequent way of coping has been to develop shopping lists of different kinds of theories and approaches. A catalogue of the lists is interesting and mind-bending. As researchers on both sides have attempted to make sense of our differences, they have developed a seeming plethora of often useful but very different sets of categories: (1) from authors usually identified as "administrative"—critical studies, cultural studies, uses and gratifications, and media effects (McLeod, Kosicki & Pan, 1991); rhetorical, semiotic, phenomenological, cybernetic, sociopsychological, sociocultural, and critical (Craig, 1999); social scientific, interpretive, and critical (Fink & Gantz, 1996); and (2) from those usually identified as "critical": mass communication, the new left, and the cultural approach (Pietila, 1994); positivist modernism, interpretive modernism, critical modernism, and postmodernism (Mumby, 1997); cultural studies, communications, media studies (Cobley, 1996).

While such categorizations are instructive, in practice they are most often presented as separate and apparently equal. There is to most mappings a kind of pluralistic innocence and tolerance, or ideology and co-optation (depending on the observer). Further, amid calls for syntheses (e.g., Pietila, Malmberg & Nordenstreng, 1990), the various syntheses have differed, sometimes radically, among themselves. Klaus Bruhn Jensen (1996) concluded this based on his reading of mass communication textbooks, suggesting the roots were disciplinary differences and calling for interdisciplinary dialogue.

There have been some, however, who have concluded that dialogue across these differences is impossible because researchers in different camps have allegiances to antithetical premises—ethical, ideological, and/or methodological

(e.g., Garnham, 1995; Gilljam, 1984). As we see it, stereotypes from the debates are still alive and well but manifested in different ways. Most communication research is increasingly insular, developed within separate scholarly communities whose walls get higher and wider and whose theorizings become more impenetrable. We see mass communication studies as now peopled primarily by segregationists and separationists. The separationists ascribe to the live-and-let-live separate but equal position. They occasionally cite work from other camps, but primarily as it supports their own. The segregationists ascribe to a separate but unequal position: "We are doing it better and want as little contact with others as possible." They occasionally cite work from other camps but primarily for critique.

Those who call for dialogue, albeit for very different reasons, are few in number. There are explanations for this—crossing disciplinary divides is a difficult thing to do (e.g., Craig, 1999; Dervin, 2003). Having said that, it is important to note that interdisciplinarity may be harder for U.S. researchers perhaps in part due to the kind of tolerant separationist pluralism that exists in the midst of a still "healthy" domination by a quantitative scientific structuralism (e.g., Valdivia, 2003); and because U.S. political history has had large impacts on limiting, indeed sometimes excluding, alternative perspectives (Schrecker, 1986).

Despite the lack of a robust presence of interdisciplinary dialogue in media studies, there are calls. Some want to reach for the coherent communication theory they feel will finally mark the field as discipline; some want researchers to acknowledge that despite theoretic differences they are talking about the same fundamental issues; some want collaboration so the different camps may present a unified face to others; some want to address with renewed vigor the performance, design, and praxis of communicating in order to better serve public interest. In actual practice the most visible rapprochement can be seen in how both critical and administrative researchers have called for multi-method approaches, reaching across the formerly impermeable quantitative-qualitative divide (e.g., Murdock, 1997; Ruggiero, 2000).

Reframing the Debates:
The (Im)Possibility of Interdisciplinary Dialogue

For this chapter, we speak of the various theories of communication as "theoretical discourses." Following Derek Layder (1990), we understand a discourse as sets of relatively integrated clusterings of concepts that provide the parameters for certain forms of argumentation and the posing and addressing of certain kinds of questions. This network or "meaning universe" conception of discourse is not meant to imply consensus within the parameters of the discourse, although it does set the bounds of disagreement. Rather, it conveys the boundary defining functions of the linguistic-conceptual structure of a discourse in relation to other

discourses. These boundaries may well take on a blurred quality, especially with across discourse borrowings. Further, discourses are not static entities but rather dynamic constructions that are continually reproduced and occasionally modified. Drawing on Layder, we aim to conceptualize scholarly products in ways that align with calls made by those attempting to develop interdisciplinary work in the academy.

One of the ethics that drives us in this chapter is our belief that communication studies can be made not more coherent but more cohesive and more useful by building dialogic bridges between discourse communities. Our reading of the "administrative" and "critical" literatures suggests that an important step needs to be more careful reading of other authors both inside and outside our own discourses. We agree, we can never "fix" the text. But, alas, as others have observed, academic writing today is too often opportunistic. In general, it is fair to say most writing in media studies rests on far-too-shallow digs of the work of others. Problems include neglecting history and lineages; talking of alien theories in stereotypes; ignoring an author's full corpus (e.g., McLuskie, 1988; Meehan, 1999; Pietila, 1994). Most troublesome and often cited is the failure to use primary sources.

Thus, while there is growing evidence of motivation to address ideas from other discourses for purposes other than tearing them down, there are inherent difficulties in crossing discourse boundaries—in accomplishing genuine interdiscourse or interdisciplinary communication. One difficulty is that far too many proponents offer their perspective as the perspective for healing ruptures. This is most obvious for authors whose discourses are anchored in foundationalist, truth-as-correspondence premises and whose discourse apparatus are based on assumptions that statistical and other procedures can provide neutral observation languages (e.g., DeFleur, 1999, Rosengren, 2000). Paradoxically, authors operating out of postmodernist and interpretivist assumptions sometimes are seen as making the same kind of moves when they call for focusing on conceptual apparatus arising from their discourses as the means of addressing diversity without marginalizing it. The difficulty, of course, is that being integrated within another discourse's framework feels too much like colonialization, even in rarified academic camps. In the face of such invitations, it is not unexpected that the reception is not welcoming.

Our point is this: Crossing discourse boundaries is very complex because of the ways in which theoretical traditions are constituted by layers of theoretical apparatus and multiple discourses both within and between camps. What gets pushed to high relief in focusing on theories as discourses is the vital role played by communities of researchers—their shared standards, unstated values, and linguistic rules—in the production and validation of knowledge (e.g., Feyerabend, 1975; Kuhn, 1962). This viewpoint posits a fundamental link between episte-

mology (what a discourse counts as valid knowledge) and politics (the problems, interests, and needs legitimated as important by a given community). The irony is that to be accepted in a discourse community one must be able to show allegiance to the community's rhetorical orthodoxy (e.g., Dervin, 2003; Sullivan, 1996). To get published authors need to offer something novel while staying within the bounds of that community's accepted and safe discourse in terms of assumptions, methods, status hierarchies, doctrinal knowledge, and how narratives are constructed.

Self-reflexive observers of practices within their own communities can readily enumerate how we replicate in the broadest sense the interpenetrated practices of our discourses in ways that imprison us, locking together theory and method, power and status, lineages and allegiances, achievements and rewards, innovations and deviance. We replicate approaches we were taught in graduate school so persistence is more valued than risk-taking. We conduct research primarily with routine and repetitious practices. We focus on winners and, hence, losers; those who get funded, and those who don't. We rush to publication and thus dabble instead of studying deep. Too many of us flit about to where funding is available. Quantitative researchers retreat to small, often infinitesimal, increments of variance accounted for; or they cloak their results in statistics inaccessible to any but the initiated and far more complex than their concepts. They retreat to method instead of discussing methodology. Qualitative researchers protest that context is unique and no generalizing conclusions can be reached while building their discourses based on generalizing propositions. They retreat to metatheory instead of discussing methodology.

To point to these difficulties is not an act of blaming this or that individual scholar. Understanding theories as theoretical discourses lets us consider the possibility that we are all imprisoned within our discourse communities and that if we want to reach outside them—yes, even see beyond the turrets that guard the moats—we must do so with deliberate acts.

Those who have been examining the call to interdisciplinarity agree that we need boundary-bridging practices. Most of these calls draw on the germinal work of Susan Star (e.g., 1989), who called for different discourse communities to locate intersecting issues and concepts while not imposing one community's mode of symbolization.

This is a call to free intellect from the prisons of our disciplines. This does not mean that disciplinarity and discourse communities will vanish. The longevity of the former and the repetitive emergence of the latter indicate that such structural constructions are extraordinarily useful. But clearly they are not enough—both for us bound within their practices and for policymakers and publics observing us (e.g., Beck, 1995).

It is at this juncture that we use a distinction between integration and cohesion that has emerged in the mass communication literature. Some authors are clearly integrationists. They call for dialogue across discourse communities because they see the differences as additive or at least synergistically combinable in some useful way. A prominent integrationist of this kind in media studies is Karl Rosengren (1993, 2000). He is not alone. He calls on scholars on both sides of what he calls the scientific-humanistic divide to abandon their traditional aversions to the works of those in the other camp. In essence, then, Rosengren and other integrationists of this kind call for more communication because they believe it will permit additive strength.

Another version of the integrationist position (e.g., Craig, 1999) calls for a different kind of integration in which communication scholars combine their forces to address communicating in the everyday world. By centralizing foci in this way Robert Craig calls for the field to become a field of communication theory. He holds out the hope that the result will be "more," but he does not presume an additive something more.

A related brand of integrationist might be labeled communication revisionists. They (e.g., Carter, 2003; Dervin, 2003; MacLean, 1975) see synthesis as possible if we address communication in more communicative ways. These revisionists ascribe to the cohesionist position albeit with a teleological focus on achieving genuine dialogue as outcome. What we label as exemplary cohesionists are calling for communicative integration without an explicit focus on developing coherent theory or a distinctive identity for the field or any a priori valued end. Rather they focus on the possibility of learning from each other and focusing together on larger problems and issues (e.g., Beniger, 1993; Newcomb, 1993). Those who aim for cohesion usually pragmatically focus on promoting theoretical and methodological tolerance.

In talking about the (im)possibility of communication, Briankle Chang (1996) referred to the impossibility of ever achieving a sense of closure, of fixing and holding firm the center. Meaning is always undergoing transformation. Even though top-down transmission attempts to fix the center and freeze meaning, wishing it to be has not made it so as history has shown. For this reason we use the term *cohesionists* to describe those who are calling for more communication *about* our communication *in* communication studies and who are explicitly not focused on any kind of a priori view that communication assures coherence, comprehension, or any kind of prescribed and valued end.

We see these exemplary cohesionists as moving from focusing on communication as outcome to communication as process. This move faces its own paradox when viewed from the perspective of competing discourse communities. This essential paradox is seen as inherent in a postmodern view of communication for when we communicate with those whom we least understand, the work will not

only be hard, it will also be wrenching. To communicate across similarity seems possible. To communicate across difference is, as our field has documented well, (im)possible. To understand another worldview is to suspend self at least temporally. For those for whom a centered self is an inherent part of their discourse's conceptual apparatus, the suspension cannot come easy and, indeed, can be rejected and resented.

Despite these difficulties, we adopt a cohesionist position for ourselves because we want to argue for treating discussions *about* communication (the phenomenon of attention) *in* communication (the communication discourse communities) in methodologically communicative ways. Facing a horizon of no easy answers, this road is, to our minds, the one that has the greatest potential for cohesionist outcomes. To this end, we provide an example of what we mean in the next section.

An Example of Communicative Boundary Bridging

Our purpose in this section is to take a new look at the discourses that have comprised the administrative and critical camps. As we suggested above, there are a plethora of comparisons of competing paradigms in mass communication studies. Too many of these leave the reader more confused, rather than less, because they are comparisons of the grocery list kind—"apples here, oranges there, oranges are clearly not apples."

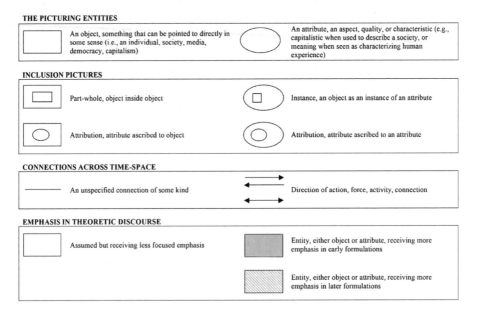

Figure 2.1. Key to picturing language used to diagram the 14 administrative and critical theoretic discourses.

Thankfully, an increasing number of deeply interesting comparisons have appeared where authors reach for some kind of abstract sense of differences and explain why these differences make a difference in terms of intellectual histories and current projects (e.g., Ball-Rokeach, 1998; DeFleur, 1999; Mumby, 1997; Pietila, 1994). The best of these are essays that exist somewhere between narratives, intellectual histories, autobiographies, and literature reviews. What is compelling about them is that the reader is able to gain some sense of authorial journeys, resolutions, and struggles.

Our approach uses a tool called *picturing* developed by Richard Carter (2003), as adapted by Brenda Dervin (1975/2002). Figure 2.1 provides a key to tool elements. Figure 2.2 applies this tool to fourteen different theoretic discourses—seven critical and seven administrative. The picturing tool as we used it here was applied by repeated readings of verbal language descriptions of theoretical discourses focusing on the entities that theorists identified and the connections between these entities. Entities consist usually of the nouns authors pointed to—things, states, events, processes, and so forth—which the authors saw as being objects that have "being," although this being need not be in any objectivist or material sense. Entities also consist of the attributes or characteristics that authors ascribed

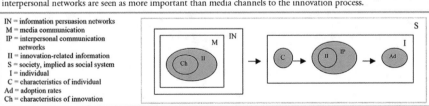

PICTURE #1—USES & GRATIFICATIONS, an "administrative discourse"
(Blumler & Katz, 1974; Palmgreen, 1984)

CORE PROPOSITION: Individuals use media (channels and programs) to satisfy different needs and gratifications based on differing demographic positions in society and other characteristics (e.g. personality).

M = media
I = individual
S = social, indexed by demography
O = other characteristics (e.g. personality)
N = needs, implied
GS = gratification sought
GO = gratification obtained
CT = channel type
PT = program type
Ch = characteristics of individual

PICTURE #2—DIFFUSION OF INNOVATIONS, an "administrative discourse"
(Rogers, 1962; Rogers & Shoemaker, 1973)

CORE PROPOSITION: Focuses on the ways in which innovations and practices spread through social systems by examining which communication processes have more impact on improving adoption rates and under what conditions for which individuals. A two-step flow is assumed with media and interpersonal networks having more or less impact depending on the nature of the innovation and the characteristics of individuals; however, interpersonal networks are seen as more important than media channels to the innovation process.

IN = information persuasion networks
M = media communication
IP = interpersonal communication networks
II = innovation-related information
S = society, implied as social system
I = individual
C = characteristics of individual
Ad = adoption rates
Ch = characteristics of innovation

Figure 2.2. Core propositions and picturing analyses of essential entities and relationships in theoretic discourse #1 through #14.

PICTURE #3—KNOWLEDGE GAP, an "administrative discourse"
(Tichenor, Donohue & Olien, 1970, 1980)

CORE PROPOSITION: As the infusion of mass media information in social systems increases, segments of the population with higher socio-economic status acquire more knowledge than do segments of the population with lower socio-economic status. This is mediated by other characteristics that are assumed to impact motivation to acquire information.

S = society
M = media prevalence
I = individual
SC = society, indexed by social class
O = other characteristics of individual
Mo = motivation
KG = knowledge gap effect
Ch = characteristics of individual

PICTURE #4—AGENDA SETTING, an "administrative discourse"
(McCombs & Shaw, 1972; McCombs, 1981)

CORE PROPOSITION: Media contents set agendas of attention. Conditions under which agenda setting effects vary include various indexes of societal conditions as the sources of influence on media (e.g. journalistic practices as well as other influences such as marketplace competition) and demographic and other characteristics of individuals.

M = media
MC = media coverage of issues
I = individual
S = society, indexed by demography
Ch = characteristics of individual
O = other characteristics of individual
Ag = agendas set by media
AE = agenda setting effect on individual
SI = sources of influences
AM = agenda for media
JP = journalism practices
OI = other influences

PICTURE #5—SPIRAL OF SILENCE, an "administrative discourse" (Noelle-Neumann, 1973, 1984)

CORE PROPOSITION: Public opinion formation in society is constrained by the spiral of silence which is induced by self-censorship (arising from fear of isolation) by some individuals, and by the ubiquity of a limited set of media messages because of market structure. The impact of the spiral is to suppress non-dominant views.

M = media
MS = media market structure
U = ubiquity of media messages
S = society
SS = spiral of silence which characterizes society
I = individual acting within spiral
OC = opinion climate
F = fear of isolation

PICTURE #6—CULTIVATION, an "administrative discourse"
(Gerbner & Gross, 1976; Gerbner, Gross, Morgan & Signorelli, 1980)

CORE PROPOSITION: Individual pictures of reality are distorted and homogenized by the impact of media's dominant role in constituting our societal symbolic environment. The impact is greater for those who use media more. Other individual characteristics play a role.

M = media
D = distortions of reality in media
S = society, implied
SE = symbolic environment
I = individual
ME = media exposure
CE = cultivation effect
PE = personal experience
Ch = characteristics of individual

Figure 2.2. Continued.

PICTURE #7—MEDIA SYSTEMS DEPENDENCY, an "administrative discourse"
(DeFleur & Ball-Rokeach, 1975; Ball-Rokeach & DeFleur, 1976)

CORE PROPOSITION: As societies become more complex and unstable, individual dependence on media increases and the cognitive, affective, and behavioral effects of media increase. Media effects are greater for those individuals who are more dependent on the media.

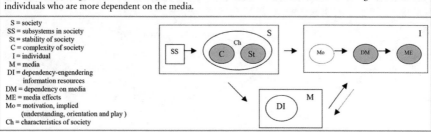

S = society
SS = subsystems in society
St = stability of society
C = complexity of society
I = individual
M = media
DI = dependency-engendering
 information resources
DM = dependency on media
ME = media effects
Mo = motivation, implied
 (understanding, orientation and play)
Ch = characteristics of society

PICTURE #8—POLITICAL ECONOMY—INSTITUTIONAL, a "critical discourse"
(Schiller, 1969; Murdock & Golding, 1985)

CORE PROPOSITION: Media, shaped by forces of capitalism, or other structural constraints on society, encode meanings. These meanings are assumed to equal the decodings by individual audience members whose interpretations are assumed to be shaped by the same forces. A more recent version suggests media only set parameters but do not fully constraint.

S = society
C = capitalism
MS = market structure
M = media
A = audience, implied
MP = message production
MC = message consumption

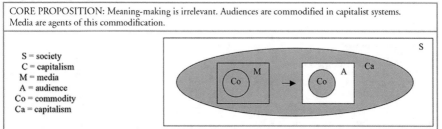

PICTURE #9—POLITICAL ECONOMY—AUDIENCE AS COMMODITY, a "critical discourse"
(Smythe, 1981; Jhally, 1982)

CORE PROPOSITION: Meaning-making is irrelevant. Audiences are commodified in capitalist systems. Media are agents of this commodification.

S = society
C = capitalism
M = media
A = audience
Co = commodity
Ca = capitalism

PICTURE #10—SCREEN THEORY, a "critical discourse" (Mulvey, 1975; Doane, 1982)

CORE PROPOSITION: The media text is characterized by symbolic encodings of systems of societal domination which are assumed to position the audience within these systems of domination.

S = society, implied
MT = media texts
SD = systems of domination in society
P = prescriptions positioning
 audience
A = audience, implied
Me = meaning, implied

Figure 2.2. Continued.

PICTURE #11—CULTURAL STUDIES—EARLY, a "critical discourse" (Hall, 1980; Morley, 1980)

CORE PROPOSITION: Understanding mass communication requires an understanding of the three moments of the communication process—media production, the media text itself, and interpretation (reception) of text by audience, all of which are bound within the social class structures of capitalism. Audience interpretations manifest these class structures because audience members are situated in different social classes.

S = society
SD = structure of domination - class
Ca = capitalism
MP = media production
MT = media text
A = audience
Me = meaning

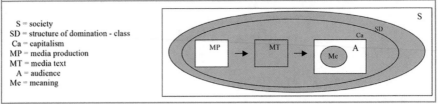

PICTURE #12—CULTURAL STUDIES—LATE, a "critical discourse" (Ang, 1985; Moores, 1999)

CORE PROPOSITION: There are complex relationships between societal structures of domination, the media, and audiences. Audience interpretations manifest moments of accepting, negotiating, and resisting systems of domination and are produced in the context of these complex relationships.

S = society
SD = structures of domination – race, age, gender, colonialism, etc
Ch = characteristics of individual
O = other characteristics
M = media (media text only)
A = audience
Me = meaning
RT = reading of text
PM = preferred meaning
+ = racism, sexism, ageism, colonialism, etc.
Ac = accepting
Ne = negotiating
Re = resisting

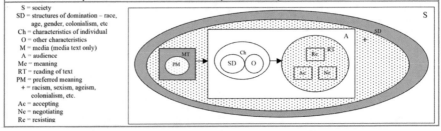

PICTURE #13—INTERPRETIVE, a "critical discourse" (Lindlof, 1987; Lull, 1980)

CORE PROPOSITION: Media are interpreted and meanings produced by individuals, conceptualized as members of interpretive communities and/or contexts who share social positionings and/or other characteristics of the interpretive community/context in common. Texts are assumed to be open to multiple interpretations.

MT = media text
ICo = interpretive context
IC = interpretive community
Ch = characteristics shared in common
Me = meaning
P = polysemy
I = individual member of community

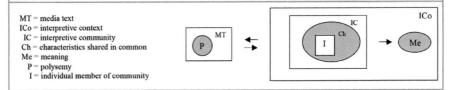

PICTURE #14—POST-MODERN, a "critical discourse" (Poster, 1990; Baudrillard, 1995)

CORE PROPOSITION: Individuals, media, and society are manifestations of text writ large (discourse), variously defined by different theorists—for example, the interpenetrated practices of power, discursive apparatuses (Foucault); the interplay of language systems (Derrida); the interplay of structures of signs and codes (Baudrillard).

TL = text writ large
SB = symbolic being (language, codes, signs, practices, symbolic structures, etc.)
S = society
M = media
I = individual

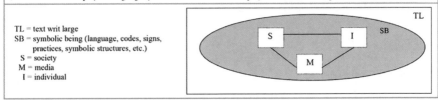

Figure 2.2. Continued.

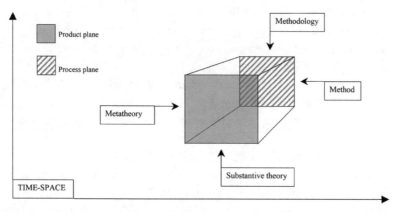

DEFINITIONS:

METATHEORY: provides general perspectives or ways of looking based on assumptions about the nature of reality and human beings (ontological); the nature of knowing (epistemological); the purposes of theory (teleological); values and ethics (axiological); and the nature of power (ideological)

SUBSTANTIVE THEORY: inductively derived and/or deductively hypothesized concepts (which define phenomena) and propositions (which suggest how and under what conditions concepts are thought to be connected)

METHODOLOGY: reflexive analysis of the "hows" of theorizing, as well as observing, analyzing, and interpreting

METHOD: the specific "hows," guided implicitly or explicitly by methodological considerations

Figure 2.3. A model of theoretic discourse mapping proposed multi-dimensional convergence of research process considerations (methodological and method) and product considerations (metatheory and substantive theory).

to these objects. In the picturing language, objects are denoted by squares and rectangles, attributes by circles or ovals. The picturing language then maps these objects and attributes in terms of their relationships to each in time-space. In our application, possible relationships include inside-outside relationships as well as relationships across time and space denoted by connective lines or by arrows. Connective lines indicate some kind of unspecified connection between entities. Arrows indicate that a direction of action, force, activity, or connectivity has been specified. Solid lines indicate an emphasized presence, dashed lines an implied presence.

To illustrate briefly, in applying the tool to uses and gratifications (Figure 2. 2, picture #1) we see that "society" (indexed by demography) is positioned as an attribute of individuals along with other characteristics, such as personality. In contrast, in picture #14—mapping postmodernism—both society and individual are instances of an attribute "language, codes, signs, symbolic structures, inter-penetrated practices" that are ascribed to an object "discourse." Without knowing the complex intellectual groundings behind either discourse, we see instantly that the former looks at society as something carried around inside people while the latter looks at both society and individuals as having being (existing would be the wrong word here) only inside discourse.

Picturing is, thus, a tool that reaches for an understanding of ideas at a very abstract level. Its intent is to strip away some of the confusions introduced in

linear languages because of their inability to show time-space connectivities. The intent is not to fix any kind of representational or correspondence quality in language but rather to assist the reader in "hearing" the author and thinking about the author's ideas.

This is not to say that we present picturing as a value-neutral observing language. Rather our point is a different one. Figure 2.3 helps in explanation. In that figure we have mapped as a cube two planes of scholarship consideration—the product plane (with metatheory and substantive theory) and the process plane (with methodology and method). We really need four dimensions but we approximate our point by interposing two planes. In intersection, these planes with their four dimensions may be constructed as the "apparatus" of theory making in a discourse community—the kind of apparatus of which Foucault (1972) spoke. As researchers we are taught characteristic ways of seeing and thinking about the world and of executing our thinkings, observings, analyzings, and concludings. Every act of researching exists in all four dimensions. All our tools, vocabularies, understandings about how to proceed are embedded inside our discourse constellations and are, thus, impediments to outsiders.

We need boundary bridging tools for comparing oranges to apples without calling them "not apples." We need precisely what those working on interdisciplinarity have called for—practices that permit diverse discourses to come together and inhabit the same time-space with intersections and without domination by any one discourse. We present picturing as an example of this kind of tool. This tool comes, of course, out of its own constellation of metatheory, substantive theory, methodology, method. It comes from a discourse that assumes that if we approach communicating systematically with a focus on articulation tools that facilitate speaking and listening without competition, we have a better chance of finding communicating useful—not as a panacea, not as a cure, but as a tool for the possibility of communicating.

We do not present picturing and its grammatical devices as unproblematic. Indeed, the extent to which scholars associated with different discourse communities may find the tool useful (both in terms of communicating their own ideas, as well understanding those from other communities) is an open question and should remain so.

In applying picturing, the authors first selected fourteen theoretical discourses: (1) seven to represent approaches usually labeled "administrative": uses and gratifications, diffusion of innovations, knowledge gap, agenda setting, spiral of silence, cultivation, and media dependency; (2) seven to represent approaches usually labeled "critical": political economy—institutional; political economy—audience as commodity; screen theory; cultural studies—early; cultural studies—late; interpretive, and postmodern. Our criteria for inclusion was twofold. We

wanted to include the most discussed approaches; and we were guided by the picturing tool. If a theoretical discourse yielded a distinctive picture, we retained it.

We also attempted to capture in our pictures in broad brushstroke how each discourse changed over time; and we added a verbal statement of what we saw as each discourse's core proposition. We stayed as close to the specific vocabulary used in each discourse community as possible. In drawing our pictures, we worked independently, then by consensus. We read as widely as we could on each discourse, focusing both on theoretic expositions, empirical applications, and criticisms. The task was not easy because discourses are messy affairs. There is always more talked about than is addressed; there are hidden aspects that emerge over time; there are aspects that appear and disappear. The presentation cannot be more readily fixed by looking at only the writings of the founding authors because it is in exchanges with others that ideas get clarified and modified. The more the author's creation is discussed, the more meanings become attached to it. Even the latest work is more often than not already history. Space limitations here demand we restrict references to two germinal sources for each of the fourteen discourses (see footnote on page 25 to obtain full bibliography).

It is important to emphasize that any given reader looking at these pictures will certainly take exception to some, usually ones picturing discourses closer to their own. Despite limitations inherent in any attempts at languaging, we propose a pragmatic test for the tool—is it useful as an aid to thinking and discussion?

Because the "picturings" are analogic spatial-temporal mappings, it would be antithetical to attempt to fully describe each picture verbally, for that would be retreating to the very linear constraints picturing was developed to escape. Instead, we draw a set of observations from the pictures and invite readers to do likewise.

1. At a surface level, the first thing that strikes the reader is how different the pictures are. Certainly, here is a source of charges of incommensurability, particularly when comparing pictures #1 through #7 with pictures #8 through #14 across the administrative-critical divide. In #1 (uses and gratifications), the individual exists as an object characterized with attributes. In #14 (postmodernism), the individual becomes an instance of an attribute characterizing the object discourse.

2. The tripartite of audience, media, society is present in all the discourses, albeit in different ways. Audience, in particular, goes through radical transformations as one moves from discourse to discourse—sometimes as aggregates of individuals (#1 through #7, the administrative theories), sometimes as amorphous mass (#8 and #9, political economy), sometimes implied within text (#10, screen theory), sometimes an instance of capitalistic or other systems of domination seen as attributes of society (#11 and #12, cultural studies early and late), sometimes as instance of

community (#13, interpretive), sometimes as elusive presence with being only inside a discourse (#14, postmodernism).

3. A substantial number of the discourses are struggling with issues of individual identity, subjectivity, and presence. We can see this, for example, by the addition to attributes theorized as applying to individuals or audiences in latter formulations—in #4 (agenda setting), for example, we see "other characteristics" added to "society," indexed by demography) as attributes of individual members of the audience; in #5 (spiral of silence), we see "fear of isolation" added to "perception of opinion climate" as an attribute of individuals; in #6 (cultivation), we see the same kind of later formulation adding "personal experience" to "media exposure" as attributes of individuals. We see somewhat the same change in #12 (cultural studies) "late" where "other" is added to "systems of domination" as attribute predictors of audience decoding of text. In every one of these cases, the more recently introduced attribute in our picturing has an unspecified relationship with its earlier partner.

4. While administrative theories are often collapsed, an examination of #1 through #7 shows a great deal of variation within. For example, #7 (media systems dependency) is pictured as a very different kind of theory than #1 through #6. It pictures a network of connectivities, for example, and is the only one of all the administrative discourses to explicitly set up the media, individual, society tripartite as three interconnecting objects. This yields a surprising similarity, in some respects, to #14 (postmodernism).

5. Further, in all but one of the pictures one can see that there is an underlying assumption of movement that ends with individuals and/or with audiences. In this sense, these thirteen discourses are all focusing on impacts in one way or another. The exception is #14 (postmodernism).

6. Over time, many of the discourses have produced more complex pictures of media influence. For a number of administrative discourses, the trend has been to seek out individual-level variables that qualify propositions about the influence of the media. For example, an examination of #3 through #6 shows that there is an increasing interest in the role that personal characteristics and experiences play in the media effects process. The uses and gratifications discourse (#1) has also followed the trend of identifying more individual-level variables though its concern is with media use not media influence. A parallel trend can be identified in the cultural studies discourses (#11 and #12), though the move here has been to seek social/society-level variables that qualify the influence of media. Over time, cultural studies' preoccupation with the class position of audiences has given way to a focus on how audience members are posi-

tioned vis-à-vis various systems of domination (class, race, gender). In essence, a number of discourses across the so-called administrative-critical divide have gradually produced more complex and nuanced pictures of the role mass communication plays in everyday life; some administrative discourses have done this by increasingly differentiating the individual; cultural studies has achieved this by increasingly differentiating the social or societal. These shifts have resulted in an incremental de-centering of the media.

When we step back from the specificity of our observations, we come to several large conclusions. One is that applying the picturing tool was enormously helpful to us in coming to grips with the chaos that seemed to be the arguments within and between these discourses. To our minds, all of these discourses were working on the same meta-level project and struggling with the same tensions: centrality versus dispersion, control versus change, domination versus resistance. We end up judging the picturing tool as useful because applying it forced us to understand the discourses in media studies in different ways. We have concluded that our discourse communities have a great deal more to talk about than we think we have.

Toward Public Presence and Utility

Because communication is a comparatively new field of study, we have been latecomers to disciplinarity and have had less opportunity to forge the cohesive face that glues disparate discourse communities within a discipline. As a result, even as all disciplines are under attack within the academy to show their relevance to other disciplines, to eliminate duplicative work, and to otherwise shape up for instrumentally imposed policy standards, our field—with its many offshoot discourse communities—has too often looked like a ragamuffin. Being a ragamuffin can be seen as both strength and weakness. The weaknesses have been much argued. The strength may well be that our fortresses are not as old as, for example, in psychology, which faces as much theoretic chaos but with a seemingly unified face.

The communication field, on the other hand, with its many media studies and other discourses, has always been a field that has drawn to it the interests of those concerned with practice and with interventions in multiple contexts in the real world. Some in our field decry this as a less prestigious origin (e.g., Berger, 1991). However, in the circumstances we now face this lineage may be strength.

On the one hand, we face a mind-bending plethora of theories, concepts, variables, and methods so great that most agree that the frameworks for communication across our divides do not exist. However, we have two kinds of strengths—strengths in practical, policy-related attentions—both emancipatory and instrumental; and strengths in communication—both participatory and top-down. These strengths may serve in the communicating task we now face—the

communicating *about* the communicating that we need to do so we can communicate more usefully with each other and with external publics. We propose that we need to reclaim and invent tools for bridging the boundaries between us, tools that allow us to do so without demanding intellectual submission to the other; tools that enable us to tolerate and protect differences and assist and encourage new kinds of thinking.

In our judgment, calls for interdiscourse talk in media studies have generally assumed that inconvenient separations in theories and understandings should willy-nilly disappear once the communicating begins. By presenting the exemplar tool of picturing in this chapter, we propose, as an alternative, systematic attempts to develop a methodology of dialogue that releases thinking and theorizing potential without mandating coherent outcomes.

This mandate is in itself a paradox. At one and the same time, it is a mandate to tolerate difference and lack of coherence while at the same time tolerating those whose particular scholarly aims and ethical commitments focus on the search for coherence. We propose that to make progress in this seemingly (im)possible journey we must give up one set of teleological assumptions regarding communication and adopt another.

In our literatures one sees two arguments that suggest this is a challenge media studies cannot refuse. One reason is political—that if we cannot find a way to move toward cohesion amongst ourselves and present a useful public face to external constituencies, the many other fields that are jumping on the communication studies bandwagon will. The second reason is ethical. While we disagree markedly on what will make communication processes work better for individuals and society, the ethical thread that shows in the weft and warp of media studies is a consuming interest in contributing to the betterment of the human condition.

If we accept these arguments we must find a way to apply ourselves more cohesively to policy issues and issues of social relevance. At the same time we need to do this in communicative ways that systematically exemplify to each other, other academic fields, and society how communication has more useful outcomes when it is pursued in dialogic ways. A major point of this essay is that this kind of communicative communicating about communication will not happen spontaneously. It must be designed.

Bibliography

Ang, I. (1985). *Watching Dallas: Soap Opera and the Melodramatic Imagination*. London: Methuen.

Ball-Rokeach, S. (1998). "A Theory of Media Power and a Theory of Media Use: Different Stories, Questions, and Ways of Thinking." *Mass Communication & Society*, 1(1/2), 5–40.

Ball-Rokeach, S., & M. L. DeFleur. (1976). "A Dependency Model of Mass-Media Effects." *Communication Research*, 3(1), 3–21.

Baudrillard, J. (1995). *Simulacra and Simulation*. Ann Arbor: University of Michigan Press.

Beck, U. (1995). *Ecological Enlightenment: Essays on the Politics of the Risk Society.* Atlantic Highlands, NJ: Humanities.

Beniger, J. (1993). "Communication—Embrace the Subject, Not the Field." *Journal of Communication,* 43(3), 18–25.

Berger, C. (1991). "Chautauqua: Why Are There So Few Communication Theories? Communication Theories and Other Curios." *Communication Monographs,* 58, 101–13.

Blumler, J., & E. Katz. (1974). *The Uses of Mass Communications: Current Perspectives on Gratifications Research.* Beverly Hills, CA: Sage.

Carter, R. (2003). "Communication: A Harder Science." In B. Dervin & S. Chaffee (with L. Foreman-Wernet) (Eds.), *Communication, a Different Kind of Horseracing: Essays Honoring Richard F. Carter* (pp. 369–376). Cresskill, NJ: Hampton.

Chang, B. (1996). *Deconstructing Communication: Representation, Subject, and Economies of Exchange.* Minneapolis: University of Minnesota Press.

Cobley, P. (1996). *The Communication Theory Reader.* London: Routledge.

Craig, R. (1999). "Communication Theory as a Field." *Communication Theory,* 9(2), 119–161.

DeFleur, M. (1999). "Where Have All the Milestones Gone? The Decline of Significant Research on the Process and Effects of Mass Communication." *Mass Communication and Society,* 1(2), 85–98.

DeFleur, M., & S. Ball-Rokeach. (1975). *Theories of Mass Communication* (3rd ed.). New York: David McKay.

Dervin, B. (1975/2002). *Communicating Ideas: An Adapted Guide to Richard F. Carter's Early Picturing Language.* Unpublished manuscript.

Dervin, B. (2003). "Sense-making Journey from Metatheory to Methodology to Method: An Example Using Information Seeking and Using as Research Focus." In B. Dervin & L. Foreman-Wernet (with E. Lauterbach) (Eds.), *Sense-making Methodology Reader: Selected Writings of Brenda Dervin* (pp. 133–164). Cresskill, NJ: Hampton.

Doane, M. A. (1982). "Film and the Masquerade: Theorizing the Female Spectator." *Screen,* 23(3/4), 74–88.

Feyerabend, P. (1975). *Against Method: Outline of an Anarchistic Theory of Knowledge.* London: Verso.

Fink, E., & W. Gantz. (1996). "A Content Analysis of Three Mass Communication Research Traditions: Social Science, Interpretive Studies, and Critical Analysis." *Journalism & Mass Communication Quarterly,* 73(1), 114–134.

Foucault, M. (1972). *The Archaeology of Knowledge.* New York: Pantheon.

Garnham, N. (1995). Political Economy and Cultural Studies: Reconciliation or Divorce? *Critical Studies in Mass Communication,* 12(1), 62–71.

Gerbner, G., & L. Gross. (1976). "Living with Television: The Violence Profile." *Journal of Communication,* 26, 173–199.

Gerbner, G., L. Gross, M. Morgan, & N. Signorielli. (1980). "The 'Mainstreaming' of America: Violence Profile No. 11." *Journal of Communication,* 30(3), 10–29.

Gilljam, M. (1984). "Pluralist and Marxist Agenda-setting Research: The Possibilities for a Convergence between Traditions." *Gazette,* 34, 77–90.

Hall, S. (1980). "Encoding/Decoding." In S. Hall (Ed.), *Culture, Media, Language* (pp. 129–138). London: Hutchinson.

Ito, Y. (1989). "What Causes the Similarities and Differences among the Social Sciences in Different Cultures? Focusing on Japan and the West." In B. Dervin, L. Grossberg, B. O'Keefe, & E. Wartella (Eds.), *Rethinking Communication: Vol. 2. Paradigm Exemplars* (pp. 93–123). Newbury Park, CA: Sage.

Jensen, K. B. (1996). "Media Effects: Convergence within Separate Covers." *Journal of Communication*, 46(2), 138–144.

Jhally, S. (1982). "Probing the Blindspot: The Audience Commodity." *Canadian Journal of Political and Social Theory*, 6(1–2), 204–210.

Kuhn, T. (1962). *The Structure of Scientific Revolutions*. Chicago: University of Chicago Press.

Layder, D. (1990). *The Realist Image of Social Science*. New York: St. Martin's.

Lindlof, T. (Ed.). (1987). *Natural Audiences: Qualitative Research of Media Uses and Effects*. Norwood, NJ: Ablex.

Lull, J. (1980). "The Social Uses of Television." *Human Communication Research*, 6, 197–209.

MacLean, M. (1975). "Communication Theory, Research, and the Practical Affairs of Man." *Journal of Communication Inquiry*, 1(2), 1–6.

McCombs, M. (1981). "The Agenda Setting Approach." In D. Nimmo & K. Sanders (Eds.), *Handbook of Political Communication* (pp. 121–140). Beverly Hills, CA: Sage.

McCombs, M., & D. Shaw. (1972). "The Agenda-setting Function of the Mass Media." *Public Opinion Quarterly*, 36, 176–187.

McLeod, J., G. Kosicki, & Z. Pan. (1991). "On Understanding and Misunderstanding Media Effects." In J. Curran & M. Gurevitch (Eds.), *Mass Media and Society* (pp. 235–266). London: Edward Arnold.

McLuskie, E. (1988). "Silence from the Start: Paul Lazarsfeld's Appropriation and Suppression of Critical Theory for Communication and Social Research." Paper presented at Paul F. Lazarsfeld Symposim: Die Wiener Forschungstradition der empirischen Sozial—und Kommunikationsforschung, Wien, Austria, May.

McQuail, D. (1985). "Gratifications Research and Media Theory: Many Models or One?" In K. Rosengren, P. Palmgreen, & L. Wenner (Eds.), *Media Gratifications Research: Current Perspectives* (pp. 149–170). Beverly Hills, CA: Sage.

Meehan, E. (1999). "Commodity, Culture, Common Sense: Media Research and Paradigm Dialogue." *Journal of Media Economics*, 12(2), 149–163.

Moores, S. (1999). *Interpreting Audiences: The Ethnography of Media Consumption*. London: Sage.

Morley, D. (1980). *The "Nationwide" Audience: Structure and Decoding*. London: British Film Institute.

Mulvey, L. (1975). "Visual Pleasure and Narrative Cinema." *Screen*, 10(3), 6–18.

Mumby, D. (1997). "Modernism, Postmodernism, and Communication Studies: A Rereading of an Ongoing Debate." *Communication Theory*, 7(1), 1–28.

Murdock, G. (1997). "Reviews." *European Journal of Communication*, 12(2), 239–243.

Murdock, G., & P. Golding. (1985). "For a Political Economy of Mass Communications." In O. Boyd-Barrett & C. Newbold (Eds.), *Approaches to Media: A Reader* (pp. 201–215). London: Arnold.

Newcomb, H. (1993). "Target Practice: A Batesonian 'Field' Guide for Communication Studies." *Journal of Communication*, 43(3), 127–132.

Noelle-Neumann, E. (1973). "Return to the Concept of the Powerful Mass Media." *Studies of Broadcasting*, 9, 68–105.

Noelle-Neumann, E. (1984). *The Spiral of Silence: Our Social Skin*. Chicago: University of Chicago Press.

Palmgreen, P. (1984). "Uses and Gratifications: A Theoretical Perspective." In R. Bostrom (Ed.), *Communication Yearbook, 8* (pp. 20–55). Beverly Hills, CA: Sage.

Pietila, V. (1994). "Perspectives on Our Past: Charting the Histories of Mass Communication Studies." *Critical Studies in Mass Communication*, 11, 346–361.

Pietila, V., T. Malmberg, & K. Nordenstreng. (1990). "Theoretical Convergences and Contrasts: A View from Finland." *European Journal of Communication*, 5, 165–185.

Pool, I. d. S., & H. Schiller. (1981). "Perspectives on Communications Research: An Exchange." *Journal of Communication*, 31(3), 15–23.

Poster, M. (1990). *The Mode of Information: Post-structuralism and Social Context.* Cambridge, UK: Polity.

Rogers, E. (1962). *Diffusion of Innovations.* New York: Free.

Rogers, E. (1982). "The Empirical and the Critical Schools of Communication Research." In M. Burgoon (Ed.), *Communication Yearbook, 5* (pp. 125–144). Beverly Hills, CA: Sage.

Rogers, E., & F. Shoemaker. (1973). *Communication of Innovations.* Glencoe, IL: Free.

Rosengren, K. (1993). "From Field to Frog Ponds." *Journal of Communication*, 43(3), 6–17.

Rosengren, K. (2000). "For a Lack of Models: A Field in Fragments?" In D. Fleming (Ed.), *Formations: A 21st Century Media Studies Textbook* (pp. 31–33). Manchester, UK: University of Manchester Press.

Ruggiero, T. (2000). "Uses and Gratifications Theory in the 21st Century." *Mass Communication & Society*, 3, 3–37.

Schiller, H. (1969). *Mass Communications and American Empire.* New York: A. M. Kelley.

Schrecker, E. (1986). *No Ivory Tower: McCarthyism and the Universities.* New York: Oxford University Press.

Silverstone, R. (2007). *Media and Morality: On the Rise of the Mediapolis.* Cambridge, UK: Polity.

Smythe, D. (1981). *Dependency Road: Communications, Capitalism, Consciousness and Canada.* Norwood, NJ: Ablex.

Star, S. (1989). "The Structure of Ill-structured Solutions: Boundary Objects and Heterogeneous Distributed Problem Solving." In L. Glasser & M. Huhns (Eds.), *Distributed Artificial Intelligence* (pp. 37–54). London: Pitman.

Sullivan, D. (1996). "Displaying Disciplinarity." *Written Communication*, 13(2), 221–250.

Tichenor, P., G. Donohue, & C. Olien. (1970). "Mass Media Flow and Differential Growth of Knowledge." *Public Opinion Quarterly*, 34, 159–170.

Tichenor, P., G. Donohue, & C. Olien. (1980). *Community Conflict and the Press.* Beverly Hills, CA: Sage.

Valdivia, A. (Ed.). (2003). *A Companion to Media Studies.* Oxford, UK: Blackwell.

Social Scientific Theory of Communication Encounters Normativity

A Personal Memoir

DENIS McQUAIL

Early Beginnings

At just past the midpoint of the twentieth century, in a corner of the world then not much disturbed by global storms, I began my own journey through the equally peaceful landscape of communication enquiry. I was equipped with a basic grounding in methods and ideas of the social sciences, especially sociology, and a confidence in their efficacy, plus an apprenticeship in communication research at the masterful hands of Joseph Trenaman. The high potential of the social sciences for answering questions, if not solving complex problems, was for me not in dispute. The issue of whether there was adequate theory to guide the process did not occur to me as a problem and was not generally raised within what I gradually came to understand as the scope of the communication sciences.

This situation was probably typical of the time and place. My own earlier education had not really prepared me to be very sensitive to theoretical issues of the kind I was going to encounter. At school, I had received a strong dose of moralistic ideas from a Catholic perspective, from unquestionable sources and with a heavy emphasis on the classification of types and degrees of personal sinfulness. This perspective paid only limited attention to the defects and needs of the larger society—despite an introduction to the emerging Catholic Social Teaching, now being extricated from its cupboard.

On the other hand, an upbringing in a home with a strong leaning toward Labour politics did give me a set of beliefs that oriented me to the problems of

society and toward ideas of how to solve them in practical ways (they were being implemented around me). There was also one quite strong pathway into a relevant terrain of reflection on values by way of an induction into the ideas of the literary critic F. R. Leavis and, by extension, into ideas about class and culture that had a later public flowering in the works of Richard Hoggart, Raymond Williams, and Stuart Hall. These theoretical impulses were limited somewhat by their literary bias. The "Leavisite" view of the world of "mass media" (not a term in the vocabulary) was distinctly elitist and even puritanical in ethical and aesthetic terms as applied to "mass culture" and, consequently, of only limited help in understanding what was going on in the real world.

The other main component of my own preparation was an undergraduate study of modern history—a somewhat early modern and English version—in the spirit of detailed empirical compilation and objective interpretation of evidence. There was virtually no invitation to theorize about doing history or about the explanations of actual events in time, except by way of an introduction to the main political theories of the modern age. My chosen specialization in economic and social history did introduce me at least into the flavor of Marxist ideas, filtered through standard historical scholarship and the sympathetic views of an inspirational tutor, Trevor Aston.

The personal appeal of the social sciences, when first discovered, was immediate and deep. They opened entirely new vistas of things to be done, new ways of thinking, and, incidentally, new ways of tackling thorny issues of culture and society. These included attention to the obvious strong correlation between high standards in culture, mainly in the sense of arts, and social class—the core issue of the mass culture debate. Fortified by new insights and methods, it seemed to me quite possible, by way of empirical inquiry, to find ways of reconciling a belief in equality of all people with the evidence of cultural preferences and habits that seemed inescapably divisive. One of the benefits of what was new for me was the realization that the eternal normative shaping by the cultural and even just educated elite of the relevant terms of debate was preempting much of what was uncertain. Maybe the issue of the supposed "low taste" of the "masses" would prove to be without substance, more an ideological construction.

Despite its pragmatic and empirically oriented character, the sociology of the time as taught to me offered satisfactory degrees and types of theorizing, essentially those of Merton's middle range variety, proceeding by way of developing basic concepts and testing of limited generalizations about measurable entities. The implicitly structural-functionalist explanation of ideas and of relations between findings, in the basic equipment of the mid-twentieth-century sociologist, was not intrusive or particularly problematic. The strength of the newly emerging (small) field of communication research at the time, formed in North America and gradually extended to Europe after the war, was its lack of dogma-

tism, its set of useful tools for new tasks, and its "common sense" theory. This could be applied to a range of questions, including some quite heavily loaded normative issues, for instance, about the potentially harmful tendencies and effects of advertising, the dangers of media monopoly, the nature and power of propaganda, the corruption or misguidance of the young, the failures of public enlightenment, and more.

Such issues, of course, do not arise from sociological, or related, theory, but from the evaluative concerns widely expressed in society. In fact, even in these early times, the field was equipped, whether welcomed or not, with its own theory—that of mass communication. This was quite heavily dependent on a concurrent theory of mass society, but having its own core rationale—the expected causal relationship between certain typical forms and processes of communication via mass media and some of the features singled out by the theory of mass society. On the media side, the key elements were the following: an extensive transmission system radiating from a center, homogeneity of content sent and received by very large numbers, little provision for response, an audience of separated individuals with no collective properties. On the society side, the sustaining conditions were of social atomization and of subordination to control and manipulation.

Early Experience in the Field

With all this behind me, I was plunged into a period of research activity, collecting and analyzing data and trying to interpret what was nearly always a quite fuzzy picture of a limited sector of the life of society. An early realization was that the facts rarely spoke for themselves, certainly not in an area of social activity characterized by subjectivity, flux, mixed interpretations, and valuations. My first encounter with the new spirit affecting the practice of communication research was the challenge from a reviewer (and erstwhile friend) to a carefully constructed and reported study of the effects of television in an election (Trenaman & McQuail, 1961). This was held up as an example of abstracted empiricism, as excoriated by C. Wright Mills (1959). There was not much defence available to me against this unanticipated charge, except to ask what the alternative might be. It did at least alert a young researcher to the fact that inquiries needed to be shaped by clear purposes and the results interpreted in terms of ideas—obvious now, but still important for me to learn. My critical friend had still, herself, to learn that employment as a sociologist in those times required not a little contamination with empiricism, whether or not abstracted.

Social scientific theory of the time was best adapted to assisting empirical inquiry into what was thought to be the central question of the communication field: that of the effects of mass media. What were or would they be? How far are they predictable or plannable? How deep and enduring? What processes are involved? What conditions are conducive? What social and psychological char-

acteristics of people hinder or help the process of effect? Inquiries into these and related questions were pushed forward in the 1950s and 1960s until the yield of general findings about media effects, although not all that rich in variety and depth, seemed close to exhaustion. The issues are still far from exhausted, to judge from recent assessments of the state of effects research (Perse, 2001; Neuman, 2011), but meanwhile the whole endeavour encountered a series of shocks that opened fissures as well as epistemological and other questions that had not earlier been troubling researchers.

Further Emergence of the Communication Research Field

The communication research field, then, as ever since, had an uncertain definition and boundaries, with the phenomenon of communication having no accepted status as a separate discipline, and no coherent body of theory that could be claimed as a social science when lines were being drawn. Tentative steps in and around the 1950s to found a science of information failed to unite disparate perspectives and did not cohere, foundering partly on a lack of an agreed definition of the key term *communication*. Its extensive (but potentially very subjective) set of foci of attention was colonized first by social psychology and then by sociology to a more limited extent. This very approximate assessment, if accurate, would partly account for the pragmatic character of the field and the continued concentration around the central spine of concern with the effects of (mediated) communication.

Although this seems a deeply un-theoretical and limited topic of enquiry for a social science, it did encompass and hold together ever-widening aspects of the communication process. The so-termed effects of communication are extremely diverse in kind, relating not only to individuals but also to social groupings of all kinds, to cultures as well as to social institutions. They cannot be studied without attention to a range of conditions, often fundamental in nature. These relate to the sources of communication, the means of transmission and their attributes, to the content, to the processes of selection, attention and interpretation, to legal and political structures, and other forms of social control.

In my own particular case, at this early stage of finding a way in a rapidly developing field, the limitations of empirical inquiry into media uses and effects were becoming apparent (my earlier critic did have a point). The answer seemed to lie precisely in better adapted concepts of processes of effect and of methods to implement them. In the event, this led to an immersion into the reviving territory of the uses and gratifications approach to mass media. This promised and delivered some light on the explanation, and even modest prediction, of various effects. The essential point was to have evidence of motives for, and orientation to, communication behavior, before posing questions about possible effects, the

latter often depending on the former. This application of an essentially function-alist view (as often characterized) also offered a bridge between patterns of indi-vidual use of and response to media and links to larger questions about the social setting, questions of integration, isolation, dependency, and so forth. A period of teaching and informal learning at one fount of wisdom and expertise in the United States, the Annenberg School of Communication, fortified my own con-fidence in the strengths of an enlightened but traditional scientific approach. It also reinforced my awareness of the extent to which public communication was becoming a front-line zone in the emerging social and political conflicts that had shattered the complacency of the 1950s. In the United States, several major crises had coincided in the following decade, all affecting deep public—and news—in-terests. These comprised the struggles over civil rights and the migration of large African American populations into the inner cities of the North, the increasingly controversial war in Vietnam, the seeming rise in crime and social disorder, and the emergence of a new "counter-culture" at home. Some of the responsibility for the resulting social discord, even if not the original problem, was often laid at the door of the mass media. Politics, too, was being deeply affected and also polarised at all levels.

Troubles of a similar kind were experienced in the UK and Europe, although the scale was more modest, and critical perceptions of media were still concerned more with issues of cultural quality, commercialization, press standards, harmful effects from television on children, and the dangers of increasing media monopoly than with questions of hidden ideology, bias, and manipulation by the media. However, this was only a prelude to stormier times to come. The rising student radicalism of the 1960s across Europe and increasing appeal of (neo-)Marxist ideas, and the growing salience of issues of international communication and development, further contributed to a changing environment for research into communication. There is no space, nor need, here to review all the elements in the storm of influences unleashed in these times on a research field with its own doubts and uncertainties at this time. Some have origins in general real-world developments in society, some in scientific changes and discoveries, and others in essentially normative challenges.

History Takes a Hand

Major upheavals in the landscape of communication research during the 1970s and 1980s were fed by multiple streams and took a variety of forms. Leaving aside the pressure of real-world events, the main influences stemmed from the input of new disciplinary sources of theory and ideas, on the one hand, and a deepening and enriching of the critical theory adapted to framing hypotheses about media on the other hand. Prominent on the side of new sources were ap-proaches based on semiology and linguistics, essentially literary theory, but with

strong implications for the uncovering of "hidden ideology." Another theoretical input came from various forms of reception analysis, some adapted from social anthropology, others simply put together for the purpose of exploring the subjective experience of communication as a member of a social or cultural group that is also a distinctive audience for certain kinds of content. Roots in phenomenology and reality constructionism also helped to anchor this emerging orientation. Third, political economy gained a firmer foothold as an explanatory framework for most questions of the structure and distribution of media communications. It provided a firm set of normative principles (essentially aligned with a Marxist critique) as well as the prospect of many concrete objects of study in the structure and processes of media systems. Not unimportant was the contribution from studies of media—especially news—organizations that offered new explanations of the immediate source of much of the content flowing through the public network of news and of the causes of systematic biases that were being widely documented.

All this did seem to promise, and did deliver, fresh impetus to both theory and enquiry, but the availability of funding for research was largely kept to traditional objectives of social order and control. Moreover, certain kinds of topics were kept somewhat apart from what was becoming a fairly identifiable field for educational programs and publication. This applies to the terrain of political communication, where political scientists largely pursued much the same questions as before of the direct effect of mass media on voting during election campaigns, producing essentially historical studies but not much new thinking. In the extensive terrain of commercial communication (advertising, sponsorship, public relations, marketing, and so forth), the early separateness remained, despite the growing impingement of political marketing on broader issues of politics and society via the emerging ideas of media logic and mediazation.

The same turbulent two decades of the 1970s and 1980s also saw the rise of several new specializations for an application of ideas and methods of research from the emerging field of media and communication studies. Three issues stand out in this connection: those related to feminism in general, the representation of women in media organizations, media output, and in audiences; those arising from the globalization of media (or perhaps recognition of this fact and its consequences); and those relating to race and migration. All three are inevitably normatively laden, but all offered rich possibilities for the application of traditional methods and also a potential for new discoveries and new thinking.

Back to the Personal

The year 1980 marks an approximate watershed in the biography of the field of communication, perhaps more in Europe, with more scope for change, than in North America. It is akin to a kind of watershed of my own journey, when

I moved from the UK to the Netherlands in the late 1970s. Before that, I had reacted in mixed ways to the developing context of actual social and disciplinary strife. I already had been disturbed, as noted, by the critique of abstracted empiricism and subsequently by objections to uses and gratifications research as variously psychologistic, behaviorist, and exploitative—a grave list of charges at the time. Temporary, but significant refuge was provided by an assignment to work for the Third UK Royal Commission on the Press (1974–1977). The central task was to apply a content analysis to the British national press, for the most part following a basic model of empirical enquiry that had its origins in earlier Press Commission research (1947). The goal was to provide solid evidence about newspaper quality that might have some relevance and utility in a policy process that was very sensitive for both political and economic reasons. The terms of reference involved a mingling of normative and empirical notions, but it could be claimed that the normative related to purpose and the empirical to the methods and outcomes. Although limited in scope and originality, the research served its purpose and also stimulated close thought about the precise meaning of the concepts in use to describe standards of quality of news. Without clarity on this, no empirical answer could be given to key questions asked by the Commission. The experience also focused my mind on what might count as reliable evidence on the matter at hand. The burgeoning of ideas and approaches briefly referred to above had not been much concerned with matters of this kind, once central to effects research. The normativization of the field that had been taking place could be inspiring, but it did carry some risks of detaching theory from evidence.

The phase of communication science/research history briefly reviewed was not just a time of applying critical theory. The quasi-political debates were paralleled by quite a bit of innovation of ideas and methods of research that were in part stimulated by the critical ideas. The shades of mass society theory were reawakening and the notion of an overarching climate of a society in respect of beliefs and culture was broadly acceptable to the research community. The source of this revival was not just historical events but also the rise of television, in quasi-monopolistic form, to a dominant position as the main window on the world for the public in general. Noelle-Neumann (1973) helped to set things in motion by her invocation of a "return to the concept of powerful mass media," even if her application of these ideas was quite narrowly conceived. Her notions of "climate of opinion" and the process of a "spiral of silence" activated by key features of mass communication were widely accepted.

George Gerbner expounded on the significance of the cultural environment we inhabit and developed the concept of cultivation to explain how widely shared and systematic exposure to repeated versions of the social reality around us defines the nature of that reality for many (Signorielli & Morgan, 1980). A method of cultivation analysis was developed to test or demonstrate the expected effects. In

respect of news and information, the hypothesis of agenda-setting by mass media on public opinion was persuasive. On a broader front and at a deeper level, research based on the idea of the framing of information both by journalists and audiences supported the notion of a social world with its information environment thoroughly structured in terms of foci of attention and predominant interpretations. In a further extension of concerns with news influence, an increased attention was paid to the distribution of news around the world and the factors that explained certain recurrent features. Notable were the absolute dominance of certain central news producers and providers and the consequent media portrait of a world highly skewed to the perception and experience of the more developed world. Visibility and status were reflected, constructed, and maintained. The explanations for most of the emerging findings, or interpretations of them, were attributed less to manipulative intent and the pursuit of hegemony and more to the bias of the systems developed for reporting on reality and the practices they entailed. In all the cases cited, there was an interaction between research evidence and theoretical ideas. At the same time, there were clear beginnings of schisms, with harder lines drawn, between different schools of thought and research that stemmed from more than just a concern with different issues and alternative values (the terrain of the normative).

Two main sources of division were manifested, one the familiar divide between critical theory and empirical, sometimes labelled "administrative," research and another separating various forms of cultural inquiry from those using more traditional social scientific tools of collecting and analysing data. Although there is more to it, it would not be difficult to identify a political or ideological choice, roughly between left and right. On the left were powerful forces drawn from veterans of mass culture wars, Marxist interpreters of class society, hard line adherents of the political economy school, concentrating on concrete material evidence of the nature, and consequences of structures of control and ownership of mass media. On the right, although its spokespersons were fewer and less united, there was a refusal to accept that media were dominated by forces of state and capitalist hegemony. Even the contrary was alleged due to the liberal leaning of most journalists (of which there was some evidence). There was, at very least, skepticism about the chances of any new order of communication, whether at the world or national level, offering any real improvement to compensate for the alleged loss of freedom entailed (in applying radical measures to the media).

On a larger canvas, it would probably be true to say that most communication research, where it was being carried out, was not much touched by such allegiances and continued to address the perennial questions of media influence, audience interests and behaviour, and certain familiar social problems attributed to media influence. This is without taking account of the large amount of applied

research for commercial purposes. The communication practices adopted for business were beginning to spread to new areas of political and social influence.

Change in the Wind

At this point, around the early 1980s (depending on where one stood), despite the expansion of research and publication, the emergence of any agreed social science of communication was as unlikely as ever. It would have been very handy, since at this time the new "discipline" of communication was being widely established as a suitable branch of university study. My own transition to the Netherlands was a side effect of this new trend and obliged me to think about the issue. It did not seem that much could be done to make good the absence of any unifying theory and it remained an assembly of theory, approaches, and methods centering on a set of problematic issues all stemming from or attendant on the growing presence of the media in societies, not only in daily life and leisure but also concerning larger political, economic, and social issues.

In some respects the rather diffuse economic crisis of the early 1980s, on top of a much troubled decade, diverted attention away from ideological disputes in the field, opening the way for more pragmatism, if not consensus. In North America and several European countries, political tides and winds favored a revival of free market thinking in respect of the mass media and especially with a view to encouraging new media developments. In the world of communication theory and research, attention gradually shifted away from the perennial questions of mass media appeal, towards new prospects opened, first by these new media and then dramatically so by the extensive development and application of digitization of all forms and phases of communication. A whole complex of technological changes in communication were speeded on their way by the relaxation of broadcast regulations and the breakup of telecommunication monopolies. The story has often been told and need not be repeated, but the essential point to emphasize is that it was—yet again—exogenous change that profoundly influenced the balance of attention in research and the nature of normative concerns in the new digital age of communication.

There are many, and probably quite obvious, reasons why the field of study has had to adapt to the new circumstances, just as old media systems are having to do. The amount of information circulating in the public domain is much greater and growing exponentially, its types of content and the balance between them is changing, in as yet uncharted ways. The relations established with audiences are often quite different than those typical of mass media, many uses and applications are still untried or in an experimental phase, new structures of control and regulation are called for, if not implemented. Much of the accumulated evidence and ideas from earlier mass communication research needs to be reevaluated, a task not even begun, and new possibilities of consequences for individuals and

societies have to be mapped out. The revolutionary implications of all this need not be exaggerated. The means of communication between people and throughout societies are changing, but societies are not obviously changing in their fundamental structure and dynamics, despite shifts of power within and between states. We should expect that much of the inherited theory of mass communication will still provide a useful guide to future outcomes. If there are some fundamentals in human communication—as communication theory presumes—then new circumstances and fresh evidence are more likely to confirm, extend, or modify what we know already than to render it obsolete.

However, another set of questions arises from the change that stems from normative considerations. The developments mentioned have initiated new debates, with a broad framing of attitude between the optimistic and pessimistic in respect of changes taking place. There are many details, but, based on a widely deployed typification of old and new forms, the innovations have either been welcomed or treated with skepticism. Optimists point to their liberating effects on the flow of information; increased access to the means of public expression; greater freedom of speech generally; stronger and closer ties across the board between people; and the end of restrictive boundaries of communication space in the world. The pessimistic view regrets the decline of social cohesion, the confusion of alienation and fragmentation with liberation, and the loss of social control and also of public purpose in the structure and conduct of public communication. Many established ways of handling issues relating to the public sphere have unraveled. There is as much impetus to inequality and new kinds of manipulation or exploitation in the emerging environment as there is potential for good. There is not much new in the underlying values implied by these remarks, although there are new questions arising from the new circumstances.

The challenges of the new have been of much interest but, because of retirement, less personally pressing to respond to. There are many now engaged on this task of reassessment. In the early period of change that accompanied digitization and convergence, my most central concern could be described as normatively driven, but empirical in orientation. The central normative issue concerned how public communication systems, of which journalism is probably the most important, could best be applied and governed so as to serve the public interest, itself a concept in need of much clarification. This general concern required both criteria for the overall evaluation of media systems and also criteria for evaluating (or guiding) actual practice in the work of communication. Neither of these tasks could be carried out with the resources of a communication science on its own, even if one existed in a coherent form. They depend on contributions from the field of public policy and governance plus social and political theory, and also from the accumulated wisdom of the relevant communication professions concerning best practices and standards of performance.

Theoretical Deficit in Review

Looking back very briefly at the origins and history of the research field of communication, possibly datable to the 1930s in the United States, it is not surprising that it did not achieve the recognition of disciplinary status, not only because it was late in arrival when such rewards had been allocated, but also because its research objectives were adequately served in essentials by the young disciplines of sociology, political science, psychology, social anthropology or speech, and rhetoric (plus practical study of journalism, advertising, and so forth). Despite the later invention of the idea of founding fathers there are really no authoritative voices or texts that provide the focus and guide that this notion seems to promise. So the field formed around a set of problematic issues for society, all in some way concerned with effects: issues around propaganda and persuasion, fears of moral and cultural harm to the masses, expected impacts on democratic politics, and others besides.

The fragmentary and ad hoc extension of the study of communication had become even more evident when it began to diffuse internationally in post-war years, impelled by much the same original impulses towards research. In the circumstances, theory forming was weakly practiced and the history of the field is characterized by an import of a succession of theoretical perspectives with origins elsewhere: Marxism, functionalism, social constructionism, semiology, systems theory, culturalism, feminism, postmodernism, and so forth. On the whole, it looks as if the theories that are most native and specific to the field are what Merton would have classified as theories of the middle range, essentially generalizations, based on accumulated evidence and a sustainable logic, about how communicative behaviour (in its manifestation as social action) in defined situations develops. The theories, however, are not enlightening visions with a capacity to illuminate large areas of relevant experience in respect of communication.

A possible exception to these remarks comes to mind, in the penchant, essentially sociological, for characterizing whole time periods in an overarching way. The sequence is started in sociology by the earliest idea of a modern society, contrasting a new, more impersonal and individualist form of "society" with the notion of a past organic "community." The mass media were seen as aiding in hastening this transition. The mass society provides the next formulation, with its heavy baggage and long life. Supplementary perceptions of predominant trends in twentieth-century society were provided by concepts that included "consumerism," "hidden persuaders," "one-dimensional man," and the "lonely crowd." The most general notion, and one lacking normative loading, was the subsequent idea of the "post-industrial" society, which has in turn paved the way for the "information society." This has heralded change since the 1980s and still offers some grasp on the key "informatizing" trends of the digital age. The idea of a "network society" has since been widely welcomed as a theoretical umbrella (Castells, 2001),

but, as with its predecessors, it begins to unravel when scrutinized for precise meaning, always a bit elusive at this elevated level of discussion.

The overall conclusion emerging is that the field of communication has been beneficiary of many theories, too many for any claim to high status in the pantheon of the social sciences, but with some benefits for its own needs. It remains open to new ideas, to taking on new questions, to adapting old theories and discarding what is obsolete. This does not resolve all its problematic aspects, the patchy and shaky basis in fundamental principles, and the limits of available methodology.

Normative Theory to the Rescue

It is tempting to suppose that what has saved the field from evolutionary extinction has been precisely its openness to normative impulses of a compelling kind. The normativity in question, essentially the formulation of ideas of good or bad, positive or negative, as applied to what communication (especially in public) might or might not achieve, is evidently very diverse in focus and form. Moreover, it is often driven by temporary problems and demands for application. The diversity is not surprising given the inexhaustible variety of communicative purposes and actions, but it does nothing for the unity of the field.

Certainly there are many dimensions of concern, relating to many issues and topics as they arise in ongoing social life. However, some classification can be applied beyond this. First, there are different sources and origins, deploying fundamentally different perspectives, for instance, philosophy; religion; aesthetics, art, culture; ethics; professionalism; politics; social theory; and more. Second, there are a smaller number of fundamental principles that appear recurrently in different forms, including freedom, power and control, exchange and relation, truth, the public good, equality, and justice. Third, there is a level of normative thinking and analysis, well beyond fundamentals, when values have to be operationalized and applied to cases in the form of concepts and precise indicators, for assessment, adjudication, guidance, and so forth. At this point, we are again returned to a situation of diversity of choice, although within a circumscribed area of meaning.

Bringing Together the Strands

These brief comments shed some light on the various interfaces between normativity and social scientific theory, and between normative theory and its application to evidence gathering and problem solving. In effect, in order to achieve relevance to the practice of communication science, all evaluative issues and questions have to be filtered according to a scientific attitude of inquiry and a recognizable theoretical framework appropriate to the topic of research. Second, all evaluative (or qualitative) variations have to be converted by way of clear definition and conceptualisation into categories that are meaningful to practitioners of research (and

often also a range of other interested parties, possibly even media practitioners). This also means a capability of objectification for purposes of observation and recognition, a potential for operationalization, although not necessarily a claim to be able to measure all qualities and attributes.

According to this view, the social scientific and the normative will always be entwined with each other, despite the aspiration and even necessity of the former to establish a degree of independence and agnosticism. In respect of most communication issues, the connection will be stronger than is usual in more mainstream fields because of the involvement of questions of meaning and of valence in every kind of communicative relationship. But, in general, the paths by which issues arising in social life make their way into the candlelight of social science, and then return as evidence or solutions, have to be negotiated with the help of normative compasses, all somewhat different in their settings.

This story as told has been generally sympathetic to a normative orientation to the field, in line with the author's personal inclinations and experience. However, there are other preferences and even possibilities for those who want to be more truly scientific and would like to concentrate on what are perceived as fundamentals of behavior and the objective forces that impel human communication of many different kinds in a range of recurrent situations of transmission, reception, exchange, and so forth. Certainly, quite a few law-like principles of communication have been established, and by experimentation and observation can be added to. Such an objectified vision of the field has the appeal of greater certainty, but the messy reality to which it is thought to relate cannot be handled in the same clinical way. Having shown these biases towards the normative view, it would be remiss not to add qualifications that also stem from my own experience and views. This is not a minor point since such biases can be a complete disregard of, even disdain for, scientific standards of evidence and interpretation on the part of those strongly committed to belief in a particular normative theory of society, but not socialized or educated into a scientific perspective. For them, the task of empirical research may be to supply convincing support for a theory that is not open to falsification. For unreconstructed empiricists, at the other extreme, the tendency may be to ignore the relative meaninglessness of data collected and measures taken, and therefore their susceptibility to multiple, even competing, interpretations and valuations. The choice among alternative designs and methods also entails subjective preferences and values and, thus, introduces bias.

Much more could be said on these themes and they need separate attention. However, it is important to leave the topic by stressing that the domain of the normative, especially as it concerns communication, can, and even must, itself be an object of (scientific) inquiry. At the very least, this should have a descriptive and clarifying purpose, seeking to discover the range of norms that might be available

and justifying their application for the purposes at hand as far as possible. This task does not itself have to involve normative evaluation.

At the end of this journey in memory, prompted by respect for a scholar who has contributed much to this area of education and inquiry and much more besides, I found myself remembering my school motto and thinking it was both relevant and oddly a bit prescient about my own coming career. It was a Latin phrase attributed to the eleventh-century Norman cleric and theologian St. Anselm: "*Fides quarens intellectum*" or "Belief seeking understanding," or perhaps reconciling faith and reason. This was not formulated in order to enlighten the path for communication researchers or normative media theorists but it has a wide general reference, and it seems to have a place here. At the very least it provides me with a sound authority.

Bibliography

Castells, M. (1996). *The Information Age: Vol. 1. The Rise of the Network Society.* Oxford: Blackwell.

Mills, C. W. (1959). *The Sociological Imagination.* New York: Oxford University Press.

Neuman, W. R. (2011). "The Evolution of Media Effects Theory: A Six-Stage Model." *Communication Theory*, 21(2), 169–196.

Noelle-Neumann, E. (1973). "Return to the Concept of Powerful Mass Media." *Studies of Broadcasting*, 9, 66–112.

Perse, E. (2001). *Media Effects and Society.* Mahwah, NJ: Erlbaum.

Signorielli, N., & M. Morgan. (Eds.). (1980). *Cultivation Analysis.* Newbury Park, CA: Sage.

Trenaman, J., & D. McQuail. (1961). *Television and the Political Image.* London: Methuen.

Understanding the Critical Political Economy of the Media

JANET WASKO

Studying the political economy of communications is no longer a marginal approach to media and communication studies in many parts of the world. Increasingly, this approach is crucial to understanding the growth and global expansion of media and information industries. Thus, more researchers have turned to this perspective as a necessary and logical way to study these developments.

This chapter will discuss the foundations and some of the major works in the study of the political economy of media and communications (PE/M).[1] The discussion presents an overview of the development of this approach, as well as providing examples of research representing the perspective. An argument will be made that the analysis of communications and culture from the perspective of critical political economy has influenced many communications researchers (such as Robert White), who may not overtly identify with the approach but often share its theories, concepts, and critical orientations.

Historical and Theoretical Foundations

To fully understand a political economic approach to studying media and communication, it is necessary to trace the foundations of political economy itself. The general study of political economy draws on eighteenth century Scottish Enlightenment thinking and its critique in the nineteenth century. For Adam Smith, David Ricardo, and others, the study of economic issues was called political economy and was grounded in social theory. Smith defined political economy

as the study of "wealth" (material goods) or the allocation of resources, and was concerned with "how mankind arranges to allocate scarce resources with a view toward satisfying certain needs and not others" (Smith, 1776/1937, p. 10). Further, political economists focused on the production, distribution, exchange, and consumption of wealth and their consequences for the welfare of individuals and society. More specifically, they studied one arrangement for the allocation of resources—they studied capitalism as a system of social production. Classical political economy evolved as capitalism evolved, adding Karl Marx and Frederick Engels's historical materialism and class analysis in the nineteenth century, which offered a radical critique of the evolving capitalist system through moral opposition to the unjust characteristics of that system.

During the last half of the nineteenth century, however, there was a fundamental shift in the study of economic issues, as the focus changed from macroscopic to microscopic analysis. Emphasis was placed on individual rather than societal concerns, and methods were drawn from the social sciences rather than from moral philosophy. These basic changes were represented in a shift in the name of the discipline—from political economy to economics.

Although neoclassical economics prevails today, political economy has continued in different forms. Several conservative versions have emerged, including a corporatist approach and public choice theory (also known as the new or positive political economy). These approaches generally argue that individual freedom can be expanded by applying neoclassical principles to a wider range of issues. Meanwhile, institutional political economy represents an approach that focuses on technological and institutional factors that influence markets. While some work in communication studies draws on institutional analysis, a radical, critical, or Marxian political economy is likely to be the tradition that is represented when one refers to "the political economy of communication."

In *The Political Economy of Communication*, Vincent Mosco defined this version of political economy as "the study of the social relations, particularly power relations, that mutually constitute the production, distribution and consumption of resources" (1996, p. 25). He explains that political economy is about survival and control, or how societies are organized to produce what is necessary to survive, and how order is maintained to meet societal goals. Mosco further delineates four central characteristics of critical political economy, which are helpful in understanding this approach:

1. *Social change and history*: Political economy continues the tradition of classical theorists, uncovering the dynamics of capitalism—its cyclical nature, the growth of monopoly capital, the state apparatus, and so forth.

2. *Social totality*: Political economy is a holistic approach, or, in concrete terms, explores the relationship among commodities, institutions, social

relations, and hegemony, and explores the determination among these elements, although some are stressed more than others.

3. *Moral philosophy:* Critical political economy also follows the classical theorists' emphasis on moral philosophy, including not only analysis of political economic systems but also discussion of the policy problems and moral issues that arise from it. For some contemporary scholars, this is the distinguishing characteristic of political economy.

4. *Praxis:* Finally, political economists attempt to transcend the distinction between research and policy, orienting their work toward actual social change and practice. As Marx pointed out: "Philosophers have hitherto only interpreted the world in various ways; the point is to change it." (Marx, 1845/1998, p. 5)

Mosco's model is similar to the formulation developed by British political economists Graham Murdock and Peter Golding, who have distinguished critical political economy from mainstream economics: the former is holistic, historical, centrally concerned with the balance between capitalist enterprise and public intervention, and "goes beyond technical issues of efficiency to engage with basic moral questions of justice, equity and the public good" (Golding & Murdock, 1991, p. 17). The latter is narrowly focused, ahistorical, uninterested in the public good, and limited to technical issues as they play out at the microscopic level.

In summary, a primary concern of political economists is with the allocation of resources (material concerns) within capitalist societies. Through studies of ownership and control, political economists document and analyze relations of power, class systems, and other structural inequalities. Critical political economists analyze contradictions and suggest strategies for resistance and intervention using methods drawn from history, economics, sociology, and political science.

Historical Development and Definitions

The academic study of communication has not always embraced economic analysis, much less a political economic approach. During the 1940s and 1950s, U.S. communication scholars focused primarily on individual effects and psychologically oriented research, with little concern for the economic context in which media are produced, distributed, and consumed. While explicit references to political economy were lacking, some critical studies are noteworthy, for example, Danielian's (1939) classic study of AT&T and Klingender and Legg's (1937) and Huettig's (1944) critical analyses of the U.S. film industry.

In the 1950s and early 1960s, former FCC chief economist and University of Illinois professor Dallas Smythe urged scholars to consider communication as an important component of the economy and to understand it as an economic entity. In addition to offering a course on the political economy of communications at

the University of Illinois as early as 1948, Smythe presented one of the first explications of a political economy of communications in 1960, defining the approach as the study of political policies and economic processes, their interrelations, and their mutual influence on social institutions (Smythe, 1960). He argued that the central purpose of political economy was to study the structure and policies of communication institutions in their societal settings. Smythe further delineated research questions emanating from policies that related to production, allocation, capital, organization, and control, concluding that the studies that might evolve from these areas were practically endless. While Smythe's discussion at this point did not employ radical or Marxist terminology, it was a major departure from the kind of research that dominated the study of mass communications at that time.

Smythe and a few other U.S. scholars, notably Herbert Schiller, and later Thomas Guback, continued to focus their research and teaching around the political economy of communication during the 1960s. They were influenced by institutional economics, but inspired as well as by the general political and economic developments of the period. Not until the 1970s was PE/M explicitly defined again, but this time within a more clearly Marxist framework and in another part of the world.

In 1974, Graham Murdock and Peter Golding offered their formulation of the political economy of communication stating, "The mass media are first and foremost industrial and commercial organizations which produce and distribute commodities" (1974, pp. 205–206). Thus, PE/M is fundamentally interested in studying communication and media as commodities produced by capitalist industries. The article established a basic model for PE/M by focusing on the consolidation, concentration (including integration and diversification), and internationalization of media institutions, and represented "a ground-breaking exercise . . . a conceptual map for a political economic analysis of the media where none existed in British literature" (Mosco, 1996, p. 102). A later piece by Murdock and Golding (1979) placed political economy within the broader framework of critical and Marxian theory, with links to the Frankfurt School, as well as to other critical theorists.

Nicholas Garnham further outlined the approach in 1979, also drawing connections to the Frankfurt School and noting that PE/M involves analyzing "the modes of cultural production and consumption developed within capitalist societies" (p. 123). He further explained that media must be seen "first as economic entities with both a direct economic role as creators of surplus value through commodity production and exchange and an indirect role, through advertising, in the creation of surplus value within other sectors of commodity production" (p. 132). An important point emphasized by Murdock, Golding, and Garnham related to the contradictions inherent in this process. More specifically, as Garnham states, despite capital's control of the means of cultural production, "it does not follow

that these cultural commodities will necessarily support . . . the dominant ideology" (p. 136).

Meanwhile, also in 1979, Armand Mattelart, a Belgian scholar who worked in Latin America and France, outlined a Marxist approach to the study of media and communication in "For a Class Analysis of Communication" (Mattelart & Siegelaub, 1979). Mattelart drew directly on Marx's *Capital* in outlining the mode of production of communication, including production instruments, working methods, and relations of production, adding special attention to issues relating to the global extension of media and communication or what he and others called cultural imperialism. This work, along with Latin American scholarship, inspired many political economists in North America, who especially were involved at the time in the critique of U.S. cultural imperialism.

Debates and Variations

As PE/M has grown and developed over the years, a number of debates have emerged. One of the most well-known has been "The Blindspot Debate," which was initiated by Dallas Smythe in 1977. In an article intended to spark such a debate, he pointed out that communication had been overlooked by Western Marxists who were mostly interested in issues relating to ideology. He further argued that the main product of media was audiences, which were sold by media to advertisers. In other words, Smythe proposed that media programming was a "free lunch" and of little significance. Furthermore, he maintained that audiences' exposure to advertising should be considered labor that added value to the audience commodity.

Smythe's article prompted a series of replies, first from Murdock (1978), who cautioned that the audience commodity was limited to advertising-dependent media and that dismissing program content was far too drastic. The debate raged on, with Smythe (1978) responding, as well as Livant (1979), Meehan (1984), and Jhally (1990) entering the discussion. More recently, with the increasing spread of privatized, advertiser-supported media, the audience commodity concept has been accepted by communication theorists other than political economists.

During the 1990s, a few political economists directed special attention to "rethinking" political economy, especially in light of global political and economic restructuring (see Meehan, Mosco, & Wasko, 1994; Sussman, 1999). Mosco's (1996) book-length overview of PE/M is subtitled "Rethinking and Renewal," and presents political economy in the broad terms of commodification, spatialization, and structuration. In addition, he examines political economy's relation to cultural studies and policy studies. Mosco emphasizes that political economy is just one "entry point" to the study of communications, which must be studied within a wider social totality.

Distinctions also have been made between different perspectives based on world regions. In his 1996 overview, Mosco pointed out that British/European political economists have generally attempted to "integrate communication research within various neo-Marxian theoretical traditions." On the other hand, North American political economy, drawing on both Marxian and institutional approaches, "has been driven more explicitly by a sense of injustice that the communication industry has become an integral part of a wider corporate order which is both exploitative and undemocratic" (p. 19). Mosco also describes another variation that might be called Third World PE/M research, which relies on dependency and world systems theory, as well as other neo-Marxist traditions. This type of research has focused on challenging the modernization paradigm and analyzing various aspects of globalization processes (p. 20).

Attention also has been given to the distinctions between PE/M approaches by David Hesmondhalgh (2002), who identified the "Schiller-McChesney tradition" (as opposed to a "cultural industries approach"). He identified this tradition as the criticism of U.S. media systems, especially media concentration, as presented by Herb Schiller and continued in the 1990s by Robert McChesney and others (e.g., Edward Herman and Noam Chomsky [1988] with their propaganda model). Hesmondhalgh argues that the Schiller-McChesney tradition has provided invaluable documentation and analysis of the cultural industries. However, Hesmondhalgh feels that this version of PE/M has shortcomings, in that it still "underestimates" contradictions in the system, fails to explain specific conditions of cultural industries, pays more attention to production rather than consumption, and mostly ignores "symbol creators," while focusing most often on information-based media than on entertainment-oriented media. Hesmondhalgh finds solutions to these problems in a cultural industries approach, as outlined by Bernard Miège (1999), but also draws on Raymond Williams (1980).

More recently, Winseck and Jin (2011) have argued that political economists studying the media need to pay more attention to empirical evidence and documentation, and have called for a broader definition of the approach that would include institutional and other types of analysis. Further distinctions are made in Wasko, Murdock, and Sousa (2011), another recent collection that features a wide range of political economists focusing on media and communication.

Mosco concluded in 1996 that even though there are variations, most explications of PE/M at least attempt to decenter the media and emphasize capital, class, contradiction, conflict, and oppositional struggles (pp. 20–21). That tradition has continued as the approach has moved into the twenty-first century.

Major Themes and Exemplars

To further understand PE/M, it may be useful to consider specific examples of the issues that political economists examine, as well as samples of research from this

approach. Because a wide range of themes pertaining to communication and media have been addressed, it is nearly impossible to completely trace the rich history and wide range of communication scholarship that draws on a political economic tradition. The following sections identify some of the general themes that are fundamental to PE/M and provide some examples of research that exemplify these themes (see Mosco 1996 and 2009 for more extensive and detailed overviews).

Historical Studies

Most PE/M research incorporates historical analysis, for it is essential to document change as well as continuity. However, many notable historical studies have traced the development of specific media. Printing and the press have been documented in the United States by Eisenstein (1979) and Dan Schiller (1981), while in Britain, emphasis on class relations and the press has characterized historical studies by Curran (1979) and Sparks (1985). Ewen's historical work (1976, 1996) presents the historical evolution of advertising and public relations, while historical studies of broadcasting have included Kellner (1990), Downing (1990), and McChesney (1993). Meanwhile, Attali (1985) presented a historical overview of the music industry, while Flichy (1991) discussed the history of media in Europe and North America. The historical evolution of telecommunications also has received attention from political economists. Beyond Danielian's (1939) classic work on AT&T, more recent research includes Duboff's (1984) historical analysis of the telegraph, Becker's (1993) work on the telephone, Dan Schiller's examination of the infrastructure of cellular telephony (2007), and Winseck and Pike's (2007) research on the rise of global media. Historical work on the film industry has included Guback's (1969) research on the international film industry, Wasko's (1982) study of financial institutions and the film industry, and Pendakur's (1990) work on the historical dominance of the U.S. film industry in Canada.

Media as Business

A good deal of PE/M research has focused on the evolution of mass communications/media as commodities that are produced and distributed by profit-seeking organizations in capitalist industries, or in other words, media as business. The trends that Murdock and Golding identified in 1974 have expanded and intensified, not only within traditional media industries but also across industrial divisions into newly converged businesses.

It is clear that the general process of marketization has moved rapidly around the world during the last few decades. Communication and information have become key components of this marketization process but have also developed as significant industries. In many countries, public media institutions have been privatized, along with other public institutions, opening additional markets for growing transnational media and entertainment conglomerates. In addition, new

communication and information systems, such as the Internet, are developing as commercialized space, contrary to promises of public access and control. This commercialization process—including the growth of advertising and public relations—has been accompanied by an ever-expanding consumer culture, thus prompting the term "cultural capitalism" as a descriptor for the current period (see Murdock & Wasko, 2007).

Analysis of media as business has involved various concepts, including but not limited to the following:

- *Commodification/Commercialization.* Increasingly, media and communication resources have become commodities—products and services that are sold by profit-seeking companies to buyers or consumers. In addition, more and more of the media landscape is filled with commercial messages and the privatization of media outlets continues.

- *Diversification.* As media companies have expanded, new lines of business have been added in a process of diversification. While media industries often begin with a relatively large number of differentiated companies, these industries today are typically dominated by huge media-entertainment conglomerates that are involved in a wide range of diversified activities.

- *Horizontal/vertical integration.* As media corporations have grown larger and more profitable, they often have added companies that are in the same line of business, thus integrating horizontally. Not only have such companies expanded their range of businesses, but with new distribution technologies and deregulated markets, media companies have integrated vertically by adding companies in the same supply chain or at different stages of production.

- *Synergy.* There is also the potential for the various businesses owned by these large diversified conglomerates to work together to more effectively market products, thus producing a synergy that maximizes profits and decreases risk.

- *Concentration.* Of course, one of the major issues pertaining to the media business is the level of competition in various markets. While a competitive market is the avowed goal of capitalism, there is an inevitable tendency for markets to become concentrated, due to any number of factors (as identified by Murdock & Golding, 1974, and elsewhere). This is especially significant for media markets, where the provision of news and public information is vital for informed citizenship and where the provision of diversified entertainment can facilitate cultural and personal development. It is obvious that in many situations (such as in the United States or in the global market for blockbuster films), a handful

of conglomerates dominate the media landscape. By documenting the actual level of competition (or lack of competition), PE/M challenges the myth of the competitive marketplace under late capitalism. Political economists also are keenly interested in the consequences of such media concentration. For example, much attention has been focused on the influence of concentration on the availability and quality of news, as well as the "blockbuster complex" and the homogenization of content in cultural industries.

Political economists of communications have investigated these trends at various levels of analysis with studies of specific commodities, individual corporations and media industries, as well as national and global media systems. Only a few examples of these studies can be mentioned here.

While Murdock (2006) generally explored communication and the commodification process, research examples would include Banks (1996), Meehan (1991), Waetjen and Gibson (2007), Lustyik (2010), Hesmondhalgh (2006), Dittmer (forthcoming), and Wasser (2001).

Work that relates to specific media organizations, especially corporations, include Wasko (2001), Budd and Kirsch (2005), Martinez (2008), Lee (2010), Fitzgerald (2012), and countless unpublished studies by masters and doctoral students. Financial relationships of media corporations have been explored by Wasko (1982), Almiron (2010), and the significance of financial information by Thompson (2009), Hope (2011), and Lee (forthcoming).

Political economists also have examined specific media and communications industries. The television industry was dissected early on by Bunce (1976) and Collins, Garnham, and Locksley (1988), and later by Downing (1990), Streeter (1996), and Meehan (2005). Specific studies have analyzed the film industry, including Guback (1969), Garnham (1990), Pendakur (1990), and Wasko (1994, 2003). Kunz (2006) examined the U.S. film, television, and cable industries, Dyer-Witheford and de Peuter (2009) analyzed the video games industry and Cvetkovski (2007) and Sirois and Wasko (2011) considered the music industry. Advertising has been examined by Janus (1984), Sinclair (1987, 2012), Jhally (1990), and Mattelart (1991), and public relations by Ewen (1996). Studies of telecommunication, information technologies, and digital media include Mosco (1989), D. Schiller (1986), Wilson (1988), Mosco and Wasko (1988), Hills (1986), Gandy (1993), Mansell (1993), McChesney, Wood, and Foster (1998), and Fuchs (2008). Many other researchers within a political economic tradition have considered the cultural industries as a whole, including Miège (1999), Murdock (1990), Barnouw and Gitlin (1998), and Calabrese and Spark (2004).

Numerous examples of research by political economists in parts of the world other than North America and Europe have explored different regional dynamics. These have included Atwood and McAnany (1986), but more recently, Mastrini

(2009), Becerra and Mastrini (2011), and Bolaño, Mastrini, and Sierra (2012), as well as Sussman and Lent (1991), Zhao (1998, 2008), and Thomas (2010).

And, finally, PE/M has concentrated special attention to issues relating to international communication, transnationalization, and (more recently) globalization. Examples include Schiller (1969), Guback (1969), Nordenstreng and Schiller (1993), Roach (1993), Dorfman and Mattelart (1975), and more recently, Herman and McChesney (1997), McChesney and Schiller (2003), Thomas and Nain (2004), and Chakravartty and Zhao (2008).

Media and Labor

Since the 1970s and 1980s, there has been a steadily growing body of work aimed at understanding the role of labor in the media. In 1983, Mattelart and Siegelaub's second volume on communication and class struggle presented many early examples of work on these issues. Around the same time, studies of labor, media, and the working class were gathered by Mosco and Wasko (1983), and later by Sussman and Lent (1998). Meanwhile, Douglas (1986) looked at trade unions in the media industry, while Nielsen and Mailes (1996) discussed labor in the film industry, and Winseck (1993) analyzed telecommunications unions in Canada. Meanwhile, Miller, Govil, McMurria, and Maxwell (2001/2008) attempted to reframe the discussion of global Hollywood in terms of a new international division of cultural labor (NICL). The authors outline Hollywood's global dominance in political economic terms, analyzing the strategies that the U.S. film industry has used to "Americanize" the production, distribution, and exhibition of film. More recent work that has addressed media and labor issues, including McKercher (2002), Fones-Wolf (2006), Kumar (2008), McKercher and Mosco (2007), and Mosco and McKercher (2008).

Media and State Relations

Even though studies of ownership patterns and the dynamics of corporate control are essential, political economic analysis is much more than merely identifying and then condemning those who control media and communication resources. To understand the media's role in society, it is essential to understand relationships between media power and state power, as well as the media's relationships with other economic sectors. Interrelationships between media and communication industries and sites of power in society are necessary for the complete analysis of communications. This approach helps to dispel some common myths about economic and political systems, especially the notions of pluralism, free enterprise, competition, and so forth.

While it is often assumed that corporations simply seek relief from government intrusion, it is crucial to understand how the state supports the economy and corporations in various ways. To cite only one example, the U.S. motion pic-

ture industry relies on the U.S. government for clearing barriers to foreign markets, as well as in tracking and punishing copyright offenders, both in the United States and elsewhere. This relationship involves the film industry's lobbying arm, the Motion Picture Association of America (MPAA), which regularly attempts to influence government policies affecting the industry and its members. (For more detail, see Guback, 1969, and Pendakur, 1990.)

Schiller's and Smythe's work paved the way for a range of issues and themes that focus on media-state relations. Smythe's (1957) early work on the electromagnetic spectrum pointed to the state's role in allocating communication resources and protecting corporate interests. Schiller's *Mass Communication and American Empire* (1969/1992) provided an important analysis of the U.S. government's use of communication resources, especially for military purposes.

Meanwhile, other aspects of state policy have also been explored, particularly pertaining to support of the corporate interests in areas such as regulation, intellectual property, and so forth. Bettig's (1997) work on intellectual property is an especially good example. Meanwhile, regulation and policy have been the focus of work by many of the previously mentioned researchers, as well as Hills (1986), Streeter (1996), and Calabrese and Burgelman (1999).

Media and Democracy

Political economists also have discussed media developments specifically in relation to the public sphere, public citizenship, and democracy. While acknowledging the powerful role that capital plays in media developments, researchers have argued that these issues have a direct bearing on citizenship and public participation. These themes have characterized some of the work of Murdock, Garnham, and McChesney, as well as many others, such as Robert Hackett, Andrew Calabrese, and Cinzia Padovani.

Relationships with Other Approaches

It is also instructive to consider PE/M's relationship to other approaches that focus on the study of communications and media. It has previously been noted that the application of political economy to communication or media most always indicates a critical approach, compared to what has been called the administrative or mainstream approach in communications research. Meehan (1999) refers to the latter research paradigm as "celebratory" and observes:

> If we begin with a shared valuation that "although some problems may exist, capitalism is fundamentally good," our research thereby takes a celebratory stance toward media products, audiences, and institutions. If our shared valuation suggests that "despite some progress, capitalism is fundamentally flawed," a critical stance is an integral part of our research. Attempts at dialogue across these mutually exclusive valuations seem bound to fail. (p. 150)

In the following sections, PE/M is contrasted with a few other approaches, first those that either ignore, misrepresent, or reject political economy, followed by examples of integrated and/or sympathetic approaches.

Political Economy and Media Economics

More deliberate attention to economics has been evident in the field of communication and media studies with scholars identifying media economics as a distinct focus of research activity. Examples include textbooks by Picard (1989), Alexander, Owers, and Carveth (1993) and Albarran (1996), as well as *The Journal of Media Economics*, which was introduced in 1988. The goal of the journal, as stated in its contributor information section, is "to broaden understanding and discussion of the impact of economic and financial activities on media operations and managerial decisions." Generally, these media economics texts and the journal echo the concerns of mainstream (neoclassical) economics and seldom present a serious critique of the capitalist media system.

For the most part, the emphasis of media economics is on microeconomic issues rather than macroanalysis and focuses primarily on producers and consumers in media markets. Typically, the concern is how media industries and companies can succeed, prosper, or move forward. In other words, they represent a celebratory position vis-à-vis capitalism. While competition may be assessed, little emphasis is placed on issues relating to ownership of media resources or the implications of concentrated ownership and control. For instance, despite the title *Who Owns the Media?*, the volumes prepared by Compaine (1982, 2000) represent a form of celebratory media economics and avoid discussion of the actual owners of media corporations or their overall connections to a capitalist system.[2] These approaches avoid the kind of moral grounding adopted by political economists, as most studies emphasize description ("what is") rather than critique ("what ought to be"). Thus, the media economics tradition typically reinforces and celebrates the status quo media system, while claiming "objectivity" and "neutrality."

Political Economy and Cultural Studies

It is especially important to look more closely at the relationship between PE/M and cultural studies, as these two approaches are often identified (rightly or wrongly) as the primary and sometimes competing ways of critically examining media. Though PE/M and cultural studies focus on different areas of inquiry or objects of study, both approaches would seem to be needed for a complete critical analysis of culture and media.

Although cultural studies has expanded to the point where any definition is bound to be too limiting, a useful formulation is offered by O'Sullivan and colleagues (1994): "Cultural studies has focused on the relations between social relations and meanings—or more exactly on the way social divisions are made

meaningful" (p. 71). Therefore, PE/M and cultural studies should share a common critical analysis, at least, even though the focus of study is directed at different elements of the media process.

However, PE/M is often considered by cultural studies scholars to be too narrow, deterministic, and economistic, despite the broad definitions and wide range of research outlined above. Many have charged that PE/M is primarily focused on the economic or the production side of the communication process, neglecting texts, discourse, audiences, and consumption. In addition, a simplistic notion of ideology is ascribed to political economists, with little room allowed for resistance or subversion by audience members.

Over the years, political economists have defended and expanded their theoretical positions in light of some of these critiques, clarifying extreme and inaccurate accusations, but also responding to reasonable criticism (compare Murdock & Golding, 1974, and Golding & Murdock, 1991). On the other hand, some political economists have found cultural studies to be lacking consistent and strong analysis of the institutional or structural context of cultural consumption, focusing too narrowly on issues relating to media texts, identity, and audience reception. Especially problematic are studies that argue that the audience's alternative interpretations of media texts represent a kind of subversive resistance to and undermining of dominant ideological definitions and thus are politically liberating (e.g., Fiske, 1988).

Over the years, numerous discussions and evaluations of this relationship have been offered by one side or the other in individual papers, articles, and books. However, the most focused debates have taken place in professional journals, for example, in the "Colloquy" in *Critical Studies in Mass Communication* in 1995. Here, Garnham and Grossberg squared off, in what Meehan (1999) has called a "ritualized debate" based on stereotypes and unproductive posturing. In other words, the "debate" was not based on a constructive and well-mannered engagement, but degenerated into spiteful and negative (sometimes false) characterizations of extreme positions within both approaches.

For many, however, there is still a need for an intellectual alliance (beginning with true dialogue, as Meehan argues) between political economy and cultural studies. Such an integration of approaches is necessary, not only to fully examine the complexities of mediated communication but also to challenge other celebratory approaches in communication research. As Murdock argues (in the debate cited above), "We need to . . . work towards the construction of a more complete account of the central dynamics of contemporary culture and to mobilize those insights to defend the symbolic resources required to extend the rights and duties of citizenship in the service of revitalizing democracy" (1995, p. 94). Examples of studies that integrate cultural studies and political economy are discussed below.[3]

Integrated Studies

Meanwhile, there are a plethora of examples of studies that actually succeed in integrating various critical approaches. Many scholars working in cultural studies, international communications, feminism, race-ethnic studies, and other forms of social research have produced work that integrates these perspectives with PE/M. In other words, they embrace a political economic perspective as only one of the lenses they use to understand media. This outpouring of research and its recognition of structuration and agency—whether individual, collective, corporate, or institutional—have been ongoing for decades. For many contextual scholars, the conceptual or methodological divisions between or among political economy, cultural studies, and social research have essentially collapsed, yielding scholarship that synthesizes these areas.

A few studies have combined political economy with other approaches to examine a particular media phenomenon holistically. An excellent early example is Gripsrud's (1995) study of *Dynasty*, which traces the program's production context, discusses its textual elements, as well as examining its distribution and reception. In my own work on the Walt Disney Company, the history and political economy of the company is presented, along with various readings of Disney's texts and people's reception of and resistance to Disney products (Wasko, 2001). Increasingly, scholars are successfully integrating political economy and cultural studies to achieve more complete and nuanced analyses. Examples include Babe (2010), Kapur (2005), and Maxwell (2001).

The integration of feminism and political economy is well represented in Meehan and Riordan (2002), in which contributors examined media representations, consumer practices, and commoditization. Byerly and Ross's (2006) collection considers how gender is implicated in media industries, among other issues. Other examples include Martin (1991) and Balka and Smith (2000). On another front, Gandy (1998) offers an important look at race and ethnicity in the evolving systems of information media. Meanwhile, Stabile's (2006) study of gender, race, and crime news combines historiography with textual, class, and industrial analysis.

Collaborative research projects have also brought together researchers from different critical approaches and often from different national settings. For example, Meehan and Byars (1995) collaborated on a textual and industrial analysis of the U.S.–based Lifetime cable channel. In the Global Disney Audiences Project, an international group of researchers using various critical approaches and multiple methodologies documented people's experiences of Disney's products and penetration into local economies (Wasko, Phillips, & Meehan, 2001).

In another collection (Hagen & Wasko, 1998), various researchers address the commonalities and tensions between political economy and audience or reception analysis. More recently, the *Lord of the Rings* Project examined the distri-

bution of the film as well as fans' reactions (Barker & Mathijs, 2007), while Biltereyst and Meers (2011) have made important contributions to the integration of political economy and audience research.

Meanwhile, some of the political economists mentioned previously have contributed interesting analyses that integrate other disciplines. For instance, Murdock (1998) draws on anthropology to look more carefully at the historical roots of consumption. Elsewhere, Pendakur (1993) integrates ethnography with political economy, delving more deeply into the impact of media technology in rural villages in India. And Mosco's (1999) work on New York City draws heavily on geography to map the evolution of commercial space. These researchers have maintained the theoretical foundations of political economy, while expanding their analysis to embrace other relevant disciplines.

It is important to note that most of these integrated approaches maintain the essence of political economy, in that the research examines the relationships of power that are involved in the production, distribution, and consumption of media and communication resources within a wider social context. PE/M still privileges issues relating to class power, not to the exclusion of other relationships, however, and emphasizes the complex and contradictory nature of such relationships. Most important, PE/M challenges media and communication development that undermines equitable and democratic societies.

Undeclared Political Economists

Some communication scholars have contributed valuable studies that call attention to political economic characteristics of media-communication but do not claim to be political economists. For instance, some international approaches are grounded in political economy or incorporate PE/M concepts without declaring a commitment to the perspective (e.g., Joseph Straubhaar, Jeremy Tunstall, Oliver Boyd-Barrett, Ben Bagdikian, and many others). These scholars explore some of the same issues and share a critical perspective with political economists. In other words, they adhere to Mosco's description of critical communications research: they challenge the status quo, analyze media in its social context, and adopt a moral position or work for change (Mosco & Wasko, 1983).

It seems to me that Robert White would also share these perspectives. From his early work in rural sociology when he explored mass media technology's role in the lives of the rural poor in developing countries, to later work supporting the New World Information Order and the liberation theology movement, White has demonstrated sympathy with a political economic position. His commitment to a values-oriented approach that embraces communication for social justice is firmly grounded in a moral position, a key theme of PE/M. Perhaps the specific moral position may differ, but it might be argued that White certainly shares with political economists a commitment to critique and change, and strives for more demo-

cratic and equitable media systems. White's critique of theories of communication for development and the concept of empowerment might provide an apt example:

Empowerment is central to the process of development, but empowerment, it is argued, needs to be located within a broader framework, which sees the goal of development as the cultural and political acceptance of universal human rights. Power must be seen as a source of social responsibility and service. Movements cannot stop at their own empowerment but must gain the respect for the rights of all in the society (White, 2004, p. 7).

Conclusion

The study of political economy of the media and communications continues to attract communication researchers in North America, as well as in international settings. For instance, the Political Economy Section of the International Association for Media and Communication Research (IAMCR) has grown dramatically over the last decade or so, attracting numerous scholars from all over the world.

Perhaps this is not so surprising given the growing importance of the media and its industrial development within an expanding international market system. In other words, a careful analysis of capitalism, its structures, the consequences of those structures, and the contradictions that abound is more than ever relevant and needed, as the recent reinvigoration of Marxist analysis attests (see, for instance, Eagleton, 2011). As Jean Paul Sartre once said, "Marxism remains the philosophy of our time because we have not gone beyond the circumstances which engendered it" (1963, p. 30). A similar argument could be made for the study of political economy of the media.

Notes

1. PE/M will be used here to signify various approaches for the study of media, communication, and information that draw on the theories and methods utilized in the study of critical political economy, as further explained in the next sections of this chapter.
2. For example, some of the differences between political economy and media economics can be found in the debate on media ownership between McChesney and Compaine (and others) that appears on the Open Democracy website: (http://www.opendemocracy.net/forum/strand_home.asp?CatID=5).
3. During the 1990s, a number of "new" approaches emerged in media studies, including creative industries, convergence culture, production culture, production studies, cultural economy, and media industry studies. While a critique of these approaches is not possible here, see Wasko and Meehan, forthcoming.

Bibliography

Albarran, A. B. (1996). *Media Economics: Understanding Markets, Industries, and Concepts.* Ames: Iowa State University Press.

Alexander, A., J. Owers, & R. Carveth. (Eds.). (1993). *Media Economics: Theory and Practice.* Hillsdale, NJ: L. Erlbaum.

Almiron, N. (2010). *Journalism in Crisis. Corporate Media and Financialization.* Cresskill, NJ: Hampton.

Attali, J. (1985). *Noise: The Political Economy of Music.* Minneapolis: University of Minnesota Press.

Atwood, R., & E. G. McAnany. (Eds.). (1986). *Communication and Society in Latin America.* Norwood, NJ: Ablex.

Babe, R. (2010). *Cultural Studies and Political Economy: Toward a New Integration.* Lanham, MD: Lexington.

Balka, E., & R. Smith. (Eds.). (2000). *Women, Work and Computerization: Charting a Course to the Future.* Dordrecht: Kluwer Academic.

Banks, J. (1996). *Monopoly Television: MTV's Quest to Control the Music.* Boulder, CO: Westview.

Barker, M., & E. Mathijs. (Eds.). (2007). *Watching Lord of the Rings.* New York: Peter Lang.

Barnouw, E., & T. Gitlin. (Eds.). (1998). *Conglomerates and the Media.* New York: New.

Becerra, M., & G. Mastrini. (2011). "Communication Economy Paths: A Latin American Approach." In J. Wasko, G. Murdock, & H. Sousa (Eds.), *The Handbook of Political Economy of Communications* (pp. 109–126). Malden, MA: Wiley Blackwell.

Becker, J. (1993). "The Political Economy of Early Telephony in Germany." In J. Wasko, V. Mosco, & M. Pendakur (Eds.), *Illuminating the Blindspots: Essays Honoring Dallas W. Smythe* (pp. 111–131). Norwood, NJ: Ablex.

Bettig, R. (1997). *Copyrighting Culture: The Political Economy of Intellectual Property.* Boulder, CO: Westview.

Biltereyst, D., & P. Meers. (2011). "The Political Economy of Audiences." In J. Wasko, G. Murdock, & H. Sousa (Eds.), *The Handbook of Political Economy of Communications* (pp. 415–435). Malden, MA: Wiley Blackwell.

Bolaño, C., G. Mastrini, & F. Sierra. (Eds.). (2012). *Political Economy, Communication and Knowledge: A Latin American Perspective.* New York: Hampton.

Budd, M., & M. H. Kirsch. (Eds.). (2005). *Rethinking Disney: Private Control, Public Dimensions.* Middletown, CT: Wesleyan University Press.

Bunce, R. (1976). *Television in the Corporate Interest.* New York: Praeger.

Byerly, C. M., & K. Ross. (Eds.). (2006). *Women and Media: A Critical Introduction.* Malden, MA: Wiley Blackwell.

Calabrese, A., & J. Burgelman. (Eds.). (1999). *Communication, Citizenship and Social Policy.* Boulder, CO: Rowman & Littlefield.

Calabrese, A., & C. Sparks. (Eds.). (2004). *Toward a Political Economy of Culture: Capitalism and Communication in the Twenty-first Century.* Lanham, MD: Rowman & Littlefield.

Chakravarty, P., & Y. Zhao. (Eds.). (2008). *Global Communication: Toward a Transcultural Political Economy.* Lanham, MD: Rowman & Littlefield.

Collins, R., N. Garnham, & G. Locksley. (1988). *Economics of Television: The UK Case.* London: Sage.

Compaine, B. (Ed.). (1982). *Who Owns the Media? Concentration of Ownership in the Mass Communications Industry.* White Plains, NY: Knowledge Industry.

Compaine, B., & D. Gomery. (2000). *Who Owns the Media? Competition and Concentration in the Mass Media Industry.* Hillsdale, NJ: Lawrence Erlbaum.

Curran, J., M. Gurevitch, & J. Woollacott. (Eds.). (1979). *Mass Communication and Society.* Beverly Hills, CA: Sage.

Cvetkovski, T. (2007). *The Political Economy of the Music Industry: Technological Change, Consumer Disorientation and Market Disorganization in Popular Music.* Saarbrücken: VDM Verlag Dr. Müller.

Danielian, N. R. (1939). *AT&T*. New York: Vanguard.

Dittmer, J. (forthcoming). "The Ochocinco Brand: Social Media's Impact on the NFL's Institutional Control." In T. Oates & Z. Furness (Eds.), *The NFL: Critical/Cultural Perspectives*. Philadelphia: Temple University Press.

Dorfman, A., & A. Mattelart. (1975). *How to Read Donald Duck*. London: International General.

Douglas, S. (1986). *Labor's New Voice: Unions and the Mass Media*. Norwood, NJ: Ablex.

Downing, J. D. H. (1990). "The Political Economy of U.S. Television." *Monthly Review*, 42(1), 30–41.

Duboff, R. (1984). "The Rise of Communications Regulation: The Telegraph Industry, 1844–1880." *Journal of Communication*, 34(3), 52–66.

Dyer-Witheford, N., & G. de Peuter. (2009). *Games of Empire: Global Capitalism and Video Games*. Minneapolis: University of Minnesota Press.

Eagleton, T. (2011). *Why Marx Was Right*. London: Yale University Press.

Eisenstein, E. (1979). *The Printing Press as an Agent of Change: Communications and Cultural Transformations in Early Modern Europe*. New York: Cambridge University Press.

Ewen, S. (1976). *Captains of Consciousness*. New York: McGraw-Hill.

Ewen, S. (1996). *PR!: A Social History of Spin*. New York: Basic.

Fiske, J. (1988). *Television Culture*. London: Methuen.

Fitzgerald, S. W. (2012). *Corporations and Cultural Industries: Time Warner, Bertelsmann, and News Corporation*. Lanham, MD: Lexington.

Flichy, P. (1991). *Une histoire de la communication moderne: Espace public et vie privee*. Paris: La Découverte.

Fones-Wolf, E. (2006). *Waves of Opposition: Labor and the Struggle for Democratic Radio*. Champaign: University of Illinois Press.

Fuchs, C. (2008). *Internet and Society: Social Theory in the Information Age*. New York: Routledge.

Gandy, O. H., Jr. (1993). *The Panoptic Sort: The Political Economy of Personal Information*. Boulder, CO: Westview.

Gandy, O. H., Jr. (1998). *Communication and Race: A Structural Perspective*. London: Edward Arnold.

Garnham, N. (1979). "Contribution to a Political Economy of Mass Communication. *Media, Culture and Society*, 1, 123–146.

Garnham, N. (1990). *Capitalism and Communication: Global Culture and the Economics of Information*. London: Sage.

Garnham, N. (1995). "Political Economy and Cultural Studies: Reconciliation or Divorce?" *Critical Studies in Mass Communication*, 12(1), 62–71.

Gay, P., & M. Pryke. (Eds.). (2002). *Cultural Economy*. London: Sage.

Golding, P., & G. Murdock. (1991). "Culture, Communication, and Political Economy." In J. Curran & M. Gurevitch (Eds.), *Mass Media and Society* (pp. 15–32). London: Edward Arnold.

Gomery, D. (1989). "Media Economics: Terms of Analysis." *Critical Studies in Mass Communication*, 6(1), 43–60.

Gripsrud, J. (1995). *The Dynasty Years: Hollywood Television and Critical Media Studies*. London: Routledge.

Grossberg, L. (1995). "Cultural Studies vs. Political Economy: Is Anybody Else Bored with This Debate?" *Critical Studies in Mass Communication*, 12(1), 72–81.

Guback, T. H. (1969). *The International Film Industry: Western Europe and America since 1945*. Bloomington: Indiana University Press.

Hagen, I., & J. Wasko. (Eds.). (1998). *Consuming Audiences: Production and Reception in Media Research*. Cresskill, NJ: Hampton.

Herman, E., & N. Chomsky. (1988). *Manufacturing Consent: A Political Economy of the Mass Media*. New York: Pantheon.

Herman, E., & R. McChesney. (1997). *The Global Media*. London: Cassell.

Hesmondhalgh, D. (2002). *The Cultural Industries*. London: Sage.

Hesmondhalgh, D. (2006). "Digital Sampling and Cultural Inequality." *Social & Legal Studies*, 15(23), 53–75.

Hills, J. (1986). *Deregulating Telecoms: Competition and Control in the United States, Japan and Britain*. London: Frances Pinter.

Hope, W. (2011). "Global Capitalism, Temporality and the Political Economy of Communication." In J. Wasko, G. Murdock, & H. Sousa (Eds.), *The Handbook of Political Economy of Communications* (pp. 521–540). London: Wiley-Blackwell.

Huettig, M. D. (1944). *Economic Control of the Motion Picture Industry*. Philadelphia: University of Pennsylvania Press.

Janus, N. (1984). "Advertising and the Creation of Global Markets: The Role of the New Communication Technologies." In V. Mosco & J. Wasko (Eds.), *Critical Communications Review, Vol. 2: Changing Patterns of Communication Control* (pp. 57–70). Norwood, NJ: Ablex.

Jhally, S. (1990). *The Codes of Advertising: Fetishism and the Political Economy of Meaning in the Consumer Society*. New York: Routledge.

Kapur, J. (2005). *Coining for Capital: Movies, Marketing, and the Transformation of Childhood*. New Brunswick, NJ: Rutgers University Press.

Kellner, D. (1990). *Television and the Crisis of Democracy*. Boulder, CO: Westview.

Klingender, F. D., & S. Legg. (1937). *Money Behind the Screen*. London: Lawrence & Wishart.

Kumar, D. (2008). *Outside the Box: Corporate Media, Globalization and the UPS Strike*. Urbana: University of Illinois Press.

Kunz, W. (2006). *Culture Conglomerates: Consolidation in the Motion Picture and Television Industries*. Lanham, MD: Rowman & Littlefield.

Lee, M. (forthcoming). "Time and the Political Economy of Financial Television." *Journal of Communication Inquiry.*

Lee, M. (2010). *Free Information? The Case Against Google*. Champaign, IL: Common Ground.

Livant, W. (1979). "The Audience Commodity: On the 'Blindspot Debate.'" *Canadian Journal of Political and Social Theory*, 3(1), 91–106.

Lustyik, K. (2010, March). "Transnational Children's Television: The Case of Nickelodeon in the South Pacific." *International Communication Gazette*, 72(2), 171–190.

Mansell, R. (1993). *The New Telecommunications: A Political Economy of Network Evolution*. London: Sage.

Martin, M. (1991). *"Hello, Central?": Gender, Technology, and Culture in the Formation of Telephone Systems*. Montreal & Kingston: McGill-Queen's University Press.

Martinez, G. (2008). *Latin American Telecommunications: Telefonica's Conquest*. Lanham, MD: Lexington.

Marx, K. (1845). "Theses on Feuerbach." In K. Marx, *The German Ideology*. New York: Prometheus Books.

Mastrini, G. (Ed.). (2009). *Mucho ruido, pocas leyes: Economía y políticas de comunicación en la Argentina* (segunda edición ampliada). Buenos Aires: La Crujía.

Mattelart, A. (1991). *Advertising International: The Privatisation of Public Space*. London: Comedia and Routledge.

Mattelart, A., & S. Siegelaub. (Eds.). (1979). *Communication and Class Struggle, Vol. I: Capitalism, Imperialism*. New York: International General.

Mattelart, A., & S. Siegelaub. (Eds.). (1983). *Communication and Class Struggle, Vol. II: Liberation, Socialism*. New York: International General.

Maxwell, R. (Ed.). (2001). *Culture Works: The Political Economy of Culture*. Minneapolis: University of Minnesota Press.

McChesney, R. W. (1993). *Telecommunications, Mass Media and Democracy: The Battle for the Control of U.S. Broadcasting*. New York: Oxford University Press.

McChesney, R. W., & D. Schiller. (2003). *The Political Economy of International Communications: Foundations for the Emerging Global Debate about Media Ownership and Regulation*. Technology, Business and Society Programme Paper, 11. Geneva: United Nations Research Institute for Social Development.

McChesney, R. W., E. M. Wood, & J. B. Foster. (Eds.). (1998). *Capitalism and the Information Age*. New York: Monthly Review.

McKercher, C. (2002). *Newsworkers Unite: Labor, Convergence and North American Newspapers*. Lanham, MD: Rowman & Littlefield.

McKercher, C., & Mosco, V. (Eds.). (2007). *Knowledge Workers in the Information Society*. Lanham, MD: Lexington.

Meehan, E. R. (1984). "Ratings and the Institutional Approach: A Third Answer to the Commodity Question." *Critical Studies in Mass Communication*, 1(2), 216–225.

Meehan, E. R. (1991). "Holy Commodity Fetish, Batman!: The Political Economy of a Commercial Intertext." In R. E. Pearson & W. Uricchio (Ed.), *The Many Lives of the Batman* (pp. 47–65). New York: Routledge.

Meehan, E. R. (1993). "Commodity Audience, Actual Audience: The Blindspot Debate." In J. Wasko, V. Mosco, & M. Pendakur (Eds.), *Illuminating the Blindspots: Essays Honoring Dallas W. Smythe* (pp. xxx). Norwood, NJ: Ablex.

Meehan, E. R. (1999). "Commodity, Culture, Common Sense: Media Research and Paradigm Dialogue." *Journal of Media Economics*, 12(2), 149–163.

Meehan, E. R. (2005). *Why TV Is Not Our Fault: Television Programming, Viewers, and Who's Really in Control*. Lanham, MD: Rowman & Littlefield.

Meehan, E. R., & J. Byars. (1995). "Once in a *Lifetime*: Cable Narrowcasting for Women." *Camera Obscura*, 33–34, 213–241.

Meehan, E. R., V. Mosco, & J. Wasko. (1994). "Rethinking Political Economy: Change and Continuity." In M. Levy and M. Gurevitch (Eds.), *Defining Media Studies: Reflections on the Future of the Field* (pp. 105–116). New York: Oxford University Press.

Meehan, E. R., & E. Riordan. (Eds.). (2002). *Sex and Money: Feminism and Political Economy in the Media*. Minneapolis: University of Minnesota Press.

Miège, B. (1999). *The Capitalization of Cultural Production*. Paris: International General.

Miller, T., N. Govil, J. McMurria, & R. Maxwell. (2001/2008). *Global Hollywood*. London: BFI.

Mosco, V. (1989). *The Pay-per Society: Computers and Communication in the Information Age*. Toronto: Garamond.

Mosco, V. (1996). *The Political Economy of Communication: Rethinking and Renewal*. London: Sage.

Mosco, V. (1999). "New York.com: A Political Economy of the 'Informational City.'" *Journal of Media Economics*, 12(2), 103–116.

Mosco, V. (2009). *The Political Economy of Communication* (2nd ed.). London: Sage.

Mosco, V., & C. McKercher. (2008). *The Laboring of Communication: Will Knowledge Workers of the World Unite?* Lanham, MD: Lexington.

Mosco, V., & J. Wasko (Eds.). (1983). *The Critical Communications Review. Vol. 1: Labor, the Working Class and the Media*. Norwood, NJ: Ablex.

Mosco, V., & J. Wasko. (Eds.). (1988). *The Political Economy of Information*. Madison: University of Wisconsin Press.

Murdock, G. (1978). "Blindspots about Western Marxism: A Reply to Dallas Smythe." *Canadian Journal of Political and Social Theory*, 2(2), 109–119.

Murdock, G. (1990). "Redrawing the Map of the Communication Industries." In M. Ferguson (Ed.), *Public Communication: The New Imperatives* (pp. 1–15). Beverly Hills, CA: Sage.

Murdock, G. (1995). "Across the Great Divide: Cultural Analysis and the Condition of Democracy." *Critical Studies in Mass Communication*, 12, 89–94.

Murdock, G. (1998). "Peculiar Commodities: Audiences at Large in the World of Goods." In I. Hagen & J. Wasko (Eds.), *Consuming Audience? Production and Reception in Media Research* (pp. 228–247). Cresskill, NJ: Hampton.

Murdock, G. (2006, December). "Marx on Commodities, Contradictions and GlobaliZations: Resources for a Critique of Marketized Culture." *Compos*. Available at www.compos.com.br/e-compos

Murdock, G., & P. Golding. (1974). "For a Political Economy of Mass Communications." In R. Miliband & J. Saville (Eds.), *Socialist Register* (pp. 205–234). London: Merlin.

Murdock, G., & P. Golding. (1979). "Capitalism, Communication and Class relations." In J. Curran, M. Gurevitch, & J. Woollacott (Eds.), *Mass Communication and Society* (pp. 12–43). Beverly Hills, CA: Sage.

Murdock, G., & J. Wasko. (Eds.). (2007). *Media in the Age of Marketization*. Cresskill, NJ: Hampton.

Nielsen, M., & G. Mailes. (1996). *Hollywood's Other Blacklist: Union Struggles in the Studio System*. London: BFI.

Nordenstreng, K., & H. I. Schiller. (Eds.). (1993). *Beyond National Sovereignty: International Communication in the 1990s*. Norwood, NJ: Ablex.

O'Sullivan, T., J. Hartley, D. Saunders, M. Montgomery, & J. Fiske. (1994). *Key Concepts in Communication and Cultural Studies* (2nd ed.). London: Routledge.

Pendakur, M. (1990). *Canadian Dreams and American Control: The Political Economy of the Canadian Film Industry*. Detroit, MI: Wayne State University Press.

Pendakur, M. (1993). "Political Economy and Ethnography: Transformations in an Indian Village." In J. Wasko, V. Mosco, & M. Pendakur (Eds.), *Illuminating the Blindspots: Essays Honoring Dallas W. Smythe* (pp. XXX). Norwood, NJ: Ablex.

Picard, R. (1989). *Media Economics: Concepts and Issues*. Newbury Park, CA: Sage.

Roach, C. (Ed.). (1993). *Communication and Culture in War and Peace*. Newbury Park, CA: Sage.

Sartre, J. P. (1963). *Search for a Method*. New York: Alfred Knopf.

Schiller, D. (1981). *Objectivity and the News*. Philadelphia: University of Pennsylvania Press.

Schiller, D. (1986). *Telematics and Government*. Norwood, NJ: Ablex.

Schiller, D. (2007). "The Hidden History of U.S. Public Service Telecommunications, 1919–1956." *Info: The Journal of Policy, Regulation and Strategy for Telecommunications, Information and Media*, 9(2/3), 17–28.

Schiller, H. I. (1969/1992). *Mass Communication and American Empire*. Boston: Beacon.

Sinclair, J. (1987). *Images Incorporated: Advertising as Industry and Ideology*. London: Croom Helm.

Sinclair, J. (2012). *Advertising, the Media and Globalization: A World in Motion*. London: Routledge.

Sirois, A., & J. Wasko. (2011). "The Political Economy of the Recorded Music Industry: Redefinitions and New Trajectories in the Digital Age." In J. Wasko, G. Murdock, & H. Sousa (Eds.), *The Handbook of Political Economy of Communications* (pp. 331–357). Malden, MA: Wiley Blackwell.

Smith, A. (1776/1937). *An Inquiry into the Nature and Causes of the Wealth of Nations*. New York: Random House.

Smythe, D. W. (1957). *The Structure and Policy of Electronic Communications*. Urbana: University of Illinois Press.

Smythe, D. W. (1960, Autumn). "On the Political Economy of Communication." *Journalism Quarterly*, 563–572.

Smythe, D. W. (1977). "Communications: Blindspot of Western Marxism." *Canadian Journal of Political and Social Theory*, 1(3), 1–27.

Smythe, D. W. (1978). "Rejoinder to Graham Murdock." *Canadian Journal of Political and Social Theory*, 2(2), 120–127.

Sparks, C. (1985). "The Working Class Press." *Media, Culture and Society*, 7(5), 133–146.

Stabile, C. (2006). *White Victims, Black Villains: Gender, Race, and Crime News in US Culture*. London: Routledge.

Streeter, T. (1996). *Selling the Air: A Critique of the Policy of Commercial Broadcasting in the United States*. Chicago: University of Chicago Press.

Sussman, G. (1999). "Introduction: Special Issue on the Political Economy of Communications." *Journal of Media Economics*, 12(2), 85–87.

Sussman, G., & J. A. Lent. (1991). *Transnational Communications: Wiring the Third World*. Newbury Park, CA: Sage.

Sussman, G., & J. Lent. (Eds.). (1998). *Global Productions: Labor in the Making of the "Information Society."* Cresskill, NJ: Hampton.

Thomas, P. N. (2010). *Political Economy of Communications in India: The Good, the Bad and the Ugly*. London: Sage.

Thomas, P. N., & Z. Nain. (Eds.). (2004). *Who Owns the Media: Global Trends and Local Resistance*. Mahwah NJ: Erlbaum.

Thompson, P. A. (2009). "Market Manipulation? Applying the Propaganda Model to Financial Media Reporting." *Westminster Papers in Communication and Culture*, 6(2), 73–96.

Waetjen, J., & T. A. Gibson. (2007). "Harry Potter and the Commodity Fetish: Activating Corporate Reading in the Journey from Text to Commercial Inter-text." *Communication and Critical-Cultural Studies*, 4(1), 3–26.

Wasko, J. (1982). *Movies and Money: Financing the American Film Industry*. Norwood, NJ: Ablex.

Wasko, J. (1994). *Hollywood in the Information Age: Beyond the Silver Screen*. Cambridge, UK: Polity.

Wasko, J. (2001). *Understanding Disney: The Manufacture of Fantasy*. Cambridge, UK: Polity.

Wasko, J. (2003). *How Hollywood Works*. London: Sage.

Wasko, J., & E. R. Meehan. (forthcoming). "Critical Crossroads or Parallel Routes?: Political Economy and New Approaches to Studying Media Industries and Cultural Products." *Cinema Studies Journal*.

Wasko, J., G. Murdock, & H. Sousa. (Eds.). (2011). *The Handbook of the Political Economy of Communications*. Malden, MA: Wiley-Blackwell/IAMCR.

Wasko, J., M. Phillips, & E. R Meehan. (2001). *Dazzled by Disney? The Global Disney Audiences Project*. Leicester: Leicester University Press.

Wasser, F. (2001). *Veni, Vidi, Video: The Hollywood Empire and the VCR*. Austin: University of Texas Press.

White, R. A. (2004). "Is 'Empowerment' the Answer? Current Theory and Research on Development Communication." *Gazette: The International Journal for Communications Studies*, 66(1), 7–24.

Williams, R. (1980). *Problems in Materialism and Culture*. London: Verso.

Wilson, K. (1988). *Technologies of Control: The New Interactive Media for the Home*. Madison: University of Wisconsin Press.

Winseck, D. (1993). *A Study in Regulatory Change and the Deregulatory Process in Canadian Telecommunication with Particular Emphasis on Telecommunications Labor Unions*. Doctoral dissertation, University of Oregon.

Winseck, D., & D. Y. Jin. (Eds.). (2011). *The Political Economies of Media: The Transformation of the Global Media Industries*. London: Bloomsbury.

Winseck, D. R., & R. M. Pike. (2007). *Communication and Empire: Media, Markets and Globalization, 1860–1930*. Durham, NC: Duke University.

Zhao, Y. (1998). *Media, Market and Democracy in China: Between the Party Line and the Bottom Line*. Urbana: University of Illinois Press.

Zhao, Y. (2008). *Communication in China: Political Economy, Power, and Conflict*. Lanham, MD: Rowman & Littlefield.

Power, Inequality, and Citizenship

The Enduring Importance of the Political Economy of Communications

PETER GOLDING AND KAREN WILLIAMSON

In his writing, as in his work, Bob White has never lost sight of the importance of power and inequality in considering questions of media and communication. Not least in his contribution to our understanding of the media's role in evolving citizenship in former colonial societies, he has always been sensitive to the intimate links between the media and processes of political power, participation, and accountability. In this he reflects some of the core tenets of a critical political economy approach to communications, aspects of which are the focus of this chapter.

Our purpose here is to demonstrate why an understanding of the media, and their pivotal role in enduring patterns of inequality and power (or lack of it), remains central to a full understanding of social order in the twenty-first century. In setting out this case, we draw on evidence from the UK, and conceptually draw inspiration from that tradition of work in the political economy of communications that we regard as essential.

This approach to the study of communications and the media has its roots in political economy more generally, which emerged as an analytical critique of capitalism in the eighteenth century, to be displaced by the later consolidation of economics as a self-consciously scientific, and it was presumed, objective study of the production, distribution, and consumption of goods and services. Political economy is associated with the work of Adam Smith, later David Ricardo, and, in the nineteenth century especially, with Karl Marx, who saw his work as a critique

of political economy. It became the antecedent for an approach to studying the media in a period of rapid expansion, both of media corporations and of critical social science in the mid-twentieth century. Not the least of its antecedents was dissatisfaction with notions of the liberal free press as a normative ideal for mass media, and concern with a diminishing range of cultural diversity despite market expansion.

Studying Media and Communications: An Enduring Essential for Social Analysis

Debate about the need for and nature of media studies in its various guises has been central to the political discussion over the future of higher education in the UK, and indeed elsewhere. Skepticism, often authoritatively and trenchantly expressed, has been commonplace. In 1993 John Patten, then minister of education, announced: "I have ordered an enquiry within the Department of Education to try and find out why some young people are turned off by the laboratory, yet flock to the seminar room for a fix of one of those contemporary pseudo-religions like media studies. . . . For the weaker minded, going into a cultural Disneyland has an obvious appeal."

The *Sunday Telegraph* proclaimed that "thousands of university students are being misled into thinking that media studies courses will qualify them for a job in broadcasting, industry experts warn," while the field was dismissed in a *Sunday Times* editorial as "little more than a state-funded three year equivalent of a pub chat."

This rhetoric and the arguments that have poured forth in similar vein in recent times are nonsense, and they remain so. It is often suggested, for example, that studying such subjects at the top end of secondary school (ages 16–18 in the UK) is, in the words of a *Times* leader, a "soft option for students," prompting the familiar cry, as reported in the same paper, that "we'll curb Mickey Mouse school courses, say Tories" or as the *Daily Express* put it, "SOFT-TOUCH school subjects like hairdressing and media studies will be drastically curbed under radical Tory plans unveiled yesterday."

Yet even a cursory review of available data shows that the subjects most often passed pro rata at school-leaving age are physics and chemistry; media studies is well into the bottom half of the pass rate. If the results are ranked by grade success, media studies is the seventh lowest (that is, fewest A+–C) out of 44. That is to say, far from being an easy option, candidates will see that their chances of a high grade in this subject are relatively restricted, and it demands a high level of achievement. And the field remains small. More than four times as many students aged 17–18 took a science subject as took media, film, or television studies added together in 2011. In 2011 students admitted to universities to study mass communications and documentation (the official category, which includes

librarianship and so forth) were outnumbered 2.6 to 1 by entrants to biological sciences, and by 5.2 to 1 by students admitted to business studies. They were even outnumbered by entrants admitted to study classics and linguistics.

This is not a field rich in research resources. Data taken from the last national Research Assessment Exercise (2001–2008) showed that the average annual expenditure in that period on academic research in media and communications stood at £2.51m. In contrast, in 2006–2007 the national broadcasting regulator Ofcom spent £5.06m on audience and consumer research. This can, in turn, be compared with a total of £1.8bn spent through private sector funding for total UK market research in 2007, which as of 2011 had increased to £3.1bn (Market Research Society, 2011). While at this time we are unable to present more recent figures of academic expenditures in media and communications (due to be compiled for the new Research Excellence Framework [REF] in 2014), it may be reasonable to speculate that there is unlikely to be a great divergence from these discrepancies.

But beyond this kind of material underpinning lies an ideological shift of profound importance in understanding the role, intellectually and politically, of the issues and questions posed by media studies. Academia has, in the UK notably but symptoms are universal, shifted in recent years in two significant ways. The first is a utilitarian drive that regards academic education and research as adjuncts of national policy, and especially of economic growth and innovation. The second shift—which has often had a very direct impact on the form and conduct of media studies—is an emphasis on what, in the UK, have been termed "subjects of national importance." These are often contained in a formulation comprising the so-called STEM subjects, that is to say, science, technology, engineering, and mathematics. The acronym and its importance have had an important role in the assessment of immigrants into the United States, and the subjects embraced by the phrase are seen, in countries such as the UK, to occupy a privileged place in higher education, needing both protection and disproportionate support. Both imperatives are fostered by an ever-increasing synergy between the work of universities and the priorities of large employers and corporations.

An example of the rhetoric behind such views may be found in the UK government's report *Higher Ambitions 2009*:

> Business and employers need to contribute more. They will do this through joint research programs, vocationally oriented courses that they part-fund, sponsorship of students and much greater use of universities for management and leadership training enhanced support for the STEM subjects—degrees in the sciences, technology, engineering, and mathematics—and other skills that underwrite this country's competitive advantages.

This was reinforced by a review of university-business collaboration commissioned by the government in 2012 (the "Wilson Report"). This came close to

constructing universities as collectively the research and development arm of UK plc. The UK Minister for Universities and Science (in the UK government structure the universities portfolio sits within the Department for Business Innovation and Skills [BIS]), in an interview with the *Daily Telegraph* in 2011, suggested that the "classic A-levels" (secondary school examinations at age 17–18) traditionally valued by top universities should be given higher ratings by the Universities and Colleges Admission Services (UCAS) and in school league tables published by the government every year. Newer subjects, such as dance, photography, and media studies, were valuable to students who wanted to specialize in those areas but it was to be acknowledged that they are "not core academic subjects." The cumulative skepticism about the value and relevance of media studies in its various guises has, not for the first time, become repetitive and deterrent, prompting the national subject association in the UK to issue a pamphlet in 2013 explaining the value and variety of university programs in the field.

Yet there has palpably never been a more important time to identify, analyze, and critique the role of media in informing people's capacity to act as citizens. One of the perennial mysteries of social inquiry is why and how societies that are variably non-egalitarian nonetheless remain stable and durable. The concept of hegemony describes but does not explain this curious and enduring truth. And the UK has become unprecedentedly unequal. Fundamental shifts are occurring in the fabric of the social order, quite unlike any in recent times. We are witnessing massive movements of power and advantage on a scale unknown since the founding of the welfare state.

Research by Incomes Data Services (IDS) in 2012 showed that FTSE 100 (i.e., the top 100 companies) directors had seen their total earnings increase by an average of 49 percent in the last financial year and were now averaging £2,697,664 per annum. This followed a similar increase the previous year. Research by Professor Ruth Lister and colleagues showed that

> there remain deep-seated and systematic differences in economic outcomes between social groups across all of the dimensions we have examined—including between men and women, between different ethnic groups, between social class groups, between those living in disadvantaged and other areas, and between London and other parts of the country. (Hills et al., 2010)

The Organization for Economic Co-operation and Development's (OECD) latest report on rising inequality finds the bottom 30 percent with just 3 percent of UK wealth, while the top third commands 75 percent. As Warren Buffet says of the class war: "My class has won." For 100 years, incomes in the UK became more equal, but since the 1980s that has gone into reverse, often in leaps and bounds, as the big bang blew the lid off top pay, trade unions lost their capacity to prevent half the population's incomes from stagnating, and unchecked property

bubbles accelerated wealth difference. Economic fatalism was law: governments must never interfere; markets are sovereign and politics effectively dead. According to a report published by the Institute for Fiscal Studies (Cribb, Joyce, & Philips, 2012), real incomes fell across the income distribution in 2010–2011. In the UK the median full-time salary in 2010–2011 was £26,200 per year, but someone working full time for the minimum wage would only earn around £11,000, while the top 10 percent earned more than £52,000. By 2012 some 1,829 people a day were losing their jobs.

Housing benefit cuts, targeted at low-income families receiving assistance with rents, are driving a version of social cleansing from private rented accommodation in major cities in the southeast. In February 2013 one London council announced that it would be moving more than 700 families (comprising nearly 3,000 adults and children) out of London to cheaper areas around the UK, in a move that was becoming increasingly common. The legislation behind this risks putting 800,000 homes out of the reach of people on housing benefits. Contrary to common (and indeed media-fuelled) mythology, people in the firing line are not "scroungers," as only one out of eight on housing benefit is unemployed.

The Institute for Fiscal Studies has predicted that, as a result of £18bn of benefit cuts, another 600,000 poor children in 2013–2014 will fall into absolute (not relative) poverty. In April 2013, 280,000 disabled, both young and old, had their welfare benefits cut. And against this background, with little resistance offered or heard in the political arena, the void has been filled by populist press anecdotes of Somalis in London mansions.

At the same time major institutions are going through quite essential reconstruction. The legal system, for example, in 2013 is undergoing a massive shift in the removal of access to legal redress and advice for lower-income households. The government now estimates that around 600,000 people will lose out on help with everyday civil legal problems as a result of the £350 million cut from legal aid for such households. A parallel shift in the legal obstacles faced by those losing jobs through disability means that employers need worry less about regulations now that their employees can get no legal aid to challenge unfair dismissal or harassment. Though evictions by private landlords have risen by 17 percent, legislation will abolish legal aid for tenants.

How is it possible to analyze the sustainability and relative stability of a social order in the face of such fundamental shifts in power, and such colossal shifts in the balance of inequality and resources? At the heart of social analysis has always been the question of ideology, whether in the guise of false consciousness or of relative deprivation. The media remain the key vehicles for the transmission of ideas, values, and symbols with which people make sense of the world around them.

Mainstream media are consumed still at very high levels. Despite fascination with the misnamed "social media" and the apparent diversity enabled by new

technologies, for most people the mainstream media of television and newspapers dominate the cultural landscape that they survey to gather cues and clues as to social and political events and processes. In 2012 television viewing for adults in the UK was at 28 hours a week on average (BARB, 2013). Just under 9 million copies (8,903,789) of the main national daily newspapers were sold each day (ABC Circulation, 2012). This is not a portrait of a dying institution. And yet the media themselves have provided much of the public drama and intrigue of the news for the past two years. It has been the era of "Hackgate." In this period we have seen the arrest and conviction of leading newspaper executives and journalists, evidence of breathtakingly inappropriate interrelationships between the police, senior politicians, and newspaper executives, and the realization that not just one but probably three leading institutions—police, media, and political leaderships—were embroiled up to their necks in what C. Wright Mills might once have enjoyed as evidence of a power elite. What now seems tawdry and depressing, if not alarming and terrifying, has brought the media back to the forefront of political and cultural critique.

The "Leveson Inquiry" into press conduct was established by the coalition government in the wake of widespread illegal and questionable phone-hacking and other methods by newspapers such as the *News of the World,* and reported in late 2012. By the end of 2012 nearly 70 people had been arrested in relation to improper activities of this kind, and the "Inquiry" report recommended a wholesale reconstruction of the apparatus of press methods and morals. Despite the report's care to stress the importance of press freedom, and the need to avoid state regulation, the press was quick to get its retaliation in first, equating any form of regulation (even a second order body to "verify" the independence of a body self-regulating press conduct) with dictatorial intrusion into freedom of speech. As the *Sun* told its readers, the proposals risked placing the UK in a disastrously dangerous position, "like Russia, Zimbabwe, and Iran," with "state stooges . . . deciding what can and can't be printed in your *Sun.*" One former editor of the *Sun* told the "Inquiry" that he recalled telling the then prime minister, "I've got a bucket of shit on my desk, prime minister, and I'm going to pour it all over you." Meanwhile, Rupert Murdoch earnestly insisted that he had played no part in seeking to influence public policy in the UK through his position as chairman and CEO of News Corporation.

Not surprisingly, public opinion was less sanguine. Over three quarters of the public prefer an independent body, established by law, to regulate the press rather than a body established by newspapers. Over two-thirds of the public agree that politicians are too close to owners and editors and cannot be trusted to protect people from unethical behavior by journalists. It is evident that on matters as socially fundamental as patterns of power and inequality an informed democracy needs, more than ever, the dependable accounts of social order that the media are, at least

in principle, obliged to provide. This "monitorial role" as Robert White and his collaborators have described it (Christians et al., 2009, ch. 5.), requires an account of power and inequality that can reflect and inform the significant shifts in social order indicated above. In the remainder of this chapter, we assess some of the aspects of these two fundamental dimensions of social order in relation to the media.

Power: Of the Media and In the Media

It remains a key proposition of political theory that an effective democracy requires the active involvement and participation of its citizens, and that this is ensured above all by their having access to the full range of information and knowledge that enables them to make effective judgments about the actions and procedures of those who rule. The media's role is to provide this diet of information, and it has been regularly argued in modern times that they do this fully, professionally, and, given the enormous innovations of new digital and online technologies, with ever-increasing diversity.

Yet the evidence of decades of media research sets a range of doubts around this proposition (argued more fully in Golding, 2010). Power is manifest first and foremost in the concentration of ownership of the national daily press, illustrated in Table 5.1.

Table 5.1. Average of circulation figures over a 6-month period from March 2012 to August 2012.

Publisher	Newspaper Titles	Total (%)	Daily (%)	Sunday (%)
News International	The Times; Sun; The Sunday Times; The Sun on Sunday	35	33.4	36.7
Associated Press	Daily Mail; The Mail on Sunday	10.7	22	20.9
Trinity Mirror	Daily Mirror; Sunday Mirror; The People; Daily Record; Sunday Mail	18.4	15.2	21.6
Northern and Shell	Daily Express; Daily Star; Sunday Express; Daily Star Sunday	12.3	13.3	11.3
Telegraph Media Group	The Daily Telegraph; The Sunday Telegraph	5.8	6.5	5.2
Guardian Media Group	The Guardian; The Observer	2.6	2.4	2.9
Independent News and Media	The Independent; The Independent on Sunday	2.8	4.1	1.4
Pearson	Financial Times	1.7	3.4	-

Source: ABC Circulation.

As the table shows, three companies own roughly two-thirds of the national circulation (more on Sunday). In the UK, news is largely defined by the national press; regional titles have higher penetration rates in their locality (since they are mostly local monopolies), but are significantly less important as definers and providers of news. This simple fact has been a manifest feature of the UK press for decades and has prompted endless discussion, though concentration and the even more powerful importance of cross-sector ownership (notably across press and broadcasting) have not been prominent features of major recent debate in or of the UK media, focused as it inevitably has been on matters of ethics and journalistic conduct.

Yet at one level we might be sanguine about the role of the news media, given compelling evidence of audience disengagement from and disenchantment with these primary sources of public knowledge. In a recent audit of public political engagement it was found that the number of 16- to 24-year-olds who say they follow news only when something important is happening has risen from 33 to 50 percent in the last five years (Hansard Society, 2012). The amount of television news watched by 16- to 24-year-olds is now at an average of below 40 hours a year, or around 45 minutes a week. And news audiences have been dwindling everywhere. In the UK news audiences have declined by roughly 25 percent in the last 40 years, while in the United States audiences for news fell from 90 percent of the TV audience in the 1960s to 30 percent by 2000. Between 1940 and 1990, newspaper circulation in America dropped from one newspaper for every two adults to one for every three adults. In the EU, younger news audiences especially have been declining for years in virtually all countries, and paid daily newspapers saw a 5.63 percent drop in circulation between 2002 and 2007.

It is often fondly assumed that this stark evidence of reducing appetite among Western audiences for conventional news media is accompanied by reassuring signs of a transfer of allegiance to newer, and possibly more diverse and effective forms of news communication, notably via the Internet. Yet again, evidence is less comforting. In the UK by July 2008 only 8 percent used the Internet even once a week for news. Its main use is for buying things and email. Use of the Internet for TV viewing is still restricted to fewer than 1 percent of the population compared to "standard" viewing, and of those who do not read a newspaper regularly only 3 percent consult a news website at least three times a week. Even more tellingly, as we shall explore below, access to the Internet and its full operational resources remains very inequitably available.

One consequence of this is widespread and systematic ignorance of the operations, locations, and sources of power. Not surprisingly political scientists regularly point to the apparent growth of apathy, or at least diminishing political activity, as registered in the conventional indicators of political mobilization and action. The annual political engagement survey mentioned above found that "interest

in politics is unchanged since last year with 52 percent of public 'very' or 'fairly' interested. 47 percent are 'not very' or 'not at all interested,'" and that "more than half of the public claim to know not very much or nothing at all about politics." The most obvious exemplar of such disenchantment is, of course, in electoral turnout. Turnout in European parliamentary elections has declined from 62 percent in 1979 to 43 percent in 2009, for example. While mass movements such as that generated around the "Occupy" protests create a powerful counterargument for both an alternative politics and an entirely new form of political communication, the evidence is at best contradictory, and doubtless both tendencies exist.

Yet, despite this palpable decline, the mainstream media remain colossally important. Whatever the data summarized above, it is the case that across Europe as a whole nearly 90 percent watch television every day and 71 percent read a newspaper at least once a week (Eurobarometer, 2011). In the UK consumption of "traditional" media, as we have seen, remains high. Thus, the importance of such media remains critical, and this is especially so where personal and everyday experience may be limited. The debate over Europe, and the UK's position in relation to the EU, is typical. The UK national press, with few exceptions, is insistently Europhobic, to such an extent that the EU London office maintains a "Euromyths" website devoted to rebutting many of the national press stories that are dottier and often xenophobic or plain bigoted. Whether being informed that "teabags banned from being recycled," or that "Eurocrats call time on light ale: bureaucrats in Brussels want to force British brewers to change the name of light ale," or even "revealed: EU's secret plot to abolish Britain," the office has its work cut out to keep up with the steady flood of stories denouncing the wayward and palpably eccentric and oppressive actions of the UK's unloved partners in Brussels.

Thus, the media exercise power both as institutions and industries with very substantial market muscle and as definers of much of the language and framing of the political landscape. While powerful in themselves, the cumulative evidence of decades of media research suggests how little light is shone into the murkier corners of power as exercised in public life. The inner sanctums of corporate decision-making and manipulation are rarely exposed to the rigors of journalistic inquiry, as so much of the astonishment expressed at the revelations of government-corporate-media liaison by the "Leveson Inquiry" made clear. This, together with the growing power of the public relations industry, and at the same time the rise of celebrity culture and its elevation in the news hierarchy, between them produce the meagre diet castigated by Nick Davies (2008) as "Flat Earth News."

Inequality: The Reproduction of Division

The increasing inequality of many Western societies, and certainly of the UK in recent years, has been buttressed by the apparent invisibility of such inequities to those most affected by them. This curious feature of late capitalist class systems

is powerfully and empirically demonstrated in one of the classics of post-war UK sociology, *Relative Deprivation and Social Justice* (Runciman, 1966). More recent research by journalists Polly Toynbee and David Walker has looked from the other end of the telescope, and noted what they describe as a dismaying lack of empathy and awareness among the rich and the super-rich of "other, less luxurious lives" (2009, p. 36). One of the powerful arguments that has recurrently emerged from the endless fascination with the social and political consequences of "new media" has been the presumption that the plethora of communication channels now available, and the apparently growing ease of access to information for citizens, has overturned previous divisions of cultural consumption and access.

This Panglossian vision assumes universal, or at least widespread, availability of such channels. The extent to which access to and readily available use of new communications technologies have been increasing has been the subject of continuing debate about the "digital divide." Initially the familiar sequence was assumed, that early adoption of new communication technologies by enthusiasts and the better-off would steadily become widespread use. However, as such goods and services percolated down through the economic structure, widespread use appears not to have happened. Unlike the diffusion of so-called white goods—electric cookers, refrigerators, central heating, and so on—in an earlier generation, new communication technologies have become widely available in a period of growing inequality. Not only that but their nature as goods requires more than initial investment. Computers have a finite life and need replacing, software must be purchased, and the Internet is available only at recurrent cost and at differentiated levels of sophistication. All of these characteristics make such goods the object of recurrent expenditure requiring significant disposable income, as well as initial capital.

Table 5.2. Percentage of UK households with selected communications goods by income (2012).

	Home computer	Internet connection	Telephone	Mobile
All	79%	77%	88%	87%
Lowest 10%	46%	41%	66%	75%
Highest 10%	100%	99%	98%	97%

Source: Adapted from ONS, *Family Spending, 2012*

For these reasons, the digital divide has proved remarkably durable—though sometimes regarded as an outmoded and simplistic concept, either because it would prove ephemeral or because the divide was actually multiple, disguising inequities of competence, attitude, and value as much as material resource or access. The divide is becoming more rather than less polarized in the United States. In the UK, while 79 percent of households have a home computer and 77 percent

have an Internet connection at home, in the richest tenth these figures are 100 percent and 99 percent, compared with only 46 and 41 percent of households in the poorest tenth. Table 5.2 shows the ownership of information and communication goods among differentiated income groups in the UK.

This matters hugely for people's ability to be and act as informed citizens. In general the higher the disposable income the lower the proportion of it that people spend on necessities such as food, clothing, or housing. The lower the disposable income the higher the proportion that goes to necessities. Despite that, in absolute terms, the amount richer people spend on such goods is greater than the amount spent by poorer groups. This general observation applies to the information sources that people can use to resource their role as citizens. As more and more information goods become commodities to be bought and sold in the marketplace, so it becomes much more crucial that their availability is determined by need rather than price. Yet communication goods have followed the pattern of price restricted availability and income determined access. This is shown in Table 5.3.

Table 5.3. Spending on communication goods as proportion of weekly expenditure: UK households 2012.

	Ratio of spending top 10%: bottom 10%	Proportion of weekly expenditure	
		Top tenth	Bottom tenth
Telephones/ Internet, etc.	3.3:1	2.2%	3.7%
TV, etc., rental/ subscriptions	2.3:1	0.8%	2.0%
Newspapers/ books, etc.	4.1:1	1.1%	1.5%

As the table shows, the richest tenth of households in the UK spend between three and four times as much as the poorest tenth on such goods as telephones, Internet, television, and newspapers. However, the proportion of their income spent on these goods is much lower—for example, about two-thirds the proportion of their income devoted to newspapers and books compared to the poorest—with 2.2 percent of their income on telephone and the Internet compared to nearer 4 percent of disposable income committed to such things by the poorest tenth. These figures indicate starkly the cost of being an informed citizen. More significant, they illustrate the extent to which it costs more but produces less among lower income households. Inequality of income translates directly into the digital divide, and again into inequities in people's capacity to act as informed citizens.

Thus, inequality in income and wealth is directly reproduced in unequal access to and opportunity for information as a key resource for citizenship. The digital divide, from being an arcane calibration of people's association with the technologies of the twenty-first century, becomes a substantial feature of the inequitable distribution of citizenship rights in the most advanced industrial societies.

Power and Inequality in the Information Society

The central thrusts of political economy, not least as related to citizenship and democracy in Robert White's work, are thus forcefully illustrated by the workings of the communications media. Several features of the emerging "information society" add emphasis to the importance of this perspective. The first is the growth of endemic ignorance, not in the form of an Olympian disdain for the educational competency of lesser mortals but as an observation of a decline in mainstream political knowledge among large sections of the population as it becomes ever more sidelined in mainstream media output and increasingly available as a priced commodity in a market to which access is inequitably distributed (see, inter alia, Anderson, 1998; Roberts & Armitage, 2008).

Second, a feature of contemporary societies many would see as diminishing the availability of information and analysis is the oft-lamented decline of the "public intellectual" (cf. Kellner, 1995). The marginalization of a high profile "commentariat" is one feature of the decline of public affairs as a news priority that has also been attributed to its replacement by a more attractive, if less didactic, celebrity culture. At worst this observation can become a patronizing form of "bread and circuses" critique, but it nonetheless captures at the very least a tendency of public culture in many societies. A third aspect of political communication many would note is the rise of "sound bite culture," the compression and often dilution of complex analysis into digestible if callow summaries for swift and easy consumption. This is sometimes observed literally in the coverage of election rhetoric and debate (Deacon, Golding, & Billig, 1998), though it refers more generally to what some would assess as the condensed and even frivolous character of much in the public domain.

Fourth, it is important to recognize the rise in many industrial societies of a reaction against the "Enlightenment tradition" of reason and rationality. Skepticism about the scientific basis of much publicly adduced evidence, or enthusiasm, for a range of different regimes of corroboration, whether in medicine, cosmology, environment, or politics, have been summarily identified by some as the rise of "unreason" (Taverne, 2005; Aupers, 2012). Loss of trust, not only in the media but in public institutions more generally, raises enthusiasm for alternative and radically dissenting accounts. This may, of course, be entirely healthy for democracy and, indeed, a signifier of a vibrant and dynamic public sphere. But it poses questions about the coherence and viability of an information society, which are

salient here, in that such widespread uncertainty leaves space for powerful and dominant accounts and formulations.

Most significant, we return to the crucial importance of the cost of being informed, and the tangible barriers of price and inequality that render the notion of an information-rich and fully equipped citizenry in a modern democracy open to such doubt. It is in this context that the pertinence of power and inequality to questions of communications and media becomes so evident, and this brings us back to the centrality of this perspective in Bob White's work as in the political economy tradition in which this chapter finds its stimulation and roots.

Bibliography

Anderson, R. D., Jr. (1998). "The Place of the Media in Popular Democracy." *Critical Review*, 12(4), 481–500.

Aupers, S. (2012). "Trust No-One: Modernization, Paranoia and Conspiracy Culture." *European Journal of Communication*, 27(1), 22–24.

BARB (Broadcasters' Audience Research Board). (2013). "Trends in Television Viewing 2012." Available at http://www.barb.co.uk/resources/tv-facts/trends-in-tv

Christians, C. G., T. L. Glasser, D. McQuail, K. Nordenstreng, & R. A. White. (2009). *Normative Theories of the Media: Journalism in Democratic Societies*. Urbana: University of Illinois Press.

Cribb, J., R. Joyce, & D. Philips. (2012). 'Living Standards, Poverty and Inequality in the UK: 2012." IFS Commentary C124. London: Institute for Fiscal Studies.

Davies, N. (2008). *Flat Earth News*. London: Chatto & Windus.

Deacon, D., P. Golding, & M. Billig. (1998). "'Between Fear and Loathing: National Press Coverage of the 1997 British General Election." *British Elections and Parties Yearbook*, 8, 135–149.

Eurobarometer. (2011). "Media Use in the European Union." *Standard Eurobarometer 76*, European Commission.

Golding, P. (2010). "The Cost of Citizenship in the Digital Age: On Being Informed and the Commodification of the Public Sphere. In J. Gripsrud (Ed.), *Relocating Television: Television in the Digital Context* (pp. 207–233). London: Routledge.

Golding, P., & G. Murdock. (2001). "Digital Divides: Communications Policy and Its Contradictions." *New Economy*, 8(2), 110–115.

Hansard Society. (2012). *Audit of Political Engagement 9*. London: Hansard Society.

Hills et al.. (2010). "An Anatomy of Economic Inequality in the UK-Summary. Report of the National Equality Panel." London: HMSO.

Kellner, D. (1995). "Intellectuals and New Technologies." *Media Culture and Society*, 17(3), 427–448.

Market Research Society. (2012). "2011 Industry League Tables." [Online]. Available at http://www.mrs.org.uk/intelligence/industry_statistics

ONS (Office of National Statistics). (2012). *Family Spending, 2012*. Available at http://www.ons.gov.uk/ons/rel/family-spending/family-spending/family-spending-2012-edition/index.html

Roberts, J., & J. Armitage. (2008). "The Ignorance Economy." *Prometheus*, 26(4), 335–354.

Runciman, W. G. (1966). *Relative Deprivation and Social Justice: A Study of Attitudes to Social Inequality in Twentieth-Century England*. Berkeley: University of California Press.

Taverne, D. (2006). *The March of Unreason: Science, Democracy and the New Fundamentalism*. Oxford, UK: Oxford University Press.

Toynbee, P., & D. Walker. (2009). *Unjust Rewards: Ending the Greed That Is Bankrupting Britain*. London: Granta.

Cultural Studies

Dialogue, Continuity, and Change

ROGER BROMLEY

The sources of cultural studies can be traced in certain debates in the nineteenth century around industrialization and democracy, in the Frankfurt School and its engagement with mass media and Americanization, and in the work of I. A. Richards, F. R. Leavis, and Denys Thompson around questions of moral value. The pedagogical practices developed in adult education classes in the 1930s and the Second World War were also influential.

Three Key Texts

All the standard accounts of British cultural studies trace its origins to the 1950s and to the emergence of three key texts. However, as Stuart Hall reminds us— whose 1980 essay, "Cultural Studies: Two Paradigms," remains in many ways the most precise and critically informed version—there are no absolute beginnings to the project of cultural studies. "Cultural Studies is a discursive formation, in Foucault's sense; it has no simple origins" (Hall in Morley & Chen, 1996, p. 263; unless otherwise specified, all further quotations from Hall come from this book). Even if this is so, it would be foolish to underestimate the impact of the works that marked its formal, textual starting point: Richard Hoggart's *The Uses of Literacy* (1957), Raymond Williams's *Culture and Society* (1958), and E. P. Thompson's *The Making of the English Working Class* (1963).

None of these texts was conceived in isolation, nor did they "arrive unaccompanied." Each was part of a wider context, which tends to be ignored by accounts

that stress the coherence and intentionality of its formative moments. In one of his last public lectures, Raymond Williams (1989) spent time reminding his audience of how much cultural studies work was being carried out prior to the 1950s by people influenced by, but critical of, I. A. Richards, F. R. Leavis, and *Scrutiny*, who were engaged in detailed analyses of popular fiction, cinema, advertising, and newspapers from a number of perspectives and under various headings. Much of this work occurred in evening classes and weekend schools under the auspices of the Workers Educational Association (WEA) and the extra-mural departments of universities. Far from being simply a matter of the founding texts, cultural studies has a longer history and deeper roots, extending back as far as army education in the Second World War and before, and being conducted very much as a vocation and a political commitment. As Williams acknowledges, many of the pioneers of cultural studies were extremely active in adult education, inspired by a dedication to popular, democratic and participatory education.

If most accounts of the origins tend to ignore the local educational and political aspects of its shaping, they nearly all refer to the wider context of the cold war, McCarthyism, the Hungarian uprising in 1956, which depleted the British Communist Party of many of its intellectuals, the Bomb and the Campaign for Nuclear Disarmament (CND), the Suez crisis, decolonization and recurring problems with the Empire, and the growing impact of American power. Much has been written about the apparent influence of the New Left and the Communist Party, but with hindsight both of these influences have perhaps been overemphasized at the expense of active Labour Party constituencies as a site for setting the agenda for much of the progressive thinking around education, welfare, and the media. As McGuigan (1992) points out, the National Union of Teachers conference, "Popular Culture and Personal Responsibility," in 1960 helped produce Williams's 1962 publication *Communications* and Denys Thompson's *Discrimination and Popular Culture* (1964), both widely used in schools, further education, and adult education, especially in liberal studies programs. Many of the people involved in this conference and its related events were Labour Party activists (Williams was a member from 1961 to 1966), and it is difficult to imagine today how seriously cultural debate around the arts, communications, and education was taken in this period.

Institutionally, Hoggart was the most significant of the founding figures in cultural studies. *The Uses of Literacy* (1957) certainly had a far wider readership for a time than any of the other seminal texts. In 1963, he moved to the University of Birmingham to take up a professorship of English, and a year later, with modest financial support from the Rowntree Trust and Penguin Books, he established the Center for Contemporary Cultural Studies (CCCS) at the university. Subsequently, and under the directorship of Stuart Hall and Richard Johnson, this Center was to become the major influence on the institutional and theoretical

development of cultural studies (in some accounts, seemingly the only influence). Hoggart's initial presence helped establish the first serious, non-elitist, study of popular culture in the United Kingdom.

Although the formative work of Hoggart, Williams, and Thompson is written specifically for, and on behalf of, the working class, its addressee, explicit or otherwise, is also a ruling class, and its companionable bourgeoisie. This addressee privileges its own values in the name of objectivity and universality but obscures their partiality and class—particularity through the exercise of power and authority that subordinates, and silences by contempt, alternative voices and oppositional resistances.

Industrialization and democratization, Williams argues in *Culture and Society* (1958), were key processes that led to the focus on the idea of culture as a response to revolutionary social change. Written consciously in the tradition of *Culture and Anarchy, Culture and Environment*—which sees culture as the primary (privileged) site for the transformation of "social being"—the book begins with the response of the Romantic Movement to industrialization and ends with a brief study of Orwell. *Culture and Society* is the first major text in Williams's monumental contribution to cultural studies that includes *The Long Revolution* (1961), *The Country and the City* (1973), *Television: Technology and Cultural Form* (1974), *Keywords* (1976), *Marxism and Literature* (1977), *Politics and Letters* (1979a), *Problems in Materialism and Culture* (1980), *Culture* (1981), *Towards 2000* (1983b), and *Writing in Society* (1983a). (There have been at least three posthumously published volumes since his death in January 1988.)

The impetus for *Culture and Society* lay in the publication of T. S. Eliot's *Notes Towards the Definition of Culture* (1948), which led Williams to trace, in an adult education class, the idea of culture through the study of a number of writers, all contemporary apart from Matthew Arnold. He was motivated to write the book as a way of countering a long line of thinking about culture from reactionary perspectives, especially to refute what he perceived as a growing contemporary use of the concept of culture against democracy, socialism, the working class, and popular education.

Williams describes the context in which he wrote *Culture and Society* as "a time when my separation from the possibilities of political action and collaboration were virtually complete. There was a breakdown of any collective project that I could perceive, political, cultural, or literary" (1979b, p. 102). Given the high premium placed on collaborative and collective work in cultural studies, this is a telling comment. When the book was finished Williams became involved with a range of political activities, including CND, writing for *Tribune*, contributing to the "Left Labour" collection of essays, *Conviction* (1958), and, in 1961, joining the Labour Party (although not a member, he had worked full-time for it during the by-election in 1939 and in the 1950 and 1955 elections). All of these social

movements used his intellectual work, together with the ideas of a number of others, to generate a level of cultural debate in political organizations that has rarely been matched since.

Williams's essay in *Conviction*, "Culture Is Ordinary," combines his cultural criticism with a clear political commitment. In the essay he argues that the making of a society is "the finding of common meanings and directions, and its growth is an active debate and amendment under the pressures of experience, contact, and discovery, writing themselves into the land" (in Highmore, 2001, p. 93). There is also the important, and much quoted, formulation: "There are in fact no masses, but only ways of seeing people as masses." Both the *Conviction* essay and the conclusion to *Culture and Society* seek to sustain the idea of a democratic culture and a popular education against the new commercial culture, and to establish an idea of value that is not merely elitist or that automatically demeans anything of a working class or popular belonging. In both pieces, Williams is writing explicitly as a socialist intellectual, a position elaborated upon in *What I Came to Say* (1989).

E. P. Thompson's critique of Raymond Williams's theory of culture is still regarded as one of the formative texts in the development of cultural studies. In his review of *The Long Revolution* by Raymond Williams (*New Left Review*, 9–10, 1961), Thompson points to particular limitations of the arguments in *The Long Revolution*, especially the lack of emphasis on struggle, the neglect of alternative reading publics and oppositional cultural forms, the suspect use of the "whole way of life" concept, a failure to come to terms with the problem of ideology, and the primacy given to the process of communication at the expense of an analysis of power. Throughout the two-part review Thompson is seeking to establish a meaningful distinction between "culture" and "not culture," a distinction that, he argues, Williams consistently blurs. Interestingly, Thompson is already arguing for the abandonment of the mechanical metaphor of base/superstructure and suggests that if this were to happen and if Williams were to discard the vocabulary of "systems" and "elements," common ground might be established by recognizing that "the mode of production and productive relationships determine cultural processes in an epochal sense" (p. 39). In the last section of the review ("History of Human Culture"), Thompson argues for seeing history as a way of conflict, and of class relationships shaping "the way of life," not patterns of culture. He reiterates Marx's claim that in class society "social being determines social consciousness" (p. 39) and is critical of the primacy that Williams gives to cultural history.

Two years after writing this review, Thompson published *The Making of the English Working Class* (1963), a monumental study of enormous influence on a whole generation of social and cultural historians. In this book, Thompson stresses that it is a study of an active process: "The working class did not rise like the sun at an appointed time. It was present at its own making" (p. 8). Like so much else that has shaped the growth of cultural studies, this is a work of rescue and

recovery, restoring the histories and practices of minorities, dissenters, and radical cultural forms. In line with the positions argued in the review, *The Making of the English Working Class* insists upon class as a cultural and economic formation, and stresses human agency, conflict, tension, and active struggle (the neglect of which he vigorously took Althusser to task for in *The Poverty of Theory*). It is this materialist, historicizing dimension of cultural studies that has been neglected by some of its poststructuralist exponents.

Refinement and Debate

Apart from Raymond Williams, Stuart Hall has been the most influential figure in British cultural studies. Outside of Britain, his work has probably been more responsible than any other for the spread of the field. Unlike Williams, his significance cannot be measured by a series of landmark books (not that Williams's role should be confined to these) but has manifested itself in an astonishing range of articles and co-authored books, many of which have a definitive place in the literature of the field. As director of the Birmingham Center for Contemporary Cultural Studies throughout the 1970s, he helped to make its break with a Left-Leavisite, humanist, cultural populism, and with others, steered it toward an engagement with European structuralist and Marxist theories, especially the work of Gramsci and Althusser. The encounter with Marxism was highly critical for, as Hall has pointed out, "Marx did not talk about or seem to understand [things] which were our privileged object of study: culture, ideology, language, the symbolic" (Morley & Chen, 1996, p. 265). Expressed simply, the key concepts to emerge from this engagement were encoding and decoding in television discourse, hegemony, ideology, the epistemological break in Marx's theoretical development, and the abandoning of the base/superstructure metaphor. The shift from the latter Hall attributes to the engagement with the work of Volosinov that ended "any lingering flirtation with even a modified version of the 'base-superstructure' metaphor to a fully discourse-and-power conception of the ideological" (Morley & Chen, p. 297). These conceptual shifts were not, of course, restricted to Birmingham but received their most pronounced institutional inflection at the Center. As many commentators have pointed out, there never was a Birmingham school as such, nor was there ever an agreed-upon position but, rather, a number of different groups worked on a range of projects, sometimes in conflict with each other and, occasionally, in an atmosphere some have described as intimidating.

"Cultural Studies: Two Paradigms" (Hall, 1980) is a summative account of the theoretical growth of cultural studies up until the end of the 1970s, and focuses upon its dominant methodologies—culturalism and structuralism—supplemented by reference to the poststructuralisms shaped by the work of Lacan and Foucault. It marks the end of Hall's period at Birmingham, prior to his becoming professor of sociology at the Open University—in the hope of engaging

cultural studies with a more "popular pedagogy" as he put it. As well as this, it is the most sustained expression of his appropriation of Gramscian ideas in which concepts of ideology and culture are not seen as being opposed to each other but are rearticulated in different ways. Throughout the 1980s, although he produced a considerable amount of material for innovative Open University courses, he was identified primarily with the definition of the concept of "Thatcherism," mainly through a series of analytical essays in *Marxism Today*, which depended upon his thesis of "authoritarian populism." He was also one of the principal architects of *Marxism Today*'s "new times" project with its somewhat surprising articulation of postmodernism with what came to be called (after Gramsci) post-Fordism. Hall's political journalism has been subject to extensive criticism for what opponents have considered to be its excessive culturalism and opportunism but, on reflection, his analysis, together with that of Eric Hobsbawn, of what was effectively neoliberalism, is still the most telling account we have of the radical transformation of British society at the economic, social, cultural, and political level since 1979.

It is not too fanciful to claim that those involved in cultural studies initially (even if many did not use the term as such) saw themselves as engaged in transforming British society to such an extent that the cultural privilege, political power, and social authority of the class that had shaped the nation until World War II would never again be regarded as legitimate currency. It was naïve, evolutionary, and, ultimately, a teleological view of the historical process, but it was nevertheless the dominant strain in radical thinking. "Agency," "intervention," "effect" were, at that time, not just items in a cultural discourse. "Class" was the primary analytical resource; education, at all levels, was seen as the principal medium of empowerment and change. For a number of years cultural studies ceased to have this activist inflection, but, interestingly, the Institute for Cultural Policy Studies, set up by Tony Bennett and colleagues at Griffith University in Australia, renewed this original project by asserting the need "to include policy considerations in the definition of culture in viewing it as a particular field of government" and "for intellectual work to be conducted in a manner such that, in both its substance and its style, it can be calculated to influence or service the conduct of identifiable agents within the region of culture concerned" (Bennett, 1992, p. 23).

Textually, Hoggart's *The Uses of Literacy* (1957) marks the first stages of the initial phase of development; arguably, *Policing the Crisis* (1978) the last. The former was written in the period 1952 to 1956, and is about changes in working-class culture during the preceding thirty or forty years, particularly as these were being shaped by mass publications. Although it is more concerned with methodology than is sometimes remembered (in fact, its major influence has been on what we could now call the ethnographic tradition), it is addressed to "the serious common reader" or "the intelligent layman [*sic*] from any class." In a sense, the outcome of

the study is announced in advance by the description of "the extraordinarily low level of the organs of mass communication." This assumption remained a given of the study of popular culture for at least two decades.

Unsystematic, autobiographical, puritanical, impressionistic, and nostalgic though it might be, *The Uses of Literacy* did attempt to discriminate between "mass" and "popular" and allowed scope for agency, choice, negotiation, and the creative use of cultural resources. The traces of Leavisite elitism, the easy-target anti-Americanisms, and the occasionally patronizing tone can all now be seen as fundamental weaknesses, but in the immediate post–Second World War period, there was deep and understandable anxiety that the hard-won literacy of the working class might not be used as part of an education for democracy and citizenship (to adopt some of the left rhetoric of the 1930s and the war period) but simply as an instrument of the culture industry. Hoggart had a high profile as a policymaker concerned with the arts, broadcasting, and youth and community services.

Hall and colleagues' *Policing the Crisis* (1978), researched and written in the period from 1973 to 1977, was a work of intervention, designed to have an effect on social policy and to produce the basis for a political judgment on issues of crime, race, youth, and black struggle. It was also a book about a society perceived as slipping into a certain mode of crisis. In many ways this was a landmark in the work of the Center for Contemporary Cultural Studies (CCCS) at the University of Birmingham, one of its finest achievements. It may seem strange to link it with *The Uses of Literacy* as, with its collectively authored approach, explicit political intent, and complex theoretical ambition, it would seem an entirely different phenomenon. All that is being argued is that it continued, and for the moment marked the end of, the interventionist academic work of British cultural studies—work that was conducted as if its outcome mattered, that could influence identifiable agents, and that had some urgent connection with the material conditions of people's lived experience.

Shifting from Its Beginnings

The academic and institutional field associated with cultural studies emerged in the 1960s, rapidly shifted from its left-liberal beginnings, and in the 1970s began a profound engagement with Marxism and continental theory that helped to transform thinking in the arts, humanities, and social sciences, certainly in Europe and the United States and, arguably, well beyond. As has been shown by Schwarz and others, this development took place in the context of decolonization and drew some of its principal arguments and examples from this experience. Among the key concepts, methodologies, and practices informing debates at this time were hegemony, ideology, semiotics and discourse analysis, and cultural materialism, which, in varying ways, led to analyses of the media using textual

analysis and the ideas of encoding and decoding and preferred readings, along with innovative approaches to texts and textualization. Together with this went a rethinking of the base/superstructure model and questions of determination, and a recasting of understandings of class that went beyond the dichotomous frameworks inherited from the nineteenth century. Many of these concepts were deployed initially in ethnographic (the study of audiences and subcultures, for example, the work of David Morley and Paul Willis), literary, historical, and sociological contexts with an emphasis on political economy, historicization, and the sociological. Levi-Strauss, de Saussure, Barthes, Benjamin, Gramsci, and Althusser were the key figures in these debates.

A preoccupation with forms of analysis based upon structuralism and post-structuralism—the work of Foucault, in particular—later supplemented by post-modernism, tended to weaken the influence of cultural materialism, with its particular inflections and emphasis on the "specificities of material cultural and literary production within historical materialism" (Williams, 1977). Strangely enough, this was also true of material culture studies with its concern with the role of objects in social relations, consumption, and the cultures of everyday lives. The stress on pleasure, resistances to power through lifestyle, fashion, consumption, and identity politics, and the celebration of playfulness and *bricolage*, chimed in well with the 1980s emphasis on individualism, privatisation, and deregulation, but it also marked a break in the field of cultural studies with the importance of political economy, the need to historicize, and the salience of class as a dimension of power. Stuart Hall's analysis of what he termed "authoritarian populism" restored this emphasis in part.

The shift away from class was not entirely negative as its most productive outcome was an engagement with questions of identity, subjectivity, and "discourses of the other" articulated through feminism, ethnicity and race, sexual politics, and the problematizing of the concept of nation, partly shaped by postcolonialism but also sharpened by the erosion of social democracy in the face of a resurgence of right-wing politics. Again, it was work at Birmingham that helped to give shape to some of these ideas, namely the volume *Women Take Issue* (1978)—but also the studies of psychoanalysis and feminism of Juliet Mitchell—and the series of essays in *The Empire Strikes Back* (1982). A major contribution to an understanding of race in British society was Paul Gilroy's *There Ain't No Black in the Union Jack* (1987). The central debates around gender, race, sexuality, space, and nation, characterized by nonreductionist approaches, were all related to the transformation of British politics in the 1980s and 1990s under the impetus of "authoritarian populism." Linked with this was the analysis of a range of concerns around empowerment, anti-essentialism, multiculturalism, and queer politics. Debates around cultural policy were also explored at this juncture, particularly evidenced

in the practices of the Greater London Council (GLC) and similar radical local authorities.

The primary assumption made by cultural studies in its early days was that the working class had become a major and sustained progressive political force, a vanguard even; hence class was the core analytical focus and struggle its central premise. Linked to this was a model of center-left democracy predicated upon the welfare state. These were the principal frameworks of understanding. Using the resources of sociology, literary studies, social history, critical theory, and cultural anthropology (a point of convergence of the humanities and social sciences), there was a teleological presumption in the programs as they set out to examine the social, political, and cultural transformations of British society from the seventeenth century onward, primarily the relation between cultural forms and the political economy. While the emphasis at Birmingham was on the contemporary, the undergraduate degree courses at Portsmouth Polytechnic and North East London Polytechnic in the 1970s both had strong historical frameworks. The main task, even if it was not explicitly articulated as such, was to understand why it was that the historic working class (remember the miners had defeated the Heath government in 1973–1974) remained subject to the power of a capitalist ruling class. Again, even if it was not phrased as such, the task, using concepts of hegemony and ideology, was seen as an intervention, at the level of theory, in the class struggle. The purpose was emancipatory.

Paradoxically, almost at the same time, another epochal transformation was taking place that, unknown to that generation of teachers, would check and undermine many of the arguments driving the program, if not its theoretical basis. The oil crisis of 1973 and the onset of neoliberalism in Chile and elsewhere heralded the long period of privatization, deregulation, and marketization that went virtually unchallenged until 2008 (the British government went to the IMF in 1975 and unemployment hit the million mark for the first time since WWII). What I want to tentatively suggest later in the chapter is that we may be on the threshold of another epochal transformation and to ask whether cultural studies still has any purchase if my assumption is true. Has, in other words, class—albeit in very different form, perhaps that of the "multitude"—returned as a factor in our current moment insofar as inequality (the 99%) has gained renewed prominence in everyday discourse, not just in the UK but on a global scale? Another assumption underpinning early cultural studies was that the subject and addressee of its analysis was a collective—a class confronted by the power of the state and the logic of capital. Hence, the prominence of concepts such as hegemony and Althusser's repressive state apparatuses and ideological state apparatuses.

Neoliberalism—impacting upon the social, economic, political, and cultural life of Western capitalist societies and elsewhere—displaced the idea of the collective with that of individualism and entrepreneurialism. This, in turn, led to a

response from cultural studies that, in some ways, focused upon the more middle-class concerns of identity politics, linked to the new social movements of the 1960s and 1970s, although always, of course, in the context of patriarchal capitalism, Western colonialism and its corollary migration, and homophobia. In other words, these were all levels of struggle—gender, race, sexuality—that were missing from the original analysis and were partly articulated with, as well as providing challenges to, hegemonic consumerism from the 1980s onward. If our primary identity now was as a consumer, not as a worker (I am thinking of the weakening of the trade unions from the late 1970s onward and the defeat of the miners in 1984–1985), then what were the cultural, political implications of this in terms of prevailing hierarchies of meaning? One response was an over-celebratory cultural populism, but, at a deeper level, concepts of negotiation, resistance, and contestation—always there, of course, in class formulations—took on new forms and meanings at the level of the active consumer, the active audience, and the idea that identity was no longer fixed but always under construction. More recent, the development of digital media has sharpened this concentration on identity, with so many manifestations of sites and resources for self-expression but, also, as we have seen in the Occupy movement, the Arab spring, and the growth of petition culture, spaces for a new kind of collective and mobilization—highly contested spaces as we know.

If industrial capitalism in Europe and North America gave rise to a powerful working class, cultural studies started from this movement as an exploration of the links between studying culture and theorizing relations of power. It was also very much concerned with questions of the democratic, on the shift of power from elites to the popular: "Democracy is not, of course, a formal matter of electoral politics or constitutionalism. It is the real passage of power to the powerless, the empowerment of the excluded" (Hall, 1988, p. 231). Given the power-based framework of analysis, cultural studies deployed a materialist methodology as its basis of cultural analysis. At the same time, it insisted on the specificity—the situated nature—and complexity of cultural experience, the need to historicize the objects, representations, and practices of its analysis, and on the importance of the empirical. Over time also, reflexivity and self-positioning about method has become important but was not really present at the outset, with a tendency to see the popular then through the "othering" lens of anthropology. Feminism, postcolonial analysis, and queer theory were instrumental in bringing about this shift. One crucial concept that had a profound influence on the work of race, gender, and sexuality in cultural studies was that of articulation, theorized by Stuart Hall and Ernesto Laclau. By this, Hall meant:

A connection or link which is not necessarily given in all cases, as a law or a fact of life, but which requires particular conditions of existence to appear at all, which has to be positively sustained by specific processes, which is not "eternal" but has constantly to be

renewed, which can under some circumstances disappear or be overthrown, leading to the old linkages being dissolved and new connections—re-articulations—being forged. (1985, p. 113)

What cultural studies was seeking to do was to relocate the popular from the margins—both phenomenologically and politically—into the constitutive memory, not just of the flows of history but of the social formation as a whole. There was fierce institutional resistance to this at both local and national level in the early 1970s, as those attempting to introduce programs of study in cultural studies were seen as heretics and subversives trying to introduce an illegitimate object of study into the monolithic legitimacy of the academic hierarchy. The ambition was not just to fragment the monolith but to reconstitute the fragments of an oppositional class culture, and to argue that culture was a contested and conflictual set of practices and representations and not a fixed given with a capital C.

Of course, this kind of approach did not cease in 1978; arguably, it was continued in the work of feminist history and in writings on race, ethnicity, and black struggle rather than in conjunctural cultural analysis of this kind. Saying this does not devalue the work done in the 1980s under the pressure of very different political circumstances, but it suggests that interventionist research was not the most prominent feature of cultural studies, partly because its twin axes of class analysis and a democratic social agenda had yielded to a more theoretical approach, and these no longer had the same resonance or salience.

This is not to propose a crude homology between the growth of British cultural studies and some kind of social democratic consensus in the period 1957 to 1978, but an attempt to indicate that, for all its radicalism, oppositional discourse, institutional marginality, and theoretical de-familiarization, cultural studies, at an institutional level, developed in a relatively uncontested space (albeit in the margins) as a sustained and substantial critique of a society that, however inarticulately and indirectly, acknowledged itself to be in crisis with no immediate likelihood of cultural, social, or political resolution. In other words, presumptuous though it may seem, the minor presence in British academic life of cultural studies exercised an influence out of all proportion to its size, insofar as the currency of much of the cultural, political, and social debate around the notion of crisis took its bearings from agendas established by cultural studies and, of course, sociology harnessed to, or by, mainstream political discourse. (I am thinking particularly of debates around the inner cities, schooling, youth subcultures, gendered discourse, and behaviour.)

Initially blunted by, and limited in its response to, the Thatcherite project, cultural studies was subject to prolific growth in academic institutions in the late 1980s and the early 1990s, mainly in the Polytechnics and new universities rather than in traditional universities. Much of this growth, shaped by the influence of postmodernist theory, was consequently lacking at times in historicized particu-

larity and, despite efforts to the contrary, was still rather about a preoccupation with a national culture focused upon a critique of "Englishness" that, on occasion, came suspiciously close to celebrating it—or, at least, seeking to find (found) a Left version of it.

Internationalizing Cultural Studies*

Since 1996, a series of Crossroads conferences have been held every two years in different venues across the world—but mainly in Europe and the United States—to fill what was perceived as a gap in the international cultural studies community (the Association for Cultural Studies, with a global remit, was formed out of these conferences). Many of the contributors to these events would probably identify themselves with, what a recent book, *New Cultural Studies* (Hall & Birchall, 2006), calls "adventures in theory." Since the early 1970s, the field has been shaped and informed by theory, mostly adopted and adapted, from Western Europe, even though a number of prominent theorists worked in, or originated, from countries outside of this area (e.g., Derrida, Levi-Strauss, Bourdieu, Kristeva, Fanon, Bhabha, Spivak, Said, and Hall).

Written self-consciously in the style of a "theory generation," the book has contributions from a generation of scholars "who have never known a time before theory" (Hall & Birchall, 2006, p. 2), seeking to understand new, diverse, and rapidly changing political cultures. They also identify themselves, or are identified, as a "post–Birmingham School" generation of cultural studies writers and practitioners. With an emphasis on the "self-reflexivity of theory," the book sets itself firmly against "modes of social, historical and economic research (political economy, social policy, and so forth)" and explores the key current debates in the field—anticapitalism, ethics, the posthuman, post-Marxism, the transnational, diaspora, the new digital and social media, technospaces, cultural memory, emotions, and the body. Why the approach they advocate cannot be harnessed to an understanding of political economy as well—particularly in the light of the rebirth and transnationalization of finance capital and its attempts to fashion a new cultural world order—is never explained. Nor is their claim that, at the time of writing, theory was in retreat backed up by any evidence. Nevertheless, the book is an important intervention insofar as it emphasizes the contribution of a range of thinkers in contemporary philosophy to cultural studies in relation to, what is correctly defined as a rapidly changing, ambiguous, complicated, and ambivalent world in which so many of the old certainties of the original cultural studies project are unravelling at the same time as the hegemonies it identified and explored are also unravelling. Interestingly, all the figures nominated as the "new theorists" are European (Deleuze, Agamben, Badiou, and Zizek) and there is very little acknowledgment of the contributions of those beyond the English-speaking

* Cultural studies in the United States is reviewed in chapter 7 and, hence, is not included here.

world. All of the contributors to the book, with two exceptions, are from Britain and North America. The two exceptions are from Australia, so there is no attempt to include work by cultural studies scholars being done in Latin America, Asia, or Africa, although the chapter by Imre Szeman, "Cultural Studies and the Transnational," does identify other genealogies and practices of cultural studies beyond Europe and North America and the need to pluralize the field of study.

An important initiative partly set up in an attempt to challenge the dominant British version of cultural studies was the series of Trajectories conferences that began in Australia in 1992. The third conference was held in Taipei in 1996 and was probably the first of its kind outside the English-speaking world. It brought together cultural theorists not only from North America and Australia but also from the East Asia locations of Hong Kong, Korea, Singapore, Taiwan, Philippines, India, and Thailand (Stuart Hall and I were the only speakers from a British cultural studies background). In the words of the book that came out of the event:

> It constitute[d] a critical confrontation between the imperial and colonial co-ordinates of north and south, east and west. Without rejecting the Anglo-American practices of cultural studies, the contributors present critical cultural studies as an internationalist and decolonized project. Trajectories links critical energies together and charts future directions of the discipline. The contributors discuss subjects such as Japanese colonial discourse, cultural studies out of Europe, Chinese nationalism in the context of global capitalism, white panic, stories from East Timor, queer life in Taiwan and new social movements in Korea. The book ends with an interview with Stuart Hall. (Chen, 1998, inside cover)

Internationalizing Cultural Studies: An Anthology (Abbas & Erni, 2005) addresses some of the gaps and omissions in the "new cultural studies" by attempting to locate theories and practices of the field developed beyond the English-speaking world in Asia, Latin America, and Africa. While many of the contributions to the book are simply examples of fairly familiar approaches to cultural studies carried out in locations outside of Europe, North America, and Australia, there is also evidence in this volume, and elsewhere, of thinking beyond the nation-national, of diasporic and border practices, and of very different articulations of some of the staple signifiers of cultural studies—for example, race, identity, the multicultural, structure, and agency—in diverse contexts situated within critiques of globalization. In their introduction, the editors identify the problem the anthology is designed to address:

> A certain parochialism continues to operate in Cultural Studies as a whole, whose objects and languages for analysis have had the effect of closing off real contact with scholarship outside its (Western) radar screen. In the current moment of what we call the "postcolonial predicament" of cultural studies, in which a broad hegemony of Western modernity is increasingly being questioned among cultural studies scholars from around the world, we must consider any form of internationalization as an effort—and a critical context—

for facilitating the visibility, transportability, and translation of works produced outside North America, Europe and Australia. (Abbas & Erni, 2005, p. 2)

There are now cultural studies programs in twenty-two countries, often with a strong emphasis on media and communications and each with their own story of the development of the field, and there are journals of African, Latin American, Inter-Asia, and South Asia cultural studies, as well as those in Europe, North America, and Australia. It is also true that cultural studies has exerted considerable theoretical influence on a range of different subjects and disciplines well beyond its own field, even on communication studies, which for a long time actively resisted it.

Thus, it may be said that cultural studies has internationalized but today, there are new, and different, fragments that have to be reconstituted, new paths of social change to be located and analysed. To do this, we shall need to develop a new, grounded theory of power (Castells, 2012) that takes account of global social formations and networks—Occupy Wall Street (OWS), the Arab spring, the *Indignados*, and so forth—that have arisen to challenge prevailing constructions of meaning and value, the symbolic manoeuvres of power brokers, and the ways in which the dominant communication resources contribute to the construction of everyday life. Are these, perhaps, the harbingers of the recovery of democratic agency, the source of a new model of the collective, and an emergent political subject, once seen as the role of the historic working class? If, as Castells argues, "Social movements throughout history are the production of new values and goals around which the institutions of society are transformed to represent these values by creating new norms to organize social life" (p. 9), then what, if anything, we will need to ask is different about the new social networking movements that have taken shape since the late 1990s?

Cultural studies began in a culture of modernity that was already at the point of exhaustion and beginning to unravel as it started. What seemed a settled object of study—a broad narrative of progress—almost immediately was unsettled and has been ever since, by changing processes in the geopolitical, techno-economic, and the cognitive, a continuing crisis of the representational currencies we commonly experience, including that of globalization itself. If this crisis is multidimensional, then could the transdisciplinary perspectives of cultural studies once again be harnessed for the analysis of the economy, society, culture, and politics as a continuum? If cultural studies can really claim to be an intellectual and political practice committed to the understanding and analysis of the conditions of those from below, is it capable of responding to the position outlined by Arrighi and Silver in 1999 but, arguably, even more apposite today?

In past hegemonic transitions, dominant groups successfully took on the task of fashioning a new world order only after coming under intense pressure from movements of pro-

test and self-protection from below. This pressure from below has widened and deepened from transition to transition, leading to enlarged social blocs with each new hegemony. Thus, we can expect social contradictions to play a far more decisive role than ever before in shaping both the unfolding transition and whatever new world order eventually emerges out of the impending systemic chaos. (p. 289)

Potentially, cultural studies is more robust now than originally because of identity politics and the new theoretical articulations, but if it is to address the systemic chaos that has now arrived and contemporary social contradictions it also needs a more holistic methodology drawn from across disciplines. The old classic models and ideologies—the society-nation-state continuum—that shaped the original cultural studies intervention need to be reformulated in order to examine both the positive and negative outcomes of a possible transformation, as these may not necessarily lead to liberation but may indeed become reactionary. A valuable anthology that helps to address the issue of intervention today is *Cultural Studies: From Theory to Action* (2005) that, as the title suggests, attempts to renew the "dialogue between contemporary critical social theories and progressive activist practices" (Leistyna, 2005, p. ix). No longer is it possible to identify with any certainty the major principle of antagonism-conflict—like class struggle up to the 1970s—as the 99% is a useful slogan but has no analytical precision or purchase, whereas antiglobalization, linked to other struggles, like OWS, the Arab spring, or those in Latin America may yet produce a new paradigm or principle of conflict. Cultural studies has always been about the conflict between the settled and the unsettled—unsettling is its primary dynamic, the taking apart of presumed, or imagined, closures (of village, nation, or identity), instability its focus.

At this time, all of what I am describing probably exists only at the level of the margins, and cultural studies, in a sense, has always been concerned with empowering margins. But they do represent the possibilities of new points of tension and departure—rehearsals, modelling experiments, and laboratories for tomorrow, the future. Nevertheless, "the conditions and problems of developing intellectual and theoretical work as a political practice" (Hall in Morley & Chen, 1996, p. 268) are increasingly difficult in the academy but all the more urgent. The question posed by John Frow in 2005 is still pertinent: "Does cultural studies . . . have the capacity to articulate a history of the present to which it can respond in ways that would be at once intellectually and politically productive?" (p. 17).

Bibliography

Abbas, A., & J. N. Erni. (Eds.). (2005). *Internationalizing Cultural Studies: An Anthology.* Oxford, UK: Blackwell.

Arrighi, G., & B. J. Silver. (1999). *Chaos and Governance in the Modern World System.* Minneapolis: University of Minnesota Press.

Bennett, T. (1992). "Putting Policy into Cultural Studies." In L. Grossberg, C. Nelson, & P. A. Treichler (Eds.), *Cultural Studies* (pp. 23–37). London: Routledge.

Castells, M. (2012). *Networks of Outrage and Hope: Social Movements in the Internet Age*. Cambridge: Polity.

Chen, K. H. (Ed.). (1998). *Trajectories: Inter-Asia Cultural Studies*. New York: Routledge.

Eliot, T. S. (1948). *Notes towards the Definition of Culture*. London: Faber & Faber.

Frow, J. (2005, December). "Australian Cultural Studies: Theory, Story, History." *Australian Humanities Review*, 37, 1-29

Gilroy, P. (1991). *"There ain't no black in the Union Jack": The cultural politics of race and nation*. Chicago: University of Chicago Press.

Hall, S. (1989). "New Ethnicities." In K. Mercer & E. Carter (Eds.), *Black Film, British Cinema: ICA Documents 7*). London: British Film Institute and Institute of Contemporary Arts.

———. (1988). *The Hard Road to Renewal: Thatcherism and the Crisis of the Left*. London: Verso.

———. (1985). "Signification, Representation, Ideology: Ideology and the Post-Structuralist Debates." *Critical Studies in Mass Communication*, 2(2), 91–114.

———. (1980). "Cultural Studies: Two Paradigms." *Media, Culture and Society*, 2, 57–72.

Hall, G., & C. Birchall. (Eds.). (2006). *New Cultural Studies: Adventures in Theory*. Edinburgh: Edinburgh University Press.

Hall, S., et al. (1978). *Policing the Crisis: Mugging, the State and Law and Order*. Basingstoke, UK: Palgrave Macmillan.

Highmore, B. (Ed.). (2001). *The Everyday Life Reader*. London: Routledge.

Hoggart, R. (1957). *The Uses of Literacy: Aspects of Working Class Life*. London: Chatto & Windus.

Leistyna, P. (Ed.). (2005). *Cultural Studies: From Theory to Action*. Malden, MA: Blackwell.

McGuigan, J. (1992). *Cultural Populism*. London: Routledge.

Morley, D., & K. H. Chen. (Eds.). (1996). *Stuart Hall: Critical Dialogues in Cultural Studies*. London: Routledge.

Thompson, D. (1964). *Discrimination and Popular Culture*. Baltimore: Penguin.

Thompson, E. P. (1963). *The Making of the English Working Class*. London: Vintage.

———. (1961), 'Review of *The Long Revolution*', *New Left Review*, 9–10.

University of Birmingham. Centre for Contemporary Cultural Studies. (1982). *The Empire Strikes Back: Race and Racism in 70s Britain*. London: Hutchinson/Centre for Contemporary Cultural Studies, University of Birmingham.

University of Birmingham. Centre for Contemporary Cultural Studies. Women's Studies Group. (1978). *Women Take Issue: Aspects of Women's Subordination*. London: Hutchinson, 1978.

Williams, R. (1989). *What I Came to Say*. London: Hutchinson Radius.

———. (1983a). *Writing in Society*. London: Verso.

———. (1983b). *Towards 2000*. London: Chatto & Windus/Hogarth.

———. (1981). *Culture*. Fontana New Sociology Series. Glasgow: Collins.

———. (1980). *Problems in Materialism and Culture: Selected Essays*. London: Verso.

———. (1979a). *Politics and Letters: Interviews with New Left Review*. London: Verso.

———. (1979b). *Culture and Society*. Harmondsworth, UK: Penguin.

———. (1977). *Marxism and Literature*. Oxford, UK: Oxford University Press.

———. (1976). *Keywords*. Fontana Communications Series. London, Collins.

———. (1974). *Television: Technology and Cultural Form*. Technosphere Series. London: Collins.

———. (1973). *The Country and the City*. London: Chatto & Windus.

———. (1962). *Communications*. Baltimore: Penguin.

———. (1961). *The Long Revolution*. London: Chatto & Windus.

———. (1958). *Culture and Society, 1780–1950*. New York: Columbia University Press.

CHAPTER SEVEN

A Mutually Radicalizing Relationship

Communication Theory and Cultural Studies in the
United States

MICHAEL REAL AND DAVID BLACK

Only an academic would consider a conjuncture an occasion for a good party.
But the conjuncture that led to the creation of cultural studies was a break-
through well worth celebrating. A conjuncture, as Stuart Hall (Hall & Massey,
2010) defines it, "is a period during which the different social, political, economic
and ideological contradictions that are at work in society come together to give it
a specific and distinctive shape" (p. 57). A conjuncture, in other words, is a mo-
ment in time when various factors in society—discursive and material—conjoin
to give life to some new and intelligible pattern defining a period's experiential
texture and deeper meaning. Conjunctures are often associated with and precipi-
tated by crisis, as society lurches forward and the kaleidoscopic elements of the
culture, first shaken, then reconfigured, assume a fresh form. One such conjunc-
ture was the 1960s, as reflected in its well-documented and revolutionary changes
to global politics and culture. But that storied decade of youth culture, women's
and civil rights, and anticolonial struggle was also the beginning of a gradual
transformation in North American communication thought. This was a transfor-
mation in which Robert White and James Carey played a vital part.

The name of Robert A. White, SJ, does not dominate bibliographic listings
but his presence is very broad in the communication field to those who knew him
as an author, editor, convener, administrator, mentor, and friend. His role at the
Center for the Study of Communication and Culture in London was important
for developing and publishing crucial initiatives in communication theory and

cultural studies. At the Center, he served from 1978 until 1989 as research director except for the three years (1984–1987) he served as acting director. He edited the quarterly *Communication Research Trends* during the 1980s; each issue focused on publications around a specific topic in communication theory and research. He also oversaw in the 1970s publication of ten titles in Spanish designed to promote interest in communication studies in Latin America, then followed that with twenty-five titles in English in the 1980s in his book series Communication and Human Values.[1] White's editing significantly improved the organization and clarity of these studies and confirmed the field's inclusion of culture and values as central concerns.

White's connections with James Carey were numerous through conferences, organizations, publications, and events. For example, Carey's 1988 edited book *Media, Myths, and Narratives: Television and the Press* notes in the brief opening acknowledgments that the book originated in a seminar "organized and chaired by Robert A. White," adding, "I am particularly indebted to Robert A. White for his assistance with this volume" (p. 7). While White's work took him from his PhD at Cornell to first Latin America, then London, then Rome, and finally Africa, Carey remained at home in Illinois for decades. Carey's stay there was interrupted only by a few significant years "next door" at the University of Iowa, although later in his career, from 1992 till his death in 2006, Carey was the CBS Professor of International Journalism at Columbia University in the American media heartland, New York City. Carey and White shared deep American roots, Catholic upbringings, and dedication to the intellectual vitality of the study of communication. They also shared a commitment to introducing the concept of culture, and the penumbra of American and European theories attached to it, into a communications discipline dominated by positivism in the first several decades after World War II.

The conjuncture they faced was a stimulating time. The concept of culture, with its entourage of American and British theorists, was nurtured by White and Carey and became celebrated in American communication study in the 1980s and 1990s in almost festive ways. It was the kind of party where an academic feels at home: spirited exchanges, provocative publications, the questioning of intellectual moorings, and dancing around positions. Like the anxious hosts of any party, White and Carey could not have been certain of the outcome of their plans. Now, with the sobering clarity of the morning after, we can evaluate what White, Carey, and others did by way of staging a dialogue between cultural studies and communication theory, one that benefited communication theory at the time and may help American cultural studies address its own contemporary problems. Their lives and careers provide a certain defining and human-size dimension to this period in American intellectual culture.

This jointly written paper attempts the following two-sided argument. Michael Real is an American colleague and protégé of White and Carey and draws on his personal experience of both to reflect on their careers and contributions. Real describes how cultural studies, including the often undervalued "North American" approach, disrupted positivism's near-monopoly on communications scholarship. David Black is a Canadian academic trained by the late Ioan Davies, the latter a Welsh-born cultural studies scholar (like Raymond Williams himself) at Toronto's York University and an acknowledged founder of cultural studies in Canada. Black examines recent major publications on the state of cultural studies in the United States. These two halves together compose an account of the radicalizing relationship of communication theory and cultural studies in North America. Before we detail the reformulations by Carey, White, and others, we need to take a look at the prominent features of the field of communication they inherited.

The View from Livermore Labs: Positivism and Communication Research in 1969

The 1969 annual meeting of the Association for Education in Journalism (AEJ) opened with a reception on the lawns of the Lawrence Livermore Laboratories high on a bluff above the Berkeley campus, with a view of San Francisco and the Bay Area. It was an unforgettable outdoor, twilight event, not least because the Livermore Labs were known to be implicated in defense research at the time. It was the first academic conference that co-author Real attended, and it was in the national hotbed of dissent: Berkeley, California. What might be the expectations of someone who came to this from working in the civil rights movement, questioning the then ongoing Vietnam War and, as an ex-clergyman, moving from the traditional pulpit in the church to the new McLuhanesque pulpit of the media?

Somewhat startlingly, the AEJ program in Berkeley seemed an endless series of sessions crowded with statistically sophisticated treatments of uninteresting questions. More attention was given to methodology than to findings. There were exceptions. But the distance between the social turmoil reflected in the streets of "Berzerkeley" and the concerns of communication research loomed large. Tough, complex questions were off the table. In that period, one noticed similar quantitative empirical dominance in meetings and journals of the International Communication Association (ICA) and the media sections of the National Communication Association (NCA). The non-American orientation of the International Association for Mass Communication Research (IAMCR) featured less positivist empiricism but not yet a culturalist focus. The Popular Culture Association (PCA) and the American Culture Association (ACA) also offered alternatives but were considered outliers of low academic prestige. Major organizations in sociology,

psychology, literature, and across the social sciences and humanities gave precious little attention to media and communication as such.

Research and theory about interpersonal and mass communication had grown steadily in the twentieth century, emerging from World War II with increasing and specialized prestige. Wilbur Schramm personified this growth and its thinking. Schramm wrote or edited a major book on mass communication almost every year from 1948 to 1977 and initiated communication research programs at Iowa, Illinois, Stanford, and eventually Hawaii. At Illinois in 1947, he became the first "professor of communication" in the world; Everett Rogers (1997), in his history of communication scholarship, states simply, "Wilbur Schramm (1907–1987) was the founder of the field of communication study" (p. 446). Under Schramm's leadership, communication graduate study and research followed the model of empirical science in helping to harness the immense technological developments of World War II for political, commercial, and entertainment purposes through rapidly developing broadcast and print technologies.[2]

Rediscovering America: New Sources for Communication Thought After Positivism

Carey was in graduate school during the 1950s at Illinois. There he was immersed in the disciplinary history Schramm helped make, but was not satisfied with the key concepts and theories. Illinois faculty members made crucial suggestions: Jay Jensen suggested he read John Dewey, George Gerbner steered him to the work of Raymond Williams, and Harry Skornia introduced him to Marshall McLuhan, a visiting scholar in 1960. By 1963, Carey was using the label "cultural studies" to identify the work of diverse scholarship that he was incorporating into his own teaching and writing. The disparate sources from which he drew were "a group largely affiliated in opposition to positivism and positive science" (Carey & Grossberg, 2006, p. 21). He was already moving outside the standard positivist paradigm that would dominate the 1969 AEJ convention and so much of communication research of the time. Within a decade, Carey would become president of AEJ, within a distinctively evolving intellectual environment, and use that platform to advance the idea of culture in the discipline. For him, the chimerical endeavor of cultural studies brought the worlds of journalism and communication deeper into understanding and coping with the meaning and consequences of human culture, media, ecology, and interaction.

A decisive shift occurred when Carey placed "culture" at the center of his work, echoing what Stuart Hall and his colleagues did in naming their Birmingham Center with reference to "culture" rather than "communication." When we look at the lead concepts in American cultural studies articulated by Carey in his books (1988, 1989, 2006) and numerous essays, they may now appear obvious but the implications were enormous. For Carey, communication begins with the

oral formation of culture, the embodied act of conversation. He zeroed in on fundamental social "ritual" that structures human affairs, preferring this to the sender-receiver transmission model so central to the dominant paradigm's view of communication (Gitlin, 1978).

An organizing principle for his thought was what he called "the contrast between ritual and transmission views of communication" (Carey, 1996, p. 313). The former explains how communication organizes our mutual existence in time, and the latter emphasizes conquest over space; both draw from the time-bias and space-bias phenomena identified by Harold Innis. The ritual view places communication at the center of daily life where social identity is given stability as well as capacity for change. Among other benefits, this formulation brought media studies into more effective interaction with the study of communication at all levels: interpersonal, group, and organizational.

How does James Carey interrelate "culture," "technology," and "communication"? Carey argues for a carefully nuanced idea of culture, one following the Geertz tradition but also drawn from Max Weber and Karl Marx, Raymond Williams and Kenneth Burke. His sense of culture parallels those of Williams and Stuart Hall, taking it as a total way of life both local and global. In addition to rejecting the primacy of technology and mass communication, Carey also insisted on the cornerstone as direct human interaction and language, a fundamentum in both his thinking and his definitions of communication. He anchored his critical and historical analysis in the symbolic constructivism of the Chicago School of John Dewey and George Herbert Mead, rather than in the empirical, positivist functionalism of Schramm's concern with mass communication structures, processes, and effects.

Carey's sense of culture was conceptual and theoretical but also historically and geographically situated. A reading of a communication technology or of a nation did not call for a recitation of historical facts but rather a grounded interpretation of the interaction among social-historical forces. His view is distinct from Foucault's tracing of history through specific discourse, but it required a similar resistance to preconceived historical explanation. The meaning of the telegraph and railroad in anchoring American national consciousness required a careful reading of these developments in their full historical context and interaction with other social forces. Such a method, for example, resulted in his dating the emergence of an identifiable shared American self-consciousness to the 1890s. This was far more complex than dating the origins of the telegraph or the completion of the transnational railway.

Carey was explicitly "American" in certain of his sources and concerns, creating an American cultural studies tradition distinct from the British tradition. Carey's expertise on Innis and McLuhan and his associations with Canada might lead to labeling the approach "North American" rather than confining it to the

United States. In any case, it emerged somewhat distinctly from the more influential British cultural studies of the time. Carey drew from and examined John Dewey, American journalistic practices, and U.S. media technologies, but his form of American exceptionalism was quite at odds with isolationist or imperialist formulations of it. To Carey, innovations and trends in America were typical of world trends but were occurring at a leading edge. Carey was most interested in what might be called the American project, such as the culmination of the aforementioned interaction of railroad, telegraph, and other media in the American national consciousness of the 1890s. This was the point—to use Carey's terms—where industrial "power technology" and its dominance were at once displaced by and integrated into the newer "information technology" and its communicative power, as telegraphy gave way to telephony, the mass circulation newspaper, radio, television, and the Internet. America was a "nation-state," and Carey maintained that the nation-state was more fundamental in how people identify themselves than ethnicity, immigration, or globalization.

The Party Flourishes: Communication Theory Under the Influence of American Cultural Studies

Now let us fast forward from Carey's innovations to more recent decades. Conferences, journals, entire academic publishing operations, promotion reviews, standards of prestige, and influence all converge around in-depth questioning of culture. Positivism seldom appears in robust considerations of multiculturalism, privilege and diversity, epistemology and ideology, subjectivity and identity, gender and sexuality, meaning and power. Despite its still controversial and disputed role, research in cultural studies generates thoughtful critiques of everything from digital convergence to polarizing political discourse. The division of AEJMC (with "Mass Communication" added to "Journalism" in the organization title mentioned earlier) that is named Cultural and Critical Studies offers exactly what was missing in the 1969 conference. The Philosophy of Communication division was created in ICA in the 1970s to feature nonempirical, nonpositivist intellectual rigor. (It is now named Philosophy, Theory, and Critique.) Both organizations welcome cultural studies in their divisions dealing with feminism, ethnicity, popular culture, and many other categories. These and other openings of the communication field to cultural studies were, of course, not directly attributable to Carey's influence, but he definitely played a role with many threads leading back, for example, to the "Illinois School" that features him as its leading figure.

In addition to numerous institutional changes, what has happened intellectually to reflect the impact of cultural studies on communication research and theory? A large number of assumptions had to be reconsidered, resulting in a changed language and context. A list of some of these assumptions indicates the

creative tension at the point where midcentury communication positivism and late century communication study meet.

- *Individuals Studied.* The individual research subject was redefined from the unproblematic and measurable person and group to the more elusive and nuanced "subject" and "other." This departs sharply from the empirically measured audience member of Lazarsfeld, Stanton, and Merton (see Sills, 1996) and opens research to interactionist, constructivist, and postmodern designations of self and other.

- *Passive vs. Active.* Viewers, readers, listeners, and users are reconfigured from passive audience members to active, participating fans as co-creators. Numerous works, among them those of Hall (1973) and Fiske (1987, 1989a, 1989b), have stressed this. The remarkable career of Elihu Katz illustrates how the sensitive researcher can move through the early positivist years of measuring personal influence, to the reformulation into a uses and gratifications model, and on to identifying the dynamics and meaning of media events, each reflecting reconsiderations of how people relate to media.

- *Power and Dominance* (see Carey, 1983). Research confined within the frameworks of the neoliberal consciousness-industries has given way to political-economy critiques of power and privilege pioneered during Carey's time by, among others, one-time colleagues at Illinois—Dallas Smythe, Thomas Guback, Herbert Schiller—and others with more in common with the Frankfurt School than the positivists. The well-known tensions between cultural studies and political economy are reflected in Carey's sometimes troubled relationships with these figures (see Carey & Grossberg, 2006, pp. 23–25).

- *Reading vs. Effect.* Research on how the public responds to media messages has changed from concern with how overt content implants the intended message to examining how readers of cultural texts and practices actively accept, negotiate with, or oppose the dominant reading intended by the producer(s). To these reformulations especially associated with Stuart Hall, Carey argues that reducing a cultural activity to "reading a text" may lose important dimensions of the interaction (Carey & Grossberg, 2006, p. 202).

- *Content.* The substance of the content communicated was defined empirically as explicit information and stated opinion. But under cultural studies' influence, content is now understood to include discourse with complex, even idiosyncratic, meanings both denotated and connotated, whether in media or interpersonal communication.

- *Evidence.* Credible research data have changed from unequivocal quantitative and statistical processes and measures to include a wide range of qualitative, ethnographic, and grounded reports. The well-known "Ferment in the Field" (Summer, 1983) issue of the *Journal of Communication* under George Gerbner's editorship highlighted this and many others among the changes listed here.

- *Knowledge.* Positivism assumed the finality of counting, measuring, and quantifying. In contrast, cultural studies has brought to the fore the complex challenges of epistemology with questions of how we know what we know in all its variant forms and formulations.

- *Ethnocentrism.* Western definitions of truth, evidence, and argument have been forced by cultural studies to pause and observe as perspectives and philosophies from variant cultures around the globe push forward to play rightful roles in scholarship and theory. Robert White's pioneering work in Latin America, Africa, and elsewhere reflects this multicultural opening.

- *Commitment.* Positivism tends to portray itself as an unbiased research perspective objectively examining topics of scientific interest with no political agenda. Cultural studies acknowledges and makes explicit the motives for selecting research topics, the personal predispositions and potential biases of the researcher, and any goals for improving society through the research project. It encourages action research aimed at social goals beyond completing research reports. In cultural studies these goals can be direct, articulated, and even integral to the project.

The Morning After: Three Reviews of the Current State of Cultural Studies

These profound reformulations added spark and substance to the lasting party that was American cultural studies, and their influence spread to many academic disciplines and concerns in the last quarter of the twentieth century and early twenty-first century. That period's impressive arc encompassed iconic conferences like 1990's "Cultural Studies Now and in the Future" at the University of Illinois and the launching in 1996 of the annual International Crossroads in Cultural Studies events, the 1992 publication of Grossberg, Nelson, and Treichler's *Cultural Studies*, the 2003 launch of the Cultural Studies Association, and the National Communication Association's 2004 inception of the journal *Communication and Critical/Cultural Studies*. But, like so many undertakings, the initiation and development of cultural studies proved a far different, and sometimes easier, challenge than the maintenance of internal coherence or fidelity to the field's goals over the long term. The better the party, it seems, the worse the hangover.

In recent years, there has been a tangible shift in mood as the field's growth has slowed, rationalization and entropy set in, and the intellectual project of cultural studies has been translated into institutional reality. Not surprising, this has invited introspection from both founding figures and younger scholars. Typical is Graeme Turner (2012), who writes that "this situation may well be the predictable consequence of what might now be seen as the unrealistic ambitions that accompanied the development of cultural studies in the USA over the 1990s" (p. 22). Turner's is one of three major books published since 2010 that have guided this self-examination, consideration of which provides the substance of the second half of this essay. That is, where the first half of this paper uses James Carey and Robert White to give human shape to how cultural studies reanimated communication theory after positivism, the second reflects on the present and future of American cultural studies using these three more recent texts as its basis. It then closes with speculation on how communication theory might return the favor by assisting cultural studies in its current crisis, and argues that the conditions in twenty-first-century America are ideally suited to invite the revival and fresh relevance of cultural studies.

The books in question are Lawrence Grossberg's *Cultural Studies in the Future Tense* (2010); Paul Smith's edited collection of essays by U.S. and international scholars, *The Renewal of Cultural Studies* (2011); and Turner's *What's Become of Cultural Studies?* (2012). Grossberg is a research professor at the University of North Carolina and mostly lauded as a pioneer of cultural studies in the United States. Smith is a faculty member in the PhD program in Cultural Studies at George Mason University, where his collection originated from a series of 2006–2007 seminars attached to the theme of "Cultural Studies: The Way Ahead." Turner is the Australian author of one of the first textbooks introducing cultural studies to North American students. To recognize that the three are both leading scholars and active participants in the intellectual and institutional developments they address is to appreciate why their books alternate between a dispassionate survey and an intensely personal account of cultural studies in the United States.

Stocktaking and soul searching, the authors—representing a wide range of nationally inflected perspectives on the field—return to the question: Where has cultural studies fallen short? As Turner (2012) asks of the current state of cultural studies: "Is this really what we had in mind?" (p. 3)

Their answers surprise, disturb, and sometimes confirm already-held suspicions. Converting research into actual social progress, and thus answering to the underlying political project in cultural studies, proves to be harder than once believed. Conferences and journals are too tempted toward brand extensions of the latest fashionable theorist or analysis of a trending media text. Research can become too theoretical and indifferent to application and the politics of these projects more performative than concerned to improve lives. Universities increasingly

called on to behave like corporations are less tolerant of cultural studies' radical challenges to academic values and practices, or they use the field's interdisciplinarity as cover to merge departments in the name of cost-efficiency.

Turner's question is rhetorical but, as Grossberg (2010) reminds us, "the most difficult part of any project in cultural studies is figuring out the question" (p. 54). If we treat these three books as representing a turning of cultural studies' own sensibility and method on itself, then drafting the right question becomes imperative. With that in mind, we can borrow from one Paul Smith offers: "What can and should cultural studies be doing right now?"

That more forward-looking query is brought to bear on these three studies and explored below with regard to some salient themes. These themes are the entry of cultural studies into the organizational environment of the university and the related disciplinary formation of the field; theory, method, and working conditions for cultural studies scholars; cultural studies and its politics; and last, and by way of apt conclusion, the future of the field. Its future includes the next stage in cultural studies' relationship with communication theory as well as the propitious conditions in American society that call for the field's renewal.

The "Undiscipline" of Cultural Studies: Intellectual Formation and Institutional Reality

The conversion of cultural studies into a regular university departmental enterprise, as contrasted with a free-floating critical and political project that criticized the academy while not being of it, was probably inevitable. Absent the resources that come with having a home in the university, even the Centre for Contemporary Cultural Studies—charmingly marginal as it was in its Quonset hut on the Birmingham campus—might not have survived as long as it did until its unceremonious demise in 2002. Cultural studies' institutional membership in the university naturally came with a certain conforming pressure to take on a disciplinary identity.

But as cultural studies gradually assumed this identity—developing and then teaching a canon in a set curriculum to undergraduates and graduates, channeling scholarship into peer-reviewed publication, and delimiting theorists, concepts, and methods as its own—it has faced some unique obstacles owing to its customary resistance to disciplinary form. What becomes of cultural studies, by definition skeptical of academic business-as-usual, as it continues as a regular institutional citizen is difficult to predict. The field, argues Turner (2012), "will have to negotiate the contradiction between a cultural studies that wants to remain free of the ties of disciplinarity and the institutional reality that requires it to embrace at least some of the protocols of a discipline in order to function as a viable organizational entity" (p. 75).

Turner goes further, identifying a curious problem with cultural studies that qualifies it for him as an "undiscipline." While its first-generation scholars came from traditional disciplines, and thus benefited from intimate exposure and training within a discipline before then rejecting history, English literature or sociology as their home, current generations of students and younger scholars have often only known cultural studies. The result is a "worst-of-both-worlds" problem. Those cultural studies purists live within an increasingly curated disciplinary milieu, but lack support within the discipline to convert the field's ways of knowing into useable method. More generally, without much experience of disciplinary formations themselves, cultural studies students and scholars are less able to negotiate this incongruous space. "The current generation must be content with the consequences of that rejection," Turner (2012) writes, "rather than themselves experiencing the grounds for it" (p. 8).

If cultural studies' inclusion within the post-secondary institutional environment is unavoidable if it is to sustain itself, the ultimate disciplinary form it takes is not such a settled matter. Carol Stabile, in her essay in the Smith volume, argues that cultural studies should oppose the standard-issue model of academic work as the product of lone heroic individuals. That is, by example and critique, cultural studies can continue its work of rethinking academic practice, but do so from inside the academy. It should support collaboration as a counterpoint to solo scholarship, reinvent conferences so that they are opportunities for real dialogue, and support alternatives to peer-review publishing by rewarding scholars who bring their research to lay publics and unconventional platforms. "Our institutional practices need to mirror our intellectual practices," Stabile (2011) writes, underlining her suggested reforms. "Otherwise, the latter will remain little more than empty promises about the emancipatory potential of knowledge" (p. 26).

The "Detour" Through Theory: Critical Practice and Professional Culture

The three texts share the conviction that cultural studies' relationship to theory be defined by a high-minded sense of theory's social utility. Theory's value for cultural studies is explained by its practical usefulness to making critical sense of, then acting on, a complex reality. Common to the three, by contrast, is a decided impatience with theory for its own sake. Andrew Ross, in a published dialogue with Smith in the latter's volume, and as erudite and prolific a scholar as American cultural studies has, stated his strong preference for the "usable intellect" over mere "smartness" (Smith, 2011, p. 246). Grossberg, following Marx (Hall, 2003), elaborated that cultural studies should make a "detour" through theory, rather than treat it as a destination. The field's ultimate point of reference should be concrete and messy reality. Theory at best is "a resource to be used strategically to respond to particular problematics, struggles, and contexts" (Grossberg, 2010, p. 28).

Grossberg goes further, arguing that cultural studies is patient with contingency and multiplicity, and not disposed to view inquiry as a reduction or simplification of reality. "Cultural studies," Grossberg (2010) reflected, "is built on the desire to find a way to hold onto the complexity of human reality, to refuse to reduce human life or power to one dimension, one axis, one explanatory framework" (p. 16). Moreover, Grossberg asked that the field avoid the easy wins of incrementalism, where scholarship offers variations on existing research for the sake of publishing much while venturing little. Cultural studies may be humble, but it should not lack courage or ambition; it "is not supposed to rediscover what we already know" (p. 28).

Where Grossberg is generous and inclusive, Smith insists on a cultural studies that should grow up and past what he terms the "looseness" of the early Birmingham work. For Smith, theory and method in cultural studies should be used with the same logical consistency evident in other disciplines. "After two or three decades of cultural studies work in the United States," he wrote (2011, p. 2), "the time has come to refute the shibboleth that 'codification' necessarily implies some sort of authoritarian policing." But Smith's harder line should not be read as a new orthodoxy. For him, by making cultural studies' resources answer to the standards asked for in other disciplines, the field gains resilience, an inner strength it will need to engage with external, global concerns since it "responds most importantly to conditions outside itself" (p. 7).

It is for the professional culture of cultural studies that Turner saves both his most poignant concern and trenchant criticism. The grooming process for tenure-track faculty now, with the onus on them to publish quickly, leaves cultural studies scholars with little time or institutional sympathy for the unorthodox and community-involved projects typical of the field. Worse still, the field has begun to confirm what its enemies have long asserted: that cultural studies is a creature of academic fashion. What if there is some truth, offers Turner (2012), in the familiar criticisms leveled at cultural studies for its seeming at times "the trendy and superficial nadir of academic endeavor" (p. 4) and for allowing trivial and unserious work to be done in its name? How many of us have not worried, he continues, "that the whole field is clearly going to the dogs"? (p. 7). In departing so frankly from the measured tones typical of academic prose, Turner here gives the clearest voice to a pathos evident throughout these three texts.

The "Phantom Limb" of Politics: Re-set and Realism

It is remarkable that, despite the sometimes elegiac tone in these state-of-the-field reviews, they affirm the political purpose in cultural studies at all. The politics here, as with the rethinking of cultural studies at large, are still measured and conditional. But the stirring memory of the more radical project of cultural studies earlier in its British and American history remains. Smith describes that memory

of a more confident activism as the "phantom limb" of the discipline. That is, even though many cultural studies research projects do not yield some social or political benefit, scholars feel the obligation to do so even when empirical outcomes are amputated from their work.

Nick Couldry, a British contributor to the Smith volume, believes cultural studies vital to helping make over the political imaginary. We need it to rethink the "politics of politics," as our current framing of the political is inadequate to our conditions (Smith, 2011, p. 12). In this, Couldry seeks a "re-set" for cultural studies. He looks to Raymond Williams's original advocacy for an expansive definition of culture, in early books like *Culture and Society* and *The Long Revolution*, as analogue and inspiration. Where Williams radicalized the meaning of culture by attaching it to working class and popular traditions in order to undo its conflation with elite interests, Couldry likewise calls on cultural studies today to reintroduce culture as "counter-rationality" (Brown, 2003) to a market-driven polity. The notable form this counter-rationality should take, Couldry indicates, is "voice." By "voice" he means both a greater number of points of view available in democracy, but also an expansion of the system's capacity to accommodate them. "The crisis of voice under neoliberalism," Couldry (2011) concludes, "generates the need for a project parallel to the one Williams called cultural studies" (p. 14).

For both Turner and Grossberg, cultural studies' own politics would benefit from being less aesthetic and more realistic and substantive. Overweening claims to politically engaged scholarship, suggests Turner (2012), tend to act as a "legitimating discourse" for the field by inflating its sense of political relevance and obscuring the actual public good that is done (p. 158). Such claims to engagement have become quixotic, tilting at too many issues without regard to the hard and uneven work that change making is. This has led to the "gradual accretion of a cultural studies mythology that has effectively masked the realities of what has become of its practice" (Turner, 2012, p. 159). In this mythology's place should be the understanding that good politics follows after the analysis is complete. "Politics and strategy are only available after the work of cultural studies," argues Grossberg (2010, p. 28). A politics worth having is one open to new knowledge, Grossberg continues, and recognizes that even committed intellectual work comes with no guarantees of translating into social progress.

A Radical Modesty: Or What Cultural Studies Can Learn from Communications

The cultural studies of today is not the same project that Robert White, James Carey, and other early advocates of the field developed in North America and beyond. Nor is it today the critical enterprise that helped liberate communications scholarship from its dependence on the midcentury media effects model and other positivisms, then opened it to structuralism and neo-Marxism from

Europe as well as half-forgotten North American theorists from the Progressive Era. Cultural studies, intellectually sensitive to contingency in the world, is now self-doubting and uncertain about its project. As joyful as the rapid expansion of cultural studies' intellectual and institutional presence in the United States was through the 1980s, 1990s, and early 2000s, the transition from youth to maturity is never an easy one. It is possible that the American academy has been captured by the romance of cultural studies just long enough that it has overlooked its middle age, as reflected in the more pessimistic passages in Grossberg, Smith, and Turner. But rather than mistake their disappointment for despair, the academy can recognize that these three sources do the hard work of evaluating what cultural studies is and can be after its carnivalesque years are over. What then is the picture of the future of American cultural studies that these books describe and that emergent conditions anticipate?

The future of cultural studies that surfaces in these three sources looks something like this. It is careful not to indulge theoreticism and more diligent about method. It recognizes its place in the university as institution, but resists becoming a discipline like any other. It believes that theory has a responsibility to serve the public good, but harbors fewer illusions about translating radical thoughts into meaningful change. It is rationally optimistic, but is less prone to making wild claims about its importance or effectiveness. It is aware of how valuable intellectual experiment is in the corporatizing university, but realistic that it is not immune to that change. Grossberg (2010) speaks in this more temperate key:

> While cultural studies seeks to change the context of its own work, it is rarely able to point, with any confidence, to the immediate benefits of its own work. Yet cultural studies continues to believe that its intellectual work matters, even if it is not our salvation. Cultural studies is not going to save the world, or even the university; rather, it is a modest proposal for a flexible and radically contextual intellectual-political practice. (p. 55)

The most radical thing about the vision of cultural studies that emerges from these sources is this newfound modesty, a change from the bravura tones of earlier work in the field. This modesty provides an ethical basis for twenty-first-century cultural studies; it gives moral compass points for a world too subtle for slogans. This circumspectly drawn disciplinary scope will be difficult for a field better at broad strokes than fine lines. But the thing about grand claims for research's radical potential is that few take such romantic posturing seriously. The more achievable the goals, the greater the accountability, precisely because people will expect them to be met. Research developed under this new dispensation will be better at avoiding the political equivalent of magical thinking. Analysis will have to work harder to understand the contexts it examines and the nature of power there, notably when the false hope of easy radical solutions is taken out of the calculation. This means not just a welcome realism, but better quality research, since logical

connections within arguments and constructive points of contact with reality will be truly earned and better articulated.

This essay began with an account of how communication theory was changed, perhaps even saved, by its encounter with cultural studies. Now, it is clearly American cultural studies' turn to experience redemption. Communication theory needed its consciousness expanded and the freedom to think without resort to positivism's narrow certitude. Cultural studies, by contrast, has much to learn from communication's remarkable success both as a disciplinary formation and an institutional citizen. The two obviously have much in common: they are interdisciplinary; they both pay special attention to discourse, media, and culture; they share a number of concepts, canonical texts, major authors, and theoretical traditions between them. But communication has managed to organize itself as a discipline without succumbing to epistemic closure. And it has thrived in the university as is evident from the estimated more than 1,500 programs in the United States.

It may well be that the early twenty-first century is bringing another conjuncture on par with the 1960s where cultural studies is concerned. A new context appears to be emerging, a reality that is a veritable laboratory for research themes dear to cultural studies.

Today's cultural studies can take heart from demographic changes in the United States, as the visible minority population becomes a majority by 2043. This brings diversity to the forefront in politics, public discourse, and popular culture. Ahead is a future where youth culture may be, just as it was in the 1960s, newly visible and energized, notably as the sustainability of the social safety net becomes a matter of negotiation between retiring baby boomers and Gen-Y workers. The future is one where LGBT people and their choices may enjoy widespread public and legislative support, beneficiaries of one of the more rapid changes in public opinion about a key social group and issue in modern history. Gender issues and feminist scholarship will continue to contribute massively not only to female success but to cultural clarification and progress. The future will also be one where digital culture's tools and ethos, and the problems that beset traditional media, create more openings for bottom-up expression and better markers for quality and coherence. It will certainly be one where venerable tropes attached to Western modernity, notably economic growth and energy-dependent technological progress, will be severely challenged as the global climate changes. It is one where income inequalities will continue to bring to the surface the structural problems with neoliberal capitalism. And this future is one where evolving political coalitions, such as the groupings in Obama-era America, rewrite ideological norms and establish new solidarities.

Diversity, feminism, youth and queer culture, media and technology, modernity, capitalism, and politics: these are themes sufficient to be confident of

the need for cultural studies in the future. Indeed, it feels like a future made with cultural studies in mind. The innovative thinking of those early formulations at Birmingham, Illinois, and through the work of Robert White and James Carey, may help model new forms of such breakthroughs. And what emerges may well provide reason enough for another party.

Notes

1. Co-author Real wrote two books for this series: *Super Media: A Cultural Studies Approach* (1989) and *Exploring Media Culture: A Guide* (1996). White's influence made the books much clearer and better organized.
2. Gertrude Robinson's (1996, p. 161) historiography of North American communication studies places Schramm in the exact middle of five periods that came after the Chicago School's first explorations of communication: Lazarsfeld and Merton at Columbia; the Frankfurt School and other WWII–era Marxists; Schramm; Blumer's 1960s reinvigoration of symbolic interactionism; and from the 1970s phenomenological and literary approaches.

Bibliography

Brown, W. (2003). "Neo-Liberalism and the End of Liberal Democracy." *Theory and Event*, 7(1), par. 42.

Carey, J. (1996). "Afterword/The Culture in Question." In E.S. Munson and C.A. Warren (Eds.), *James Carey: A Critical Reader* (pp. 308-339). Minneapolis: The University of Minnesota Press.

Carey, J. (1989). *Communication as Culture: Essays on Media and Society.* New York: Routledge.

Carey, J. (Ed.). (1988). *Media, Myths, and Narratives: Television and the Press.* Newbury Park, CA: Sage.

Carey, J. (1983, Summer). "The Origins of the Radical Discourse on Cultural Studies in the United States." *Journal of Communication Event*, 33, 311–313.

Carey, J., & L. Grossberg. (2006). "James Carey in Conversation with Lawrence Grossberg, Parts 1 and 2." In J. Packer & C. Robertson (Eds.), *Thinking with James Carey: Essays on Communications, Transportation, History* (pp. 11–28, 199–225). New York: Peter Lang.

Couldry, N. (2011). "The Project of Cultural Studies: Heretical Doubts, New Horizons." In P. Smith (Ed.), *The Renewal of Cultural Studies* (pp. 9–16). Philadelphia: Temple University Press.

Dennis, E., & E. Wartella. (Eds.). (1996). *American Communication Research: The Remembered History.* Mahwah, NJ: Lawrence Erlbaum.

Fiske, J. (1989a). *Reading the Popular.* Boston: Unwin-Hyman.

Fiske, J. (1989b). *Understanding Popular Culture.* Boston: Unwin-Hyman.

Fiske, J. (1987). *Television Culture.* New York: Methuen.

Gerbner, G. (Ed.). (1983, Summer). "Ferment in the Field." *Journal of Communication* (Special Issue), 33(8).

Gitlin, T. (1978). "Media Sociology: The Dominant Paradigm." *Theory and Society*, 6(2), 205–253.

Grossberg, L. (2010). *Cultural Studies in the Future Tense.* Thousand Oaks, CA: Sage.

Hall, S. (2003). "Marx's Notes on Method: A 'Reading' of the 1857 Introduction to the Grundrisse." *Cultural Studies*, 17(2), 113–149.

Hall, Stuart (1973). *Encoding and Decoding in the Television Discourse.* Birmingham, UK: Centre for Contemporary Cultural Studies.

Hall, S., & D. Massey. (2010). "Interpreting the Crisis: Interview with Stuart Hall." *Soundings: A Journal of Politics and Culture*, 44(1), 57–71.

Munson, E. S., & C. A. Warren. (Eds.). (1997). *James Carey: A Critical Reader*. Minneapolis: University of Minnesota Press.

Packer, J., & C. Robertson. (Eds.). (2006). *Thinking with James Carey: Essays on Communications, Transportation, History*. New York: Peter Lang.

Robinson, G.J. (1996). "Constructing a Historiography for North American Communication Studies." In E.E. Dennis and E.A. Wartella, *American Communication Research: The Remembered History* (pp. 157-168). Mahwah, NJ: Lawrence Erlbaum Associates.

Rogers, E. M. (1997). *A History of Communication Study: A Biographical Approach*. New York: Free.

Ross, A. (2011). "Cultural Studies: A Conversation." In P. Smith (Ed.), *The Renewal of Cultural Studies* (pp. 245–258). Philadelphia: Temple University Press.

Sills, D. L. (1996). "Stanton, Lazarsfeld, and Merton—Pioneers in Communication Research." In E. E. Dennis & E. Wartella (Eds.), *American Communication Research: The Remembered History* (pp. 105–116). Mahwah, NJ: Lawrence Erlbaum Associates.

Smith, P. (2011). "Introduction." In P. Smith (Ed.), *The Renewal of Cultural Studies* (pp. 1–8). Philadelphia: Temple University Press.

Stabile, C. (2011). "The Nightmare Voice of Feminism: Feminism and Cultural Studies." In P. Smith (Ed.), *The Renewal of Cultural Studies* (pp. 17–27). Philadelphia: Temple University Press.

Turner, G. (2012). *What's Become of Cultural Studies?* Thousand Oaks, CA: Sage.

Thinking Communication in Latin America

JESÚS MARTIN-BARBERO

Constructing the complex history of the field of communication history of the field of communication in Latin America will require mixing information with analysis and narration. Making it difficult is the fact that the author of this text is not a distant observer but someone involved in both the academic and research debates that will be presented here as well as the social and political circumstances. And it becomes even more complicated when recognizing that the continent has experienced the greatest transformation in its history during these fifty years of Latin American thought on the world of communication.

The 1960s–1970s: Constructing the Field of Study

The construction of the field of studies in communication began in Latin America in the 1960s by amalgamating the new ideas rooted in dependency theory with the North American and European academic education of several researchers, and these together with a crucial binding agent: the will to insert the media into the processes of social development and democratization of the Latin American countries. The functional-diffusionist conception promoted by U.S. agencies in those years identified Latin American countries as underdeveloped and linked development directly to the quantitative growth of the number of copies of newspapers sold or the number of radios and television sets per person. However, the communication theory that was being developed in these countries provided a socio-historical approach that made it impossible to separate the action of the

media from its context and the political processes from their region. What was ultimately a real issue during the early years of Latin American research was not the weight of the media in the modernization of these countries, but the meaning of communication in the emancipation of Latin American societies. Because of this, academic training in communication was born, marked with dual functions: (1) to study the action and conformity of the mass media, mostly commercial, seeking thereby to introduce the voices of social actors who were normally absent on their pages and programs, and (2) to work on a generation of alternative media that would be democratic.

The first milestone in developing Latin America's own theory was the idea of communication that Paulo Freire introduced in the beginning of the 1960s as a key ingredient of an adult education program. He founded the latter in northeastern Brazil under the name "Liberating Education." For adults, literacy is the ability to claim ownership of one's language as writing grants them the opportunity to tell their own story, that is, to communicate, participate and decide. The pedagogy of Paulo Freire (1963, 1967) begins with the question: what is an illiterate person? He responds by saying that illiterate persons are unable to state their own word, unable to perform as citizens. For Freire, language is not made up of syntax and semantics only but also of pragmatics, since language is also part of action, including a program of action released when the word is spoken, read, or heard. The domination that exists within language can silence action through empty words and verbiage, which is nothing but the other side of the deep silence of the majority who do not participate in social and political life.

A second milestone was the institutionalization of the study of communication and media research at the Central University of Venezuela and the creation of the Instituto de Investigaciones de la Comunicación [Institute of Communications Research] (ININCO) in 1974 that was carried out by Antonio Pasquali and included Oswaldo Capriles, Elisabet Zafar, Luis Anibal Gomez, and the RATELVE Project that initiated the study of policies that would ensure a place for public service media. In a way, both the institutionalization of the field and the project for public communications policy are based on a groundbreaking book published in 1970, *Comprender la comunicación* [*Understanding Communication*] by Pasquali, which brought firsthand information to Latin America about the Frankfurt School of Critical Theory and the debate on the differences between communication and information.

The third milestone was formed by a set of voices and institutions that used this alternative theory in research and policy proposals by linking communication, education, and development. The research work discovered the existence of practices and pioneering experiences in the educative and social use of a mass medium, the radio, the most typical and important in societies that were still culturally oral: Radio Sutatenza [Sutatenza Radio] in Colombia, created and operated

by a Catholic organization; the Radios mineras [Mining Radios] from Bolivia, created and regulated by the mining unions and backed by religious and educational organizations after the nationalization of tin, which, in 1950, comprised a total of thirty-three partner stations.

Luis Ramiro Beltrán, a Bolivian who explicitly followed the teachings of two of his American professors, Everett Rogers and Wilbur Schramm, and also knew about the Colombian and Bolivian experiences, revitalized an informal association, along with Diaz Bordenave from Paraguay, Bosco Pinto Mario from Brazil, Mario Kaplun from Uruguay, and Reyes Mata from Chile, that helped make critical discourse communalized and actionable. In 1973, *Centro Internacional de Estudios Superiores de Periodismo* [International Center for Advanced Studies in Journalism] (CIESPAL) convened in Costa Rica to head the first seminar on Communication Research in Latin America, which established the foundations for research involved in the creation of national communication policies. Later in 1976, the Primera Conferencia Regional de UNESCO en Políticas de Comunicación [First UNESCO Regional Conference on Communication Policy] was held in Costa Rica. At that conference, the Latin American experiences of Antonio Paquali and Juan Somavía were made visible, and they would eventually have a decisive role in the creation of the *Informe MacBride* [*MacBride Report*] (1978) on *El Neuvo Orden Mundial de la Comunicación y la Información* [The New World Information and Communication Order] (MacBride & UNESCO, 1980).

Also, in Chile and Argentina a group of scholars and researchers was assembled, marking another milestone: that which combined Marxism and structuralist semiology with elements of dependency theory. They elaborated both a theoretical and methodological proposal for the ideological analysis of messages in the mass media, which was used especially in the press and in television. At the head of this group was Armand Mattelart from Chile and Hector Schmucler from Argentina, whose united action prompted the birth of the first journal with a Latin American purpose: *Comunicación y cultura* [*Communication and Culture*] whose subtitle was *La comunicación masiva en el proceso político latino americano* [*Mass Communication in the Latin American Political Process*]. At that time, *Comunicación y cultura* quickly became the center of debates and conversations that concerned researchers from across Latin America, even against the great difficulties that the Latin American countries had in the diffusion and circulation of journals and books. The same thing occurred with the wide circulation of books by A. Mattelart (1970, 1973), and particularly, with the book *Para leer al Pato Donald* [*How to Read Donald Duck*] (1974) written by Mattelart and A. Dorfman with a prologue by H. Schmucler.

Last, the milestone that was the most significant of all was the creation in 1978 of Asociación Latino americana de Investigadores de Comunicación [Latin American Association of Communication Researchers] (ALAIC), and Federación

Latino americana de Facultades de Comunicación Social [Latin American Federation of Departments of Social Communication] (FELAFACS) in 1981. Established between Caracas and Lima, ALAIC pooled multiple actors and projects, diverse intellectual movements and political alternatives. With ALAIC, Latin American thought acquired international status in terms of research as well as in its presence in various global forums like the AIERI-IAMCR, UNESCO, and IBERCOM conventions.

During the creation of ALAIC, the needs of communication prompted the exile of many researchers from their home countries and took them primarily to Mexico and Central America. There was a draw from the south to Mexico—a country that has a long history of hosting exiles and, hence, for a decade Mexico became the center of attraction of international institutions like Instituto Latino Americano de Estudios Transnacionales [Latin American Institute of Transnational Studies] (ILET) or Federación Latino Americana de Periodistas) [Latin American Federation of Journalists] (FELAP), as well as the new location of the direction and publication of journals like *Comunicación y cultura* [*Communication and Culture*], and the growth of Latin American publishers such as Siglo XXI. Although very weak in resources at the beginning, ALAIC used imaginative means to attract and unite members and establish its presence in various congresses and international seminars. The ALAIC members carried in their luggage books written by their affiliates so that they would be circulated in other countries beyond the ones in which they were published. Also, ALAIC promoted the first book collection that put together the state of the art in the research field as divided by countries, first starting in Venezuela, Colombia, Peru, Chile and Argentina.

FELAFACS was founded in Lima in 1981 with the purpose of thoroughly renovating the professional-university instruction of communicators, carried out through the creation and development of postgraduate studies directed to update instructors and advise teachers. The second field of action was the promotion of the relationship and exchange of ideas and experiences with permanent links between social communication associations and departments in Latin America and in other regions. FELAFACS propelled two types of measures for its action: the support of academic experiences and the teaching of communicators to promote curriculum renovation and teacher qualification. The second measure was the coordination and publication of the journal *Dialogos de la Comunicación* [*Dialogues of Communication*]. It has not only reached eighty-four issues over many years, but after the journal *Comunicación y Cultural* [*Communication and Culture*] was discontinued, *Dialogos* has been the forum for intense and prolific debates both on the professional instruction of communicators and on the agendas and experiences in research.

By the late 1970s, a shift from media analysis toward the processes of sociocultural understanding began, stemming from the complexity of power shaping

the thought of Michel Foucault: from mere state devices, the media are shaped by processes, practices, and mechanisms of power that go beyond ideology. Discourse analysis is no longer one of many instruments, but rather that which is part of the very body of power (Martin-Barbero, 1978).

The 1980s–1990s:
Investigating Communication in Cultural Terms

In the 1980s, communication studies showed substantive changes that originated not only from within the field itself, but rather from changes in the social sciences of Latin America. First, the movements that sought conceptually and methodologically to rebuild the field of communication came as much from the experience of the social movements as from the reflection that cultural studies provided. It began with the blurring of boundaries that previously divided the field of communication: the borders, the vicinities, and the topographies are not the same as they were even ten years ago nor are they so defined. With new forms of media, processes and dimensions that incorporate historical knowledge, anthropologies, and aesthetics began to work. At the same time, no longer in a marginal way, sociology, anthropology, and political science started to take charge of the media and the ways in which cultural industries operate. In sociology, research focused on the place of the media in cultural transformations through the themes of media consumption and cultural policies. From the neighborhood history of everyday-life cultures in the lower income sectors of Buenos Aires at the beginning of the century, sociology moved to the history of the transformations undergone by black music in Brazil in its route from the slave plantations to the overcrowded city and its legitimization by radio and records as urban and national music. Anthropology gave an account of the changes in both the production system and the symbolic economy of craftworks, including the exploration of the urban carnival rituals, the body and soul rituals embedded in religious practices, and the transformation of communication in large cities to urban youth cultures.

The crucial point in the intersection between communication studies and social and cultural research was a seminar organized by Consejo Latino Americano de Ciencias Sociales [Latin American Council of Social Sciences] (CLACSO) in October 1983 in Buenos Aires. This coincided with the first elections after the tragic period of the military regime and the return of a large group of exiles to Argentina. This Seminar on Media and Popular Culture was a unique opportunity for dialogue and discussion between scholars of communication, historians, political scientists, analysts of cultural change, and art critics. Among the many publications that reflect what was the hatching point at the seminar, the titles of four books give a good account of what was forged there: N. García Canclini and R. Roncagliolo, *Cultura trasnacional y cultural populares* [*Popular Culture and the*

Transnational Cultural] (1988); H. Herlinghaus and M. Walter, *Posmodernidad en la periferia: Enfoques latinoamericanos de la teoria cultural* [*Postmodernism in the Periphery: Latin American Approaches to Cultural Theory*] (1994); N. García Canclini, *Culturas híbridas* [*Hybrid Cultures*] (1990); and J. J. Brunner, *América Latina: cultura y modernidad* [*Latin America: Culture and Modernity*] (1992). A strategic dimension of what has changed can be seen in how happenings in the media are based on the complex world of social reality. There is also the clear example of the study on television that is no longer referred to by its commercial structure alone, but to what also links this medium to public life (Landi, 1992).

Furthermore, latent globalization, still under the name of transnationalization, made apparent the conflict between the transnational nature of the economic structure and the national nature of the political sphere. This contradiction seems to be associated with the restructuring of political forces, still on the battlefields, although no longer so clearly divided as compared to some years ago. Being aware of this meant that the era of big claims, which are always necessary, was giving way to a difficult and more obscure, but not less risky, job: the fight against the eclectic combination that functionalized criticism and the resistance to neopositivism. An environmental neopositivism was no longer only in the right wing but was well disguised in a certain type of left-wing thought, such as the Althusserian Marxism. Neopositivism was continuing to reduce the media to ideological apparatuses of the ruling class and state. This entailed ignoring what was beginning to take shape in these ICTs—satellite dishes and media interfaces. What was being launched was the strategic shift from the use of media as an instrument to the configuration of a new model of society, and consequently to a new political-cultural network. New technologies, applied with this social model, allowed the fundamental changes to be seen.

Stuart Hall (1981, 1984) helped us to understand its true scope: communications are penetrating to the heart of the work and production system, and especially by considering information as raw material of any production so that the entire Western democratic model was being affected by the direction followed by the information society. Later, the strategic relationship between culture and industry was emancipated from Frankfurtian determinism by Hall (1984) and Golding and Murdock (1985) who began to decode social and ideological determination, no longer in terms of context but by setting limits and enforcing boundaries.

It was finally possible to investigate the other sense of the structures of production, that is, in terms of the relationship between technology, the market, and the productive routines. A common knowledge was acquired by the professions that materialized a message to see and to explain what is seen. This new horizon for analysis was reinitiated in Latin America by the study of the social uses of technologies that, for the first time, did not come second-hand. Social condi-

tions prevented the majority of people from accessing these new technologies, and their use was introduced at an inopportune moment and with anachronisms that revealed the heterogeneity of Latin American cultures, which a mere ideological analysis of the contents would not be able to explain.

Still, more than an alternative source of idealizations, what the practices of common communication unveiled was the extreme impoverishment that the mercantilization of social life was producing in the daily communications of the masses. In contrast to the idealism of difference theory—which places indigenous cultures in a position outside of capitalist development—and resistance theory—which overestimates the capacity for ethnic cultural survival—N. García Canclini (1982) proposed "a path between two vertigos: no indigenous culture can exist with the autonomy sought by anthropologists and folklorists, nor are they the abnormal appendages of a capitalism that devours everything." This gave rise to a new map: the survival of ethnic groups as an integral structure of capitalism, while, in turn, a producer of an inexhaustible cultural truth. Far from being a mere marginality, what is commonplace constitutes a social, economic, and symbolic space in a continuous battle against entropy; but this space, at the same time, is strategic for city dwellers who suffer from an emptiness of roots that drives them to search for objects that summon the depth of the past. The popular world will insist on the conversion of the ethnic to what is mainstream.

This process, in which the nation-state places a key role in converting craftwork, dances, food, and musical rhythms into a "national heritage," is a way to praise them as common cultural capital used to confront the rapid social fragmentation and politics of these countries. It began by introducing the cultures of the people in the communication process and becoming aware of the activity of the dominated people as accomplices of their own domination but also as subjects capable of replicating their master's discourse. It is the issue of the so-called receptor that is starting to be radically rethought. For example, an emphasis on "receptor" recognizes that domination is not the passive resignation of the oppressed, but it is also activity, resistance, and response. Our sophisticated instruments of analysis are not made to understand this activity. We are only now beginning to feel the need for a methodological shift that would give us access to readings produced by various popular groups. One reading tries to open the way for other voices, a word that introduces noise and that mocks and undermines power relations.

This has given rise to a new map. Far from a mere marginality, what is popular constitutes a social, economic, and symbolic space, in a constant struggle against entropy, while also serving a strategic role in understanding the formation of urban masses. With modern advancements, popular modes of communication become the key to understanding the cultural *mestization* in Latin America. Still, *mestization* is not a thing of the past, that racial explanation from which these countries and towns originated; rather it is the story of modernity and cultural

discontinuities, long running memories and fleeting imaginaries that intertwine the indigenous with the rural and the rural with the urban, old folklore with mass culture, and what is popular with the mass culture that the media represents (Martin-Barbero, 1987).

We are in debt to a group of female researchers for having known the value of the invisible medium that is the most present in the lives of the vast majority, the radio. It is almost as if the gender reading that is often spoken about today started in Latin America with the feminine way of listening to the speech of the towns-people on the radio. In Argentina, Patricia Terrero (1981) laid the foundations of radio history by implementing a central analysis of the spaces of continuity between popular traditions and mass culture. These spaces were expressions of the shared national imaginary with the common mythological and belief processes that play a key role in the shaping of social and cultural identity in the public sector.

From the minstrel and balladeer tradition, radio has collected a long process of cultural sedimentation that has resulted in populist discourse and, within it, the shaping of urban masses. In Chile, Giselle Munizaga and Paulina Gutierrez have investigated the special ability of radio to create a link between popular symbolic-expressive rationality and informative-instrumental modernizing ratio-nality. Through sonority—voice, music, sound effects—that enables the overlap-ping of time and tasks and the exploitation of colloquial expressions, radio not only channels but also triggers or drives a subjectivity that, finding no place in highly formalized political activity, is relegated to the cultural market. This exclu-sion seriously questions the position condemning dominant ideology. The effort was preserved in order to investigate how and why, because of radio, the worker learned to move within the city, the migrant still found ways to stay connected to his homeland and his wife, serving as an outlet for the expression of forbidden emotion.

In Peru, the works of Rosa María Alfaro (1987, 1990) have drawn a detailed map of the ways in which radio captures the density and diversity of the living conditions of the people. The broadcast "popular urbana" [Urban Popular] has its own space, but under populist direction and from other sectors that foster it from outside. Nevertheless, the mainstream makes itself present there under the unify-ing creole identity: a competition to dramatize poverty and the ingeniousness of the people, a language that brings to the radio the phonetics, the vocabulary, and the syntax of the street, and a vast music presence in which the urban *mestizo* is expressed today in Lima: the "*chichi.*" Through it all, the broadcast questions the mainstream "us," although constructed with collective populist voices. It activates dimensions of the cultural life of the country, which are unrecognized or denied by international stations.

Also, in Argentina, María Cristina Mata (1987, 1988) conducted a thorough analysis of everyday life built from radio discourse through devices that she constructs between the fragmentation of specific spaces and the diversity of the continuity programs. First, the continuity *de la jornada* [of the day] is achieved by linking the issues and the voices that "read" the daily news for their audience. Second, there is continuity in time between the speakers and listeners, a memory that binds the questioned neighbors on the radio as part of the neighborhood community and the users and petitioners of public services and institutions. Also, in Brazil, Maria Immacolata Vasallo (1988) investigated the expressive representations of the popular sectors in certain programs that were produced by narrators who brought the language of the urban masses to radio, pouring into it crime and detective narratives in which situations and lifestyles of the most marginal peoples surface, all of them coming from journalism and police blotters.

The study of television in Latin America would soon leave behind the analysis of its contents to focus on television's role in the transformation of urban life, since countries in the 1960s had the majority of their population living in the countryside but were experiencing a fast migration to the cities. One of the first scholars to study the relationship between film, television, and the city was the Mexican Carlos Monsiváis (1988, 1995). He revealed the cultural and communicative realm of the senses and emotions of the urban masses by using musical poetics that stemmed from ranchera to tango, along with film and television. In just a few years, Latin American television melodrama, the *telenovela*, became not only a fantastic commercial phenomenon—especially in Mexico, Brazil, Colombia, and Venezuela—but also a cultural production whose success demanded a closer reading into the political, social, and narrative *mestization* operating in the *telenovela*. There is much more than domination when analyzing a modern melodrama made from complicities, resistances, and inventions, from old familiar moralities and new contexts of conflict and rebellion, from a dense cultural re-understanding of the humiliated and excluded whose truth constitutes a deep challenge to both erudite aesthetics and intellectualized ethics (Ortiz, 1989; Martin-Barbero & Muñoz, 1992; Vasallo, 2002).

The issue of audiences, or the reception and consumption of the media, has become an increasingly dense area of research since the early 1990s. What propels the study is the analysis of the socioeconomic, political-cultural, and technical interventions that regulate the forms of consumption and modalities of reception. The purpose has been to make the figures emerge and observe the reasoning behind the re-understanding that popular audiences experience, substantiating an "us" that was, until now, unknown by communication research (Orozco, 1991, 1994; Jacks, 2011).

The other line of study in those years was the relationship between communication and politics, moving from political analysis of media content to the new

strategic place of communication in political processes and practices. The pioneering studies in this field were those of the Argentine Nicolas Casullo (1985), which repositioned a substantive issue: What technological transformation of the media that fragment audiences and remake the modes of circulating information and creating public opinion are meaningful for politics? From the other side, the brutal bursting of a pipe that nearly destroyed a thickly populated neighborhood in the city of Guadalajara, Mexico, was used by Rossana Reguillo (1996) to investigate from below. He started with the emergence of fear in the everyday lives of thousands of people and the disruption of all public services. He took account of the immediate mustering of solidarity among the poor, as well as the delayed and incompetent efforts of the city's public institutions. For Reguillo, while people's distrust of politics increases, the appearance of protective forces, based on the symbolic efficacy of myths and rituals, grows. This last aspect was continued by this Mexican researcher (2000) in one of the first ethnographic studies about the forms of communication among young people and how they communicate with society. A few years later (2006) he studied the delocalization of politics in the presence of the new social insecurities and new civic visibilities.

From Colombia, German Rey (1998) studied the new mass-interventions of politics, that is, the new place of modernized technologies in becoming a crucial stage of public life. On one side, this deals with investigating the conceptual reconfiguration of "what is public" as "what is common for everyone, when diffused or made public." This definition stems from H. Arendt and R. Sennet and, in turn, from the relationship between the common interest, civic space, and communicative interaction. This is translated into the recognition of new rights for citizens: to be informed, but also to be able to inform, to hear and to be able to speak, to become visible in the full gamut of social inequalities and cultural diversities. A few years later (Rey, 2009) what marked the research agenda was the new complexity of public politics at the crossroads of communications and new cultures.

At the Turn of the Century: Globalization and the Technocultural Transformation of Communication

Globalization is not a mere avatar of the economy and the market but a movement that makes communication and information the keys to a new model of society. It pushes all societies toward increased connections and conflicts within the network, exposing cultures to one another like never before. Hence, the location of communication study in these new settings gives rise to perplexing challenges. It requires deep thinking about the sociocultural density of technological intervention, not only in communication but also in production and even in society as a whole. Technological transformations today, beyond their purpose of innovative devices, affect ways of perception and language, new awareness and writings. We

are facing a cultural change involving the association of new production with a new way of communicating, which converts knowledge into a direct productive force. What in today's world of communication has become the focus of a technocultural transformation is what affects our societies from within and as a whole. But as Manuel Castells (1997, pp. 31–32) repeats time and again, "Technology does not determine society; it captures it. And it especially captures its ability to transform. Technology is society and this cannot be understood or represented without its own technical tools."

What communication demands is the consideration of the hegemony of communicational reason, whose devices—the fragmentation that dislocates and deviates, the globalizing and pressurizing flow, the dematerializing hybrid connection—are engineering society's future market. What Latin America is searching for is precisely communicational hegemony like the market: communication turned into the most effective engine to exclude and incorporate cultures—ethnic, national, or local—in the space-time of the market. In the same sense, Latin America needs to consider the new strategic location of communication in shaping new models of society.

This calls Latin Americans to distinguish between two very different projects. One stems from the cultural-economic magnitude acquired by audiovisual and computer technology in the accelerated processes of globalization. This project looks to take over technology in building cultural policies that address the desocializing effects of neoliberalism and explicitly insert cultural industries into the economic and political construction of the region. The other is the combination of technological optimism accompanied by a most radical political pessimism that seeks to legitimize, through the power of technology, the omnipresent intermediation of the market. By perverting the sense of political and cultural demands that find expression in technological transformations, any questioning of social order generated by the market and technology is discredited. But, how can the discerning social density that sheaths communicational technologies be assumed? Does it not inevitably yield to the reality that technological fascination produces? Does it not lead to neoliberal complicity with the market as the only principal organizer of society as a whole?

From the field of cultural sociology, Renato Ortiz (1994, 2006) introduced the need to disentangle the unifying logic of economic globalization that makes culture worldwide. Cultural globalization does not operate from outside spheres driven by autonomy like national or local ones. Globalization is a process that is constantly made and unmade, and that makes it impossible to talk about a world culture that is placed above national or local cultures. Globalization should not be confused with the standardization of different ways of life produced by industrialization, the cultural industry that was the focus of the Frankfurt School's analysis.

Now we face another kind of process, expressed as a culture of world modernity, that is, a new way of being in the world. This can be seen in the profound changes in life: work, love, food, and leisure. Because of the prolonged workday, it is impossible for millions of people to have lunch at home, and each day more women are working outside the home, children are becoming more independent from their parents at an earlier age, the patriarchal figure has been devalued as much as the work of the woman has gained value, and food has stopped being a tradition that gathers the family together. De-symbolized, everyday food has found itself as fast food. The success of McDonald's or Pizza Hut speaks less to the imposition of North American food than to the substantive changes in the everyday life of people, changes that these products, without a doubt, represent and what make them so profitable. The new ways and food products, detached from the eating rituals and places that symbolize family gathering and respect for patriarchal authority, lose their strength in these dominions and customs, and become generalized information above the diversity of contexts.

From political geography, Milton Santos, starting in 1996, proposed that the absence of analytical categories pertains to the social sciences and is anchored to the core concept of the nation-state. However, what we need to consider now is the world internationalized by globalization. Not that the category "society" does not continue to have validity—the expansion and exasperation of nationalisms attest to this—but because collective knowledge about what is national arises from a paradigm that cannot yet account, neither historically nor theoretically, for the reality in which individuals, classes, nations and nationalities, cultures and civilizations take part.

Santos' thought presents a challenging vision of globalization as much a perversity as a possibility. He called it a paradox, whose frantic pace threatens to paralyze both thoughts and actions but is able to change their course. Globalization fables the enslaving process of the market, a process that while making the world uniform also divides it, as the inequalities grow bigger. Hence, the systemic perversity that entails and creates increasing human poverty and inequality, chronic unemployment, and diseases such as AIDS becomes devastating not in the poorest but in the most plundered of continents. However, globalization also represents a unique set of opportunities and changes that are now possible and based on radically new facts, among which two stand out: one is the enormous and dense mixture of peoples, races, cultures, and tastes that is taking place today on every continent—although with major differences and asymmetries. The other is the fact that the new technologies are increasingly appropriated by subordinate groups making a real "cultural revenge" possible, that is, the construction of a counterhegemony throughout the world.

This set of possibilities opens humanity for the first time in history to an empirical universality and then to a new historical narrative. But the construction of

this narrative lies in a political mutation, a new kind of utopia that would be able to take on the magnitude of the following challenges:

- the existence of a new technical system of global scale that transforms the use of time by causing worldwide convergence and simultaneity of events;

- the shift from the old to the new technologies that takes us from a specific influence to a cross-influence and connection that affects every country directly or indirectly;

- the fragmentation of production like never before because of technology. Political unity never has been stronger and tends to dictate this stage and rule this arena by means of a powerful "engine unit" that leaves behind the multiplicity of engines and design that were used by the old imperialism. The new type of engine that drives globalization is the exponential competitiveness among companies around the world that demands more science, more technology, and better organization every day;

- the peculiarity of the crisis that capitalism is experiencing lies then in the continuous clash of the changing factors that are now beyond the old gradations and measurabilities, and overflow territories, countries, and continents;

- this clash, made of the extreme mobility of relationships and the great adaptability of the actors, reintroduces the centrality of the periphery, not only at the state level but also in terms of those socially marginalized by the economy, which is now refocused as the new foundation in the strengthening of the realm of politics.

From the fields of anthropology and cultural criticism, N. García Canclini started with *La globalización imaginada* [*Imagined Globalization*] (1999), a proposed agenda that would assume the advances and impasses of social disciplines. Some of the latter are still separated and suspicious, fighting over the areas of social knowledge, so that the academic boundaries are blurred and misplaced by everything in the life of both the Latin American countries and the world. For García Canclini, they must be together when we think about the multiplicity of scenarios in which our societies and cultures are risking their lives. According to García Canclini, the central academic role is taken by the "interculturality" category since it denotes both the density of social conflicts and the density of the exchanges that ethnicities, regions, and nations are experiencing. Interculturality also directs us to new ways of using research to give the imagination back to politics. This means re-instituting it for the management of society, because only then can culture reveal what it is ultimately the question of the meaning of life in common, that is, what we share as an ethnic group, region, or nation.

In his book *Diferentes, desiguales y desconectados* [*Different, Unequal and Disconnected*] (2006), García Canclini faces the controversies and misunderstandings that occur when trying to solve the nondilutable social inequalities with the sole defense of cultural difference, and also when explaining the symbolic density problems and cultural rights in socioeconomic terms. His stance is clear: "Some anthropologists are as interested in helping the marginalized groups become established and developed, as in understanding the conditions that may spread their marginalization and assessing the intercultural opportunities that people are looking for in order to be competitive, exchange with others, and live together" (p. 144). He anticipates misunderstandings among those for whom the incorporation of disconnection, as a form of social exclusion, may sound like a celebration of technique and states: "We can connect with others to obtain information only, as you would do with an information providing machine. Knowing the other, however, is dealing with their differences" (p. 194). This requires the redefinition of what Latin America means in the world, a horizon where it is no longer a region of isolated minorities and disconnected projects.

There are three features of this redefinition that are especially pertinent and challenging. The first is that, in the new definition, it is necessary to include not only what intellectuals and researchers think and what creators do in their assorted creations but also what their editors and distributors produce as well. That is, in the intense intermediation between creators and audiences, we must recognize that while some intermediations are expansive, others are asphyxiating, equalizing, uniformized, and functionalized. The second challenge is an arduous but urgent question of the actors who are thinking and constructing a truly intercultural Latin America—once suppression is tended to, the financial flows (cost and worth) are recognized, and immigrant displacement is accounted for. The third is the strategic importance today of clarifying the place from where Latin America is named. That has nothing to do with semantics but with what is, ultimately, the political arena, that is, the ways of relating to Latin America as a cultural space and project of emancipation, namely, as a utopia.

García Canclini (2002) has explicitly bound the subject of globalization to the question of the place of Latin America in the world. To summarize the complexity of the answer, the author uses the incendiary outline of T. S. Eliot regarding three names that cats have, applied to Latin America: (1) the generic one, which stands for the whole. A great part of the social sciences has been dedicated to understanding the generic name, and it seeks to label what we have in common as diverse and dispersed people and nations; (2) anthropology, especially, and also the humanities, have been given the task of unraveling what differentiates us inside and outside, what makes us unique; (3) not satisfied with those two names, the most famous literary trend, that of magic realism, has tried to penetrate the unconsciousness of this new world by unveiling its third name, the secret of its

name, its magic, its mystery. García Canclini (2004, p. 143) warns us lucidly why, in these dark times of downfalls and devastation, this third Latin American name could and should serve us, not as an alternative when what is rational fails but rather as a utopic reference of social movements whose effects go beyond those provided by the structures.

Thus, information, culture, and communication technologies, more than mere political objects, form a primordial political battlefield today over recuperating their symbolic dimension. Their capacity to represent the bond among citizens, the feeling of belonging to the community, and thus to confront the erosion of the collective order—these are what the market cannot do, no matter how effective it might be.

Upon reaching the end of this freehand map, three names should be mentioned that go beyond both timelines and subject matter. Eliseo Veron was the pioneer of complex analysis of media discourse, and gave rise to the idea of subject-active receptor in the process of communication (1969, 1988), and in his latest work he emphasized visual culture and the concept of agenda (2002). Anibal Ford, from the world of publishing and journalism, entered the study of communication in the mid-1980s with his book on popular culture (1985), which he then positioned in relationship to electronic and narrative cultures with an analysis that intertwined aesthetics with politics (1994), and concluded with a strong and critical study of globalization in a 1999 book with a title—*La marca de la bestia* [*The Mark of the Beast*]—that sounds apocalyptic without the book being so. José Marques de Mello, a researcher and man of action, who founded and headed INTERCOM, *la Sociedad Brasilera de Estudos da Comunicaçao* [the Brazilian Society of Communication Studies] has been the most long-standing president of ALAIC, and manages a research center dedicated to assessing Latin American thought on communication. The paradigms of Latin American research have been his subject and his obsession from his beginnings (1974) to his most recent publication (2008).

Translated by Lauren Hetrovicz

Bibliography

The 1960s–1970s: Constructing the Field of Study

Beltrán, L. R. (1976a). "La investigación en comunicación en Latino américa: ¿indagación conanteojeras?" *Cuadernos ININCO*, 1, Caracas.

Beltrán, L. R. (1976b). "Premisas, objetos y métodos foráneos en la investigacións obre comunicación en Latino américa." *Chasqui*, 1, Quito.

Freire, P. (1967). *Educação comoprática da liberdade*. São Paulo: Paz e Terra.

Freire, P. (1963). *Alfabetização e conscientização*. Porta Alegre: Editora Emma.

Kaplun, M. (1988). *Una pedagogía de la comunicación*. Madrid: Ed. La Torre.

Kaplun, M. (1973). *La comunicación de masas en América Latina*. Montevideo: Ediciones Paulinas.

MacBride, S., & UNESCO. (1980). *Un solo mundo, voces multiples: comunicación e información ennuestro tiempo*. México: FCE.

Martin-Barbero, J. (1978). *Comunicación masiva, discurso y poder*. Quito: Ciespal.

Mattelart, A. (1973). *La comunicación masiva en el proceso de liberación*. Buenos Aires: Siglo XXI.

Mattelart, A. (1970). *La ideología de la dominación en una sociedad dependiente*. Buenos Aires: Signos.

Mattelart, A., & A. Dorfman. (1974). *Para leer al Pato Donald*. Buenos Aires: Siglo XXI.

Pasquali, A. (1970). *Comprender la comunicación*. Caracas: Monte Avila.

The 1980s–1990s: Investigating Communication in Cultural Terms

Alfaro, R. Ma. (1990). *Cultura de masas y cultura popular en la radio peruana*. Lima: Calandria Tarea.

Alfaro, R. Ma. (1987). *De la conquista de la ciudad a la apropiación de la palabra*. Lima: Tarea.

Brunner, J. J. (1992). *América Latina: cultura y modernidad*. México: Grijalbo.

Brunner, J. J., & C. A. Catalán. (1989). *Chile: transformaciones culturales y conflictos de la modernidad*. Santiago: Flacso.

Casullo, M. (Ed.). (1985). *Comunicación: la democracia deficil*. Buenos Aires: iLET Folios.

Da Matta, R. (1981). *Carnavais, malandros, herois*. Rio de Janeiro: Zahar.

García Canclini, N. (Ed.). (1994). *Políticas culturales en América Latina*. México: Grijalbo.

García Canclini, N. (1990). *Cultura ahibridas*. México: Grijalbo.

García Canclini, N. (1982). *Las culturas populares en el capitalism*. México: Nueva Imagen.

García Canclini, N., & R. Roncagliolo (Eds.). (1988). *Cultura transnacional y cultural populares*. Lima: IPAL.

Golding, P., & G. Murdock. (1985). Capitalismo, comunicaciones y relaciones de clase. In *Sociedad y comunicación de masas*. Mexico: F.C.E.

Gutierez, L., & L. A. Romero. (1985). *Sectorespopulares y culturapolítica*. Buenos Aires: Sudamericana.

Hall, S. (1984). "Estudiosculturales: dos paradigmas." *Revisa Hueso Húmero*, (19), Lima, 67.

Hall, S. (1981). "La cultura, los medios de comunicación: el efectoideológico." In J. Curran, M. Gurevitch, & J. Woollacott (Eds.), *Sociedad y comunicación de masas* (pp. 387–388). México: F. C. E.

Herlinghaus, H., & M. Walter. (1994). *Posmodernidad en la periferia: enfoques latino americanos de la teoria cultural*. Berlin: Langer Verlag.

Jacks, N. (Ed.). (2011). *Análisis de la recepción en América Latina*. Quito: Ciespal.

Landi, O. (1992). *Devórameotravez: quéhizo la televisión con la gente, qué hace la gente con la televisión*. Buenos Aires: Planeta.

Martin-Barbero, J. (1987). *De los medios a las mediaciones*. Barcelona: Gustavo Gill.

Martin-Barbero, J., & S. Muñoz. (1992). *Televisión y melodrama*. Bogotá: Tercer Mundo.

Martin-Barbero, J., & G. Rey. (1999). *Los ejerciciosdel ver*. Barcelona: Gedisa.

Mata, M. C. (1988). "Radios y públicos populares."*Dialogos de la comunicación* (19), Lima, 55–70.

Mata, M. C. (1987). "Cuando la comunicación puedes ersentida comopropia, una experiencia de radio popular." In *Comunicación y culturaspopulares* (pp. 216–229). México: Gustavo Gill.

Monsiváis, C. (1995). *Los rituals delcaso*. México: Ediciones Era.

Monsiváis, C. (1988). *Escenas de pudo y liviandad*. México: Grijalbo.

Orozco, G. (1994). *Televedencia. Perspectivas para el análisis de la recepción televisiva*. México: Univ. Iberoaméricana.

Orozco, G. (1991). *Recepción televisiva. Tres approximaciones parasu studio*. México: Univ. Iberoaméricana.

Ortiz, R. (Ed.). (1989). *Telenovela: historia e producao*. São Paulo: Brasiliense.

Reguillo, R. (2000). *Estrategias del desencanto. Emergencia de culturas juveniles*. Buenos Aires: Norma.

Reguillo, R. (1996). *La construcción simbólica de la ciudad: sociedad, desastre, comunicación.* Guadalajara, México: Iteso.

Reguillo, R. (1991). *En la calleotravez. Las Bandas: identidad urbana y usos de la comunicación.* Guadalajara, México: Iteso.

Rey, G. (2009). *Industrias culturales: creatividad y desarrollo.* Madrid: AECI.

Rey, G. (1998). *Balsas y medusas: visibilidad comunicativa y narrativas politicas.* Bogotá: Fescol.

Sodré, M. (1983). *A verdades educida. Porun conceito de cultura no Brasil.* Rio de Janero: Codecrí.

Squef, E., & J. M. Wisnik. (1983). *Musica: O nacional e o popular na cultura brasileira.* São Paulo: Editore Brasiliense.

Terrero, P. (1981). *El radioteatro.* Buenos Aires: C.E. de A.L.

Vassallo, M. (2002). *Immacolata, coord. Vivendo con a Teelenovela.* São Paulo: Summus.

Vassallo, M. (1988). *Immacolata.* São Paulo: Edicoes Loyola.

Various Authors. (1987). *Comunicación y culturas populares en Latino américa.* México: G. Gili.

At the Turn of the Century: Globalization and the Technocultural Transformation of Communication

Castells, M. (1997). *La sociedad red, 1, de La era de la Información.* Madrid: Alianza.

Ford, A. (1999). *L marca de la bestia: identificación, desgualdades e info entretenimiento en la sociedad contemporánea.* Buenos Aires: Norma.

Ford, A. (1994). *Navegaciones: comunicación, cultura y crisis.* Buenos Aires: Amorrurtu.

Ford, A. (1985). *Medios de comunicación y cultura popular.* Buenos Aires: Legasa.

García Canclini, N. (2006). *Diferentes, desiguales y desconectados.* Barcelona: Gedisa.

García Canclini, N. (2002). *Latino americanos buscandolugar en estesiglo.* Buenos Aires: Paidós.

García Canclini, N. (1999). *La globalización imaginada.* Barcelona: Paidós.

Marques de Mello, J. (2008). *História politica des ciências da comunicação.* Rio de Janeiro: Editora Mauad X.

Marques de Mello, J. (1998). *Teoria de la comunicaçao: paradigmas latino-americonos.* Petrópolis: Vozes.

Marques de Mello, J. (1974). *Comunicaçao social: teoria e pesquisa.* Petrópolis: Vozes.

Ortiz, R. (2006). *Mundializacao: sabers e crencas.* São Paulo: Brasilense.

Ortiz, R. (1994). *Mundializacao e cultura.* São Paulo: Brasilense.

Santos, M. (2004). *Porotra globalización.* Bogotá: CAB.

Santos, M. (1996). *A natureza do espaço.* São Paulo: Hucitec.

Veron, E. (2002). *Espaciosmentales: Efectos de agenda 2.* Barcelona: Gedisa.

Veron, E. (1988). *La semiosis social.* Barcelona: Gedisa.

Veron, E. (1969). *Ideología y comunicación de masas.* Buenos Aires: Nueva Visión.

Toward a Theory of African Communication

JOSEPH OLÁDÈJO FÁNÍRAN

Following political liberalization in Africa in the early 1990s, the African media landscape has altered radically due to deregulation and emergence of new communication and information technologies. Consequently, there has been a rapid increase in the numbers of radio and television stations, newspapers and magazines, computers, and social media. One of the outcomes of this development is the continuous integration of the African continent into the emergent globalized world, with its increasingly competitive and pluralistic public spheres.

The same cannot be said of present-day communication education in Africa. It has no rich tradition of a long-standing university system, and like other disciplines, it remains largely an import from Western Europe and North America. Most of the research and publications are concerned with the relationship between media development and political democratization, and the role of communication in national development. A major lack in communication research is that of a paradigm that can be called "homegrown" within the African context (de Beer, 2008; Hecht & Ndiaye, 2008; M'Bayo, Sunday, & Amobi, 2012). Drawing inspiration from African philosophy, sociology, and communication, this chapter proposes the concept of communalism as a possible indigenous paradigm. This position is the fruit of an ethnographic study of the way people communicate among the Yorùbá of the southwestern part of Nigeria (Fáníran, 2008). The study was inspired by and carried out under the able supervision and guidance of Professor Robert White SJ, who not only gave me fish but also taught me how to

fish and thereby fed me forever. What follows here is the fruit of that marvelous encounter with him.

In Search of a Research Tradition

The first challenge that the mentoring by Professor White helped this author to overcome was the search for a research tradition that would be appropriate to study how Africans communicate and how this can be explained in a scientific way. Following the work of Karin Barber (1997, pp. 1–12), the research framework of the binary paradigm of traditional and elite was found to be inappropriate in that it overlooks the complex intermeshing of the relationship between the rural and the urban, the traditional and the modern, and the ongoing conversation between the two cultures through education, popular culture, and in the works of critical intellectuals. An example of such a conversation can be gleaned from the answer given by Chinua Achebe to one of the questions posed by Nasrin Pourhamrang, the Iranian editor in chief of *Hatef Weekly* magazine in the northern province of Gullan, about his new book, *There Was a Country—A Personal History of Biafra*:

> I discovered while working on the book, quite interestingly, that it would not be a straight forward work. I found that I had to draw upon prose, poetry, history, memoir, and politics and that they were independently holding conversations with each other—perhaps because no one genre or art form could bear the weight of the complexity of our condition. (Pourhamrang, 2012)

In answer to the subsequent question, Achebe frankly admitted that he "borrowed proverbs from our culture and history, colloquialisms and African expressive language from the ancient griots, the world views, perspectives, and customs from my Igbo tradition and cosmology, and the sensibilities of everyday people" (Pourhamrang, 2012).

Similarly, it was discovered that the behaviorist paradigm fails to grasp this fluid social context in which contemporary Africans, like Chinua Achebe, find themselves and their resultant struggle to forge new kinds of self and consciousness. Hence, the choice fell on the cultural studies tradition that understands communication as a function of culture, and is rooted in the anthropological-ethnographic school of Clifford Geertz and Victor Turner (Fáníran, 2008, pp. 5–10). Starting with the interplay between culture and communication, the rest of the essay unravels the stages of development of communalism as a possible theory of African communication.

Interplay Between Culture and Communication

Culture is made public and shared through communication, while the forms of communication are shaped through culture (Lie, 2003, p. 13; Lie & Servaes,

2000, p. 308). Nonetheless, there exist as many definitions of culture as there are authors. This essay, therefore, takes as its benchmark the one preferred by Clifford Geertz, where he defines culture as "an historically transmitted pattern of meaning embodied in symbols, a system of inherited concepts expressed in symbolic form by means of which men communicate, perpetuate and develop their knowledge about and attitude towards life" (1973, p. 89). As if to unpack that definition, Ann Swidler (1986, pp. 273–286) explains that culture can be understood in terms of the publicly available symbols through which people experience and express meaning. It is a style, a set of skills, or a tool kit from which individuals and groups select differing pieces to construct different lines of action. Included in this tool kit are worldview, ethos, myth, and ritual.

While worldview articulates the type of community those in the interactive situation are building, ethos or value refers to the normative definition of how they should behave in that social situation. Myth explains where they, as a people, are coming from, and where they are going. Ritual is the repetitive social practice that is composed of a sequence of symbolic activities like dance, song, speech, and gestures or the manipulation of objects, adhering to a schema and closely connected to a specific set of ideas that are often encoded in myth (Schultz & Lavenda, 2000, p. 355).

W. Lance Bennett (1980) asserts that "in the most general sense of the term, culture consists of the patterned relations among the basic beliefs, values, and behaviours that organize social interaction and communication" (pp. 166–167). He then identifies myth and ritual as the two most important elements that bear specifically on the communication process. To him, myths are like the lenses in a pair of glasses: they are not the thing people see when they look at the world, but what they see with. They are the truths about society that are taken for granted and are woven throughout everyday social discourse. Encoded in folktales, myths recount exploits of groups, or convey social lessons through the acts of individual heroes through whom people first encounter the ideals that are held dear by the society. Some myths explain the causes of social adversities and show how people overcome them. Others explain the principle of politics, the standard of civility, and the nature of society. Hence, myths are embedded deeply in consciousness as associative mechanisms that link personal experience, ongoing reality, and public history into powerful frameworks of understanding (Bennett, 1980, pp. 168–169).

Thus, there exists a strong connection between myths and rituals and both of them combine to impact on the process of communication. On the one hand, rituals grant their participants the glimpse, the touch, and the taste of the imagined, mythic world; on the other hand, the imagined or the mythic world depends on rituals for its instantiation (Driver, 1991, p. 136). In other words, the meaning that is constructed and narrated in myths is celebrated and shared in

rituals. Rituals, therefore, create solidarity by enabling the participants to have a subjective experience of sharing the same meaningful world. Victor Turner (1974) particularly brings this out in his concept of *communitas*, an essential and generic human bond that develops in the participants a deep sense of obligation and responsibility for the solidarity of the community. Different from the camaraderie found often in everyday life, the bonds of *communitas* represent "the desire for a total, unmediated relationship between person and person, a relationship which nevertheless does not submerge one in the other but safeguards their uniqueness in the very act of realizing their commonness" (p. 274).

Furthermore, the condensed nature of the ritual symbols enhances the experience of *communitas*. Representing multiple meanings, actions, and things all at once, the condensed symbols explode with meaning when released in a ritual situation. For example, ordinary objects like flags, bread, wine, crosses, and vestments expand and fill the situation with meaning, as the inevitable flow of meaning washes over the ego of the participants, floods their consciousness, and reinforces their identification with the shared meaning. But when social change removes the normalized pattern of behavior that supports a condensed symbol, it can suddenly appear to be unmasked, with little or no referent or function. Nonetheless, rituals remain seriously effective and, therefore, powerful, most of the time. For example, in the ritual of the rites of passage, boys are turned into men, girls into women, single individuals into married couples, private citizens into public servants, soldiers, or priests, as the case may be. In summing it up, Clifford G. Christians (1989, p. 23) maintains that communication is the symbolic process of expressing human activity and grounding cultural formation, while culture is the womb in which symbols are born. We can add here that myths and rituals are vehicles for expressing what Victor Turner (1974, p. 64) calls "root paradigms of culture," those unquestioned assumptions about the fundamental nature of the world and humanity that act as the unseen scripts that govern, direct, and give form and stability to every action of each member of the culture.

African Cultures as a Template of African Communication

If the foregoing has dwelt on the basic elements of culture in general, and the interplay between culture and communication, the following discussion applies these elements to African cultures. The word *cultures* is employed here in recognition of the diverse nature of the continent. Its terrain comprises forbidding deserts punctuated by numerous oases, mountain ranges, and their watered valleys, arid steppes, rain forest, and rain savannah grassland; its climate spans tropical, temperate, as well as Mediterranean types. The combination of these factors accounts for the disparate cultures among the different peoples of Africa (Abraham, 1992, p. 13). As the second largest continent, Africa has a population of 1 billion peo-

ple, drawn from over 1,000 ethnic groups. These ethnic groups are distributed within 55 countries and speak well more than 1,000 languages (M'Bayo, Sunday, & Amobi, 2012, p. 2).

Yet, there is a consensus among African scholars and statesmen alike that the powerful, taken-for-granted framework of understanding or the root paradigm of these cultures remain communalism. While scholars like Christians (2004) and Fackler (2003) favor the term *communitarianism*, and others like Gyekye (1997) use the terms *communalism* and *communitarianism* interchangeably, yet others, like Nyamnjoh (2004, 2005), prefer *interconnectedness, conviviality, shared ideas of personhood and belonging*, this writer agrees with the argument of Andrew A. Moemeka (1998) and Ike Odimegwu (2007), who employ the term *communalism* to describe the root paradigms of African cultures.

J. K. Kigongo (2002) explains that the state of affairs whereby individuals consistently pursue certain fundamental virtues on the basis of enhancing a common or social good is called *African communalism.*[1] Polycarp Ikuenobe (2006) goes further to establish communalism

> not just as a set of ideas, belief systems, values, or ways of life but also a methodology by which African people morally, socially, and politically organize their lives and thoughts, acquire and justify beliefs, solve problems, and explain phenomena. . . . [It] is one common or dominant theme or feature in African cultures that emerges from the African way of life. (pp. 15–16)

In his early essay on this topic, the Ghanaian social philosopher Kwame Gyekye defines communalism as "the doctrine that the group (that is, the society) constitutes the focus of the activities of the individual members of the society." It "places emphasis on the activity and success of the wider society rather than, though not necessarily at the expense of, or to the detriment of, the individual" (1987, p. 155). In a later work (1997, pp. 35–76), Gyekye distinguishes between radical and moderate models of African communalism. To him, radical communalism emphasises communal values, goods, and shared ends over and above the individual without fully recognizing the status and relevance of individual rights. It whittles away the moral authority of the person and makes the being and the life of the individual totally dependent on the activities, values, projects, practices, and ends of the community. It diminishes the freedom and the capacity of the individual to choose or re-evaluate the shared values of the community. For instance, Ifeanyi Menkiti asserts that "as far as Africans are concerned, the reality of the communal world takes precedence over the reality of the individual life histories, whatever this may be" (quoted in Gyekye, 1997, p. 37). Gyekye sees this model of communalism as providing the ideological groundwork for the advocates of African socialism who insisted that the underlying principles of African communalism are identical with those of socialism.

Dismissing the radical model as overstated and somewhat misleading, Gyekye argues that the moderate model better expresses the African reality. Here, African communalism is understood in terms of humanism,[2] a philosophy that sees human needs, interests, and dignity as of fundamental importance and concern. Thus, African communalism takes into consideration not only the natural sociality of the persons but also their individuality. In other words, while the person is communal by nature, that is, a being that is naturally oriented toward other persons, that relates with them, and is partially constituted by these relationships, the person remains an individual with intrinsic worth and dignity, responsibility and effort (Gyekye, 1997, pp. 40–41).

This is why Ikuenobe (2006) insists that to understand and fully appreciate the nature of communalism as a way of life in African cultures, one needs to understand the conceptions of person, community, and the relationship between the two. Thus, for Ikuenobe, the idea of community is a conceptual foundation on which most of African ideas, beliefs, values, ontology, cosmology, and ways of life are grounded. It is also the logical and epistemic foundation of the normative conception of a person and the basis for a person's own view of self-identity and ways of doing things. For the African:

> the needs, reality, and existence of the community is *logically prior* to those of the individual. In fact the interests and needs of the individual derive from those of the community. The attitudes, sentiments, motives, intentions, mental, and moral dispositions of an individual are formed by virtue of her belonging to a community. (Ikuenobe, 2006, p. 54)

According to Ikuenobe, this is different from the Western liberal, rational, autonomous, solipsistic, atomistic, and individualistic self. Rather, for the African, the moral person is a rational, emotional, and autonomous person who has been sufficiently equipped by the normative attitudes, structures, and principles of his or her community to give credence to caring, sympathy, and relationships. When Africans speak of a "we," they are not referring to a community that is simply an aggregated sum of individuals, but an organically fused collectivity of individual selves. These include traditions, interests, values, and beliefs that are metaphysically connected to living people, the dead, ancestors, and posterity. Tradition, ancestral spirits, and the existential concrete and social reality are elements that fuse the group together into a human community (Ikuenobe, 2006, pp. 51–54).

Indeed, Francis B. Nyamnjoh (2004) shares Ikuenobe's view where he insists that African cultures emphasize interdependence between individuals and their community as opposed to neoliberal notions of individual autonomy (p. 36). In the words of Gyekye (1996), we can describe this interplay between the individual and the community in African communalism in terms of a tense relationship.

> The fact that the African people express appreciation for both communal and individualistic values means that for them these two seemingly opposed concepts can co-exist,

however precariously. . . . Their idea is that the individual cannot develop outside the framework of the community, but the welfare of the community as a whole cannot dispense with the talents and initiative of its individual members either. The interaction between the individual and the community (or group) is therefore considered basic to the development of the individual's personality as well as to the overall success and well-being of the community. (p. 50)

Martin Nkafu Nkemnkia (1999) defines this tense relationship between the individual and the community in philosophical terms as "a vision of totality in which beings, while perceived as distinct, are nevertheless ontologically and intimately related with each other" (p. 172).

At the end of his comparative analysis of the concept of person among the Akan of Ghana, the Igbo and the Yoruba of Nigeria, Olatunji A. Oyeshile (2002, p. 105) locates the locus of this distinct and yet ontological and intimate relationship between the individual and the community in kinship. Earlier on, Mbiti (1970) pointed out that kinship "governs the behavior, thinking and whole life of the individual in the society of which he is a member." Continuing, he maintains that "indeed, this sense of kinship binds together the entire life of the 'tribe', and is even extended to cover animals, plants and non-living objects through the 'totemic' system" (p. 104). Schultz and Lavenda (2000, pp. 444–469) later add that kinship enmeshes people in a web of relationships that makes each person aware of his or her responsibilities and rights, and clarifies the position of each in relation to others in both space and time.

The Nature of Communication in Communalistic Cultures of Africa

In his path-breaking work on the topic, Moemeka (1997, 1998) distils the distinct and yet ontological and intimate relationship between the individual and the community into five principles or indices that characterize communication in communalistic societies. They are the unseen scripts that govern, direct, and give form and stability to the way people communicate in these cultures. The five principles include the supremacy of the community, the sanctity of authority, the respect for old age, the usefulness of the individual, and religion as a way of life. These principles can further be subsumed under the following three headings: (1) the supremacy of the community, comprising the sanctity of authority and the respect for old age; (2) the usefulness of the individual; and (3) religion as a way of life. The values inherent in these principles reflect a unique pattern of communication that marks communalistic societies.

Perceived as a dynamic process of human interaction, communication is primarily concerned with confirming, solidifying, and promoting the communal social order, while its secondary purpose is to maintain or improve interpersonal relationships. "In a communalistic environment," writes Moemeka, "communica-

tion is not just an ever-present act constitutive of every other act; it is the bedrock and sustaining power of social relationships and social order" (1997, p. 184). For example, in Yorùbá, as well as in other African languages, there is no direct translation for the word *communication*. The nearest equivalent is *ìbánisòrò*, which means the act of speaking one's word, sharing one's thought, one's personality, one's world with others. In that process a communal culture is created and the individual finds meaning within the relational culture. The Yorùbá proverb that says *àìlesòrò nì ìbèrè orí burúkú* underscores this understanding of communication. This means that the inability to speak, to communicate is the beginning of a "bad head." *Orí burúkú*, or a bad head, signifies a stunted, unproductive, and unfulfilled life. Conversely, *orí rere*, a "good head," is a successful, fulfilled, and fortunate life, a life that is well integrated into the communal structure starts with *ìbánisòrò*, the ability to communicate or express oneself.

In this cultural space, communication is a phenomenon that lies at the core of what makes someone a person and what makes a community human. As expressed by Elochukwu Uzukwu (1996, p. 44), the ability to communicate, to speak one's word, is of the essence of the person and it is in communication that the individual subject enjoys autonomy and rights. We can add here that communication is understood not only as media or means of transporting information from sender to receiver, or a profit-making venture that is governed by the dictates of the market, but also as human interrelationships that build up the community.

Hence, Patrick Kalilombe (1994, p. 122) observes, "Where Descartes said, 'I think, therefore I am,' the African would rather say, 'I am related, therefore, we are'" (quoted in Fackler, 2003, p. 325). This sets limits to and exerts pressure on the way people communicate, what they communicate, to whom, and when. Thus, vertical communication follows the hierarchical socio-political ranks within the community, while horizontal communication is relatively open and usually occurs among people of the same age or status. As the communicative act maintains and improves interpersonal relationships, so does it confirm, solidify, and promote the communal social order.

When the sharing of life and meaning, quintessentially expressed in communication, takes place in a ritual context, the communal bonds that cement the interactions within the community and bind that community together are strengthened. Hence, to Moemeka's analysis one can add the part played by myths and rituals in this communalistic understanding of communication. As already noted, myths are the truths about society that are taken for granted and woven throughout everyday discourse, and rituals are their deeper emotional media of dramatic performance. In rituals, ideas and material forms of expression, individual interpretations, and collective structures of languages, symbols, and meanings, the particularities of the communicative situation and the generalities of tradition and culture are fused into one (Rothenbuhler, 1998, p. 58).

This communalistic theory of communication was tested in an ethnographic study of the way Africans communicate that was carried out in the cultural context of the Yorùbá of Nigeria and reported in Fáníran (2008). Twenty-five families were interviewed, of which seven were in rural areas, fourteen in urban areas, and the remaining among the descendants of the returnees to Nigeria from Brazil, Cuba, and Sierra Leone. In the process, five indices of communalistic culture were studied in seven rituals of life transition in three different socio-cultural contexts, namely, rural families, urban families who are still in contact with the rural culture, and urban families who have only minimal contact with that culture. The five indices include supremacy of community, usefulness of the individual, sanctity of authority, respect for old age, and religion as a way of life. Since rituals socialize people into communicative relationships and sustain these relationships, the following seven rituals of life transitions were chosen for study: childbirth and naming ceremony, interaction within families, the use of *oríkì*, adulthood attained by marriage, human habitation, politics and mobilization, and the death-funeral ceremony.

From the findings, the conclusion was drawn that when the phenomenon of communication among the Yorùbá is examined in terms of their worldview, ethos, and rituals of everyday life and the peak moments of their life, including the way they select their symbols and organize their rituals, communalism forms the basic root paradigms of the way they communicate. However, with colonialism and the subsequent penetration of their peasant culture by the modern urban culture of the West, the Yorùbá remain flexible in their selection of symbols and organization of their rituals. Rather than rejecting their communalist culture for the individualist, they are creating pathways to expressing new meaning, order, and community by creatively blending the two. The metaphor chosen to explain the process is hybridization in terms of the "trunk and branches." This implies that the "trunk" of the tree is rooted in their culture, while the "branches," which stand for the new culture being borrowed from other cultures, are grafted onto the tree trunk. Nyamnjoh (2005) gives expression to this tendency when he writes: "Africa's creativity simply cannot allow for simple dichotomies or distinctions between old and new technologies, since its peoples are daily modernizing the indigenous and indigenizing the modern with novel outcomes" (p. 4).

Perhaps a couple of examples will illustrate the point being made here. In the familial rituals of the naming ceremony, staged eight days after the birth of the new child, the family, members of the extended family, and neighbors come together to create, share, and celebrate the new meaning by giving the child its name and *oríkì*, a Yorùbá poetic genre that serves as the key to a person's essential nature (Akínyemí, 1991, p. 152; Barber, 1991 , pp. 67–76). The new meaning, encapsulated in the names and the *oríkì* given by the lineage, defines the child not as a being-unto-itself, but a being-in-relation with others, who derives his or her

significance from the family, the lineage, and the community. As a performance-oriented style of communication, *oríkì* generates in the child a feeling of well-being, of solidarity with the family or lineage, and of pride in the ancestry. This is because *oríkì* indicates where a person originates from, how powerful or wealthy the ancestors were, and all the noble things they had done (Olátúnjí, 1984, pp. 67–107). Thus, the ritual of the naming ceremony preserves the supremacy of the family as the foundation of the life of the couple and their child, renews the bond of communion between the members of the extended family. As those present at the ceremony return to their separate ways of life they carry with them the sweet memory of the unity of their family.

The tense relationship between the individual and communal cultures is becoming noticeable in the rituals of everyday relationship in the family. For example, in both rural or urban homes, parents continue to teach their children to recognize the presence of others with whom they come into contact by greeting them, by kneeling or prostrating for them if the others are older, and by employing the vocabulary of respect, that is, the plural "you," "*èyin*" or "*è*" when addressing them. Similarly, wives adopt the vocabulary of respect when conversing with their husbands and greet them with the plural "you." But today, due to their exposure to Western education, husbands and wives are beginning to see and relate to one another as interdependent beings and to use the language of mutual respect instead of that of the hierarchical order. In most cases, husbands prefer and encourage the use of Yorùbá, while their wives favor English. Being more conservative, husbands want to continue with the ritual language that preserves the hierarchical social order and the asymmetrical social role between them. The preference of the wives points to their desire to assert their self-identity, and English, a tool of modern culture, becomes a convenient way of expressing themselves without the cumbersome necessity of having to use the subordinate vocabulary of the plural "you," "*è*" or "*eyin*," each time they address their husbands.

There is no better domain to test the aptness of Nyamnjoh's (2005) observation that "no technology seems too used to be used, just as nothing is too new to be blended with the old for ever newer results" (p. 4) than in the way the Yorùbá, in particular, and the Nigerian video filmmakers, in general, have appropriated the video technology for making meaning. When video equipment was first introduced into the Nigerian market in the late 1970s, it was mainly used as fashionable equipment that bestowed class on all those who used it to cover the *àríyá* they staged to celebrate their birthday, child-naming, weddings, chieftaincy installation, and burial rites. By the end of the 1980s, video cameras had been so creatively adopted and adapted as a narrative medium that it effectively displaced the Yorùbá Travelling Theatre and became the dominant technological medium of popular culture and entertainment not only in Yorùbá urban centers but also throughout the country.

The present author studied a sample of Yorùbá video films and found out that:

> in appropriating the new medium of communication to tell their own story, the producers reach deep into the basic assumption of their culture, namely that beings are distinct and yet ontologically and intimately related, and at the core of this relationship is the tense bond between the individual and the community. This core assumption informs the plot of the stories told and moves the narration forward. (Fáníran, 2007, p. 70)

A similar conclusion was reached in the study of some Nollywood films carried out by Ebere Uwah (2008, pp. 87–112), where he deduced that the attraction of the video film for the Nigerian people and for other Africans lies in its closeness to the life of the people, a factor that has made the home video an important site for the creation of meaning for millions of Nigerians and other Africans.

If the practice of journalism in African cultures today leaves much to be desired, it is precisely because the professional training given to journalists by and large has ignored this communalistic approach to understanding communication in general and to media practice in particular. Rather than dismissing the communalistic values and ethics as outlined here as being "based more on a romantic reconstruction of the precolonial and a frozen view of harmony in rural Africa" (Nyamnjoh, 2005, p. 9), we can say from the outcome of the empirical study reported here that these values and ethics should form the building blocks of their training into which the global influences can be creatively inserted. This is because "communication, which is not somehow consistent with the deepest assumptions of its audience about the world, the nature of humankind and the expectations about human motivation and action, which people take for granted, will have little chance of success" (Biernatzki, 1993, p. 131).

Conclusion

Much of what has been published so far on African communication has concentrated on media development, political participation, and the strategies of communication in national development. Little attention has been paid to the fundamental aspect of how Africans communicate and the factors that shape that communication. To bridge that gap, this essay identifies communalism, a totality in which beings are distinct and yet ontologically and intimately related, as the root paradigm of interactions, the unseen script that impacts on communicative actions. In other words, African cultures comprise individuals who are not atoms, but beings-in-relation, who maintain a tense relationship between individuals and the community, which, in turn, impacts on every aspect of their lives, including the process of communication and meaning making.

As the African continent becomes more and more integrated into the global world, there is the need to strengthen this root paradigm, while remaining open

and flexible enough to integrate the new culture into its system of meaning making. As a scholar once observed, "The test of any theoretical formulation is its ability to generate compelling explanations that provide tools for interacting with empirical reality" (Slack, 1984, p. 4). This is precisely what this essay has attempted to establish for communalism, as it examines the way Africans communicate from interpersonal, to group, and mass levels of social interaction.

Notes

1. It is necessary to use the adjective *African* to distinguish this type of communalism from that of India. Achin Vanaik and Praful Bidwai (1995) provide an insight into Indian communalism when they explain that it "is a combined process of: competitive desecularization in a religiously plural society—a competitive striving to extend the reach, power and importance of religious institutions, religious ideologies and religious identities—which along with non-religious factors help to harden divisions and create or deepen tensions between religious communities" (p. 132). This is obviously far from African communalism under discussion here.
2. Again, *African* humanism needs to be distinguished from *Western* humanism. Gyekye (1987) points out the difference, where he writes: "Unlike Western humanism, however, Akan (African) humanism is not antisupernaturalistic. On the contrary, it maintains a rigid supernaturalistic metaphysics that is rejected by Western humanism" (p. 143).

Bibliography

Abímbólá, W. (1976). *Ifá: An Exposition of Ifá Literary Corpus*. Ìbàdàn: Oxford University Press.

Abraham, W. E. (1992). "Crises in African Cultures." In K. Wiredu & K. Gyekye (Eds.), *Person and Community: A Ghanaian Philosophical Studies 1* (pp. 13–35). Washington, DC: Council for Research in Values and Philosophy.

Aké, C. (1995). "The Democratization of Disempowerment in Africa." In J. Hippler (Ed.), *The Democratization of Disempowerment: The Problems of Democracy in the Third World* (pp. 70–89). London: Pluto.

Akíntólá, A. (1999). *Yoruba Ethics and Metaphysics*. Ìbàdàn: Valour.

Akínyemí, A. (1991). "Poets as Historians: The Case of Akùnyùngbà in Òyó." *Odù: A Journal of West African Studies*, New Series, 38, 142–154.

Akìwòwò, A. A. (1999). "Indigenous Sociologies: Extending the Scope of the Argument." *International Sociology*, 14(2), 115–138.

Akìwòwò, A. A. (1991). "Responses to Makinde/Lawuyi and Taiwo." *International Sociology*, 6(2), 243–51.

Akìwòwò, A. A. (1986). "Contributions to the Sociology of Knowledge from an African Oral Poetry." *International Sociology*, 1(4), 343–58.

Akìwòwò, A. A. (1983). *Ajobi and Ajogbe: Variations on the Theme of Sociation*. Inaugural Lecture Series 46. Ile Ife: University of Ife Press.

Babalolá, A. (1972). *Àwon Oríkì Orílè* (3rd imp.). Glasgow: Collins.

Barber, K. (2003). "Text and Performance in Africa." *Bulletin of the School of Oriental and African Studies*, 66, pt. 3, 324–333.

Barber, K. (1997). "Introduction." In K. Barber (Ed.), *Readings in African Popular Culture* (pp. 1–12). Oxford, UK: James Curey.

Barber, K. (1991). *I Could Speak Until Tomorrow: Orki, Women and the Past in a Yoruba Town*. Edinburgh, UK: Edinburgh University Press.

Bennett, L. W. (1980). "Myth, Ritual, and Political Control." *Journal of Communication*, 30(4), 166-179.

Biernatzki, W. E. (1993). "Religious Values and Root Paradigms: A Method of Cultural Analysis." In C. Arthur (Ed.), *Religion and the Media: An Introductory Reader* (pp. 125–136). Cardiff: University of Wales Press.

Christians, C. G. (2004). "*Ubuntu* and Communitarianism in Media Ethics." *Ecquid Novi: African Journalism Studies*, 25(2), 235–256.

Christians, C. G. (1989). "Constructive Revolutionaries." *Media Development*, Special Congress Issue, October, 23.

De Beer, A. (2008). "Communication as an Academic Field: Africa." In W. Donsbach (Ed.), *The International Encyclopedia of Communication*, vol. 2 (pp. 591–595). Oxford, UK: Blackwell.

Driver, T. F. (1991). *The Magic of Ritual: Our Needs for Liberating Rites that Transform Our Lives and Our Communities*. San Francisco: Harper.

Fackler, M. (2003). "Communitarian Media Theory with an African Flexion." In J. Mitchell & S. Marriage (Eds.), *Mediating Religion: Conversations in Media, Religion and Culture* (pp. 317–327). London: T & T Clark.

Fáníran, J. O. (2008). *Foundations of African Communication with Examples from Yorùbá Culture*. Ibadan: Spectrum.

Fáníran, J. O. (2007). "The Visual Rhetoric of Yorùbá Video Films." *Humanities Review Journal*, 7, 58–72. Available at http://www.ajol.info/index.php/hrj

Gao, G., & S. Ting-Toomey. (1998). *Communicating Effectively with the Chinese*. London: Sage.

Geertz, C. (1973). *The Interpretation of Cultures*. New York: Basic.

Gyekye, K. (1997). *Tradition and Modernity: Philosophical Reflections on the African Experience*. Oxford: Oxford University Press.

Gyekye, K. (1996). *African Cultural Values: An Introduction*. Accra, Ghana: Sankofa.

Gyekye, K. (1992). "Person and Community in African Thought." In K. Wiredu & K. Gyekye (Eds.), *Person and Community: Ghanian Philosophical Studies I* (pp. 101–122). Washington, DC: The Council for Research in Values and Philosophy.

Gyekye, K. (1990). *An Essay on African Philosophical Thought: The Akan Conceptual Scheme* (Rpt. ed.). New York: Cambridge University Press.

Gyekye, K. (1987). *An Essay on African Philosophical Thought: The Akan Conceptual Scheme*. Cambridge, UK: Cambridge University Press.

Hallen, B. (2006). "Yoruba Moral Epistemology." In K. Wiredu (Ed.), *A Companion to African Philosophy* (pp. 296–303). Oxford, UK: Blackwell.

Hecht, M. L., & K. Ndiaye (2008). "Communication Modes: African." In W. Donsbach (Ed.), *The International Encyclopedia of Communication*, vol. 2 (pp. 771–775). Oxford, UK: Blackwell.

Ikuenobe, P. (2006). *Philosophical Perspectives on Communalism and Morality in African Traditions*. Lanham, MD: Lexington.

Kalilombe, P. A. (1994). "Spirituality in the African Perspective." In R. Gibellini (Ed.), *Paths of African Theology* (p. 122). Maryknoll, NY: Orbis.

Kigongo, J. K. (2002). "The Concepts of Individuality and Social Cohesion." Available at http://www.crvp.org/book/series02/II-2/chapter_iv.htm

Lie, R. (2003). *Spaces of Intercultural Communication: An Interdisciplinary Approach to Communication, Culture, and Globalizing/Localizing Identities*. Cresskill, NJ: Hampton.

Lie, R., & J. Servaes (2000). "Globalization: Consumption and Identity, Towards Researching Nodal Points." In G. Wan, J. Servaes, & A. Goorasekera (Eds.), *The New Communication Landscape: Demystifying Media Globalization* (pp. 307–332). New York: Routledge.

M'Bayo, R. T., O. Sunday, & I. Amobi (2012). "Intellectual Poverty and Theory Building in African Mass Communication Research." *Journal of African Media Studies*, 4(2), 139-156.

Mbiti, J. S. (1970). *African Religions and Philosophy*. New York: Doubleday.

McQuail, D. (2000). *McQuail's Mass Communication Theory* (4th ed.). London: Sage.

Moemeka, A. A. (1998). "Communalism as a Fundamental Dimension of Culture." *Journal of Communication*, 48(4), 118–141.

Moemeka, A. A. (1997). "Communalistic Societies: Community and Self-Respect as African Values." In C. Christians & M. Traber (Eds.), *Communication Ethics and Universal Values* (pp. 170–193). London: Sage.

Nkemnkia, M. N. (1999). *African Vitalogy: A Step Forward in African Thinking*. Nairobi: Paulines.

Nyamnjoh, F. B. (2005). *Africa's Media, Democracy and Politics of Belonging*. London: Zed.

Nyamnjoh, F. B. (2004). "Reconciling 'the Rhetoric of Rights' with Competing Notions of Personhood and Agency in Botswana." In H. Englund & F. B. Nyamnjoh (Eds.), *Rights and Politics of Recognition in Africa* (pp. 33–63). London: Zed.

Odimegwu, I. (Ed.). (2007). *Perspectives on African Communalism*. Oxford: Trafford.

Olátúnjí, O. O. (1984). *Features of Yoruba Oral Poetry*. Ìbàdàn: University Press.

Oyeshile, O. A. (2002). "Towards an African Concept of a Person: Person in Yoruba, Akan and Igbo Thoughts." *ORITA: Journal of Religious Studies*, 34(1–2), 104–114.

Payne, M. W. (1992). "Akiwowo, Orature and Divination: Approaches to the Construction of an Emic Sociological Paradigm of Society." *Sociological Analysis*, 53(2), 175–187.

Pourhamrang, N. (2012). "Peaceful World My Sincerest Wish—Chinua Achebe." *Hatef Weekly Magazine*. Available at http://www.veteranstoday.com/2012/08/10/chinua.achebe-interview

Rothenbuhler, E. W. (1998). *Ritual Communication: From Everyday Conversation to Mediated Ceremony*. London: Sage.

Schultz, E. A., & R. H. Lavenda. (2000). *Anthropology: A Perspective on the Human Condition* (3rd ed.). London: Mayfield.

Slack, J. D. (1984). *Communication Technologies and Society: Conceptions of Causality and the Politics of Technological Intervention*. Norwood, NJ: Ablex.

Swidler, A. (1986). "Culture in Action: Symbols and Strategies." *American Sociological Review*, 51, 273–286.

Turner, V. (1974). *Dramas, Fields and Metaphors*. Ithaca, NY: Cornell University Press.

Uwah, I. E. (2008). "Nollywood Films as a Site for Constructing Contemporary African Identities: The Significance of Village Ritual Scenes in Igbo Films." *African Communication Research*, 1(1), 87–112.

Uzukwu, E. E. (1996). *A Listening Church: Autonomy and Communion in African Churches*. Maryknoll, NY: Orbis.

Vanaik, A., & P. Bidwai. (1995). "Communalism and the Democratic Process in India." In J. Hippler (Ed.), *The Democratization of Disempowerment: The Problems of Democracy in the Third World* (pp. 132–152). London: Pluto.

White, R. A. (1983). "Mass Communication and Culture: Transition to a New Paradigm." *Journal of Communication*, 33(3), 279–301.

Wingo, A. H. (2001). "Good Governance Is Accountability." In T. Kiros (Ed.), *Explorations in African Political Thought* (pp. 151–170). London: Routledge.

Wiredu, K. (2001). "Society and Democracy in Africa." In T. Kiros (Ed.), *Explorations in African Political Thought* (pp. 171–184). London: Routledge.

Theorizing About Communication in India

Sadharanikaran, Rasa, and Other Traditions in Rhetoric and Aesthetics

KEVAL J. KUMAR

During the mid-1980s the Centre for the Study of Communication and Culture (CSCC), London, was a popular meeting place for doctoral students from Asia and Africa. The Centre was known to have the finest library in Britain on international and development communication. But it was not so much the library that drew doctoral students to the CSCC but rather the opportunity to meet and talk to Robert (Bob) White, the research director and also editor of the Centre's publication *Communication Research Trends*. White (1976) had done pioneering work in grassroots, participatory development communication [*communicacion popular*], particularly in the cultural context of Honduras, and actively promoted alternative and indigenous traditions in theory and research. It was this radical cultural perspective, I believe, that proved to be an inspiration for many scholars from the developing world, and paved the way for later developments in Asian and African theories of communication. My own teaching and research on alternative paradigms has been influenced by his prolific scholarship in Latin American (and more recently, African) perspectives in communication. My quest for Asian and Indian theories of communication is perhaps traceable to that influence.*

For three decades now, this quest has been articulated by a host of communication scholars led by Wimal Dissanayake (1987, 1988, 2006, 2009, 2011), Syed Farid Alatas (2006, 2011), and Yoshitaka Miike (2006, 2009, 2010, 2011),

* An earlier version of this chapter was published in *Asian Religion and Communication Journal*, 3(2), 2005, 90–106. Bangkok: St. John's University.

the major influences at work being Edward Said's work on Orientalism (1979), Molefi Kute Asunte's on Afrocentrism (1988, 2011), and Samir Amin's on imperialism and dependency (1977). The landmark publications that have given expression to the need for de-Westernization include edited books (e.g., Dissanayake, 1988; Kincaid, 1987; Kim, 2002; Wang, 2011) and academic journals (e.g., Goonasakera & Kuo, 2000; Miike & Cheng, 2007). This has now grown into a full-fledged movement of resistance to the hegemony of Eurocentrism in communication theory. De-Westernization of communication theory and research has taken on a new vibrancy, particularly in Asian journals such as *Asian Journal of Communication, Media Asia, Journal of South Asian Studies, China Media Research*, and about half a dozen online journals.

Mainstream Western journals such as *Media, Culture and Society* (2003), *Intercultural Communication Studies* (2003), and the *Journal of Multicultural Discourses* (2009) have brought out special issues dedicated to Asian perspectives on communication theory. McQuail (2000, 2010) has acknowledged the Western bias in mass communication theory, though the first major call for de-Westernization in Europe was articulated in Curran and Park's *De-Westernizing Media Studies* (2000). Recently published handbooks (Schlesinger & Downing, 2004; Eadie, 2009; Nakayama & Halualani, 2010) and encyclopedias (Donsbach, 2008; Littlejohn & Foss, 2009) on communication theory carry prominent entries on Asian communication theory, Buddhist communication theory, Chinese harmony theory, Confucian communication theory, Hindu communication theory, Islamic communication theory, Japanese *kuuki* theory, and Taoist communication theory.

The emergence of China and India as economic powers in the new millennium has speeded up this quest for non-Western systems of knowledge and Asiacentric social science paradigms relating to "humanity, diversity and transversality" (Miike, 2010; Gunaratne, 2008, 2011). To theorize human communication, argues Miike (2010), is to theorize the way humanity is expressed and understood. Humanity is deeply felt by cultural particularities, not by universal abstractions. Communication is, so to speak, a culturally particularistic expression of being human. Yet, universality and particularity are not in opposition but in continuity, for "the universal is contained in the particular just as the particular is contained in the universal" (Miike, 2010, p. 2). Hence "Asiacentric studies of Asian communication are a *sine qua non* for the humanity of Asian peoples because Asians continue to interact through Asian cultural particularities" (Miike, 2010, p. 1). This chapter focuses on one such Asian cultural particularity, the sub-continent of India, which itself is infinitely diverse and pluralistic in its religious, cultural and linguistic traditions.

Indian Traditions in Public Communication

India has had a long tradition of public discussion, debate, and argument, going back to the second millennium BCE, when the earliest religious and philosophical works in Sanskrit, Prakrit, Pali, and Tamil were put down in writing. Amartya Sen, the Indian Nobel Laureate and Harvard economist, delineates this tradition in his provocatively titled book on Indian history, culture, and identity, *The Argumentative Indian* (2005). This age-old tradition included philosophical arguments about speech, language, etymology, grammar, and phonetics as well as about aesthetics in poetry and drama. The culture of argument is already seen in the Sanskrit epics and in Vedic and post-Vedic literature. The tradition of public communication and the rules for democratic discussion are traceable to the Buddhist *sanghas* or councils promoted by King Ashoka in 300 BCE. The Mughal emperor Akbar actively promoted eclecticism and dialogue among different religious groups through multi-religious institutions like *Din-Ilahi* [Persian for "Divine Faith"] to promote dialogue among major religious communities in India. It is this tradition, argues Sen (2005), that has been the historical and cultural basis of the pluralism, secularism, and multiculturalism of modern Indian democracy.

It is evident that not all these pluralistic Indian thinkers were Hindu, for among them were Buddhists, Jains, and even agnostics and atheists. Further, not all of them wrote exclusively in Sanskrit, nor were they all from the northern regions of the Indian subcontinent. The Sangam literature in Tamil, for instance, was part of the same tradition. In later years, Muslim saints, poets, and emperors contributed significantly to this "argumentative" tradition. So it was not just Brahmin and high-caste scholars from the priestly class who debated and discussed issues in religion, ethics, language, and poetry but also Buddhists, Jains, and atheists, and later, Muslims and Christians; the discussants included women and lower-caste saints and scholars as well.

Indian scholars have argued fiercely about language, its structure, grammar, and meaning, in poetry [*kavya*] and drama, dance and music [*natya*]. The language they analyzed in such painstaking detail was the language of poetry and drama; the written language as well as the everyday colloquial and the vernacular. They looked closely at the relationship between words and statements and, above all, the literal and the implied metaphorical meanings of speech and utterances. Most significant, the scholars focused attention on the essential aesthetic pleasures [*rasas*] realized in drama and poetry, and how this approximated to or led to *ananda* [bliss]. In essence, Indian debates on poetry, drama, and language explored the meaning of aesthetic pleasure and its relationship to the spiritual. It is noteworthy that there is hardly any concern among the ancient Indian philosophers of language with rhetoric or speech communication as the art of persuasion.

Indian communication theory has been spelled out by a group of scholars, led by the Sri Lankan Wimal Dissanayake. The primary inspiration for such a theory

has been classical Sanskrit, Prakrit, and Pali texts on dramaturgy, aesthetics, rhetoric, grammar, religion, and philosophy. Perhaps the most widely discussed theory is that of *sadharanikaran* [universalization, simplification]. Others include *rasa* [aesthetic delight], *dhvani* [sound, suggestion], *apoha* [differentiation], and *lila* [play, fun] theories. A major source of such theorizing has been Bharata's *Natyashastra*, an encyclopedic work dealing with the theory and practice of drama, including music and dancing, and commentaries on it by Abhinavagupta and Bhattanayaka. A second source has been Bhartrhari's *Vakyapadiya*, a Sanskrit treatise on language and meaning. Yet another source has been the various schools of Indian philosophy. The assumption has been in such attempts to formulate an Indian communication theory that any theory worth its salt should have its roots in religious and cultural practice.

This chapter describes Indian attempts to understand the nature of speech, communication, language, meaning, and aesthetic pleasure. In the pluralistic Indian tradition, there are various theories of communication that can be found in this huge corpus of literature in Sanskrit and other Indian languages on grammar, language, etymology, phonetics, meaning, poetry, and drama. Indian theories of communication are intimately related to linguistic concepts and in the writings of the six systems-schools [*darsanas*] of Indian philosophy.

Early Indian Reflections on Communication

One of the fundamental concerns of ancient Indian poet-philosophers was language, the primary instrument for communicating their mystic experiences, what they heard [*sruti*] and what they recalled [*smrti*]. This instrument was of course deeply flawed, but essential. Hence, even as the poet-philosophers recognized the limitations of the spoken and the written word, they praised language as a powerful and benign deity [*Vak*], ever ready to bestow favors on her devotees (Coward & Raja, 2000). Some attributed the entire creation to divine speech [*Vak*], much like the biblical Word. For instance, the *Rig Veda*, the earliest Sanskrit literature, begins with effusive tributes to the power of speech [*Vak*] and the goddess of speech [*Vagambhrni*]. The *Brhadaranayaka Upanishad* exclaims that "speech, truly, is Brahman" (4.1.2), and in a later verse advises: "One should meditate on speech as a milch-cow" (5.8.1). And again: "The ultimate abode of speech is this Brahman / The place of *Vak* is at the peak of the universe / On the top of yonder sky, they say, is *Vak*, who knows all, but does not enter all" (quoted in Coward & Raja, 2000).

Two schools of thought are discernible in the Indian approach to the philosophy of language. The Mimamsa school was primarily concerned with the methodology of textual interpretation in order to give a cogent explanation of prescriptive scriptural texts. Philosophers of this school used both analysis and synthesis, and also the concept of metaphor. The Nyaya school, on the other hand, was primarily

interested in the theory of knowledge and in the truth and falsity of judgments, so they developed a theory of meaning. Further, the Buddhist and Jain schools of thought also devoted considerable attention to the working of language. They analyzed speech utterances in terms of sentences and words, stems and suffixes, morphemes and phonemes. Other schools of thought included Vaisheska, Sankhya, Yoga, Vedanta, and Advaita; they too joined in the debate on language, meaning, and communication (Coward and Raja, 2000).

Indian literature on language, grammar, phonetics, aesthetics, and logic is extensive, going back to the Vedic period. Much of that literature is in Sanskrit, but other ancient languages such as Prakrit, Pali, and Tamil too made a significant contribution. Then there is the literature in the modern Indian languages such as Marathi, Kashmiri, Assamese, and so forth. These traditions can be classified into four groups: grammarians [*vaiyakarana-s*], logicians [*naiyayka-s*], literary critics [*alamkarika-s*], and Vedic exegetes [*mimamskara-s*]. Indeed, early Indian philosophers of language developed four linguistic disciplines: *Siksa* [phonetics], *Vyakaran* [grammar], *Chandas* [meter], and *Nirukta* [etymology].

First, and perhaps the oldest, is the work of grammarians [*vaiyakaranas*], primarily Yaska, Panini (400 BCE), Katyayana (300 BCE), Patanjali (150 BCE), Bhartrhari (AD 450), and Nagesa (1700). The second group comprises logicians (*naiyayikas*) such as Gautma Aksapada (100), Uddyotakara (600), Jayantabhatta (950), and Udayana (late 1700s). Some Buddhist logicians too must be included in this second group: Dinnaga (450), Dharmakirti (600), Santaraksita (750), and Ratnakirti (1000) (Raja, 2000, p. 319).

Among the third group of literary critics who contributed to Indian explorations of aesthetics as they relate primarily to poetry and drama, the foremost is Bharata (c. AD 400), the author of *Natyashastra*, "an encyclopaedic work dealing with the theory and practice of drama, including music and dancing, and which contains the earliest discussions of the theory of *rasa*" (Raja, 2000, p. 320). After Bharata, perhaps the most noteworthy literary critic was Anandavardhana (late 900s), author of *Dhvanyaloka*. But it was Abhinavagupta (1100)—author of the Locana commentaries on the *Natyasashtra* and the *Dhvanyaloka*—who established once and for all the basic principles of poetry and drama in India. Mention must also be made here of Dhanamjaya (976), who wrote the *Dasarupa*, a simplified summary of the *Natyashastra*.

The fourth group comprises Vedic exegetes whose main concern was the principles of interpretation of statements or sentences on sacrificial rituals in Vedic texts. The basic text of the Mimamsa school is the Mimamsa sutra-s of Jaimini (300 BCE); Sabara (AD 200) wrote an elaborate *bhasya* [commentary] on this. A host of other works on Vedic hermeneutics is extant, both of the Mimamsa and Bhatta schools. What is significant here is that the Advaita Vedanta school of philosophy follows the Bhatta school's approach to textual interpretation. From the

point of view of communication, the most relevant work in this context is *Sphota-siddhi* [Principles of Sphota] by Mandanamisra (800), which counters the attacks by Mimamskas and Buddhist commentators on the principles of the doctrine of *sphota* [bursting forth].

The *Rasa* Theory of Communication

The Vedic poet-philosopher was called both *Rishi* [seer or sage] and *Kavi* [poet] and the hymn he wrote was called *Rasa* [essence or most delectable thing], and the Upanishad said that what was well done and perfect was indeed the most delectable thing [*rasa*] (Raghavan, 1965, p. 382). This concept of *rasa* is at the heart of Indian aesthetics; it also points to one of the earliest Indian theories of communication.

The theory is elaborately developed in Bharata's treatise, *Natyashastra,* through a series of questions raised by sages and responses given by the author. The lengthy treatise, which runs to 5,000 verses [*shlokas*] (divided into 4 sections and 36 chapters), deals not only with the principles of drama but also with poetics, language, dance, music, costume, and acting. The primary purpose of the arts is the stirring of emotions [*rasas*], for they are the quintessence of drama [*natya*]. In the words of the treatise, "Just as people conversant with foodstuffs and consuming articles of food consisting of various things and many spices enjoy their taste, so also the learned men enjoy the *sthai bhavas* [permanent moods] in combination with gesticulations of *bhavas* [moods] mentally" (verses 32–33).

The human psyche in terms of this theory is composed of permanent moods, called *sthai bhavas*. These moods are capable of arousing a corresponding state of feeling [*rasa*]. There are eight permanent moods and they give rise to eight *rasas* or forms of aesthetic pleasure. For instance, the permanent mood *bhayanaka* [terror, fear] arouses the *bhayanak* [furious] *rasa*, the *harsha* [joy] triggers the *hasya* [laughter] *rasa*, the *dina* [pity], the *karuna* [compassion] *rasa*, and so on. The entire range of human emotions is encompassed in this extremely elaborate categorization. The state of arousal of the eight permanent moods is termed *rasa utpathi*.

The permanent moods are accompanied also by many fleeting or secondary moods that are common to several dominant moods and serve the purpose of completely manifesting the permanent mood, such as *nirveda* [despondency] or *glani* [fatigue], and may help to manifest the permanent moods, like the erotic helps the pathetic. These are called *sancharis* or *vyabhichari bhavas* [transitory states]. In addition, there are *vibhavas* [determinants] and *anubhavas* [consequents], the emotions that unite a man and woman in love. It is at the climax of this relationship that *sadharanikaran* [universalization, simplification] is attained.

The epic poem, the *Ramayana*—together with its several regional variations—for instance, owes its origin to the emotion of pathos [*karuna rasa*]. "When the hero and the heroine or the hero and his adversary presented the effects of their

emotions, the corresponding emotion in the spectator's heart was stimulated in a pleasurable manner" (Raghavan, 1965, p. 383). For Bharata, author of *Natyashastra*, the best spectator was one who could enter into the play and feel glad when the character is joyous, and sad when he is sorrow-stricken. Bharata and his commentator, Abhinavagupta, argued that drama was imitation or representation of men and women in different actions and states of feeling (Raghavan, 1965).

The *rasa* theory of communication is thus centered on spectators and their emotional experience. There was, however, one school of literary critics represented by Bhamaha and Dandin (AD 700) and Vamana (AD 800) who defined poetry as word-and-sense in unison and endowed with beauty. This beauty was the result of the choice of proper words and constructions, avoidance of literary flaws, addition of stylistic qualities, and figures of sound and sense and emotions. The emotions, too, they said, went to embellish only the expression in poetry.

But the foremost Indian aesthete, the Kashmiri Anandavardhana (AD 900), unified aesthetics by taking into account both poetry and drama, and applying the same principles to all forms of literary expression. The principal question he raised was how *rasa* or emotion was conveyed by the text and realized by the spectator or reader. Emotional experience could not be part of the direct meaning of words and sentences, nor of their secondary significance. Between the text and the emotions, the only possible relation is suggestion, manifestation, or revelation [*dhvani, vyanjana, prakasa*].

Language and the *Sphota* Theory of Meaning

What is meant by *arth* [meaning], asked the ancient philosophers of language, Hindu, Buddhist, Jain, and atheist (Charvaka)? What was the basic unit of meaning? What was intended: the universal or the particular? In Indian linguistic philosophy, two main approaches to the question of meaning are evident: the *khandapakasa* and the *akhandapakasa*. According to the *khandapakasa*, or the analytical method, a word is considered an autonomous unit of thought and sense, and language studies are made on the basis of words, and the sentence is taken to be a concatenation of words (Raja, 2000, p. 6). Thus the *Nyayasutras* discuss the nature of words only; the discussions about the factors necessary for the understanding of a sentence are found in later *Nyaya-Vaisesika* works, and in the writings of the Mimamsa school. (Mimamska is called *vakyasastra* [the science of the sentence]).

But according to the *akhandapakasa* (of which Bhartrhari is the foremost advocate), the fundamental linguistic fact is the sentence. He defines the sentence as a single integral symbol [*eko navayah sabdah*] that is revealed by the individual letters and the words that comprise it, and the meaning is conveyed by it as an instantaneous flash of insight or intuition [*pratibha*]. The meaning is also part-less. The words have no reality of their own; they are only hints that help the listener

to arrive at the meaning (Raja, 2000, p. 9). For the Mimamskars (adherents of the Mimamsa school), it was the complete utterance of the sentence [*vakya*] that was the fundamental unit [*vakyasphota*], but for the Nyayakas it was the word or sound [*sabd*] produced by the speaker and heard by the listener, and it was impermanent (Raja, 2000).

While the Mimamsa school held that the primary meaning of a word is the universal and the sense of the particular in a sentence is obtained either through secondary signifying power or through both the universal and the particular being grasped by the same perceptive effort simultaneously, the Nyaya school argued that the meaning of words comprised the universal [*jati*] configuration [*aakrti*] and the particular. The later Nyaya version stated that the primary meaning of words is the individual as qualified by the universal. However, the Buddhists of the Dignaga school held that meaning is *vikalpa*, a mental construction that has no direct correspondence with the real, its nature being to exclude other things [*anyapoha*] (Raja, 2000). This typically Buddhist approach to meaning (semantics) is the basis of the *apoha* [differentiation] theory of communication spelled out by Dissanayake (2009).

For Audumbarayana and Bhartrhari, it is the statement as a whole that is regularly present in the perceptive faculty of the hearer, and not individual words that make for meaning. Some ancient scholars like Yaska emphasized the unreal nature of words. The scholars of the Mimamsa school provide us a detailed study of sentences and developed canons of interpretation; but even this approach was based on words and word-meanings and, consequently, the relationship between word and sentence, between word-meaning and sentence-meaning.

Bhartrhari, author of *Vakyapadiya*, developed the concept of *sphota* to fathom the speech situation better. Raja (2000) elaborates:

> First, we have the actual sounds of the words uttered; this is the *vaikrta-dhvani*. These sounds reveal the permanent *prakrta-dhvani* which is an abstraction from the various *vaikrta-dhvani*-s, or which may be considered as the linguistically normal form devoid of the personal variations which are linguistically irrelevant. The third stage is the *sphota* which is the whole utterance considered as an integral unit, as an indivisible language-symbol. It is this *sphota* that reveals the meaning which is in the form of an intuition. Strictly, both the *sphota* and the meaning are different aspects of the speech-principle. Bhartrhari seems to synthesize these various aspects of speech with the three fold nature of the revelation of speech: *pasyanti, madhyama* and the *vaikhari* stages, corresponding respectively to *sphota, prakrta-dhvani* and *vaikrta-dhvani*. (*Prakrtadhvani* is the linguistically relevant sound pattern revealing the sentence or the *sphotas* which is the meaning-bearer.) (p. 114)

Anandavardhana developed the ideas of Bhartrhari further. He introduced the theory of *vyanjana*, or suggestion, in order to explain the creation of meaning. Under the term *artha* or meaning he included not only the cognitive, logical meaning but also the emotive elements and the "socio-cultural significance of

utterances which are suggested with the help of contextual factors" (Raja, 2000, p. 10). The situation or the context was central to the understanding of the emotional meaning of an utterance; this was particularly true of poetry. Anandavardhana advocated the Dhvani theory (which is *vyanjana* applied to poetry) to better understand how poetic language works.

Indian philosophers of language recognized that language is indispensable for communication, but that there was more to language than words, sentences, and sounds. The *Yogasutra* of Patanjali, for instance, assumes that "word, idea and object are really distinct entities and that though in ordinary experience they are found to be interrelated, they may be separated from one another by a process of abstraction" (Kaviraja, quoted in Raja, 2000, p. 11). Ogden and Richards (1936), Peirce (1991), Barthes (1968), de Saussure (1974), Eco (1977), and Korzybski (1948) were to wrestle with these very issues centuries later.

Sadharanikaran Theory of Communication

It is interesting to look at the various terms for communication in Sanskrit and other Indian languages. The three terms most widely used today in Indian languages (those deriving directly from Sanskrit, such as Hindi and Marathi) as equivalents of communication are *sampreshan*, *saunyapan*, and *samwaad*.

The first, *sampreshan*, appears to fit with the idea of communication as a one-way transmission, the traditional Western approach to communication, traceable to Aristotle's *Rhetoric*. The second, *saunyapan*, relates more closely to knowledge and has its roots in the philosophy of communication, while the third, *samwaad* [dialogue or conversation], has its roots in popular everyday communication. These varied terms suggest varied approaches to thinking about the process of communication in Indian philosophy, linguistics, and the performing arts.

But ancient Sanskrit texts like Bhartrhari's *Vakyapadiya* speak of communication in terms of *sadharanikaran*, which literally means "simplification" or "universalization," much like the Latin roots (*communis, communicare*) of the English word "communication." The term occurs for the first time in the *Vakyapadiya*, essentially a work on the language of Sanskrit poetry. But *sadharanikaran* must not be seen in isolation; it has to be seen in relation to discussions in Indian writings on concepts such as *rasa, sphota, vyanjana, dhvani,* and *lakshana.* What is interesting about such discussions is the wrestling with the fundamental meaning of concepts and how they relate to the spiritual, as well as to pleasure, experience, and meaning.

According to Tewari (1992) and Yadava (1984, 1987), the Indian theory of communication forms a part of Indian poetics and can be traced to a period between the second century BCE and first century AD in Bharata's *Natyashastra*. It hinges on the concept of *sadharanikaran*. Yadava (1984) points out that the term was first used in the tenth century by Bhattanayaka in a commentary on the

Natyashastra to explain the *sutras* related to *rasa*. Bhattanayaka stressed that the essence of communication lay in achieving commonness and oneness.

The most important assumption in the process of *sadharanikaran* is that it can be achieved only among *sahridayas*, that is, only those who have a capacity to accept a message. This is an innate ability acquired through culture, adaptation, and learning. Thus, communication is an activity among *sahridayas*. It is to be noted, says Tewari (1992), that the concept of *sahridaya* is not co-terminus with a predisposition to or in favor of or against. It only denotes the quality of mind or receptivity on the part of the audience. It does not speak of the quality of attitude—positive or negative—on the part of the audience. It may, however, qualify the depth or level of sensory experience that shapes the human personality.

Yet, the process of *sadharanikaran* is fundamentally asymmetrical, and the sharing or oneness it connotes is among *sahridayas* alone, unequal, perhaps, but one in heart. The goal of *sadharanikaran*, therefore, is not persuasion but rather the enjoyment of the process of sharing. At the same time, the source is perceived as having a higher status, and the receiver of the message a lower status. As Yadava (1984) puts it, the relationship is hierarchical, one of domination and subordination. The source is held in high esteem by the receiver of information, a relationship idealized and romanticized in the *guru-chela* tradition. There is thus a certain elitism present in the concept, however. *Rasa* is the art of the ordinary, but it can be understood only by the *sahridaya* and the only proof of its existence is the *aswada* [the taste], which only a *sahridaya* has. He or she alone is capable of *sadharanikaran*.

Yadava (1984) draws out two implications or resonances of the term *sahridaya* [literally "of one heart"]. He believes that the term is synonymous with identification and simplification—the identification of the communicator with the receiver through the process of simplification. Mahatma Gandhi, for instance, achieved this identification with the masses through simplification of his message [*satyagraha*], the common religious symbols he employed, and, above all, by the utter simplicity of his life (cf. Singh, 1978, 1980; Kumar, 1984, 1986; Gonsalves, 2010).

At the community level, Yadava (1984) notes, the saints, Sufis, and Brahmins of old propagated religious and cultural values through simplification and illustration. He sees this practice as continuing today in the conversation and traditional media of rural folk throughout the Indian subcontinent. This dimension of *sadharanikaran* seems to have become the common heritage of the Indian people. Further, the asymmetrical aspects of *sadharanikaran* helped in the blossoming of Indian civilization in earlier times through efficient communication and division of labor, but in centuries resulted in highly rigid and hierarchical closed social structures.

The concept of *sadharanikaran*, one of the fundamental concepts in Indian aesthetics, also has religious implications. As in the Vedanta, objects of experience are held to be not the ultimate reality but only manifestations of that reality. Words and the expressed meaning are regarded as the mere external experience of art, and the emotional mood [*rasa, bhava*] that a work communicates is thus the essence of reality—the highest communication endeavor indeed.

Dissanayake (1988) draws on the Vedas, the Upanishads and non-philosophical traditions (such as Bhartrhari's *Vakyapadiya* and Bharata's *Natyashastra*) to build an Indian model of communication. The primary focus of interest in his model is how the receiver makes sense of the stimuli he receives so as to deepen his self-awareness. In Indian tradition, he argues, "communication is an inward search for meaning—a process leading to self-awareness, then to freedom, and finally to truth" (Quoted in Kumar, 2010, p. 28). Thus, it transcends language and meaning and is interpretation- or reception-oriented, not expression-oriented like the Western models. The intrapersonal dimension is of greater importance than the interpersonal in the Indian approach, for individualism and manipulation have no place in it. Jayaweera (1986) observes that the Vedantic philosophy of *advaita* [absolute monism] has profound implications for contemporary understanding of communication.

Dissanayake (1988, 2009) and Jayawardana (1986) propound a Buddhist theory of communication derived from the concept of dependent co-origination [*pattica-samupadda/pratitya-samutpada*]. This concept lies at the heart of the Buddha's teaching. It is related to the three principles that sum up worldly existence: *anitya* [impermanence], *dukkha* [suffering], and *anatma* [no-self]. It is a highly connotative concept that implies that every phenomenon, including communication, is in a state of impermanence and flux.

Saral (1983) looks at communication theory from a Hindu philosophical perspective. The Hindu's concept of the universe is based on the *Virat Purush* [cosmic man] view. A natural extension of this concept is that it espouses the systems approach, the authority of universal law, the law of *Dharma*. *Dharma* is the basic principle of the whole universe and exists eternally. This natural law of *Dharma* regulates human existence and governs relations of individual beings; communication too is governed by the same law.

Saral (1983) believes that the distinctive marks of Western philosophy are categorization, classification, linear sequencing, and rational logic. Indian philosophy, on the other hand, is characterized by complexity and pluralism; it is holistic and intuitive, and believes that reality is one. Oliver (1971) states that in Indian rhetoric "opposites are co-ordinates, contradictions are illusory, and the world is a dramatic portrayal of God playing hide-and-seek with himself, trying to reassemble all the divergent parts back into their original unit" (Quoted in Kumar, 2010, p. 29). This relates to what I have described as "the *lila* [or play] theory of

communication" (Kumar, 1995, p. 19). Islamic theories of communication, based largely on the scriptures, traditions, and the concept of *umma* [community] have been proposed by West Asian scholars like Mowlana (2003, 2007) and Ayish (2003) (for a critique of Mowlana, cf. Khiabany, 2003).

Conclusion: Diversity in Indian Communication Theory

Indian theories of communication, then, are reception and interpretation oriented. The Indian definition of communication would be that it is an inward search for meaning (Dissanayake, 1987; quoted in Kumar, 2010, p. 28). But meaning is that which transcends language, for meaning, according to traditional thought, was seen as a process leading to self-awareness, then to freedom, and finally to truth. Here by freedom was meant the liberation of worldly bondages consequent on the perception of the illusoriness of the world and the comprehension of the artificial categories constructed all around us by language and logic. The Indian model of communication is intrapersonal rather than interpersonal, and this intrapersonal communication must lead to a transpersonal communication in which oneness of the world is unambiguously perceived.

But Indian traditions in public communication are as deep-rooted as those for intrapersonal and transpersonal communication. In the history of public communication in India, considerable credit must be given to the early Indian Buddhists, who had a great commitment to discussion as a means of social progress (Sen, 2005, p. 15). That commitment produced, among other results, some of the earliest open general meetings in the world. These "Buddhist councils" aimed at settling disputes between different points of view, drew delegates from different places and from different schools of thought. The first of these four councils was held after Gautama Buddha's death; the second about a century later in Vaisali, and the third in Kashmir in the second century AD. The last was held under the patronage of King Ashoka in the third century BCE in Pataliputra (now Patna). These councils were primarily concerned with resolving differences in religious principles and practices, but they evidently also addressed the demands of social and civic duties and, furthermore, helped in a general way, to consolidate and promote the tradition of open discussion on contentious issues.

King Ashoka was perhaps the first to codify and propagate the earliest formulations of rules for public discussion. He demanded "restraint in regard to speech, so that there should be no extolment of one's own sect or disparagement of other sects on inappropriate occasions, and it should be moderate even on appropriate occasions." Even when engaged in arguing, "other sects should be duly honored in every way on all occasions" (Sen, 2005, p. 15). This approach to public communication finds echoes in the court of Akbar, the Mughal emperor, almost two thousand years later. Akbar's overarching thesis—that the pursuit of reason rather than reliance on tradition is the way to address difficult problems of social har-

mony—included a robust celebration of reasoned dialogues. This is illustrated in his attempts at evolving a Din-Ilahi, a synthetic religion, and a Tarikh-Ilahi, a common integrated calendar (cf. Sen, 2005, pp. 41–42).

It was these contacts with people from different religious, cultural, and linguistic traditions over the centuries that enriched Indian thought, through a process of assimilation and enculturation. As Indian communities became more diverse with each new conqueror and invader or trader, so did the tradition of public communication. For instance, the various Mughal "invaders" and rulers influenced the indigenous languages and modes of communication. Akbar's royal court brought together religious scholars from various religious traditions. English education introduced in India by Macaulay's Minute exposed the Indian elite to Western literature and philosophy. The nationalist movement for self-rule and independence was inspired by similar struggles in Europe and other parts of the world, but it used communication strategies rooted in what the social historian Bayly calls the "Indian ecumene" (Bayly, 1996, 2005) as Christian missionaries and European Indologists (such as William Jones and Max Mueller) translated and analyzed classical Indian texts. Through all these centuries of resistance, Indians found their own voices and their own modes of communication. Traditional modes of communication were re-invented in order to enable the peoples of the land to give expression to new forms of communication shaped by the nationalist experience under imperial rule. Independence and democracy revived folk and traditional forms of public communication, and in the process these were integrated into the mass media and the new media. These continue to find expression in the many festivals celebrated round the year by India's numerous and diverse communities, as well as in the print, film, electronic, and digital media, where the stories of Indian religious epics and the centuries-old historical experience are told and retold in narrative forms that mix folk, tradition, and the modern in ways uniquely Indian.

This exploratory study of the historical evolution of what might be termed an "Indian theory of communication" is not essentialist or nativist. Neither is it romantic or nostalgic about the ancient past; this is the obsession of the advocates of Hindutva, the religious and political ideology of the Hindu right in India, and in sections of the diaspora. This is not even a response or reaction to the movement of resistance against Eurocentrism or Westernization where binary thought prevails. It certainly does not analyze texts that reflect Indian communication from a de-Westernizing perspective. Rather, it is an attempt to look at communication theories that are implicit in some of the classical Indian texts on language, grammar, aesthetics, rhetoric, and religious literature. This effort represents just one of the many ways of looking at communication from an Indian historical, religious-spiritual, and literary perspective. Other possible perspectives would include, for instance, the subaltern/dalit/tribal perspective, another is the Tamil or Dravidian

perspective, a third the Islamic perspective, a fourth the Gandhian or nonviolent perspective. Communication theory is, after all, a highly contested terrain; it is always in ferment. There can be no one grand theory for communication or any other socio-cultural and political phenomena. All that we can attempt to do from our own particular cultural locations and worldviews is to clutch at straws and wildly hope that we have perhaps found some nugget of truth about that ineffable (even miraculous) human experience called communication or *sadharanikaran*.

Bibliography

Alatas, S. F (2011). "The Definition and Types of Alternative Discourses." In G. Wang (Ed.), *De-Westernizing Communication Research: Altering Questions and Changing Frameworks* (pp. 238–253). New York: Routledge. Contemporary Asia series.

Alatas, S. F. (2006). *Alternative Discourses in Asian Social Sciences: Responses to Eurocentrism*. New Delhi: Sage.

Amin, S. (1977). *Imperialism and Unequal Development*. New York: Monthly Review.

Asunte, M. K. (2011). "De-Westernizing Communication Strategies for Neutralizing Cultural Myths." In G. Wang (Ed.), *De-Westernizing Communication Research: Altering Questions and Changing Frameworks* (pp. 21–27). New York: Routledge. Contemporary Asia series.

Asunte, M. K. (1988). *Afrocentricity: The Theory of Social Change*. Trenton, NJ: Africa World.

Ayish, M. (2003). "Beyond Western Communication Theories: A Normative Arab Islamic Perspective." *Javnost—The Public*, 10(2), 79–92.

Barthes, R. (1968). *Elements of Semiology*. London: Cape.

Bayly, C. A. (2005). "The Indian 'Ecumene': The Indigenous Public Sphere in India." In A. Rajagopal (Ed.), *The Indian Public Sphere: Readings in Media History*. New Delhi: Sage.

Bayly, C. A. (1996). *Empire and Information: Intelligence Gathering and Social Communication in India 1780–1870*. Cambridge: Cambridge University Press.

Bharata. (2000). *Natyashastra*. English translation (2nd rev. ed.). New Delhi: Indian Books Centre/ Sri Satguru.

Coward, H., & K. K. Raja. (Eds.). (2000). *Philosophy of the Grammarians*. Princeton, NJ: Princeton University Press. Vol. 5 of *Encyclopedia of Indian Philosophies*.

Curran, J., & M.-J. Park. (2000). *De-Westernizing Media Studies*. London & New York: Routledge.

De Saussure, F. (1974). *Course in General Linguistics*. London: Fontana.

Dissanayake, W. (2011). "The Production of Asian Theories of Communication: Contexts and Challenges." In G. Wang (Ed.), *De-Westernizing Communication Research: Altering Questions and Changing Frameworks* (pp. 222–237). New York: Routledge.

Dissanayake, W. (2009). "The Desire to Excavate Asian Theories of Communication: One Strand of the History." *Journal of Multicultural Discourses*, 4(1), 7–27.

Dissanayake, W. (2006). "Post-colonial Theory and Asian Communication Theory: Toward a Creative Dialogue." *China Media Research*, 2(4), 1–8.

Dissanayake, W. (Ed.). (1988). *Communication Theory: The Asian Perspective*. Singapore: AMIC.

Dissanayake, W. (1987). "The Guiding Image in Indian Culture and Its Implications for Communication." In L. D. Kincaid (Ed.), *Communication Theory: Eastern and Western Perspectives* (pp. 151–160). San Diego: Academic.

Donsbach, W. (Ed.). (2008). *The International Encyclopedia of Communication*. 12 Vols. London: Wiley-Blackwell.

Eadie, W. F. (Ed.). (2009). *21st Century Communication: A Reference Handbook*. 2 Vols. Thousand Oaks, CA: Sage.

Eco, U. (1977). *A Theory of Semiotics*. London: Macmillan.

Gonsalves, P. (2010). *Clothing for Liberation: A Communication Analysis of Gandhi's Swadeshi Revolution*. New Delhi: Sage.

Goonasakera, A., & E. Kuo. (Eds.). (2000). "Towards an Asian Theory of Communication?" Spec. issue of *Asian Journal of Communication*, 10(2), 1–123.

Gunaratne, S. (2011). "Emerging Global Divides in Media and Communication Theory: European Universalism versus Non-Western Reactions." In G. Wang (Ed.), *De-Westernizing Communication Research: Altering Questions and Changing Frameworks* (pp. 28–49). New York: Routledge.

Gunaratne, S. (2008). "Falsifying Two Asian Paradigms and De-Westernizing Science." *Communication, Culture and Critique*, 1, 72–85.

Haas, G. C. O. (1962). *The Dasarupa*. English translation. New Delhi: Motilal Banarsidas.

Intercultural Communication Studies. (2003). "Asian Approaches to Human Communication," Special Issue, 12(4).

Iyer, S. K. A. (1965). *The Vakyapadiya of Bhartrhari*. English translation. Poona: Deccan College Postgraduate Research Institute.

Jayawardena, R. D. K. (1986). "Communication Theory: The Buddhist Perspective." *Media Asia*, 1, 29–31.

Jayaweera, N. (1986). "Some Thoughts on Communication Theory." *Media Asia*, 1, 37–42.

Journal of Multicultural Discourses. (2009). "New Frontiers in Asian Communication Theory," Special Issue, 4(1).

Khiabany, G. (2003). "De-Westernizing Media Theory, or Reverse Orientalism: Islamic Communication as Theorized by Hamid Mowlana." *Media, Culture and Society*, 25(3), 415–422.

Kim, M.-S. (2002). *Non-Western Perspectives on Human Communication: Implications for Theory and Practice*. Thousand Oaks, CA: Sage.

Kincaid, L. D. (Ed.). (1987). *Communication Theory: Eastern and Western Perspectives*. San Diego: Academic.

Korzybski, A. (1948). *Selections from Science and Sanity*. Lakeville, CT: International Non-Aristotelian Library.

Kumar, K. J. (2010). *Mass Communication in India* (4th rev. ed.). Bombay: Jaico.

Kumar, K. J. (1995). *Media Education, Communication and Public Policy: An Indian Perspective*, Bombay: Himalaya Publishing House.

Kumar, K. J. (1986). "Mahatma Gandhi as a Mass Communicator." In G. Robinson (Ed.), *Communicating the Gospel Today* (pp. 171–197). Madurai: Tamilnadu Theological Seminary.

Kumar, K. J. (1984). "Gandhi's Ideological Clothing." *Media Development*, 31(4), 19–21.

Littlejohn, S. W., & K. K. Foss. (2009). *Encyclopedia of Communication Theory*. 2 Vols. Thousand Oaks, CA: Sage.

McQuail, D. (2010). *Mass Communication Theory* (6th ed.). London: Sage.

McQuail, D. (2000). "Some Reflections on the Western Bias of Communication Theory." *Asian Journal of Communication*, 10(2), 1–13.

Media, Culture and Society. (2003). "Alternative Media," Special Issue, 25(3), May.

Miike, Y. (2011). "Culture as Text and Culture as Theory: Asiacentricity and Its *Raison d'être* in Intercultural Communication." In T. K. Nakayama & R. T. Halualani (Eds.), *The Handbook of Critical Intercultural Communication* (pp. 190–215). Chichester, West Sussex: Blackwell.

Miike, Y. (2010). "An Anatomy of Eurocentrism in Communication Scholarship: The Role of Asiacentricity in Dewesternizing Theory and Research," *China Media Research*, 6(1), 1-11.

Miike, Y. (2009). "New Frontiers in Asian Communication Theory: An Introduction." Spec. issue of *Journal of Multicultural Discourses*, 4(1), 1–5.

Miike, Y. (2006). *Non-Western Theory in Western Research? An Asiacentric Agenda for Asian Communication Studies*. Boston: National Communication Association.

Miike, Y., & G.-M. Cheng. (Eds.). (2007). "Asian Contributions to Communication." Spec. issue of *China Media Research*, 3(4), 1–111.

Mowlana, H. (2007). "Theoretical Perspectives on Islam and Communication." *China Media Research*, 3(4), 23-33.

Mowlana, H. (2003). "Communication Philosophy and Religion," *Journal of International Communication*, 9(1), 11-34.

Nakayama, T. K., & R. T. Halualani. (Eds.) (2010). *The Handbook of Critical Intercultural Communication*. Chichester, West Sussex: Blackwell.

Ogden, C. K., & I. A. Richards. (1936). *The Meaning of Meaning: A Study of the Influence of Language Upon Thought and the Science of Symbolism*. London: Routledge.

Oliver, R. T. (1971). *Communication in Ancient India and China*. Syracuse, NY: Syracuse University Press.

Peirce, C. S. (1991). *Peirce on Signs: Writings on Semiotics by Charles Sanders Peirce*. (Ed. J. Hoopes). Chapel Hill: University of North Carolina Press.

Raghavan, V. (1965). "Indian Poetics." In A. Preminger (Ed.), *Princeton Encyclopedia of Poetry and Poetics*. Princeton, NJ: Princeton University Press.

Raja, K. K. (2000). *Indian Theories of Meaning* (2nd ed.). Madras: Adyar Library & Research Centre.

Said, E. (1979). *Orientalism*. New York: Vintage.

Saral, T. B. (1983). "Hindu Philosophy of Communication." *Communication*, 8, 47–58.

Schlesinger, P., & J. Downing. (Eds.). (2004). *The Sage Handbook of Media Studies*. London: Sage.

Schlesinger, P., & H. Mowlana. (Eds.). (1993). "Islam and Communication." Spec. issue of *Culture and Society*, 151.

Sen, A. (2005). *The Argumentative Indian—Essays in Indian History, Culture and Identity*. New Delhi: Penguin.

Singh, K. (1980). "Mass Line Communication: Example as the Message." Paper presented at International Conference, the Annenberg School of Communications, University of Pennsylvania, May 12–18.

Singh, K. (1978). "Gandhi and Mao as Mass Communicators." PhD Thesis submitted to University of Pennsylvania.

Tewari, I. P. (1992, March). "Indian Theory of Communication." *Communicator*, 35–38.

Wang, G. (Ed.). (2011). *De-Westernizing Communication Research: Altering Questions and Changing Frameworks*. New York: Routledge.

White, R. A. (1976). *Mass Communications and the Popular Promotion Strategy of Rural Development in Honduras*. Stanford, CA: Stanford University Press.

Yadava, J. S. (1987). "Communication in India: The Tenets of *Sadharanikaran*." In L. Kincaid (Ed.), *Communication Theory: Eastern and Western Perspectives* (pp. 161–171). San Diego: Academic.

Yadava, J. S. (1984). "Trends in Communication Research." Paper presented at the National Seminar on Communication Research: Trends and Priorities. New Delhi: Indian Institute of Mass Communication.

Thematic Approaches

Voice, Citizenship, and Civic Action

Challenges to Participatory Communication

THOMAS TUFTE

In recent years the world has experienced a resurgence in practices of bottom-up communication for social change, a plethora of agency in which claims for voice and citizenship through massive civic action have conquered center stage in the public debate. This resurgence has sparked a series of questions about how these new calls for social change and their principles and communicative practices are influencing and informing the way participatory communication is conceptualized and practiced by governments, civil society, or other social actors. What underlying notions of participation, civic action, and social change inform the agents of change, be they the new generation of social movements on the one hand, or the established and institutionalized field of communication for social change on the other? These are the questions that drive this chapter.

There are examples of bottom-up processes in the form of social movements across the globe: the Arab Spring, the Indignados movement, the Occupy movement, the Autonomous movement, the use by broader civil society of Ushahidi, the Chilean movement for Education, the Israeli mobilization against price rises, and the many other social movements worldwide. These social mobilizations and collective actions have at least one common denominator: the call for a more inclusive development process in which the unemployed, students, the poor, the youth, or simply the citizens demand not just to be heard, but to have a say on the content and direction of development.

New digital media are playing a central role in these contemporary social movements, circulating information, opening up spaces for social critiques, and facilitating new forms of social mobilization. In this respect, 2011 was a seminal year, giving rise to a number of social movements of continuing importance that, I argue in this chapter, constitute a new generation of participatory communication that continues the long history in this field.

Despite the existence of a common language and some degree of discursive consensus around the merits of media and communication in enhancing bottom-up development and citizenship, many different interpretations persist. This chapter deconstructs some of these interpretations, introducing a series of conceptual distinctions that can help distinguish one discourse from the other.

The "new tyranny" of participation, as Bill Cooke and Uma Kothari characterized the discursive dominance of participation in "devspeak" more than a decade ago (2001), seems to be repeating itself in ComDev speak. Communication for development discourse is all about participatory communication, but what does it actually mean? Most development agencies focus on developing vertical spaces for participation, in which target audiences, through strategic communicative interventions, are invited to participate, gain knowledge, deliberate, debate, and change behavior. However, these participatory communication practices have little or nothing in common with the new generation of social movements.

The differences between an institutionalized participatory communication practice and the ways social movements mobilize and communicate for social justice and social change are in part explained by their different approaches to participation. The development agencies largely understand participation as social processes closely tied to program and project cycles and the underlying logics that inform their organizational inertia (Tufte & Mefalopulos, 2009). Consequently, the citizen-led participatory processes seen in recent social mobilizations are a difficult match with the logics of most development organizations. Although very much engaged in participation and citizen-driven processes, the development organizations seem hardly able to connect with what is happening in the horizontal spaces of deliberation created by contemporary social movements.

Substantial social mobilizations occurring outside formal institutional and political arenas are generating previously unseen processes of deliberation, social and political critique, collective action, and social change. However, they are doing this with no clear organizational structures, fixed membership, or explicit communication strategy and, in many ways, as social movements in flux that are difficult to clearly identify, monitor, and evaluate. Many contemporary social movements are a fit with the "Segmented, Polycentric, Integrated Networks" (SPIN) that Gerlach and Hine's defined in 1968 and Lance Bennett also reflected on (2003).

Participatory communication has become a dominant discourse within organizations that produce institutionalized communication in the form of campaigns

and similar interventions. In contrast to these invited spaces for participation, social movements use media and communication technologies as a practice embedded in the spaces they create themselves, outside formal systems of governance and social organization. These are spaces, they claim, to demand and occupy.

Participatory Communication: New Contexts, Stakeholders, and Dynamics

The situation for civic action and thus participatory communication has radically changed in recent years. When assessing contemporary challenges to participatory communication, a myriad of new contexts, stakeholders, and societal dynamics can be identified. They are observable and highly concrete social actions and processes that inform the possibilities and limitations of participatory communication in contemporary society. They can roughly be structured around four meta-processes.

The Emergence of a New Generation of Social Movements

The social movements that have emerged in recent years have seriously challenged the power structures in society. Although they have some similar traits to the identity-based *post-material* social movements that emerged in the 1960s and 1970s (Ingelhart, 1977; Tourraine, 1981; Melucci, 1985), the current wave seems also to be articulating highly material demands for jobs, an income, housing, food, and education—social and economic rights issues familiar from the social movements of the industrial era. The post-material social movements put a heavy emphasis on specific social groups with specific social and cultural claims, often tied up with questions of identity and universal human rights. They thereby distinguished themselves from the first generation of social movements, which only emphasized more material demands and rights.

The most recent wave of social movements, in both North and South, is less specific in its demands. These movements fundamentally question the marginalization of large sectors of society. They argue for the right to be included in defining the direction of and participate in the development of society, moving beyond the basic voter rights of a democracy.

Mario Diani maintains that social movements are distinct social processes characterized by conflictual relations with clearly identified opponents, linked by dense informal networks, and share a distinct collective identity (Diani in Della Porta & Diani, 2006, pp. 20ff). However, Thompson and Tapscott rightly remind us to be cautious about our understanding of social movements being too caught up in Western paradigms as their "genesis, form and orientation are likely in many, but not all, instances to be significantly different" (2010, p. 2). There may be some generalizable traits in the mechanisms through which social actors engage in collective action, but it is essential to localize these dynamics and un-

derstand the concrete departure point that gives rise to collective action and social movements. As my generational approach to social movements indicates above, it is both at the general and the specific levels that things are changing.

The Growth and Expansion of Civil Society

There has been a significant development of civil society in the past twenty to twenty-five years, locally, nationally, and transnationally (Jordan & Van Tuijl, 2006; De Oliveira, 2008; Selchow, 2008; Gaventa & Tandon, 2010). Drawing on Scholte (2000), Lisa Jordan and Peter Van Tuijl define civil society as "the realm (that is, the public sphere) where citizens associate voluntarily, outside families or businesses, to advance their interests, ideas or ideologies" (p. 9). It includes nongovernmental organizations (NGO), civil society organizations, and social movements, but profit-making or governing activity are not included. NGOs in particular have conquered a central role in development processes as key agents of advocacy and change, with all the rights, risks, and responsibilities that entails. It is beyond the scope of this chapter to delve into the details of their differing roles, but it is important to emphasize how media and communication enhance the participatory processes of civic action with high potential that are opened up by the rise of civil society.

In this process of the emergence of a new generation of participatory communication with media and communication playing central roles, the issue of accountability has sparked heated debates about the correspondence between actions and objectives. As Jordan and Van Tuijl explain, changes in development paradigms have produced changes in emphasis on NGO accountability. They provide a useful overview and identify five dominating syllogisms in the past twenty-five years of NGO activity: (1) the classic role of complementing government, 1980–1989; (2) the strong emphasis on civil society development now strongly associated with democracy and governance, 1989–1995; (3) emphasis on the importance of good governance, legitimacy, and establishing self-regulation mechanisms, 1995–2002; (4) the return of the supremacy of the state, since 2002; and (5) the main syllogism today—a human rights–based approach that focuses on balancing multiple responsibilities to different stakeholders, using a variety of mechanisms (Joran & Van Tuijl, 2006, pp. 9–13). It is first and foremost within this human rights–based approach that social accountability mechanisms emerge in the ways NGOs use new digital media (Wildermuth, 2013, forthcoming).

Changing Development Paradigms and the Political Economy of the Development Industry

Changing concepts of development are increasingly relativizing and nuancing what development means. The Western discourse on development is losing its global dominance, as demonstrated by the fundamental questioning of Western models of development that have dominated development discourses since 1945,

which has led to the emergence of new paradigms of development and post-development discourse in global scholarship. These paradigms range from China's technocratic growth model, centered on national economic growth mixed with Confucianism, to Latin American claims of a sustainable development process informed by notions of *buen vivir* (good living) (Silva, 2011). *Buen vivir* resonates with some dimensions of the Bhutanese Gross National Happiness index, which is receiving growing international attention (Ura & Galay, 2004). The recent social uprisings can be seen as a fundamental questioning of the neoliberal development paradigm, which is central to the dominant Western models of development (Couldry, 2010).

Karin Wilkins and Florencia Enghel (2013) critically assess the tendency to privatize development, using examples drawn from the Bill and Melinda Gates Foundation and the ONE project, arguing that such development projects serve the agenda of privatized development within a neoliberal project. This trend inherently counters the optimism attributed to much of the new political dynamic arising from recent social mobilizations, or at least serves as a relevant context to be aware of when assessing the new generation of participatory communication.

Media Development and the Diffusion of New Information and Communication Technologies

Complementary to and deeply embedded in the above three meta-processes is this fourth meta-process of the diffusion of new information and communication technologies. These developed in a dynamic synergy with the new social and political dynamics. Many new research projects are discovering the relations emerging between decision makers and citizens, media and activists, and offline and online spaces of deliberation (Bruijn, Nyamnjoh, & Brinkman, 2009; Lievrouw, 2011; Sáez, 2011; Tufte, 2009; Tufte et al., 2013; Wildermuth, 2013, 2014). However, the same new media developments have resulted in private media companies emerging as strong drivers of change, promoting and reinforcing a market-driven economy and development process.

All four dimensions are defining new contexts, stakeholders, and dynamics within which we have to redefine participatory communication. I expand below on the fourth dimension, *the proliferation of mobile telephony and the Internet*, exploring the interconnections between social movements and social media use, as well as wider relations between citizenship formation and the role of citizen media, and assessing the co-evolution of different forms and channels of media and the generalized sense of needing to know more about their social uses.

Citizenship and Citizen Media

In the aftermath of the recent turbulent years of social mobilization, a whole sub-discipline in media and communication studies is gaining ground, analyzing and theorizing about social movements, insurgent politics, and new forms

of deliberation and communication. John Downing, in his massive compilation, illustrates the breadth of historical and contemporary experience of social movements using the media and communication in pursuing their agendas (Downing, 2010). Manuel Castells reinforces the potential for "mass self-communication" by which social media open up the possibility of even small social movements gaining visibility and power by their articulation or mass self-communication through networks (2009). Castells shows the strategic role new social media have played in articulating social and political change, although he does not go so far as to link communication theory with social movement theory.

A useful attempt to build this theoretical bridge is found in the work of Anastasia Kavada (2011). In bringing together social movement theory, political communication, and organizational communication, Kavada develops a conceptual framework and a typology with which to understand and argue the centrality of media and communication in social movements. Her typology outlines four flows of digital communication: from "membership negotiation" to "organizational self-structuring" and "activity coordination" to "institutional positioning." Kavada's conceptual framework is a promising outline of how we can bring analysis of media and communication practices close to social movement theory.

A Perverse Confluence of Political Projects

A recurrent debate in communication for development is how the social uses of information and communication technologies enhance processes of civic engagement and strengthen citizenship. This debate starts from the assumption that participation enhances citizenship, but the lack of consensus in defining citizenship results in different takes on what participatory forms of media use and communicative practice entail and what they should aim to achieve. The debate is locked in what Brazilian political scientist Evelina Dagnino (2011) has called the "perverse confluence" of two different political projects. She outlines the radical democratic notion of citizenship on the one hand, and the neoliberal appropriation of participation on the other, but while they use similar or even identical language, their political aims contrast with each other: "The perverse nature of the confluence between the participatory and the neoliberal projects lies in the fact that both not only require a vibrant and proactive civil society, but also share core notions, such as citizenship, participation and civil society, albeit used with very different meanings" (p. 419).

In its radical democratic definition, citizenship is not just a set of rights and responsibilities bestowed by the state but also a multidimensional social practice that speaks to the identities and actions of people as individuals and also as collectives. Citizens not only audiences or receivers of communication-based strategies for change. They are equally as much to be seen as participants in or activists for change. This approach was characteristic of the social movements in

Latin America that struggled for democracy in the 1980s. Fundamentally, they were struggling for a deepening of democracy and striving for a different notion of what constitutes the political arena. The political scientist Chantal Mouffe (2005) subsequently solidified the conceptual basis of this approach.

The neoliberal version of citizenship, according to Dagnino, has led to a severe displacement of issues such as poverty and inequality: "In being addressed solely as technical or philanthropic issues, poverty and inequality are effectively withdrawn from the public (political) arena and so from the proper domain of justice, equality and citizenship, and reduced to a problem of ensuring a minimum of conditions for survival" (2011, pp. 424–425). It has also resulted in a shift in the focus of civic action away from collective processes to an emphasis on individual opportunities.

Wilkins and Enghel's findings on the privatization of development aid, and their pinpointing of individual success as a key criterion for success in privately funded development projects, reinforces similar points. They state that the development project *Living Proof* "illustrates how individual pursuit of happiness and empowerment are identified as the most effective approach to social change in a privately funded, media-driven development initiative" (2013, p. 2). They problematize this individualization of development and social change: "It also privileges individual empowerment at the expense of structural solutions to social problems. Redistributive social justice cannot be addressed within this framework, in which individuals are applauded for achieving success in a global market" (2013, p. 8). This resonates with Dagnino's points about the individualization and depoliticization of poverty and inequality.

To counter such tendencies, within radical democracy, and in line with what Couldry calls a "post-neoliberal politics," civic action is the active and collective manifestation of citizens as claimants of development, a process in which identity and action come together in deliberate communicative action for social change. Becoming media producers, citizen journalists, and bloggers, and taking on similar participatory roles in a mediated development process can be seen as part and parcel of this process, although they can also be seen as detached and individual expressions of opinion and civic engagement.

In an attempt to build on the traditions of alternative media and radical media known not least from Latin America but also from social movements elsewhere, the Colombian media scholar Clemencia Rodriguez (2001) developed an interesting conceptual basis for the term "citizen media." Rather than launching an alternative paradigm, her aim was to put the citizen center stage in media and communication practices—seeing participatory communication and ultimately social change occurring exactly where collectives of citizens enact transformation through communication:

> The term "citizens media" implies, first, that a collectivity is enacting its citizenship by actively intervening and transforming the established mediascape; second, that these media are contesting social codes, legitimized identities and institutionalized social relations; and, third, that these communication practices are empowering the community involved, to the point where these transformations and changes are possible. (Rodriguez, C., 2001, in Gumucio-Dagron & Tufte 2006, p.774)

By conceptualizing public media as citizen media, governments and their international partner organizations not only develop a sensitivity to the citizen, listening and holding conversations with them to understand them better, they also place the center of agency and transformation in the hands of citizens or, rather, in the hands of collectivities of citizens.

Co-evolution of Media and a Call for Qualitative Studies of Their Social Uses

The academic perception of the new digital media's role in these political arenas and in broader social change processes is usually either as revolutionizing our organization of time, space, and social relations or just business as usual, that is, as an extension of the old media and its role in society. Many cases demonstrate that the Internet and mobile telephony offer an extension of established media and communication practices while also providing new social dynamics that are challenging the established social order.

Concepts such as "prosumer" and "produser" indicate the breakdown of traditional dichotomies in the logic of linear models of communication. A consumer is also a producer and, more generically, a user of the media can also produce media content. Audiences become producers and producers become audiences. A whole new vocabulary is emerging that indicates a new generation of participatory communication practices, including such concepts as citizen journalism, participatory journalism, citizen media, nano media, and social movement media. They are, on the one hand, an extension of the established history of participatory media, known, for example, as alternative media, horizontal media, community media, or tactical media, but, on the other hand, part of the growing international research interest in the active involvement of citizens with media and communication processes.

The co-evolution of new and old media has opened up space for some quite unknown and still to be explored social uses of media. There is a strong call among media and communication researchers for audience studies and especially for inquiries into the changing communication ecologies and the social uses of media (Downing, 2014; Kavada, 2014). Some interesting media ethnographic work can be found, for example, in the research project "Mobile Africa Revisited" (see Bruijn, Nyamnjoh, & Brinkman, 2009). Some of these social uses of the media are, I argue, a manifestation of citizenship in everyday life. This argument is

based on the radical democratic notion of citizenship in which social practice is grounded in everyday experiences and where enhancing citizenship is about more than the right to vote. It is about ordinary people being "the claimants of development" rather than just the beneficiaries (Gaventa, 2005, p. xii). From this conceptual perspective, participatory communication is about the active communicative practices carried out by citizens in their everyday life. Enhancement of citizenship and the active use of citizen media are integral elements of such participatory communicative practice.

Post-neoliberal Politics and the "New Technologies of Voice"

As set out above, radical democracy constitutes an opposing political project to the neoliberal development project. As Evelina Dagnino (2011) notes, some of the same language and concepts are used in both radical democratic and neoliberal discourses, that is, such concepts as citizenship, participation, and civil society. But how can a post-neoliberal politics be a politics and practice that enhances voice, citizenship, and civic action in critical opposition to neoliberal development policies and practices?

British media scholar Nick Couldry formulates a fundamental critique of the neoliberal development paradigm that has influenced large development organizations across the globe. His main criticism is that our ways of thinking development have historically not been very inclusive. There have not been proper ways and means to secure citizens a solid voice in the processes of development. Governments have not been good at enhancing voice and taking the voices heard into consideration in their political practice. In pursuit of a post-neoliberal politics, Couldry outlines the challenges and spells out some of the important new resources such a politics could draw on. He speaks of the "new technologies of voice" (2010, p. 139), outlining five new possibilities that media and technology are enabling.

First, *the new technologies are allowing voice in public for a vastly increased range of people*. This is already apparent, especially with the proliferation of mobile telephony worldwide. Issues linked to a lack of access, resources, and competencies still produce significant digital divides, but the active use of mobile telephony is spreading—as sub-Saharan Africa demonstrates (Bruijn, Nyamnjoh, & Brinkman, 2009; Wildermuth, 2013).The use of the Internet and video are equally significant examples of increased voice, as is the proliferation of You Tube, which is used for a diverse set of purposes, including self-expression and the substantial commercial circulation of popular culture but also video activism. Tina Askanius analyzed three major political mobilizations in Europe: the European Social Forum in Malmo, 2008; the G20 counter-summit in London, 2009; and the alternative climate summit in Copenhagen, 2009. Although radical online video

activism provided new and extended dynamics for political engagement, there was also a clear line of continuity with earlier video activism (Askanius, 2012).

Second, *a greatly increased mutual awareness of these new voices has emerged.* We can circulate more stories, more quickly, to more of our peers. In other words, the imagined communities Benedict Anderson spoke about in the era of the mass media a few decades ago (1983) have materialized as real-time networked communities for a growing proportion of the world's population. Political processes in far-away countries have come closer, and the mutual awareness of these voices and this possible transnational attention is becoming a core characteristic and dimension of political advocacy processes. Anastasia Kavada's analysis of transnational advocacy networks and their use of new technologies underscores this point. In exploring the patterns of new transnational networking and their relationship with new communication technologies, she outlines the characteristics of a new generation of transnational activist networks that ultra passes both the highly NGO-centered transnational activist networks (TANs) and the more fluid, multi-issue and less NGO-centric networks known, for example, from the Global Justice Movement (Kavada, 2014).

Third, we are seeing *new scales of organization thanks to the Internet.* Events during the Arab Spring are a case in point. Demonstrations were organized through web-based communications, which ties in well with Kavada's (2011) emphasis on "organizational self-structuring." However, it is important to distinguish between the use of the Internet to organize a one-off event and its use for the more demanding organization of a sustainable social movement that works long term for a cause (Duncombe, 2007). In the aftermath of the insurgencies of 2011 and 2012, there have been major challenges in sustaining the articulated social movement. In many cases, the everyday, long-term challenges are linked to all the basic challenges of running an ongoing initiative that requires organizational strength.

Fourth, *our understanding of the spaces that are needed for political organization has changed.* Making active use of these new spaces, which are often online spaces, will be a key challenge. From a government perspective, however, the challenge is to accept and collaborate with these new spaces for political organization and voice: "Seeing new people as relevant to political exchange requires seeing new spaces of narrative exchange as possible: this requires a pragmatic understanding of political space" (Couldry, 2010, p. 147).

Finally, and crucially, all the above-mentioned changes are generating the potential for *new forms of listening.* This resonates with what Wendy Quarry and Ricardo Ramirez called for when arguing for stronger attention to "listening before telling" in the practice of communication for development (Quarry & Ramirez, 2010). Governments are no longer able to say that they cannot hear the voices of the people as new relations are possible between citizens and politicians.

Couldry is cautious about how to assess these opportunities, but he outlines interesting suggestions for what he calls "new acts," suggesting acts of exchange and of listening but also paying attention to the challenge of making governments use the voice of citizens in the way they make policy. While the mass social uprisings of recent years have used new digital media in their articulation of strong voices against the socially and politically exclusionary forces of current development processes, Couldry's outline of the "technologies of voice" constitutes an analytical and maybe even a strategic resource for identifying a communicative and political pathway that moves beyond the neoliberal development paradigm.

Increasingly, development planning is seen as a response to the initiatives of the communities at the grassroots. The people at the base of the development process have an awareness of their own needs and priorities. This builds on the traditional organizational forms, the knowledge of the people in agriculture, health, the existing practices of environmental conservation. Robert White proposes as a substitute for centralized bureaucratic planning and initiative a "response to initiatives" model of development (White, 2004, 2008). The process of development is not "centrifugal" (from the top down) but centripetal (from the bottom, the edges toward the center). This is a much more sustainable form of development because it is owned by the people and can continue even when outside programs are removed. Such a program of development is necessary because the state and other outside agencies simply do not have the resources to initiate the processes of development. The role of NGOs, government, and other agencies is mainly to facilitate the ideas, decision making, and organizational capacity of the local initiatives and to help local organizations form district and regional associations.

Particularly important is to channel initiatives into the formation of community-based organizations that are able to mobilize existing interpersonal communication patterns in the community and establish linkages with outside resource agencies (Joram & White, 2011).

The NGO-ification of Development and Politics

Some of the key players providing platforms and supporting the articulation of citizen voices are NGOs. The recent history of development has seen a rapid and significant global development of civil society in which there has been an enormous growth in the number of NGOs. While this has changed relations between citizens and decision makers, making citizens powerful brokers in the business of influencing development, some scholars speak of an *NGO-ification* of development (Manyozo, 2013).

Participation by citizens in civil society, from this perspective, has become synonymous with NGOs. This point is emphasized by Dagnino in her critical assessment of citizenship and the perverse confluence between participatory and neoliberal projects. She emphasizes that within the neoliberal development project, civil society organizations have increasingly taken over the role of providing

services that are the responsibility of the state, while at the same time the power to decide on such developments remains with the state (2011, p. 425).

Arundhati Roy (2004) makes a similar point, tying NGO-ification to the challenge of donor dependency and citizens' de facto loss of power to set the agenda.

> In the long run, NGOs are accountable to their funders, not to the people they work among. . . . Eventually . . . the capital available to NGOs plays the same role in alternative politics as the speculative capital that flows in and out of the economies of poor countries. It begins to dictate the agenda. It turns confrontation into negotiation. It depoliticizes resistance. It interferes with local peoples' movements that have traditionally been self-reliant. . . . The NGO-ization of politics threatens to turn resistance into a well-mannered, reasonable, salaried, 9-to-5 job. With a few perks thrown in. Real resistance has real consequences. And no salary. (pp. 44–46)

In line with Dagnino, and resonating with Wilkins and Enghel's individualization of social change, Roy warns us about the depolitization of resistance. The ordinary citizen engaging with NGOs is subjected to a double challenge in seeking to advance a radical democratic development project: donor-dependency and support for a neoliberal development project.

Despite such challenges, and in the midst of this development of civil society, civil society–driven media platforms continue to grow and to invite citizens to engage and participate. These platforms typically use the printed media and community media platforms, but they are also rapidly opening up to the new opportunities for citizen-driven media production of news and other content.

Femina HIP is an example of a civil society–driven media platform. It is the the largest of its kind in East Africa, with eight different media outlets in Tanzania, including the two of the largest print magazines in the country, a successful television talk show, and a radio drama. Femina HIP is an NGO with aspirations to create a social movement for youth across the country in order to engage in Tanzania's development process (Tufte, 2011). The research project I have directed since 2009 focuses on media, empowerment, and democracy in Kenya and Tanzania. Our empirical focus is on the role of youth in the democratic development of Tanzania, in particular young women and the communicative practice of Femina HIP, and the reception for and social uses of their media outlets.

The young women are severely affected by the HIV/AIDS pandemic and by high levels of unemployment. A further constraint for them is their lack of an effective voice in public life, especially in regard to decisions on policies and laws that directly affect their livelihood. While media and information and communications technologies (ICTs) *can* be powerful tools in promoting social inclusion, the question driving our research was how and to what degree civil society is facilitating this. Are civil society–driven media platforms empowering young

women to participate in the public debate and engage in other ways in processes of participatory governance?

Femina HIP is the largest producer of print media in Tanzania. Its two widely disseminated glossy magazines tell stories and provide information about sexual and reproductive health. *FEMA* targets secondary school youth, and *Si Mchezo* targets out-of-school youth. Each has a print run that is ten times bigger than any daily or weekly newspaper in the country. Both magazines carry well-researched stories, are embedded in youth culture, and are sensitive in the way they deal with the topics they discuss. They are written in colloquial language and designed to appeal to today's youth. Most of their content is in Swahili. *FEMA* puts enormous effort into establishing credibility and the trust of its audience.

The production process is based on participatory journalism, and youth across the country provide input into many stages of content development, under the auspices of a professional editor and a team of journalists employed by *FEMA* to research each story. Femina HIP makes strenuous efforts to connect with the world of the youth they are trying to engage in a dialogue, and whose lives they are seeking to improve.

Accountability is a central analytical perspective in our work. Femina as an organization is accountable both upward to decision makers and downward to its own constituency, the youth of Tanzania. There is no doubt that Femina is gaining political clout thanks to the millions of youth who engage with its media outlets. This is increasing Femina's ability to approach and engage with decision makers. Nonetheless, Femina must strike a delicate balance between being a powerful vehicle for social critique and public debate while avoiding sanctions from the government, something other NGOs have experienced.

Downward accountability is also a challenge. Femina is a mass vehicle that claims to be participatory, dialogic, and opening up spaces for personal involvement by its millions of readers, listeners, and viewers. The physical spaces offered by the Femina clubs, outreach programs, and national events they organize for clubs, teachers, and others—together with the interactive forms of dialogue offered through SMS feedback mechanisms, published letters and radio phone-ins—help to maintain a subtle balance between an invited space for participation and a space that citizens can claim, demand, and occupy (Tufte, 2011; Tufte et al., 2009).

A different and highly innovative example of the use of social media platforms to mobilize, document, and deliberate is Ushahidi in Kenya. Ushahidi is crowd-mapping software that is increasingly being used to engage citizens with a variety of development challenges. As a web- and mobile phone–based platform for aggregating and channeling the concerns and observations of citizens, it serves a number of Kenyan NGOs as a useful media platform for advocacy and accountability purposes. As an integrated platform built on an independent, open-source framework, it has been picked up and used in a variety of contexts from the af-

termath of the devastating earthquake in Haiti in 2010 to activists' struggles for human rights in Syria in 2012 (Wildermuth, 2013).

The Ushahidi type of social movement and civic engagement uses new communication technologies to generate "crowds of individuals" (Juris, 2012, p. 267). It builds on a "logic of aggregation," which Juris explains as a "coming together of actors qua individuals" (p. 266). Anastasia Kavada (2014) argues that this sort of civic action represents a whole new type of social movement. This speaks directly to the dilemmas outlined above and the dynamics of an individualization and possible depoliticization of civic engagement versus the emergence and growth of collective social movements.

Both these civil society–driven media platforms invite citizens to engage with particular social, human rights, or political problems—detecting violations and abuse and reporting them, and voicing both individual and community concerns in the process. They allow what Kavada (2011) calls "activity coordination" when analyzing social movements and their use of media and communication. Participatory communication practices thereby enhance concrete and grounded discussions about poverty and equality, and about citizenship, good governance, and democratic development.

It is fair to say that the boundaries between NGO-ized development practice and social movements are sometimes difficult to draw. The above examples illustrate this point. Ushahidi is a crowd-mapping tool developed by an NGO and used increasingly by social movements in Kenya and elsewhere, while Femina HIP's successful proliferation of its many media outlets illustrates an NGO's aspirations to connect with its potential constituency and to articulate a social movement among Tanzania's youth.

The questions that emerge from this analysis highlight the social dynamics and the civic action these media uses and communication practices entail. How, and to what extent, are these civil society–driven media platforms altering relations between decision makers and citizens? Are they leading to new spaces for deliberation and public debate, and to new spaces for critique and civic action? Are they invited spaces or claimed spaces? What difference does this make? These new communicative practices and social dynamics need to be much better understood. In line with our calls for audience studies and analyses of communicative ecologies, Costanza-Chock has called for a less platform-centric focus and a focus instead on the communicative ecologies of everyday life, suggesting a deeper study of "social movement media cultures" (2012).

Participatory Communication in the Post-Arab Spring Era

In the light of the Arab Spring and related social uprisings across the globe, researchers of participatory communication need to revisit our notions of development and our perceptions of how media and communication are used, and to turn such reflection into a reconsideration of the possibilities and limitations

of strategizing our way to social change. A distinction has been drawn between invited, system-driven spaces for participatory communication and bottom-up, informal and non-institutionalized spaces. This chapter has analyzed some of the practices of communication for social change emerging out of the latest generation of social movements, materializing in their activist-driven claims for influence, visibility, participation, and inclusion in society. In conclusion, I wish to outline some of the key challenges I see for the reformulation of participatory communication at this moment in history. I believe that five constitutive features will challenge the field of participatory communication in the future.

First, the concept of development will—once again—require profound debate. At a time when the Western model of economic growth is in a state of fundamental crisis, and when alternatives have been emerging and discussed for decades, how do communication for development scholars and practitioners position themselves? From Fanon's post-colonial thoughts on Escobar's post-development discourse, to the Buddhism-inspired Gross National Happiness index currently being operationalized in Bhutan, how do scholars and practitioners in the field of communication for development relate to these and other takes on development and social change, be they ecological, human rights–based or something else? An explicit normative stance is fundamental to guiding the interpretation of the problems we, the citizens, mobilize, strategize, and advocate for, be it from inside or outside systems and organizations.

Second, the new social movements have re-emphasized the need to recognize power struggles as a core context in which we communicate for development and social change. Governance is part and parcel of this debate, as governance is about having the power to administer the resources of a society. Participatory governance is about citizens having a role to play in these processes beyond the mere election of politicians at election time.

Third, recent media developments have led to a proliferation of new spaces for deliberation, participation, and agency. Public debate has long been recognized as a founding pillar of democratic development, but the participants in and spaces for the debate are changing. Couldry's emphasis on the technologies of voice in a post-neoliberal politics must be factored into communication for development and social change. Multiple public spheres are generating many different voices.

Fourth, as the network society evolves, and social media become integrated into the social practices of everyday life across the globe, an increased dissolution is evident between previously separate forms of communication, with interpersonal communication on one side and mass communication on the other.

We have already witnessed a transition from the dominance of monologic media formats to dialogic media formats, but we are now moving to polyphonic media formats. Networked social relations and communication practices mean that many today can communicate with many in a mix of online and offline settings. The most significant feature seems to be the networked character of social

relations and forms of communication, allowing a multiplicity of voices to speak together. This is becoming a key premise for any communication, and is loosely connected with the notion of an emerging polymedia communicative environment developed by Mirca Madianou and Daniel Miller (2012) in their in-depth ethnographic study of human communication in migrant families.

Finally, influencing power structures, having a voice, or gaining a say in processes of social and political change are a growing articulation of tactics by citizens who are becoming claimants of development, mobilizing in social movements, and, in this context, articulating tactics to engage in development and social change. According to Michel de Certeau (1984), tactics are the efforts made by ordinary people to create spaces for themselves by which they can overcome the strategies or power structures to which they are subjected. The response from ordinary citizens is to seek to develop ways and means of carving out their own use and meaning in everyday life. By considering citizen tactics within the communicative dynamics of the network society, institutions—be they civil society or governmental—can develop a sensitivity to citizens, listening and holding conversations with them in order to understand them better. Without losing sight of the political economy side of things, institutions in society might well see the center of agency, participation, and social transformation develop in the hands of citizens. The challenge for participatory communication will be to sustain such processes while pursuing the overall goals of citizenship, equality, and justice.

Bibliography

Anderson, B. (1983) *Imagined Communities. Reflections on the Origin and Spread of Nationalism.* London, New York: Verso.

Askanius, T. (2012). *Radical Online Video: YouTube, Video Activism and Social Movement Media Practices.* Lund Studies in Media and Communication 17. PhD dissertation, Lund University.

Bennett, L. (2003). "New Media Power." In N. Couldry & J. Curran (Eds.), *Contesting Media Power* (pp. 17–38). Lanham, MD: Rowman & Littlefield.

Bruijn, M. de, F. Nyamnjoh, & I. Brinkman. (Eds.). (2009). *Mobile Phones: The New Talking Drums of Everyday Africa.* Bamenda & Leiden: Langaa/African Studies Centre.

Castells, M. (2009). *Communication Power.* Oxford: Oxford University Press.

Cooke, B., & U. Kothari. (Eds). (2001). *Participation, the New Tyranny?* London: Zed.

Cornwall, A. (Ed.). (2011). *The Participation Reader.* London: Zed.

Costanza-Chock, S. (2012). "Mic Check! Media Cultures and the Occupy Movement." *Social Movement Studies*, 11(3–4), 375–385.

Couldry, N. (2010). *Why Voice Matters: Culture and Politics after Neoliberalism.* London: Sage.

Dagnino, E. (2011). "Citizenship: A Perverse Confluence." In A. Cornwall (Ed.), *The Participation Reader* (pp. 418-427). London: Zed.

De Certeau, M. (1984). *The Practice of Everyday Life.* Berkeley: University of California Press.

Della Porta, D., & M. Diani. (2006). *Social Movements: An Introduction.* Oxford: Blackwell.

De Oliveira, M. D. (2008). "Part 2: Democracy." In M. Albrow, H. Anheier, M. Glasius, M. Price, & M. Kaldor (Eds.), *Global Civil Power Society 2007/8* (pp. 58–143). London: Sage.

Downing, J. (2014). "Social Movement Media in the Process of Constructive Social Change." In K. Wilkins, T. Tufte, & R. Obregon (Eds.), *Handbook of Development Communication and Social Change.* Malden: Blackwell-Wiley.

Downing, J. (2010). *Encyclopedia of Social Movement Media*. London: Sage.

Duncombe, S. (2007). *Dream: Re-imaging Progressive Politics in an Age of Fantasy*. New York: The New Press.

Gaventa, J. (2005). "Foreword." In N. Kabeer (Ed.), *Inclusive Citizenship: Meanings and Expressions*. London: Zed.

Gaventa, J., and R. Tandon (eds). (2010). *Globalizing Citizens. New Dynamics of Inclusion and Exclusion*. London: Zed Books.

Gerlach, Luther P.; Hine, Virginia H. *Journal for the Scientific Study of Religion*. Spring 68, Vol. 7 Issue 1, p. 23–40.

Gumucio-Dagron, A., & T. Tufte. (Eds.). (2006). *The Communication for Social Change Anthology: Historical and Contemporary Readings*. South Orange, NJ: Communication for Social Change Consortium.

Hemer, O., & T. Tufte. (Eds.). (2005). *Media and Glocal Change: Rethinking Communication for Development*. Göteborg & Buenos Aires: Nordicom & CLACSO.

Inglehart, R. (1977). *The Silent Revolution: Changing Values and Political Styles Among Western Publics*. Princeton, NJ: Princeton University Press.

Joram, N., & R. White. (2011). "The Effectiveness of Interpersonal Communication for HIV/AIDS Persons in Tanzania." *African Communication Research*, 1, 11–47.

Jordan, L., & P. Van Tuijl. (2006). "Rights and Responsibilities in the Political Landscape of NGO Accountability: Introduction and Overview." In L. Jordan & P. Van Tuijl (Eds.), *NGO Accountability. Politics, Principles and Innovations* (pp. 3–20). London: Earthscan.

Juris, J. (2012). "Reflections on Occupy Everywhere: Social Media, Public Space, and Emerging Logics of Aggregation." *American Ethnologist*, 39(2), 259–279.

Kavada, A. (2014). "Transnational Civil Society and Social Movements." In K. Wilkins, T. Tufte, & R. Obregon (Eds.). *Handbook of Development Communication and Social Change*. Malden, MA: Blackwell-Wiley.

Kavada, A. (2011). "Digital Communication Technologies and Collective Action: Towards a Conceptual Framework." Paper presented at the Political Communication Section of the IAMCR General Conference, Istanbul, July13–17.

Lievrouw, L. A. (2011). *Alternative and Activist New Media*. Cambridge: Polity.

Madianou, M., & D. Miller. (2012). *Migration and New Media: Transnational Families and Polymedia*. London: Routledge.

Manyozo, L. (2013). "Communication for Development in Sub-Saharan Africa: From Orientalism to NGO-ification." In T. Tufte, N. Wildermuth, A. Hansen-Skovmoes, & W. Mittullah (Eds.), *Speaking Up and Talking Back? Media, Empowerment and Civic Engagement of Africa Youth*. Göteborg: Nordicom.

Marshall, D. (2002). "Behavior, Belonging and Belief: A Theory of Ritual Practice." *Sociological Theory*, 20(3), 360–380.

McDonald, K. (2006). *Global Movements. Action and Culture*. Malden, MA: Blackwell-Wiley.

Melucci, A. (1985). "The Symbolic Challenge of Contemporary Movements." *Social Research*, 52, 789–816.

Mouffe, C. (2005). *The Return of the Political*. London: Verso

Quarry, W., & R. Ramirez. (2010). *Communication for Another Development: Listening Before Telling*. London: Zed.

Rodriguez, C. (2001). *Fissures in the Mediascape*. Cresskill, New Jersey: Hampton Press. Excerpt published in A. Gumucio-Dagron & T. Tufte (Eds.), (2006), *The Communication for Social Change Anthology: Historical and Contemporary Readings*. New Jersey: Communication for Social Change Consortium, p. 762–777.

Roy, A. (2004). *Public Power in the Age of Empire*. New York: Seven Stories.

Sáez, V. M. (2011). *Comunicar para transformer, transformer para comunicar. Tecnologías de la información desde una perspectiva de cambio social.* Madrid: Editorial Popular.

Scholte, J. A. (2000). "Global Civil Society." In N. Woods (Ed.), *The Political Economy of Globalization* (pp. 173–201). Basingstoke, UK: Palgrave Macmillan.

Selchow, S. (2008). "Part 3: Communicative Power." In M. Albrow, H. Anheier, M. Glasius, M. Price, & M. Kaldor (Eds.), *Global Civil Power Society 2007/8* (pp. 144–243). London: Sage.

Silva, J. S. de. (2011). *Hacia el 'Dia Después del Desarrollo'. Descolonizar la comunicación y la educación para construir comunidades felices con modos de vida sostenibles.* Asunción, Paraguay: SICOM & ALER, Arandurá Editorial.

Thompson, L., & C. Tapscott. (2010). "Introduction: Mobilization and Social Movement in the South—The Challenges of Inclusive Governance." In L. Thompson & C. Tapscott (Eds.), *Citizenship and Social Movements: Perspectives from the Global South* (pp. 1–34). London: Zed.

Tourraine, A. (1981). *The Voice and the Eye: An Analysis of Social Movements.* Cambridge: Cambridge University Press.

Tufte, T. (2011). "Mediápolis, Human (In)Security and Citizenship: Communication and Glocal Development Challenges in the Digital Era." In M. Christensen, A. Jansson, & C. Christensen (Eds.), *Online Territories: Globalization, Mediated Practice and Social Space* (pp. 113–131). New York: Peter Lang.

Tufte, T. (2009). "Media and the Global Divide: A Bottom-up and Citizen Perspective." Spec. Jubilee issue of *Nordicom Review,* 30.

Tufte, T., et al. (2013). *Speaking Up and Talking Back: Media, Empowerment and Civic Engagement among East and Southern African Youth.* Yearbook 2012 of the International Clearinghouse on Children, Youth and Media. Gothenburg: University of Gothenburg, NORDICOM, & UNESCO.

Tufte, T., et al. (2009). "From Voice to Participation? Analysing Youth Agency in Letter Writing in Tanzania." In T. Tufte & F. Enghel (Eds.), *Youth Engaging With the World: Media, Communication and Social Change.* International Clearinghouse on Children, Youth and Media. University of Gothenburg: NORDICOM and UNESCO.

Tufte, T., & P. Mefalopulos. (2009). *Participatory Communication.* Washington, DC: World Bank, Working Paper Series.

Ura, K., & K. Galay. (Eds.). (2004). "Gross National Happiness and Development." Proceedings of the First International Seminar on Operationalization of Gross National Happiness. Thimpu, Bhutan: Centre for Bhutan Studies.

White, R. (2008). "Review Article: Ten Major Lines of Research on Grassroots Participatory Communication in Africa." *African Communication Research,* 1, 11–47.

White, R. (2004). "Is Empowerment the Answer? Current Theories and Research on Development Communication." *International Communication Gazette,* 66, 1.

Wildermuth, N. (2014). "Communication for Transparency and Social Accountability: The Affordances of ICT." In K. Wilkins, T. Tufte, & R. Obregon (Eds.), *Handbook of Development Communication and Social Change.* Malden, MA: Blackwell-Wiley.

Wildermuth, N. (2013). "Information and Communication Technology-facilitated E-citizenship, E-democracy and Digital Empowerment in Kenya: The Opportunities and Constraints of Community-based Initiatives." In T. Tufte et al. (Eds.), *Speaking Up and Talking Back. Media, Empowerment and Civic Engagement among East and Southern African Youth.* Yearbook 2012 of the International Clearinghouse on Children, Youth and Media. Gothenburg: University of Gothenburg, NORDICOM, & UNESCO.

Wilkins, K., & F. Enghel. (2013). "The Privatization of Development Through Global Communication Industries: Living Proof?" *Media, Culture and Society,* Vol. 35, Issue 2, pp. 165–181.

CHAPTER TWELVE

Media, Culture, and the Imagination of Religion

STEWART M. HOOVER

Rooted mainly in the social sciences, the study of mass communication has moved through a number of paradigms, from an early concern about instrumental effects to thinking about "the media" as a larger social and cultural category. This was part of an interdisciplinary shift, with mass communication scholars—now thinking of themselves increasingly as "media scholars"—turning more toward the humanities and to qualitative and interpretive social sciences. Other significant discourses, such as feminist scholarship, also pushed these things ahead as it became clear that to understand this broader framing of the question of mass communication, the whole range of human experience needed to be brought to bear in understanding the mediation of experience across time, space, and technology.

This shift can be seen in a number of places, not least in the increasing attention paid to media by other disciplines. In the field of mass communication—now "media"—studies itself, this was notably present in the major new emphases, first on "critical" and later on "culturalist" scholarships. What the object is that is at the core—this thing "media"—remains somewhat elusive.

The instrumentalism that continues to vex scholarship about media, which is also present as other disciplines attempt studies of media, stems from a historical fact. From at least the development of moveable-type printing onward, processes and practices of mediation have been conditioned and framed by changes in communication technology. Deep readings of cultural history have helped us

to understand that these developments have not determined communication and media so much as they have framed and conditioned them, making new possibilities possible and new practices practical. The world has changed as the result of these technological changes, but it is their interaction with broader historical traditions, legacies, and processes that is the issue, not their unitary determinism.

So, media scholarship today owes much to its roots in "mass communication" studies, but can be described as having gone through a shift in paradigm away from the assumed affects and implications of media toward the media and process of mediation itself. Today we are invited to look at mediation as a whole as it were, asking where and in what contexts and under what circumstances certain modes and means of mediation make sense.

Religion Emerging on the Agenda

These shifts in paradigm have also opened up new fields of inquiry and analysis. Nowhere is this more so than in what we might call "religion," "spirituality," or the range of meanings and motivations and practices that fit under the title of "the religious," or which once did and no longer do, or which now resist these labels. Religion was always a difficult challenge for mass communication research and theory. This perhaps had its roots in a general acceptance in the social sciences of the theory of "secularization." A too-simplistic reading of secularization could assume that with ongoing social progress in the industrialized West—and with development and industrialization elsewhere—religion would simply fade away. It would be a residual category of social structure and social space, and perhaps not worthy of much attention. It could also be that religion threatened to defy some deeply held assumptions of the social sciences, particularly that as "sciences," these disciplines must limit their purview to that which could be empirically measured or accounted for. Religion, as traditionally conceived, was thought to be about the transcendent or about belief, not about concrete action in the social sphere and, thus, perhaps beyond the purview of science.

The media-studies ferment I have described in fact opened up new space for a scholarship of religion and media or "the mediation of 'the religious.'" The encounter with anthropology introduced deep and substantive work in that field, for example, in the tradition of Clifford Geertz's (1993) pioneering work on religion in *The Interpretation of Cultures* and Victor Turner's (1969) *The Ritual Process*, which showed how patterns of religious-meaning practice could be amenable to substantive theoretical and empirical analysis. Important work in the field of religious studies itself also moved the needle, shifting away from the hidebound essentialisms of earlier times to an appreciation that it may not be "religion" in some pure or essential form that should be at issue, but instead the form and shape of "the religious" and its constitution. The question then becomes how things are practiced as religious and how religions are constructed. This obviously opens the

whole range of processes, which include the media and mediation, to academic scrutiny by scholars interested in religion.

The shifting grounds of mass communication scholarship—the turns first in critical and then in culturalist directions—opened up scholarly purchase as well. These frames redirected focus away from the effects of media on audiences to the ways that media articulate with meaning-making among audiences. This suggested that what people do with media is as important as what media do to people (to use an overly simplistic formulation). This suggested to culturalist scholars, at least, that the media should be seen as the grounds on which meanings are made and potentially as resources to social and cultural action (Turner, 2002; Grossberg & Treichler, 1992). Allowing for the full range of such potential uses and contexts necessarily opens explorations of the religious to interpretation and analysis.

Religion and spirituality and their presence in public and popular culture (the necessary turf of contemporary "mass" mediation) were not problematic to media scholarship only because of their ambiguous place in the academy and academic scholarship. They were also problematic due to the ambiguous place religion holds in the public sphere and in public discourse. Across most of the twentieth century, in the West at least, religion seemed to be receding from the center of public life. Or at least that was the way it was thought of by cultural, social, and political elites. There was an inevitability to this narrative, as it seemed to be assumed that what was happening in the developed West would also be the trajectory in the developing world. Daniel Lerner's (1964) *The Passing of Traditional Society* was emblematic of this perspective, essentially claiming that modernity would simply brush religion aside across the global south.

Instead, religion persists, both in the West and elsewhere. The ambiguities of religion thus stem from its anticipated trajectory toward the peripheries of modern life being confronted by realities "on the ground" that seem to contradict that picture. This is obvious in large contexts as well as small ones. For many in the United States, the persistence of religion in modernity was starkly illustrated by such things as the rise of evangelical politics in the 1970s and by the Islamic revolution in Iran in 1979. These events led to a reappraisal of arch notions of secularization. Religion's global force and presence was further illustrated by the events of 9/11 and the Bali and London bombings. It has increasing profile in political discourse both in the United States and in Europe, where religion is modulated in places such as ethno-nationalist parties, and in Africa and Latin America, where the lines between religion and politics are becoming increasingly blurred. It also has increasing presence in the cultural marketplace of the "consciousness industries," as religiously motivated demand has generated an increasing supply of religious and spiritual resources. The old ways of thinking about religion thus are no longer adequate. Religion can no longer be seen as entirely a matter of individual and group practice in the private sphere. It clearly has developed a public

face. And religion can no longer be thought of as fading away. It seems to be here to stay.

Religion's ambiguous place in modern life can be seen across a range of domains, from the private to the public, from the informal to the formal, from the material and commercial to the political. And, it can be seen across a range of media and processes of mediation. With hindsight, it is surprising that the fields of media scholarship were so slow to address religion. Aside from one important work, Parker, Barry, and Smythe's (1954) *The Television-Radio Audience and Religion*, mass communication scholarship was largely silent on religion until well into the 1970s. Then, it was the emergence of evangelical television broadcasting (what we now know as "televangelism") that sparked some interest (Horsfield, 1984; Hoover, 1988; Hadden & Swann, 1981; Hadden & Shupe, 1988; Frankl, 1987).* Much of this work was in the "effects" tradition, though, charting how essentialized religion might be using essentialized media. Other studies looked at such things as religion journalism and religion news readership. Again, the approach was rather conventional, looking at religion and media as more or less hermetic categories. The approach was conventional in yet another way. Much of it—as with much of public discourse—assumed that the religion and media divide was also a sacred-secular divide. That is, it was all too easy to assume that religion should be thought of as some rarified and essential category of meaning practice, rooted in authentic *Gemeinschaft*, while media are harsh, rational, modern, and disenchanted. These assumptions reveal much about the way forward for theory in relation to media and religion, then and now.

The paradigm shifts in the field of media and religion have addressed such assumptions by shifting the terms of discussion away from instrumental relations and toward what various forms and practices of religious and spiritual mediation actually *produce*. What happens when modern means of communication (not limited to technological means, but nonetheless rooted in the affordances of technologies) interact with, articulate to, or produce the religious? It has become clear that what is needed is something akin to what Jeffrey Alexander (1996) has called a "strong program" in cultural sociology. Working along a parallel but related line, Alexander has observed that the way sociology has thought about culture has in fact been too instrumentalized and essentialist. It is not just a question of "the sociology of culture," according to Alexander, where culture is opened as a scholarly field of analysis by thinking of it as just another sociological category. What is needed instead is a "strong program" in "cultural sociology," where the object of culture is thought about on its own terms.

* I cannot let this moment pass without noting that Robert White was largely responsible for the appearance of two of the first scholarly accounts of televangelism, Horsfield (1984) and Hoover (1988), which he commissioned and published in the series for which he was editor. Each of these books showed strongly his influence in pushing the analysis in more humanistic, less instrumentalist, directions.

Similarly, the most important developments in the field of media and religion studies have pointed toward a strong program in media and religion, where the mediation of religion and spirituality, those moments and places and practices where and when new forms and new meanings are produced, becomes the central focus of study. This has emerged to a certain extent because it has become clear that rather than remaining separate spheres (sacred or not) media and religion are in fact *converging* in contemporary life, domestically and globally. It is no longer possible to think about religion or spirituality without thinking about their mediation. And much of this mediation is conditioned by the industries and practices of concern to media and communication scholars. The media do not "affect" religion, and religions do not just "use" media. Media and religion come together in important ways.

I have argued elsewhere (Hoover, 2006) that this convergence results from changes in both religion and the media, which are themselves embedded in broader structural trends. What had once been thought to be a decline in religion wrought by a process of secularization, we now know to be a decline instead in the clerical and doctrinal *authority* of religions. Individuals—those we once thought of merely as "adherents"—are today in the driver's seat in religion as a practice known as "seeking" or "questing" continues to define religious and spiritual action to a great degree. People today feel a greater sense of authority or autonomy in religion as they search for religious and spiritual resources that satisfy their own particular wants and needs.

This is related to a larger social trend toward individual autonomy. Anthony Giddens (1992) has persuasively argued that this is a process of perfection of "the self." Individual practice today is concentrated on a reflexive and autonomous practice of the self, articulated to felt needs for security in the face of what is seen to be an era of greater risk. The result is a collapse to the individual and to the local. But it is important to note that this trend—in social practice in all areas, including religion—is one that also involves a sense of autonomy and self-determination. The individual is the active agent, involved in an ongoing quest to craft self and identity. In this process, cultural resources of a variety of kinds are treated as a kind of inventory from which the newly autonomous individual can choose (Hoover, 2006; Roof, 1998; Clark, 2007).

The effects on religion have been profound. Religious authority is no longer what it once was. Along with other sectors, confidence in religious leaders is on the decline. This has gone hand-in-hand with an increasing "relativization" of religions. As individuals begin to look for religious and spiritual resources, hierarchies begin to fall away. No one religion is necessarily more authentic or convincing than another. All are in a more-or-less horizontal inventory of cultural "supply."

The media have also changed. Today there are more and more channels of media available to more and more eyes and ears. And, the traditional legacy media

today find themselves in competition with emergent new and digital and social media that radically alter the rules of the game. One of the most important dynamics here has to do with the market logics that have been set in motion by the rise of "seeking" and "questing." In critical media-theory terms, we can see that these are contemporary expressions of the religious impulse fitted to the neoliberal global marketplace. Religion has always, of course, been defined by various markets and market logics, but the evolution of the contemporary media marketplace, governed by the logics of contemporary consciousness industries, gives more motive force and effervescence to market practice and questions of choice and autonomy. The speed, depth, and global distribution of practices of choice are new and emergent factors made possible by modern media. And the affordances of digital media have particularly compelling and profound implications for the making and remaking of religion. The accommodation of the legacy media to this new form of religious expression was an early signal of the direction things would move—toward the convergence of media and religion nationally and globally. As early as the 1990s, commercial television in the United States began having unprecedented success with entertainment programs focused on religion. Two of these, *Touched by An Angel* and *Seventh Heaven*, stand out for their audience success and their longevity. They were joined by entertainment programs that were less conventionally religious, most notably *Buffy the Vampire Slayer* (Clark, 2005).

Prior to this, commercial television in the most religious of the Western nations had been remarkably reluctant to include religion, explicit or implicit, in content. After the 1990s, as the authority of religion in the public sphere began to be restructured by social forces including the rise of personal autonomy in matters of faith, people expressing that autonomy became increasingly likely to turn to public, commercial, and entertainment media—what theological authorities had theretofore dismissively called "popular culture"—for resources, symbols, and experiences. And the legacy media responded. A growing array of programs dealing implicitly and explicitly with religion, faith, spirituality, transcendence, and meaning-quests began to emerge (Winston, 2009). This is the ground on which the digital and social media instantiations of "the religious" have been built.

The strong program in media and religion research that began to emerge late in the last century was fitted to a time of great ferment and change in these worlds of religious mediation. Focusing on the "object" of contemporary religious mediation encouraged a broad, cross-disciplinary look at critical developments in contemporary culture. These developments, in religion and in media, created facts on the ground that have pushed scholarship ahead, sometimes in spite of itself. Thinking about media and religion in this way makes much of the early received theoretical and methodological legacy of mass communication more and more marginal to the fundamental historical developments that demand attention today. A turn in more humanistic, cross-disciplinary, and interpretive directions was

called for, a turn that is becoming almost taken for granted today as work in the material culture, visual culture, embodied practices, rituals, and performances of the religious increasingly comes to the fore particularly among younger scholars and graduate students intent on accounting for the contemporary evolution of religion and media.

A Definitive Scholarly Voice: CRT

It would be wrong, though, to suggest that there have not been important voices from much earlier in this history that moved things in these more profound and productive directions. Here is an important example. Two of the turns I have discussed above—toward humanistic scholarship and toward the culturalist media scholarship that emerged in the 1980s—were prefigured in a series of editions of the very influential *Communication Research Trends* across a period stretching from 1979 to 1995. A publication of the Center for the Study of Communication and Culture in London, *CRT* was a quarterly briefing on emerging trends in media and communication theory and research. Scholars and students alike considered it a gold mine of information on trends in theory and methodology. Its review essays were sophisticated, substantive, and forward-looking in their scope on the field. Even more important, they were synthetic, interdisciplinary, and international, constituting an important point of scholarly and collegial networking for researchers and teachers across the globe. It was extremely influential, charting some of the most important developments in the field during the years of its greatest influence. And, for our purposes here, it was also unique in that it regularly addressed issues and questions of religion, both in its main pages, and in a supplement, *Research Trends in Religious Communication*.

No less than eight editions of *CRT* across those years explicitly addressed the questions of the paradigmatic ferment that underlay the development of substantive work in religion and media. The particular shift advocated by the editor of *CRT* was focused directly on the implicit instrumentalist narrowness of much of the received theory and method in the field. He and the other scholars associated with the Center wanted to shift the study of mass communication much more in a humanistic direction, suggesting that the media constitute central resources to the culture with profound implications well beyond the questions typically addressed by so-called effects research. To this way of thinking, television and (we can say by extension) all of the popular and social media we are concerned with today are more than mere inputs into social structure. They can serve as broad narratives that help define the culture, a "cultural forum," in the words of Horace Newcomb (1983), whose work was influential at the time and who was associated with the Center.

Two issues of *CRT/RTRC*, numbers 1 and 2 in 1987, were particularly forceful and insightful in their address of the issues I have raised here. The first of these

began by taking Horace Newcomb's idea of a cultural forum in a profound and substantive new direction through a review of the late Roger Silverstone's (1981) *The Message of Television*. Under the title "Television Myth and Narrative," the editor of *CRT* conducted a synthetic and sophisticated exploration of Silverstone's work, extending it into an exploration of media as potentially central to social and cultural-meaning systems through its role in relation to myth.

> Myth, Silverstone notes, does not refer to primitive, fable-like explanations of natural events that modern science has done away with. All cultures, primitive, and modern, have their grand narrative histories that explain the origins of a people and present their ultimate destinies and ideals. . . . Every culture has its area of practical, "scientific" exploration of the world as it is, but every culture also has its area of exploration of how life and history should unfold and how we want to make it develop. Myths gather up pieces of the science of the day, common sense, philosophical presuppositions, literary imagination, and weave all this into an orderly "map" of our collective future. In our myths we find the meaning of life and inspirational symbols for everyday challenges. (White, 1987a, p. 1)

It is hard to imagine today how profoundly paradigm shifting it was at that time to connect television with the notion of cultural myth. The received view of television alternatively instrumentalized and particularized it as trivial. Against this, Silverstone, and through Silverstone, *CRT*'s editor, were substantially shifting the terms of the analysis of television and other media. Reviewing this publication as I was preparing this essay, I was impressed as well with its representation of a growing network of theory and scholarship that was coming to look at media in these terms. One can see there the seeds of the culturalist scholarship of today.

RTRC in the same issue undertook an equally paradigm-shifting analysis focused on the way media and religion should be thought about. His argument stands as an articulate challenge to scholars to substantially shift the terms of analysis. He addressed the religion versus media dualism I raised earlier through a critique of the received wisdom of religious authority vis-à-vis television.

> In the "culture" of the church, there has long been an underlying attitude of distrust toward the popular media of film, radio and television. It has been especially difficult to see in the living, light-hearted, ever-changing fashions of the entertainment media a genuine expression of the human spirit. Seminarians, for example, were kept away from the popular media because these were considered useless or even harmful distractions. The cloud of censorship still persists in the desire for a media education which will inoculate TV viewers from the expected bad effects. At best, film and TV are relegated to a marginal world of "mere relaxation"; religion is placed in the more important realm of purposeful, rationalistic discourse. Official statements of the church admit the powerful cultural influence of the mass media, but consider it to be "good media" only when they are used for serious, didactic aims. Rarely is it accepted that the imaginative, affective experience of the everyday popular culture might have a value in itself. (White, 1987b, p. 1)

Anticipating one of the most substantive and productive directions that media and religion research would ultimately take, he suggested that rather than mere "instruments," the media might be better thought of as the center of exploration of religion and spirituality in contemporary life.

> The experience of transcendence . . . is always mediated through cultural symbolism. Although there is an enshrined religious, church vocabulary, this symbolization is often too remote from the everyday, common-sense language of people. Artists of the popular media are some of the first to capture in inchoate form new religious sensibilities. . . . Television, of all the popular media, is the least time-bound and is constantly translating both new knowledge and classical mythic themes into contemporary symbols to form a new state of common-sense knowledge. (White, 1987b, p. 1)

In another anticipation of the scholarly perspectives we take for granted today, the essay also addressed the issue of audience activity and autonomy, and the potential role of media in interactions and cultural meaning production.

> The popular media are the public "marketplace" where many subcultures and specialized interest meet to debate the current issues and celebrate major cultural events considered central to a common cultural heritage. (White, 1987b, p. 3)

But, it is not enough to see these things as solipsistic or wholly individual in direction and significance. The mediation of meaningful practice takes place in larger contexts of community and aspiration to cultural participation. This leads to the evolution of what many current scholars of religion and media suggest is a set of common cultural narratives of shared value and meaning. Important, the editor here suggests—as many of us do today—that this results from the constructive action of meaning-making rather than the structural attributes of the media.

> But as David Thorburn and Horace Newcomb would argue, this "mass production" leads the popular media toward a language of "consensus narrative," that is, a constant repetition of essentially the same story themes, heroes and fundamental human problems. The very centrality of the popular media to a culture, ironically, often makes its expression of deeper human significance. (White, 1987b, p. 3)

There is yet another important conceptual turn in this publication. It is not enough to simply understand the cultural mechanisms in play as religion and spirituality are mediated through the instruments of mass communication, we also need to try to understand the purpose behind these acts. How do these practices of audience participation actually work in the lives of their participants? In yet another cutting-edge postulation that prefigures the way many scholars think about these things today, the editor suggested that anthropologies of ritual be looked to for ideas and models.

The fact that the mass popular media have become a major form of leisure activity has meant that they are a major component of the leisure experience of exploration and definition of personal identity. There has been a major shift in the perspective of media scholars from a view of media as capable of impressing specific effects on a relatively passive audience to a view of the audience as much more active in selecting elements of media to construct their own personal world of meaning. This has generated a much deeper understanding of how media contribute to our efforts to define our personal life stories. (White, 1987b, p. 5)

Leisure in modern societies is also the locus of what anthropologists of ritual, performance, and leisure, such as Victor Turner, have called the liminal. Liminality is a space of cultural freedom and exploration in which persons or communities disengage from commitments to pragmatic, short-term goals of economic survival to live momentarily in a ritual, symbolic world of ultimate mythic reality and then return to the mundane world with a new evaluation of the meaning of life. (White, 1987b, p. 5)

Once again, it is hard to imagine today how radical and revolutionary such claims were in 1987. Today, through the interaction of scholarship on the media with emerging scholarships in religion, ideas such as these routinely undergird important work in ritual, pilgrimage, material culture, and the mediation of religious experience. Not so in 1987. That these ideas have now become commonplace is a testament to the intellect, theoretical sophistication, and creativity of *CRT* editor Robert White, about whom there is much said elsewhere in this essay and in this volume. What this issue of *CRT*—and the following issue, number 2 of 1987 that focused on cultural studies research and theory—did was lay the groundwork for a great deal of rethinking of media theory in general, but their significance for the development of scholarship in media and religion is particularly profound. The seeds of what I have been calling a "strong program" in media and religion are here. What has happened since 1987 in this emerging field is due in no small measure to the contribution of work such as this. And things continue to develop and evolve.

A Legacy: The ISMRC

The "strong program" in media and religion today comprises a broad interdisciplinary discourse that appears in a number of different published venues and influences discourse in disciplines from media studies to religious studies, anthropology, sociology, aesthetics, and cultural studies. Its research is conducted throughout the world, drawing from and learning much from contexts outside the developed West. Its scholarly participants meet at academic gatherings within the traditional disciplines as well as at specialized meetings, including the biennial meetings of the scholarly association devoted to studies in this area, the International Society for Media, Religion, and Culture (ISMRC). The ISMRC con-

ference has been held in Sweden, the United States, Scotland, Finland, Brazil, Canada, and Turkey.

This strong program has also generated larger theoretical reflections on the mediation of religion, again drawing on diverse disciplinary traditions. I have suggested elsewhere (Hoover, forthcoming) that in contemporary discourses at the cutting edge, one can identify a number of perspectives that might be said to fit into four broad categories.

First, there is the perspective that focuses on the ways that religion and religions are transformed by their interactions with media. This is most clearly and forcefully articulated by proponents of a theory called "the mediatization of religion." Proposed by Danish media scholar Stig Hjarvard (2012), this view holds that contemporary media, particularly in their industrial, electronic, "mass media" forms, have created entirely new structures of meaning, action, publication, association, and power that have transformed the prospects of religion. To paraphrase Hjarvard, in the current era, religion gradually takes on a media form as it accommodates to these new contexts of framing, action, and possibility. Hjarvard and others working in this direction (cf. Hepp & Kronert, 2010; Hjarvard, 2012) point to the myriad ways that the traditional location of religion, particularly of religious authorities and religious institutions, has been destabilized by modern practices of mediation. Something new is produced as religion encounters modern mass communication, in their view, and that something new operates according to the logics of the media and of mediation.

This mediatization thesis is valuable for suggesting that we have to think about the transformation of religion into something different as a result of its interactions with mass communication. It is not a simple question of how religion is framed or treated by media or a question of how religions use the media to meet various goals. Instead, we must look at the variety of ways that the media implicitly and explicitly change the terms of reference through which religions function. But it is not just a question of instrumental effects of media "on" religion. Entirely new forms of religion emerge, some consistent with tradition, some entirely distinct from it. The mediatization paradigm is a clear statement of the view I raised earlier—that we must understand the ways that media and religion are in fact *converging*, though it could be—and has been—criticized for an implicit instrumental determinism. In mediatization theory, the media are the first cause, with consequences flowing from their conditioning and framing of the prospects of religion, the latter understood primarily in structural or essential terms.

A contrasting view focuses instead on "the mediation of religion," suggesting that we must focus on the ways that religion and religions (along with faith, spirituality, and the range of practices that bear a family resemblance to religion) are always "mediated" in some way, and it is their mediation that should be the focus. Rather than assuming the determination of specific and particular means

of mediation (such as the modern "mass" media), we should instead think in terms of the historic trajectories of means, locations, and practices of mediation. So-called modern media are but a new iteration in a longer stream of social and cultural action. Scholarship should then focus as much on continuities as on discontinuities, and chart the ways that new possibilities and affordances emerge as new mediations are located, imagined, and brought into being.

Ideas of the mediation of religion are broadly humanistic in orientation but also draw on work in anthropology, folklore, and cultural studies. Important voices include anthropologist Birgit Meyer (2008), art historian David Morgan (1999), media scholar Jeremy Stolow (2010), religion scholar Kwabena Asamoah-Gyadu (2005), as well as a number of others. Meyer has demonstrated the value of the mediation paradigm through her persuasive theoretical contributions on the sources, extents, and practices of mediation. For example, she has provided a valuable concept through her work on aesthetics in relation to mediation, arguing that different forms of mediation encompass different attributes of practice. She has been particularly noted for her work on what she calls the "sensational forms" of religious mediation, the ways that logics of practice in mediation flow from the affordances of mediation as much as from history, doctrine, or other aspects of what we might want to think of as the "essentially" religious.

A third paradigm has persisted in a number of forms from the very beginning of at least the television era. This is a view that I call the "anachronistic" paradigm. Thinkers in this tradition focus on the ways that contemporary mediation of religion (often with particularly emphasis on the so-called modern mass media) approximates, replaces, or embodies the central places in the culture we think of as once occupied by religion. The emergence of television seemed to invite speculation about the ways that this new medium might take on the cultural role once assigned to religion in an earlier era. What Tönnies called *Gemeinschaft* assumed a central and determining role for religion, and it was compelling to think about the ways that television might be approximating that.

Among the early thinkers attracted to such an approach were Marshall McLuhan, Jacques Ellul, and Walter Ong. Mass communication scholar George Gerbner articulated a similar, though somewhat less grandiose, version with his notion that television might be thought of as "The New State Religion" (Gerbner & Connolly, 1978). These and other related approaches share in common the idea that the emergent systems of modern media constitute contexts that can carry various social and cultural burdens once carried in more self-evident ways by "religion." Much work on media ritual would also fall into this category, including Rothenbuhler's early (1998) and more recent (Rothenbuhler & Coman, 2005) efforts, Marvin and Ingle's (1999) *Blood Sacrifice and the Nation*, and, of course, the very influential work represented by Dayan and Katz's (1992) *Media Events*. What each of these suggests in its own way is that "religion qua religion" has somehow

been displaced in modernity and that its traditional functions can now be seen in other, typically mass-mediated, settings.

More recent work has taken up this perspective, though in some unique directions. Nick Couldry's (2003) *Media Rituals* explored the ways that contemporary practices of mediation, particularly affordances of practice introduced into the subjectivities of audiences, fulfilled important functions once associated with religion, assuming that religion ever did play the central, unifying role across cultures suggested in Durkheim's classic theory. Gordon Lynch's (2012) fascinating and persuasive work on contemporary conceptions of "the sacred" steps outside some of the traditional categories to suggest that what is centrally compelling in the culture—what it thinks of as sacred—emerges from broad public discourses and interactions that are a condition of contemporary life and its media.

A fourth direction for a strong program in religion and media is rooted more in interactionist and constructivist ideas about the nature of cultural practice. It is articulated more to the emergent digital media perhaps than to the large and central legacy media of earlier times. The digital media differ from earlier media in the important ways that they are more diverse and atomized than the so-called mass media, and "involve a presumption of generativity, interaction, and participation by their audiences." Consumers of digital media are "pro-sumers," it is argued, invited to think of themselves as active participants in the production process. They participate in making the media they consume.

It is, therefore, important to center analysis not on the institutions or texts of media but on the behaviors and practices of production and consumption of audiences. This fourth approach draws then on deeper traditions in media studies, particularly culturalist media studies, in focusing on audience practice and audience action, asking where and how and by whom new things in the way of religion and spirituality are imagined, created, and produced (Clark, 2005; Hoover, Clark, & Alters, 2003; Hoover, 2006). There is a large and growing literature in "digital religion," and most of it takes this interactivist-constructivist direction (Campbell, 2012; Helland, 2012).

My colleagues and our work on digital media in relation to religion and spirituality is a good example (Hoover & Echchaibi, 2012b). We initiated a study of religion in contemporary media we called "Finding Religion in the Media." We hoped to chart the ways and locations that senses of religion, spirituality, and the religious are present in the media landscape. Our hope was to develop a new taxonomy of forms of the mediation of religion. As our explorations proceeded, we became aware that the real momentum in contemporary mediation of religion is not in any of the legacy media but in the digital media, and that the way to understand it was through the practices of audiences and producers in making new and different things through their interactions with and through digital space. These efforts are interactive in a very fundamental way and assume that meaning

practices are instantiated in contexts where their practices of making these things and our (and others') practices of interpreting these things are best understood as constructed, not given or determined.

The digital and its affordances revealed themselves to be so important, in fact, that we have begun to use an entirely new conceptual turn to account for them. We have argued that in important ways, people inhabit the digital as "Third Spaces" between individual and community, between private and public, between informal and formal, between traditional and novel or elastic, and between authoritative and resistive. Ours and others' work on digital and social media thus extends the paradigm shift from traditional and instrumentalist views of media and mediation onto new turf, where practices can be seen and accounted for in their own terms.

What is obvious from the evolution of a strong program in media and religion in its varying and evolving forms is that some unique, some self-evident, and some necessary conditions for the development of scholarship on media and religion have now been met. These conditions were not as present at the dawn of the disciplines that surround media studies, particularly the field of mass communication. One of these was the recognition that there are things about religion, spirituality, and related domains that are unique, that are not simply variations on other themes. Religion is both like and unlike gender or race or ethnicity or political attitudes. The unique condition is that its own central uniqueness needed to be centered in order for media and religion scholarship to find its place and full force.

It should have been self-evident that religion was going to persist as a social and cultural force, in spite of the dominant thinking at midcentury. It is now clearer that attention to religion is justified by the category of "the religious" in its own terms. It exists, it persists, and it continues to motivate meaning and action by real actors in real locations worldwide. It cannot and should not escape scrutiny.

The necessary condition or conditions have been the evolution—through interdisciplinary interaction and through careful intellectual and conceptual work—of tools necessary to meet the challenges of studying religion in all its complexities and ambiguities. The media have also been their own challenge to scholarship, and new ways of thinking about media also needed to evolve before we could get to the place where we now find ourselves, with religion and media research the subject of a growing substantive, productive, and promising scholarly discourse.

None of these conditions and none of these developments evolved on their own. They were in the hands of human actors, people we think of as scholarly visionaries. We owe them much. We need them to push us, and our scholarship, forward. One who deserves to be thought at the center of the evolution of scholarship I have been describing here is Robert White. We owe him a great deal, and

the field of media and religion would not be what it is today, were it not for his vision, his efforts, and his scholarship.

Bibliograpy

Alexander, J. C. (1996). "Cultural Sociology or Sociology of Culture?" *Culture*, 10(3–4), 1–5.

Asamoah-Gyadu, J. K. (2005). *African Charismatics: Current Developments Within Independent Indigenous Pentecostalism in Ghana*. Amsterdam: Brill.

Campbell, H. (2012). "Understanding the Relationship between Religion Online and Offline in a Networked Society." *Journal of the American Academy of Religion*, 80(1), 64–93.

Clark, L. S. (2007). "Introduction." In L. S. Clark (Ed.), *Religion, Media, and the Marketplace* (pp. 1–36). New Brunswick, NJ: Rutgers University Press.

Clark, L. S. (2005). *From Angels to Aliens: Teenagers, the Media, and the Supernatural*. New York: Oxford University Press.

Couldry, N. (2003). *Media Rituals: A Critical Approach*. London: Routledge.

Dayan, D., & E. Katz. (1992). *Media Events: The Live Broadcasting of History*. Cambridge, MA: Harvard University Press.

Frankl, R. (1987). *Televangelism: The Marketing of Popular Religion*. Carbondale: Southern Illinois University Press.

Geertz, C. (1993). "Religion as a Cultural System." In C. Geertz (Ed.), *The Interpretation of Cultures* (pp. 87–125). New York: Oxford University Press.

Gerbner, G., & K. Connolly. (1978, March–April). "Television as New Religion." *New Catholic World*, 52–56.

Giddens, A. (1992). *Modernity and Self-Identity*. Stanford: Stanford University Press.

Grossberg, L., & P. Treichler. (1992). "Cultural Studies: An Introduction." In L. Grossberg, C. Nelson, & P. Treichler (Eds.), *Cultural Studies* (pp. 1–16). New York: Routledge.

Hadden, J., & A. Shupe. (1988). *Televangelism: Power and Politics on God's Frontier*. New York: Henry Holt.

Hadden, J., & C. Swann. (1981). *Prime-Time Preachers: The Rising Power of Televangelism*. Reading, MA: Addison-Wesley.

Helland, C. (2012). *Internet Communion and Virtual Faith: The New Face of Religion in the Wired West*. New York: Oxford University Press.

Hepp, A., & V. Kronert. (2010). "Religious Media Events: The Catholic World Youth Day as an Example of the Mediatization and Individualization of Religion." In N. Couldry, A. Hepp, & F. Krotz (Eds.), *Media Events in a Global Age* (pp. 265–282). New York: Routledge.

Hjarvard, S. (2012). "Three Forms of Mediatized Religion." In S. Hjarvard & M. Lövheim (Eds.), *The Mediatization of Religion: Nordic Perspectives* (pp. 21–44). Gothenburg: Nordicom.

Hoover, S. (forthcoming). "Religious Authority in the Media Age." Introduction to S. M. Hoover (Ed.), *The Media and Religious Authority*.

Hoover, S. M. (2006). *Religion in the Media Age*. London: Routledge.

Hoover, S. M. (1988). *Mass Media Religion: The Social Sources of the Electronic Church*. London: Sage.

Hoover, S. M., L. S. Clark, & L. Rainie. (2004). *Faith Online*. Pew Internet & American Life Project. Available at http://www.pewinternet.org/~/media//Files/Reports/2004/PIP_Faith_Online_2004.pdf.

Hoover, S., & N. Echchaibi. (Eds.). (2012a). *Finding Religion in the Media: Case Studies of the "Third Spaces" of Digital Religion*. Boulder: Center for Media, Religion, and Culture, University of Colorado.

Hoover, S., & N. Echchaibi. (2012b). "The Third Spaces of Digital Religion." In S. Hoover & N. Echchaibi (Eds.), *Finding Religion in the Media: Case Studies of the "Third Spaces" of Digital Religion*. Boulder: Center for Media, Religion, and Culture, University of Colorado.

Hoover, S., L. S. Clark, & D. Alters. (2003). *Media, Home, and Family*. London: Routledge.

Horsfield, P. (1984). *Religious Television: The American Experience*. New York: Longman.

Lerner, D. (1964). *The Passing of Traditional Society: Modernizing the Middle East*. Glencoe, IL: Free.

Lynch, G. (2012). *The Sacred in the Modern World: A Cultural Sociological Approach*. London: Oxford University Press.

Marvin, C., & D. Ingle. (1999). *Blood Sacrifice and the Nation: Totem Rituals and the American Flag*. New York: Cambridge University Press.

Meyer, B. (2008). "Religious Sensations: Why Media, Aesthetics and Power Matter in the Study of Contemporary Religion." Lecture, Faculty of Social Sciences, Free University of Amsterdam, July.

Morgan, D. (1999). *Protestants and Pictures: Religion, Visual Culture, and the Age of American Mass Production*. New York: Oxford University Press.

Newcomb, H. (1983). "Television as a Cultural Forum: Implications for Research." *Quarterly Review of Film Studies*, 8(3), 45–55.

Parker, E., D. Barry, & D. Smythe. (1954). *The Television-Radio Audience and Religion*. New York: Harper.

Roof, W. C. (1998). *Spiritual Marketplace: Baby Boomers and the Remaking of American Religion*. Princeton, NJ: Princeton University Press.

Rothenbuhler, E. (1998). *Ritual Communication: From Everyday Conversation to Mediated Ceremony*. Beverly Hills: Sage.

Rothenbuhler, E., & M. Coman. (2005). *Media Anthropology*. Beverly Hills: Sage.

Silverstone, R. (1981). *The Message of Television: Myth and Narrative in Contemporary Culture*. London: Heinemann.

Stolow, J. (2010). *Orthodox by Design: Judaism, Print Politics, and the Art Scroll Revolution*. Berkeley: University of California Press.

Turner, G. (2002). *British Cultural Studies: An Introduction*. London: Routledge.

Turner, V. (1969). *The Ritual Process: Structure and Anti-Structure*. New York: Transaction.

White, R. (1987a, January). "Media Myths and Narratives." *Communication Research Trends*, 8(1). Center for the Study of Communication and Culture, London.

White, R. (1987b, January). "Mass Media and the Religious Imagination." *Research Trends in Religious Communication*, 8(1). Center for the Study of Communication and Culture, London.

Winston, D. (2009). *Small Screen, Big Picture: Television and Lived Religion*. Lubbock, TX: Baylor University Press.

CHAPTER THIRTEEN

Theorizing Development, Communication, and Social Change

PRADIP N. THOMAS

Paulo Freire's life and work were marked by his wanting to democratize the act of knowing in order that people may change the world. Both Freire's theory and method have definitely contributed to my own understanding of communications as a practice and engagement and to my theorizing of communication for social change. In addition, Peter Golding's lectures on political economy at the Centre for Mass Communication Research, University of Leicester; Indian social psychologist Ashis Nandy's always unsettling but deeply intriguing interpretations of tradition and modernity; along with the lifework of an assorted group of activists in India have contributed to my conviction that theory as a framework for understanding the world needs to be conversant with context. The Marxian tradition, too, has offered me the means to reflect on the material basis of exploitation, and my writings on social change, religion, communication rights, and the media have rather unapologetically highlighted theory supportive of change. I have also realized in my journey that no theory is perfect and that the theories best suited to deal with life's complexities are those that factor in openness and contingency.

Most of my writings on development reflect what I consider as critical engagements with reality. Development remains one of the key challenges of our times, although as an industry, it remains, for the most part, impervious to the pathways to change that have been highlighted in the literature on development. This disjuncture is best reflected in the gaps that exist between theory and practice in development and also in development communication/communication and

social change, an area that Robert White has engaged for more than four decades. White's (2004) overview, titled "Is Empowerment the Answer," reviews some of the key CSC issues but strikes a cautious note on the limits of "empowerment," a term that is used rather freely by CSC theorists.

> The concept of empowerment, as it has been developed so far, is, at best, incomplete and possibly dangerous if it is not oriented more clearly towards the service of society. Empowerment needs to be explicitly located within a broader framework of commonly agreed upon parameters of human and social equity . . . one may ask if "empowerment" and "power" are, in themselves, a sufficient basis for policy and for theory of communication and development. Perhaps more important is the culture of service, the culture of dialogue and community and the culture of human rights. (White, 2004, pp. 21–22)

In the context of the industrialization of development, I would concur with Robert White that theory has become ossified and that many of the concepts that could have contributed to the making of a new order—participation, empowerment, civil society—have been evacuated of critique and now exist merely as buzzwords. At the very same time I would argue that any theory based on the project of modernity simply has to converse with indigenous categories that cannot be wished away. People in the South often live simultaneously in two worlds. Theories often do not account for this fact.

This chapter will focus on the theorizing of communication and social change. It will argue that theory must enable people to know the world. It will also argue the limits to token participation and the unsustainability of "behavioral change communication" that is theorized outside of structures, power flows, and cultures. Using the Right to Information movement in India as a case study, this chapter will explore grounded meanings of "voice" and "participation" and will argue the need for a theory of communication for social change that is informed by people's needs and struggles. If theory is a set of principles informed by and drawn from observations of everyday needs and practice, its explanatory power is bound to remain consistent over time. Theory offers us a framework for knowing the world and the validation of concepts that are critical to apprehending and making sense of reality. I argue in this chapter that the Right to Information movement in India gives opportunities to explore communication and social change theory from the bottom up.

An Impasse in Theorizing Development Communication

How to theorize communications and social change previously known as "development communication" remains a challenge today. This challenge is a result of many factors: the changing context of both development and communication; the large-scale institutionalization of development as an enterprise, resulting in the co-option of the many key words in development that we take for granted

including empowerment, participation, and access; the many possibilities and limitations of new technologies; and the ascent of and accent on market-oriented solutions such as social entrepreneurship. While the focus on behavioral change communication has certainly resulted in theoretical innovation in areas such as health and participatory communication, to novel understandings of communication as process and alternative media, for the most part the practical horse has galloped ahead of the theoretical cart.

The field itself can no longer boast of the unity it once had via the traditions associated with the triumvirate consisting of Daniel Lerner, Everett Rogers, and Wilbur Schramm. While the dominant paradigm has been critiqued for its limitations, traditions such as the diffusion of innovations did offer practical solutions to farmers, especially those who had the resources to translate scientific information into actual practice and increased productivity. Among the failures of the dominant paradigm was its inability to factor in context, explore solutions from below, and nonmarket solutions. Despite its limitations, this tradition remains strong in many parts of the world precisely because an increase in agricultural productivity requires farmers who are willing to try out innovations and new scientific practices that are communicated through information transfers. Access to information, for example, on health and nutrition, enables people to make choices and adopt practices that can make a difference in their lives. However, this tradition's top-down nature is its Achilles heel given that it is perfectly suited to replicate and reinforce information flows consonant with top-down hierarchies. The inability of this tradition to offer flexible solutions has attracted criticism.

The advent of the participatory model has stymied further theoretical innovation, given that this was interpreted as the Holy Grail that would usher in the Promised Land characterized by communications for all. Key words such as "development," "participation," "social capital," "poverty reduction," "civil society," and "empowerment," among others, have an auratic power that disallows any form of questioning. Issue 4–5 of the journal *Development in Practice* (2007) is devoted to a deconstruction of such key words, and Andrea Cornwall (2007), in an article titled "Buzzwords and Fuzzwords: Deconstructing Development Discourse," makes the following observation:

> Development's buzzwords are not only passwords to funding and influence . . . The word *development* itself . . . has become a modern shibboleth, an unavoidable password, which comes to be used to convey the idea that tomorrow things will be better, or that more is necessarily better. . . . The very taken-for-granted quality of development . . . leaves much of what is actually *done* in its name unquestioned. (p. 471)

The critique of the dominant paradigm and of its triumvirate Schramm, Rogers, and Lerner is now passé, although arguably the dominant paradigm today is the participatory model favored by the development enterprise. There is a confu-

sion with understandings of participation and an inability by theorists to critique the domestication of participation within the global neoliberal economic order. Emile McAnany's (2012) history of communication for development and social change, for example, offers a very U.S.–inspired history of this field, while not engaging with social movements that arguably have demonstrated the scalability of participation, an impossibility that NGOs find hard to replicate because of the bounded and local-specific nature of many of their activities. The book also fails to account for the primacy of voice that, in my way of thinking, is the key to successful social entrepreneurship, which is highlighted in the book as an emerging innovation in this field.

The Critique of Participation

Participation has become the raison d'etre of governments and civil society shaped by the rhetoric and reality of interactivity via new technologies, the promise of a leaner and more pro-active government 2.0, and the promise of redemption via consumption. This vision of a new, technologically mediated world has been contested and has pitched academics, such as Henry Jenkins, who largely see the benefits of convergence culture to the individual against those such as Mark Andrejevic, who have pointed out the deeply market-driven model that interactivity fundamentally supports, and the role played by individuals in contributing personal information to the market often without becoming aware of the economics is at the heart of social networking. Andrejevic (2011), in an article on the "affective economics" of interactivity and the limits of the kind of thinking exemplified by Henry Jenkins' *Convergence Culture*, refers to "sentiment analysis" as a new marketing technique that is used to "probe the emotional pulse of the Internet" (p. 610). At the end of the day, audience identification with brands, in spite of the hype of interactivity, are attempts at control and not empowerment.

However, the critique of participation has most cogently been made by those who have queried the "redemption through consumption" model of development that does not require any change in existing structures of society. This model of development is committed to charity, although typically it is described as a type of partnership extended through consumption. The corporate sector has perfected this art or perhaps artifice since it recognizes that the act of giving does have affective components that can also be usefully included in the very act of consumption. In this environment, participation has become mainstreamed and has itself become the basis for the renewal of capitalism via a variety of acts of "causumerism" whereby the act of consumption of a given product, say Fair Trade coffee, is also a redemptive act in that it enables correspondences between one's affective ties with a distant suffering.

There are, at any given time, a range of such initiatives best illustrated by Red products endorsed by AMEX, Levis, Bono, and others. Lisa Ann Richey and Stefano Ponte (2011) use the example of Red products and its creation of value that

> provides an easy solution to current crisis in international development—one that enables corporations to raise their CSR profile without substantially changing their normal business practices while consumers engage in low-cost heroism without meaningfully increasing their awareness of global production-consumption relations or the struggles of people living with HIV/AIDS. (pp. xiii–xiv)

The purchase of a given Red range product also involves a commitment on the part of the manufacturer of that product to donate money to a Third World cause—such as that of fighting AIDS in Africa.

Žižek (2009), in his book *First as Tragedy, Then as Farce*, uses the example of Starbucks' corporate social responsibility to illustrate this redemption through consumption mode of thought. In their advertisement, buying coffee at Starbucks not only involves buying into a high-value product but an ethically sourced product—good coffee karma!!—thus reinforcing what one might term "affective capitalism."

> At the level of consumption, this new spirit is that of so-called "cultural capitalism" we primarily buy commodities neither on account of their utility not as status symbols; we buy them to get the experience provided by them, we consume them in order to render our lives pleasurable and meaningful. . . . The price is higher than elsewhere since what you are really buying is the "coffee ethic" which includes care for the environment, social responsibility towards the producers, plus a place where you yourself can participate in communal life, dare I say, from the comfort of our armchair. (pp. 52–54)

This engagement with brands extends charity because what it does is what charity does best and that is to engage the symptoms and not the causes of poverty and deprivation.

Bill Cooke and Uma Kothari's (2001) edited volume, *Participation: The New Tyranny*, remains among the most cogent critiques of the theory and practice of participation and of the institutions that have invested participation with an almost mythical status. They address three tyrannies—tyranny of decision-making and control, tyranny of the group, and tyranny of method—through the exploration of three questions:

> Do participatory facilitators override existing legitimate decision-making processes? Do group dynamics lead to participatory decisions that reinforce the interest of the already powerful? Have participatory methods driven out others which have advantages participation cannot provide? (pp. 7–8)

In their introductory chapter, they state some of the findings highlighted in the chapters throughout the volume, including

the naivety of assumptions about the authenticity of motivations and behavior in partici-
patory processes; how the language of empowerment masks real concern for managerialist
effectiveness; the quasi-religious associations of participatory rhetoric and practice; and
how an emphasis on the micro level of intervention can obscure, and indeed sustain,
broader macro-level inequalities and injustice. (p. 14)

In the context of what is resolutely a neoliberal discourse of development, nongov-
ernment organizations (NGOs) typically gravitate toward a minimalist embrace
of participation, a concept largely transformed into an empty signifier. While
there are at any given time a plethora of NGOs in India involved in community
radio, participatory video, cultural action, media advocacy, and ICTs in develop-
ment, there are few studies available on the impact of such projects and the extent
to which they have contributed to the making of participation into a genuinely
empowering process and ethic. In fact, across the border in Nepal, a home for
close to 170 community radio stations, most of them run by one sort of NGO or
the other, many run by families, participation has been problematic and has led to
the development of a station-monitoring kit that measures the levels and quality
of the overall effectiveness of these stations.

The Basis for a Theory of Communication and Social Change

Any communications and development project is based on four distinct levels:

1. *A theory of knowledge,* that is, an epistemological understanding of why
 and how a communications intervention will result in the required
 change. So, in the case of edutainment, this epistemology is based largely
 on Albert Bandura's concept of para-social identifications, or audience
 identification with a role model, as the basis for behavioral change. A
 theory of knowledge in the context of communication and development
 will need to be explicit about the nature of access and participation.

2. *A knowledge of structures,* meaning the institutions and power flows that
 play a role in the structuring of interventions. In an extensive district-
 wide health communications project, those involved in the project—
 from the health ministry to local health intermediaries, those involved in
 creative interventions—must read from the same page and must buy in
 to the project. In other words there needs to be political will.

3. *A specific understanding of practice* and, in particular, the relationship
 between communication channels and processes. In the community ra-
 dio movement, for example, there is a specific belief in the validity of
 community-based participation in operating community radio. Today, a
 whole raft of participatory communications practices—from participa-

tory rural appraisal to participatory planning and evaluation and action research–related processes—have now become mainstreamed.

4. *A specific understanding of context*, meaning the environment and community that is the location for the intervention. Any intervention has to be conversant with the locality in all its complexity—tradition, hierarchy, culture, norms, divisions. Theory, in other words, needs to be grounded for it to become effective.

When these four levels are applied to an assessment of communication and development projects, it is clear that in the case of the vast majority of projects, one or the other level is often privileged at the expense of other levels, resulting in an incomplete denouement of the project. For example, in development projects in India, it is clear that the dominating level is that of practice. There is a belief that telecenter projects, for example, will result in "push" and "pull" effects and eventually to information flows that make a difference in the lives of people. E-governance, for example, is based on the "pull" factor—meaning people accessing and making use of online information related to a variety of services. In other words the theory of knowledge associated with ICTs is more often than not taken for granted rather than based on a clear and sophisticated understanding of the interrelated nature of knowledge generation. Often the knowledge of structures is not factored in and neither is a knowledge of context. There are exceptions such as the Bhoomi (Land records) project in Karnataka, India, that was specifically directed toward creating an accessible database of land records that could be accessed by the local farmer without having to enlist the help of the local revenue officer. In the case of Bhoomi, the computerization of land records and the provision of district-wide kiosks based on biometric identifications helped "disintermediate"—that is, cut out the middle man—resulting in an efficient, transparent exchange of information on land records.

Theory Building from Below: The Right to Information Movement in India

While one should not discount the contributions made by NGOs to participatory communications, one can argue that nationwide social movements like the Right to Information movement (RTI) have contributed to the mainstreaming of life-affirming processes of participation that today have nationwide legitimacy. The strength of such movements is that they have transformed tried and tested local forms of participation into a nationwide ethic and, in that process, validated the low-cost and everyday cooperative styles and local communicative practices. As opposed to formulaic, top-down participation, movements like the RTI have turned participation as a skill, ethic, and process into the very basis for people's empowerment. It can be argued that local cultural forms and activities are typi-

cally relational, and it is this accent on process that facilitates individual buy-in into a movement. Klandermans and Oegema (1987) refer to the four-step processes involved in individual participation in movements

> becoming part of the mobilization potential, becoming target of mobilization attempts, becoming motivated to participate, and overcoming barriers to participate. The first two steps are necessary conditions for the arousal of motivation. Motivation and barriers interact to bring about participation: the more motivated people are the higher the barriers they can overcome. (p. 519)

The Right to Information movement is one of the most significant social movement success stories in India. One of the consequences of this movement is the Right to Information Bill (2005) that has influenced and, in turn, has been molded by prior right-to-information legislation in a number of states in India inclusive of Rajasthan, Madhya Pradesh, Maharashtra, Goa, Tamil Nadu, Karnataka, Delhi, and Andhra Pradesh. From a citizen's perspective, the fact that the key impetus for this bill began through struggles at a grassroots level—more specifically via a peasant's movement in the state of Rajasthan, the Mazdoor Kisan Shakti Sangathan (MKSS), a movement committed to land, livelihood, and wage rights—is little short of remarkable. The MKSS was officially formed in 1990 by local activists including Aruna Roy, Nikhil Dey, and Shankar Singh in Devdungri, a village in the state of Rajasthan. Their early work focused on struggles for minimum wages, land, and women's rights, mainly with landless laborers, and struggles to make the Public Distribution System accountable. Their own Spartan lifestyles, their life with people, and their refusal to accept international or government funding for their work placed them in a different category from the average NGO employee in India who is, for the most part, beholden and captive to the exigencies of foreign funding. In 1994, and in the face of official recalcitrance and unwillingness to cooperate with people's demands, the MKSS decided to organize public hearings [jan sunwais].

Theorizing Voice

As important, these hearings have indeed provided opportunities for the subaltern to speak and indeed be heard and listened to. The post-colonial writer Gayatri Spivak had written a classic text, *Can the Subaltern Speak?*, a critique of the methods and focus of subaltern studies. As Marcus Green (2002) points out, Spivak's critique was substantive for it pointed out that the re-creation of subaltern consciousness from old, colonial, British records was a flawed project.

> The major problem with such a project is that it requires one not only to know the consciousness and position of the subaltern but also to represent that consciousness. This problem is illustrated in the fact that the subalternists rely on British, nationalist, and colonialist records to research and validate their work. In Spivak's view the subaltern leave

little or no traces of their existence within elite, colonial documents and, if the subaltern are represented at all, they are represented as the Other within dominant, elite ideology. It is in this sense that the subaltern cannot speak, according to Spivak, because representations of the subaltern are embedded within the dominant discourse. (p. 16)

Unlike the dilemma faced by subaltern theorists who were involved in re-creating counter-narratives from fragments of text, the subaltern histories of people involved in the RTI movements can indeed be written precisely because voicing was a deliberate process and method that was central to these public hearings that became a powerful case in favor of transparency and accountability.

One of the fundamental contributions of the RTI in India is the valorization of Voice. Voice needs to be seen as the politics of speaking in contexts in which the right to speak is a privilege associated with the structures of domination undergirded by caste, class, and gender. Taken in this sense, the spoken voice in the context of public hearings popularized by the RTI movement in India is an invitation to listen and dialogue. The empowerment that results from naming corruption and non-accountability is an act of freedom precisely because that act connects self, and the obligations of self to, the community, thus strengthening the larger environment of a communicating public. Eric Watts (2001) has argued

that voice is a particular kind of speech phenomenon that pronounces the ethical problems and obligations incumbent in community building and arouses in persons and groups the frustrations, sufferings and joys of such commitments. . . . Voice, then, is the sound of specific experiential encounters in civic life. (p. 185)

In the context of these public hearings, there is always a public acknowledgment of voice that leads to the valorization of agency. These public hearings demonstrate, in a profound manner, ideal environments for communication rights—environments in which any given person's right to speak is no lesser than the right of others. These are also environments that are conducive to listening. One can argue that enabling both voice and listening has been the key to reinvigorating participation.

Nick Couldry's (2010) book, *Why Voice Matters: Culture and Politics after Neoliberalism*, is fundamentally a critique of neoliberalism and market rationalities that have made it impossible for ordinary persons to give "an account of themselves," a process that is fundamental to democracy. He decries the fact that neoliberalism is selective in the way in which it values voice and critiques the manner in which markets facilitate a type of voice that does not further deliberativeness or an agonistic public sphere. This book offers us the resources to explore voice as process, in particular those structures and frameworks for voice and ways of organizing that are founded on a recognition of voice. The recognition of such frameworks for voice-making is important precisely because within neoliberal contexts, the morality of deliberativeness and systems based on deliberativeness

have been elided in favor of an unquestioned acceptance of the market and its logic. As Couldry points out, "An attention to voice means paying attention, as importantly, to the conditions for effective voice, that is, the conditions under which people's practices of voice are sustained and the outcomes of these practices validated" (p. 11). It is this enabling of voice within environments supportive of voice that has led to new possibilities for social change in India. Arguably, such examples point toward practices that can become the basis for a theorizing from below—a theorizing that has eluded the enterprise of communications for development.

The RTI is an essential aspect of the Right to Know, and this knowing—and being able to act on what is known as a consequence of one's access to information—is what is ultimately significant. The information that people access in the context of the RTI can make a difference in their lives and is thus vital to the leveraging, facilitation, and knowledge of change processes. In other words, this knowing can result in empowerment that can have a major impact on the project of substantive democracy and citizenship. Empowerment, even on a local scale, can be powerful, simply because submerged or marginalized voices can now be heard. Ananda Mitra (2002) observes that "an examination of voice extends well beyond the intentions or motives of a speaker. Voice calls upon us to consider how a particular act of public discourse or how rhetoric in general constitutes the ways in which a community sustains or reinvents itself" (pp. 483–484).

The right to speak was used powerfully to counteract the right of established voices such as that of politicians who, in the early 1990s, used *Rath Yatras* (motorized chariots used in political campaigns) and other means to consolidate the Hindu vote against minorities, in particular Muslims. The MKSS empowered villagers to use their voices in *yatras* (mobile campaigns) of their own, thus demonstrating to people that voice is not a privilege but a right. Aruna Roy (2004) describes the "truck *yatras*" that were used by the MKSS:

> Called the *Jan Nithi* and *Jan Adhikar Yatra*, 40 to 50 volunteers travelled through several districts in Rajasthan in the back of a truck. One objective was to lampoon political *yatras* themselves. Street theatre, music and other forms of cultural expression were used to take the debate about democracy and participatory governance to the people. The *yatras* have been extremely useful in starting genuine debates, emanating from the common people's concern about their future, and the future of the country. (p. 17)

Validating Theory from Below: The *Jan Sunwai* and Empowerment

The *Jan Sunwai* [public hearings] is an important indigenous means and pedagogical device used by this movement to mobilize, radicalize, and give voice to marginalized people who have traditionally been expected to remain silent, even

in the face of the most atrocious atrocities committed by the forward castes and wealthy. As Jenkins (2006) describes it,

> The MKSS's key innovation . . . was to develop a novel means by which information found in government records could be shared and collectively verified: the *jan sunwai*. A *jan sunwai* is a publically accessible forum, often held in a large open-sided tent pitched on a highly visible sport, at which government records are presented alongside testimony by local people with firsthand knowledge of the development projects that these records purpose to document. Key pieces of information from project documents are read aloud. Those with direct knowledge of the specific government projects under investigation are invited to testify on any apparent discrepancies between the official record and their own experiences as laborers on public-works projects or applicants for means-tested antipoverty schemes. (p. 60)

Public hearings played an important role in creating popular understandings of the Right to Know.

The strength of the Right to Information movement in India includes the following. It is an indigenous social movement that was a response to felt needs. It started as a grassroots movement supported entirely by voluntary, local contributions, and it employed familiar pedagogical tools like the *Jan Sunwai* that were used to strengthen and valorize Voice. The *Jan Sunwai* is often used by traditional organizations in India, such as guilds and associations of small traders and manufacturers, to make themselves accountable to their publics. The *Jan Sunwai* as described in the *Lokniti Newsletter* (2005) is "an empowering process in that, it not only does away with civil society structures that are stacked against the marginalized but also inverts power equations in favor of the marginalized, by making them the center of the discussion. There are no experts and hence no chance of objectifying the victim, since victims represent their cases without any technical assistance." In the words of the Dalit intellectual Gopal Guru (2008),

> The *sunwai* is a public hearing but it is different from legal and procedural hearings instituted by the state which by its official, legal, and almost pompous nature, place the victim at an inherent disadvantage. The *sunwai* restores to a person his place in the system by allowing him to represent himself and make himself heard.

Most important, the *Jan Sunwai* is a mechanism that affirms Voice, strengthens self-confidence often in contexts where caste and class collude to silence people. In the context of the RTI movement, these public hearings allowed local people to examine both the information and dis-information on local development, the collusions, the silences, the corruption, and the political economy of underdevelopment. Fifteen *Jan Sunwais*, organized in advance, became critical to the empowerment process. These public hearings were complemented by *dharnas* [sit-ins] at the office of the chief minister and local government in the face of official inaction on the evidence of corruption. The *dharna* as nonviolent civil

resistance also became the space for celebrating solidarity. There were instances when the *dharnas* stretched over days in the context of stalemates.

These hearings took the form of an audit of local level development projects, especially the social audit of "employment muster rolls" and expenses related to public works and wages paid to workers. This led to the demand that all copies of documents related to public works be made public. However, local government officials were not cooperative in the beginning and, in fact, launched their own counter-campaigns against the Right to Information movement. These hearings, however, took on a life of their own. As more and more people throughout the state began to hear the literally hundreds of stories of corruption, they became empowered to act on this information. In district after district, these hearings exposed the vast gaps between official expenditures on development projects and the actual expenditures. These hearings unearthed evidence of widespread corruption and the systemic links between local officials and politicians who were also involved in a variety of scams. This evidence discussed at the public hearings led to nonviolent civic actions, boycotts, and sit-ins at government offices that were systematically used to wear down the opposition and elicit a response from the government. These local resistances reinforced what the public already knew, the fact that there was gross misappropriation of funds—wages paid to the fictitious, even to workers who had died years back, incomplete public works projects such as roads and buildings that were listed as complete when they were either partially complete, abandoned, non-existent, and often made from substandard building materials.

At local levels, the right to information as opposed to, say, the more abstract right to communication has become a proven, essential human right in the sense that it has become the basis for prying open other rights and entitlements denied to people. In the context of real increases in poverty during the last decade, the right to information has become a means of survival for India's poor. Jha, Gupta, Nedumpra, and Karthikeyan (2003) in a monograph on "Trade Liberalization and Poverty in India" observe that studies have shown

> an increase in the incidence of poverty among rural laborers. Despite healthy growth, poverty levels remained high because of the increase in inequality and the decline in agricultural wages, and, also on account of the rise in food prices, especially in the subsidized food prices in the PDS . . . the targeting and coverage of the PDS have been inadequate and therefore the system has failed to shield the poor from the rise in food-grain prices that has followed the rise in the price of fertilizers and the procurement of food grains in the aftermath of reforms. (p. 14)

All available studies seem to indicate that the Right to Information movement has played no small role in revitalizing participatory democracy in India and has contributed to the revitalization of the theory of communication for social change. Rather significant, however, the success of this movement is linked not just to the

validation of voice but to voice becoming the basis of entitlements within environments supportive of voice-making, and to structural change inspired by the need for transparency and accountability.

Conclusion: Fragments of Theory

1. Public hearings have played an important role in creating the momentum for participatory democracy, through public participation and the creation of new spaces, arenas, and environments supportive of a new politics of possibility. This has been vital to the reestablishment of democracy from below and to the renewal of traditional political instruments leading to a grassroots revitalization of democracy at state and central levels in India that was in dire need of an overhaul.

2. Unlike in the West and other parts of the world where the right to information is tied to freedom of expression and press freedom, the struggle in India has tied this right to the basic rights to life and survival (to issues such as drought, employment, health, electoral politics), marking a distinct and in fact radical departure from other struggles around information rights. In the words of Sivakumar (2004), "It really is this integration taking place with a wide range of issues, from food security, to displacement to communal violence that is relatively new and continues to give it life and sustenance" (online version). This tying in to the politics of basic needs is an important statement that India today, irrespective of its emergence as a software manufacturing center, is still home to 350 million people who are below the poverty line, half the population who are illiterate, high infant mortality, and among the highest child labor rates in the world.

3. The Right to Information movement, through its innovative struggles has revitalized the project of participatory communication in India. The creation of the Right to Information Bill (2005) and the various state level legislations on the right to information have been unprecedented. While these legislations vary in their democratic potential, the fact remains that the impact of this particular movement cannot be compared to the impact of any other movement related to media reform. Furthermore, this movement has demonstrated the political potential of indigenous civil society in creating an impetus for reform.

4. The example of the Right to Information movement in India, and in particular the relationship between public hearings and voice, does suggest that CSC theory can be reinvigorated and revitalized through the exploration of interventions and innovations that are culturally relevant

and local. The theorization of voice does contribute to understandings of participation and social change. Most important, the example of the Right to Information movement does suggest that when local people are involved in articulating needs, there will be sustainability of the practice of communication and social change and opportunities to theorize from practice—assumptions that Robert White has indeed espoused over many years of research.

Bibliography

Andrejevic, M. (2011). "The Work that Affective Economics Does." *Cultural Studies*, 25, 4–5.

Cooke, B., & U. Kothari. (Eds.). (2001). *Participation: The New Tyranny*. London & New York: Zed.

Cornwall, A. (2007). "Buzzwords and Fuzzwords: Deconstructing Development Discourse." *Development in Practice*, 17(4–5), 471–484.

Couldry, N. (2010). *Why Voice Matters: Culture and Politics after Neoliberalism*. Los Angeles & London: Sage.

Development in Practice. (2007). 17(4–5).

Green, M. E. (2002). "Gramsci Cannot Speak: Presentations and Interpretations of Gramsci's Concept of the Subaltern." *Rethinking Marxism: A Journal of Economics, Culture and Society*, 14(3), 1–24.

Guru, G. (2008, February 11). "*Jan Sunwai*: A New Instrument of Democracy in India." *Democracy Asia*. Available at http://www.democracy-asia.org/casestudies_gopal_guru.htm

Jenkins, H. (2006). *Convergence Culture: Where Old and New Media Collide*. New York: New York University Press.

Jha, V., S. Gupta, J. Nedumpra, & K. Karthikeyan. (2003). "Trade, Liberalization and Poverty in India." UNCTAD. Available at http://www.unctadindia.org.studies_tradeliberalisation AndPovertyinIndia.pdf

Klandermans, B., & D. Oegema. (1987). "Potentials, Networks, Motivations, and Barriers: Steps Towards Participation in Social Movements." *American Sociological Review*, 52(4), 519–531.

Lokniti Newsletter. (2005, November). p. 8.

McAnany, E. (2012). *Saving the World: A Brief History of Communication and Development and Social Change*. Urbana: University of Illinois Press.

Mitra, A. (2002). "Theorizing Cyberspace: The Idea of Voice Applied to the Internet Discourse." *New Media & Society*, 4(4), 479–498.

Mitra, A. (no date). "The Right to Information Discourse in India." MKSS. Available at http://www.mkssindia.org/node/50

Richey, L. A., & S. Ponte. (2011). *Brand Aid: Shopping Well to Save the World*. Minneapolis & London: University of Minnesota Press.

Roy, A. (2004, May 3). "Fostering Informed Choices: Ethical Challenges for the Fourth Estate." Convocation Address, Asian College of Journalism, ASJ, Chennai, 1–24.

Roy, A. (1996). "Survival and Right to Information." Gulam Rassol Third Memorial Lecture, MKSS, Rajasthan.

Sen, P. (2006). "The Right to Information Act: Turning It into an Effective Tool to Combat Corruption in Government." pp. 1–8. Available at http://papers.ssrn.com/sol3/papers.cfm?abstract_id=981256

Sivakumar, S. K. (2004, December). "A Battle for Information." *Frontline*, 21(26), 18–31. Available at http://www.frontlineonnet.com/fl2126/stories/20041231002009600.htm

Watts, E. K. (2001). "Voice and Voicelessness in Rhetorical Studies." *Quarterly Journal of Speech*, 87(1), 179–216.

White, R. (2004). "Is Empowerment the Answer? Current Theory and Research on Development Communication." *International Communications Gazette*, 66(7), 7–24.

Žižek, S. (2009). *First as Tragedy, Then as Farce*. London & New York: Verso.

Human Rights and Communication

Reflections on a Challenging Relationship

CEES J. HAMELINK

The Beginning of a Relationship

The most essential standard in human rights law that relates to information and communication is the entitlement to free speech.

When, during World War II, drafts for a post-war international bill of rights were prepared, freedom of expression figured prominently. In a text produced by a commission of the U.S. Department of State in 1942, it was stated, "All persons shall enjoy freedom of speech and of the press, and the right to be informed." Immediately after the war in 1945, the UNESCO Constitution was adopted, It was the first multilateral instrument to reflect concern for the freedom of information and was largely based upon U.S. drafts (Wells, 1987). These drafts included, among others, a proposal stressing the paramount importance of the mass media and "the need to identify opportunities of UNESCO furthering their use for the ends of peace." To promote the implementation of the concern for freedom of information, a special division of "free flow of information" was established in the secretariat in Paris.

In 1946, the delegation of the Philippines presented to the UN General Assembly a proposal for a resolution on an international conference on issues dealing with the press. This became UNGA Resolution 59(I), which was adopted unanimously in late 1946. According to the resolution, the purpose of the conference would be to address the rights, obligations, and practices that should be included in the concept of freedom of information. The resolution called freedom

of information "the touchstone of all the freedoms to which the United Nations is consecrated."

The 1948 conference produced a draft treaty on freedom of information that was adopted by the General Assembly in 1949 but was never opened for signatures because of the ideological battle between the United States and the USSR. The key provision on the standard of free speech was phrased in the Universal Declaration of Human Rights (1948) in Article 19. This article provided that "everyone has the right to freedom of opinion and expression; this right includes freedom to hold opinions without interference and to seek, receive and impart information and ideas through any media and regardless of frontiers."

These beginnings were not inspired by one grand theory in the sense of a coherent set of concepts with explanatory and predictive validity. They were inspired by the philosophical visions that led to the emergence of the new human rights regime. These were views from the tradition of natural law in which natural equality was a dominant notion. Hobbesian views (Hobbes, 1651), for example, postulated that in their natural condition, all individuals possess equal rights because over time they have the same capacity to do each other harm. Lockean views (Locke, 1690) are another example, in which Locke argued that all human beings have the same natural rights to ownership and to freedom. Insights from Rousseau (1755) ought to be included, too, that is, his declaration that social inequality was a regression from natural equality in a harmonious state of nature. And Kant's (1791) moral philosophy is an important beginning, also, in which the same freedom for all rational beings was recognized as the sole principle of human rights. These Enlightenment ideas came to play an essential role in modern constitutions and declarations of human rights, such as the 1789 *Déclaration des droits de l'homme et du citoyen* during the French Revolution in which equality, freedom, and fraternity were the basic normative standards.

When, after World War II, the international human rights regime took shape, these philosophical views were complemented by political-ideological perspectives reflecting the positions of the West (the United States and allies) and the East (the Soviet Union and satellite states). The first international debates on freedom of information were dominated by opposing positions on the media: liberal views on the ownership and management of news media clashed with reservations about commercial control of the media and the formation of media monopolies.

Crucial for the human rights regime was the recognition of the universal validity of its constituent normative principles. Human rights came to be seen by the international community as the only universally available set of standards for the dignity and integrity of all human beings. A global social contract was concluded that was reaffirmed by the 1993 United Nations Conference on Human Rights. Its final declaration stated, "The universal nature of human rights is beyond question." In a series of international and regional instruments, close

to one hundred different rights were codified. All of them, however, were based upon four key standards: dignity, equality, freedom, and security. These human rights standards inspired around the globe provisions in national constitutional instruments and in the rules of professional conduct for journalism.

Communication Rights

These standards also became essential to those human rights that could be labelled communication rights. These human rights pertain to standards of performance with regard to the provision of information and the functioning of communication processes in society. They encompass freedom rights, protection rights, and cultural rights. Freedom rights refer to the right to freedom of opinion and expression, the right to freedom to hold opinions without interference, the right to seek information and ideas through any media and regardless of frontiers, the right to receive information and ideas through any media and regardless of frontiers, the right to impart information and ideas through any media and regardless of frontiers, and the right to freedom of thought, conscience, and religion.

Protection rights refer to the right to the protection of informational privacy and the confidentiality of communications, the right to protection against forms of public communication that are discriminatory in terms of gender, race, class, ethnicity, religion, language, sexual orientation, physical or mental condition, the right to protection against propaganda for war, the right to protection against incitement to genocide, the right of prisoners of war to the protection against public exposure, the right to the protection of the presumption of innocence, and the right of children to the protection against injurious materials.

Cultural rights refer to the right to freely participate in the cultural life of one's community, the right to enjoy the arts, the right to share in scientific advancement and its benefits, the right to the protection of the moral and material interests resulting from any scientific, literary, or artistic production of which one is the author, the right to a fair use of copyrighted work for purposes like criticism, comment, news reporting, teaching, or research, the right to adequate provisions created for the use of minority languages where needed, the right to promote, protect, and preserve the identity, property, and heritage of cultural communities, and the right of children to media products that are designed to meet their needs and interests and foster their healthy physical, mental, and emotional development. The state of these rights is an essential yardstick for the democratic quality of political systems, for the cultural sustainability of societies, and for the level of human security in the face of rapid technological development.

From a Right to Free Speech to a Right to Communicate

Practically all human rights provisions refer to communication as the "transfer of messages." This reflects an interpretation of communication that has become

rather common since Shannon and Weaver (1949) introduced their mathematical theory of communication. Their model described communication as a linear, one-way process. This is, however, a very limited and somewhat misleading conception of communication that ignores that, in essence, "to communicate" refers to a process of sharing, making common, or creating a community. Communication is used for the dissemination of messages (such as in the case of the mass media), for the consultation of information sources (like searches in libraries or on the World Wide Web), for the registration of information (as happens in databases), and for the conversations that people participate. In international human rights law, only provisions on the protection of confidentiality refer—albeit insufficiently—to the fourth pattern: the conversational mode.

In 1969 Jean d'Arcy introduced the right to communicate by writing, "The time will come when the Universal Declaration of Human Rights (UDHR) will have to encompass a more extensive right than man's right to information. . . . This is the right of men to communicate" (p. 14). The motivating force for this new approach was the observation that the provisions in human rights law such as Article 19 in the Universal Declaration of Human Rights do not adequately deal with communication as an interactive process. Article 19 addresses one-way processes of seeking, receiving, and disseminating information and ideas. It deals with communication in the sense of "transfer of messages."

The discussion of a right to communicate focusses on the conversational mode of communication, and its proponents argue that communication, in the sense of conversation or dialogue, needs special protective and enabling provisions. Human rights law—in both Article 19 of the UDHR and Article 19 of the International Covenant on Civil and Political Rights—covers the fundamental right to freedom of opinion and expression. These articles are undoubtedly an essential basis for processes of dialogue among people but they do not directly pertain to interactive processes. They protect the freedom of the speaker at Hyde Park Corner to whom no one has to listen and who may not engage in interaction with anyone in his audience. The Articles also refer to the freedom to hold opinions: this pertains to opinions inside your head that may serve the communication with yourself but bear no necessary relation to communication with others. They mention the right to seek information and ideas: this provides for the freedom to gather news, among others. Highly important, but there is no provision for processes of exchange. The Articles also contain the right to receive information and ideas: this is, in principle, also a one-way process. The fact that I can receive whatever information and ideas I want does not imply I am involved in a communication process. Finally there is the right to impart information and ideas: this refers to a form of dissemination that goes beyond the mere freedom of expression but it does not pertain to interactive processes. In sum, all the provisions in the "freedom of information" articles in international human rights law address one-way processes of

transport, reception, consultation, and allocution, and do not pertain to the two-way process of conversation. Even if the news and entertainment media would have a maximum freedom of expression and would have fullest possible access to information sources, this would not guarantee that people are enabled to participate in societal dialogues.

The WSIS and Human Rights

In the early twenty-first century, the United Nations convened a World Summit on the Information Society (WSIS, 2003 in Geneva and 2005 in Tunis). This conference provided the opportunity to address the emerging reality of global interactive technologies and the expansion of societal networking that call urgently for a shift from the prevailing distribution paradigm to an interaction paradigm. This shift requires the adaptation of human rights standards to the new reality of interaction. The WSIS could have addressed this challenge. However, the combination of the UN World Summit on the Information Society and the international human rights regime turned out to be an unhappy marriage. Most of the participating UN member-states had great reservations about adopting statements that went beyond a reference to Article 19 of the Universal Declaration of Human Rights. And even the inclusion of Article 19 and a general reference to the UDHR in the Final Statement demanded an enormous investment in lobbying efforts. Also the civil society media caucus (and in particular the World Press Freedom Committee) showed strong resistance against any move beyond Article 19.

In his assessment of the WSIS, the UN Special Rapporteur for Freedom of Information wrote that the treatment of human rights by at the Summit was grossly inadequate. Part of civil society—in particular members of the Communication Rights for the Information Society (CRIS) campaign—tried to re-introduce into the international debate the notion of the human right to communicate. This caused heated exchanges during the second WSIS Prepcom in February 2003. The issue of the right to communicate strongly divided even the more progressive part of the civil society family. In order to avoid an unproductive clash of ideologies within civil society, the right to communicate protagonists decided at a CRIS meeting in February 2003 to steer a compromise course and—at least for the time being—to put this right on the back burner. Ironically enough, after this decision the right to communicate received global public support from the secretary general of the UN in his message on World Telecommunication Day in May 2003 and from the ITU secretary general in a commercial message in *Business Week*. Meanwhile also the European Union began to refer to the right to communicate in various WSIS preparatory papers. In any case, the CRIS campaign had decided to present at the World Forum on Communication Rights in December 2003—one of the side-events during the WSIS—to merely present a Statement on Communication Rights and ask for endorsement by its constituency.

Although the way in which the WSIS addressed human rights was certainly inadequate, one must also note that the WSIS Declaration of Principles refers frequently to human rights, and where this is not explicitly stated there are many proposals made in the spirit of the international human rights regime.* Evidently, these references could have been more explicit. Even so, there seemed to be a moral human rights consensus in the WSIS community. And this is also precisely the problem! In international politics, parties may have a common vision on moral standards but they will usually fundamentally differ when it comes to the political implementation of these standards. Worldwide there is a fair degree of commonality in the acceptance of the Universal Declaration of Human Rights. This is, however, a moral statement without reference to its concrete political realization. If the UDHR had stated ways to realize its normative provisions, the unanimity would have quickly dissolved.

There is a twofold problem with the human rights references in the WSIS Declaration. In the first place they are de-contextualized. It would seem as if the WSIS discourse takes place in a societal void without any serious and critical structural analysis of the political-economic context. There is no serious criticism of existing international agreements such as in the field of telecommunications and intellectual property rights that undermine human rights provisions such as universal and affordable service and equitable access to knowledge. There is no criticism of current national security measures that erode privacy rights. There is no criticism about the absence of fair arrangements for the international transfer of technology.

In the second place, the human rights statements do not contain indications for their concrete implementation. There is no concrete translation of human rights principles into the Plan of Action. There are no proposals for the concrete allocation of resources. There are no proposals for remedial measures. Among the many examples is the following. The Plan of Action encourages the development of domestic legislation that guarantees the independence and plurality of media. A welcome proposal, but rather useless if there is no mention of funding, no mention of anti-cartel laws, and no mention of editorial statutes. Basically, the Plan of

* In paragraph 1 there is a reference to respecting and upholding the Universal Declaration of Human Rights (UDHR); in paragraph 3 the Declaration reaffirms the 1993 Vienna Declaration of the UN World Conference on Human Rights; in paragraph 4 there is a reaffirmation of Article 19 of the UDHR; paragraph 5 reaffirms Article 29 of the UDHR; in paragraph 18 it is stated that nothing in this Declaration may impair, contradict, restrict, or derogate from the principles of the UDHR; in paragraphs 24 to 28 there are references to universal access to information and to knowledge; in paragraph 35 the need to strengthen privacy is mentioned; paragraph 36 says that the use of information resources and technologies for criminal and terrorist purposes should be prevented, while respect for human rights should be secured; paragraph 42 refers to the protection of intellectual property rights; paragraph 45 refers to the management of the radio frequency spectrum in the public interest; in paragraphs 52 to 54 cultural diversity, linguistic diversity, and local content are mentioned; paragraph 55 stresses the freedom of the press; paragraph 56 calls for respect for peace, and for the values of freedom, equality, solidarity, and tolerance; in paragraph 58 it is stated that the use of ICTs and content creation should respect human rights, including privacy and freedom of thought; paragraph 59 warns against abusive use of ICTs and calls for actions and measures against racism, racial discrimination, xenophobia, hatred, violence, and child abuse.

Action affirms that the principles in the Declaration are good and they should be respected. However, the Plan does not tell us how to do it and does not question whether the international community is at all capable of doing this!

The second phase for the WSIS in Tunisia in 2005 did not change this and did not offer the world concrete plans for the realization of human rights in relation to information and communication. There were serious obstacles that did impede change toward more concreteness. Among these were the interests of the key economic and political players that were unresponsive to the radical erosion of the power of hegemonic forces that the respect for human rights inevitably entails.

A fundamental change of direction is particularly difficult with regard to the domain of communication rights. There is a lot stake presently, both politically ("war on terrorism") and economically ("neoliberalism") that impedes a full realization of these rights. There is also the problem of a globally growing antagonism between state and citizens.

To expect a more robust statement by the international community on communication rights is not realistic as the issue is at present very sensitive, contested, and polarised. In many countries crucial communication rights are currently suspended as part of the war on terrorism. The protection of cultural rights implies a rule on cultural exemption in word trade that is not popular with the major trading parties. Intellectual property rights—a rapidly growing and profitable global business—are robustly enforced as trading rights and not as human rights. The commercialisation of knowledge impedes greater equality in access to and use of knowledge. Communication rights imply the preservation of public space, which is rapidly withering away worldwide.

On Human Rights as Normative Theory

When using human rights standards such as "equality," one should note that in conventional human rights theories there is a bias towards an interpretation that assumes that all human beings are equally capable in asserting their rights and in which the legal system is formally based upon the assumption of the initiative of autonomous citizens to defend their rights. These liberal foundations of human rights laws neglect the reality of widely differing capacities to such initiative. In reality, the powerful are always better at asserting their rights through litigation than the less powerful. The conventional approach to human rights provides antidiscriminatory protection in the sense of repairing the negative effects of social differentiation. Correcting social disadvantages through the equal treatment of unequals does, however, not structurally change unequal relations of power. Equal treatment can even reinforce the inequality. Providing equal liberties to unequal partners often functions in the interest of the more powerful. It needs, therefore, to be observed that there is a deep collision between the dominant conventional and the "cosmopolitan" school of human rights thought. In the conventional ap-

proach (very much present in the Universal Declaration of Human Rights, 1948), equality is not an inherent feature of humanity. Actually, human rights are based upon the inequality of power relations between the state and the citizen.

There is little the citizen can do about this inequality in power. Human rights manage this inequality by correcting its most obvious negative social effects but do not fundamentally erase it. In the conventional approach, human rights may contribute to minimizing the negative effects of economic inequality but do not fundamentally change this. The structural political and economic forces (state and capitalism) that are at the roots of many human rights abuses are not addressed. Whenever the concept of equality is used this usually pertains to the Lockean interpretation of "one rule for rich and poor" or to the Kantian interpretation of nondiscrimination: the law should treat all citizens as equals. In these interpretations the law recognizes a formal concept of equality that is related to the perception of inequality as a form of social differentiation that can and should be corrected. Here the law is anti-discriminatory in the sense of repairing social disadvantage by the equal treatment of unequals. This, however, does not change the structurally unequal relations of power. In a more adequate interpretation "equality" means equal entitlement to the social conditions that are essential to emancipation and self-development.

The currently prevailing conventional human rights discourse emerged from a liberal tradition that is deeply influenced by the value of human autonomy and the implied freedom of individuals to speak, believe, vote, and participate in the life of society as they see fit and the right to own and protect private property.

Post-colonial Cosmopolitanism

The conventional discourse has—despite the formal pretence of universalism—no strong interest in the cosmopolitan ideals of communal responsibility and collective welfare. Against this conception there is a cosmopolitan human rights discourse that stresses the need to accept reciprocal obligations among the members of a society. To realize such cosmopolitan ideals this discourse needs to combine, as Immanuel Kant already suggested, autonomy and reciprocity (Woodiwiss, 2005, p. 13).

The essential issue of cosmopolitanism is the conversation with the other. How is this global conversation conducted? On whose terms? Often engagement with the other is managed by a dominant, missionary culture and thus remains a colonial adventure. For a twenty-first-century human rights framework a post-colonial cosmopolitanism is required that accepts that others are different and yet equal in dignity.

Since the prevailing human rights discourse prefers autonomy over reciprocity, individual freedom over collective responsibility, it hampers the realization of equality as distributive justice. In order to design a constructive approach to

the persistent inequalities in social communication, a balance needs to be found between the two normative principles that represent the different human rights discourses mentioned above.

The conventional international human rights regime cannot provide a solid normative theoretical frame for distributive justice in social communication since it lacks a genuine cosmopolitan basis. This is due to the prevalence of autonomy and freedom over responsibility and reciprocity. Reciprocity means being aware of the effects your acts may have on others. It points to the realization that the destinies of the powerful and the powerless are intertwined. It implies caring about the social exclusion of others and about sharing with others and about reciprocal obligations. Our own claims to equality and freedom necessarily imply the need to respect the other's claim to the same. The deepest challenge of a human rights approach to communication issues, such as the digital divide or the freedom of expression, may be the question whether we are capable of accepting the reciprocal obligations that a genuine post-colonial cosmopolitanism requires.

The Illustration of Internet Governance

A prominent domain where in the twenty-first century the relationship between communication and human rights is challenged is the issue of Internet governance. In the end—however one defines it—Internet governance is about making choices. Current discussions between net neutrality advocates and net neutrality opponents are about choices for or against such fundamental human rights principles such as freedom, discrimination, and equality. I believe that the Dutch parliament and senate understood this when, in May 2012, they adopted legislation to protect the openness and security of the Internet in The Netherlands.

In the context of a realist and post-colonial cosmopolitan human rights framework such choices will have to be assessed against the criteria of full participation, accountability, and reversibility. Following human rights standards public choice has to be organized through democratic arrangements. This implies that the standard of political equality is extended to the broadest possible participation of all people in the processes of public decision making. The issue of the democratization of public decision making in the fields of information and communication has been on the civil society agenda in the recurring debates on the Right to Communicate, in the initiative for a People's Communication Charter (in 1992), and in the nongovernmental contributions to the United Nations World Summit on the Information Society (2003 and 2005). A democratic arrangement has rules, procedures, and institutional mechanisms to secure public accountability. The principle of accountability logically implies the possibility of remedial action by those whose rights to participation and equality may be violated. Only through effective recourse to remedial measures can fundamental standards be implemented. If those who take decisions engage in harmful acts, those affected should have access to

procedures of complaint, arbitration, adjudication, and compensation. The process of establishing the responsibility for decisions taken and demanding compensation for wrongs inflicted secures the egalitarian nature of the democratic arrangement.

The accountability issue regards all Internet users. The current tendency to give up rights to free speech and privacy in exchange for either promises of security or low tariffs may have dramatic effects on the future use of cyberspace. Also the ordinary user will have to be ready to account for his or her choices.

Choices about future Internet rules and practices have to be made under the condition of uncertainty. Effects in the future of choices made today are unknown. The future is open because we have no information about it. If we had such information, there would be no real choice. A serious human rights assessment would point to the risks of realizing choices that may have not fully foreseeable side effects and that may be irreversible once they are implemented. The possibility of error in public-choice making is unavoidable. Therefore, the readiness to learn from past errors and to revise choices already made is essential to the respect for human dignity. Human rights require that Internet governance conquers the insensitivity to error that Barbara Tuchman (1985) has described as the imbecility of government.

Abstractions Versus Realities

It would seem obvious—given today's global embrace of human rights principles across political and business circles—to take an unequivocal human rights approach to communication issues. The proviso that should be made, however, is that this support of human rights might fail to see what the costs of implementing these principles are. Human rights principles are in essence abstractions that tend to clash with the realities of human nature. The principle of a shared humanity suggests that we ought to see the "other" as a bearer of fundamental human values. In reality, most of the time, we prefer our own tribe over others and feel most comfortable with our own group's cultural identity. Universalism is the humanist expectation and national tribalism is the psychological reality. We need to realize that the incredibly difficult task ahead is to give genuinely concrete meaning to normative standards that are often useless abstractions in real-life situations.

As I have argued elsewhere (Hamelink, 2000), the key principles at stake in future communication societies are equality, security, and freedom. A basic obstacle to their realization is not the lack of legal enforcement or the lack of robustness in their articulation, although there remains space for improvement here. It is primarily the fact that most human beings do not accept that the equality, security, and freedom they are willing to recognize for their own circle (tribe, family, clan, race, gender, and so forth) is also granted to those who do not matter to them. The basic premise of the human rights culture as enshrined in the UDHR is that "all people matter." But this a moral proclamation, not a historical and

political reality. The reference to the commonness of human beings ("We are all human") is not sufficient to get people to treat those they do not see as part of that common humanity in a respectful way. The differential treatment of "insiders" versus "outsiders" is not necessarily based on moral depravity. It is often inspired by perceptions of the risks the others pose to them. Only if we manage to control the massive fear mongering that is common in today's global media under these conditions will it become possible to see fellow human similarities as more similar than different.

Culture of Fear

Communication media (both entertainment and news media and both conventional and new media) offer day after day a discourse of anxiety. Every single day the media warn us of some impending danger. Around the world one finds in many radio and television newscasts and newspapers' lead articles strong references to "crisis" (food crisis, oil crisis, climate crisis, population crisis, terrorism crisis), fear, and risk. Much of this language has little to do with actual world incidents. Although over a longer time span—1986–2007—there is a decline of terrorist incidents, governments and their complicit media kept up a credible global threat.

There is a growing cottage industry of "fear marketeers" offering their services to deal with concerns people might not even have realized they harbored. These concerns are about health; lifestyles; after-life styles (funeral fashion); appearance; aging; financial status; home security; ADHD kids; marital stress; sexual performance, size, and look of their private parts; culinary expertise; vinological knowledge; the psychopathology of their pets; or garden architecture (even if they have no garden). People are made anxious by telling them there is something wrong with them (like advertising or medical TV programmes do), by suggesting uncertain and probably very troubled futures (in daily newscasts about issues like the credit crisis), or by making them fearful (by discourses on terror, evil, and war).

Media render fear a shared perspective on life. For the first time in history millions of people across the globe can watch stories of fear and crisis simultaneously. For these global audiences the media construct a world that is filled with warnings that the world is a dangerous place and things may get worse. Fear has become a particularly dominant feature of media discourse. Certainly after the 9/11 events the U.S. media prominently displayed a discourse of fear. Many media have generously and uncritically adopted the threat rhetoric by uncritically using words like "war," "rogue states," "axis of evil," or describing enemies with animal metaphors.

Human principles remain abstractions if we do not manage to control the massive fear mongering that is common in today's global media. Only if you can be totally secure about your own position and do not feel threatened by the others, it becomes possible to treat them as not different from the members of your

own tribe and to feel empathy with their situation. Only if fear is transformed into trust will it be possible to see fellow human beings as partners in a shared moral universe.

Towards a Participatory Human Rights Regime

A more effective human rights regime will have to be developed from people's real needs, aspirations, expectations, and hopes. The conventional approach to human rights has been predominantly the expert approach with the legal and political professionals in the driver's seat. This is not a self-empowering approach that would require a bottom-up approach. Human rights are abstractions formulated and codified for people, not by people. Ordinary people may be entitled to the highest possible standard of information provision, but they cannot realistically expect that the authorities in charge—irrespective of their lip service to information and communication rights—will support their claims to the implementation of these rights. The only way towards some measure of success will have to be the mobilization of "soft power" by people in their local communities. The mobilization of the power to speak out, to make claims, to demand accountability, and to network with fellow communities that have managed to achieve the respect for their basic entitlements is a crucial tool on the road from abstractions to realities.

A "grand" theory on the relationship between human rights and communication has not emerged so far and probably never will. Even if a comprehensive theoretical framework would develop, the chance that it would inspire concrete policymaking must be considered marginal at best. There is little evidence that media policymakers (in the media themselves or in media politics) base their policy plans upon the theoretical insights that academics have to offer. Most studies done on the impact of social research on public policy are rather discouraging. A constant finding is a good 50 percent of civil servants totally ignore research, and some 40 percent, even if hard pressed, find it difficult to point to research they would consider useful. Social scientific research, if used at all, mainly serves the improvement of bureaucratic efficiency, the delay of action, the avoidance of responsibility, or functions to discredit opponents, to maintain prestige, or to ask for more research.

Academics may have failed to produce sufficiently useful theory for policy and planning, but it would be short-sighted to not also ask the policy field to share part of the blame. The deficient theory-policy encounter is also due to the opportunism, lack of analytical rigour, and often anti-intellectualist hostility of policymakers. In fairness it should be recognized though that it is not always easy for policymakers to judge the quality of the theoretical expertise offered to them. Science no longer can claim undisputed authority. Cases of fraud, plagiarism, and dubious bonds between academics and industrial interests make it uncertain whether scientific contributions may be tainted by nonscientific motives.

The conclusion, therefore, is that the field of theory does not always offer useful material to the policymakers and the policy field is not always interested in the best available evidence. However, this should not discourage future generations from trying to find creative solutions to the persistent, pressing, and perplexing challenge of communicating in a multicultural world.

Bibliography

D'Arcy, J. (1969). "Direct Broadcasting Satellites and the Right to Communicate." *EBU Review*, 118, 14–18.

Hamelink, C. J. (2000). *Ethics in Cyberspace*. London: Sage.

Hobbes, T. (1651). *The Leviathan*. London: Printed for Andrew Crooke.

Kant, I. (1791). "Equality of Rights in Theory and Practice." In H. Reiss (Ed.), *Kant: Political Writings* (2nd ed.). Cambridge: Cambridge University Press, 1991.

Locke, J. (1690). *An Essay Concerning Human Understanding*. London: Baffet.

Rousseau, J.-J. (1755). *Discourse on the Origin and Basis of Inequality among Men*. Netherlands: Marc-Michel Rey.

Shannon, C., & W. Weaver. (1949). *The Mathematical Theory of Communication*. Urbana: University of Illinois Press.

Tuchman, B. (1985). *The March of Folly*. London: Sphere.

Wells, C. (1987). *The UN, UNESCO and the Politics of Knowledge*. London: McMillan.

Woodiwiss, A. (2005). *Human Rights*. London: Routledge.

Struggle, Vatican II, and Development Communication Practice

RUTH TEER-TOMASELLI AND
KEYAN G. TOMASELLI

This chapter examines the Second Vatican Council (Vatican II) theology as the implicit background to Robert White's studies on development communication. We will then examine White's influence on the Center for Communication, Media and Society's graduate program in development communication.

In 1988, two years before the end of apartheid, Keyan, Bob White, Michael Traber, and others were at a Missio workshop on grassroots communication in Lusaka, Zambia. They were witness to a car bombing of African National Congress cadres in the hotel's parking lot. This event underlined Keyan's own presentation on the use of video in anti-apartheid cultural resistance in a black Durban township. During the same week he received distressing news of the assassination of one of the community organizers with whom he and his students had been working (O'Connell, 1989, p. 2; *Group Media Journal*, 1989, p. 15).

The point is that Missio, the World Association for Christian Communication, and its collaborators were always in the thick of things, testing theory and practice to the limit, taking on the enemies of democracy, and writing from the noisy smoke- and fire-filled coalface. As Missio's Klaus Müller (1989) observed, "Brutal reality has caught up with us and provided clear evidence that concrete, active grassroots communication is never risk free" (p. 2). That is why theory emerging from such conditions is at the cutting edge, and why it takes on direct resonance with ordinary people, communities of struggle, and others who daily confront poverty, oppression, and disease.

These are the conditions in which praxis-oriented academics often find themselves. The job is never done. Even after liberation, the new cadres often assume the repressive practices of those that they sought to replace. This is what is meant by *a luta continua*—as struggle now moves into the structures of the new institutions that tend to forget the reasons for the original resistance.

At the root of Bob White's epistemology of our own communication has been Vatican II theology (see, e.g., Tomaselli & Teer-Tomaselli, 2003). The implicit influence of this theology in many areas of our mutual work in communication needs to be examined. The contemporary situation remains similar. The new elites differ in strategy only from those they have replaced. This chapter examines Vatican II in relation to approaches to development communication and the way in which Bob White used these insights to build the foundation of a graduate-level module in the Centre for Communication, Media and Society (CCMS) at the University of KwaZulu-Natal in Durban, South Africa.

Vatican II: The Origins of Social Communication

The roots of social communication within the Catholic Church emerged more than 150 years ago. The Church had adapted to increasingly powerful secular states between the installation of Pius IX as Pope in 1846 and the end of the papacy of Leo XIII (1878–1903). Under Pius IX the Church opposed the theological and social tendency of these changes, viewing them as threatening to the authority of the papacy. Leo XIII also opposed democracy and liberalism and increasingly centralized the Vatican's authority. However, Leo's pontificate also marked a turning point, as he developed a tactical alliance with the modern world instead of refusing it.

In issues of social justice politics, Leo was pragmatic: modern states provided a buffer against anarchy. His encyclical *Rerum Novarum* [On the New Things] (1832) was the first of the modern social missives, and outlined the "Rights and Duties of Capital and Labor." This indicated a shift in strategy rather than of fundamental philosophy. The Church still refused the legitimacy of the French Revolution, clinging rather to the idea of the divine right of kings and the indestructible connection of church and state.

More important from the point of view of modern communication, Leo XIII revitalized the Catholic intellectual framework and restored the thought of Thomas Aquinas to the center of Catholic theology. Part of the intellectual revival encouraged by Leo XIII in his encyclical *Aeternin Patris* [Of the Eternal Father] (1879) resulted in the application of a rational, Neo-Scholastic theology to be taught in seminaries and university faculties of theology throughout Europe. The document argued that philosophy, far from threatening the entrenched positions of the Catholic Church, may be able to aid the faithful. In a revolutionary move, it contended that prayerfully applied "reason" and "science" may call people to

faith and might well allow for a more fruitful understanding of the revealed truth. Catholic Rationalism took hold from this Thomist beginning.

Neo-Thomism, while influential among the new intellectual circles of the Church, was not readily absorbed by the mass of Catholic clergy and laity. Alongside this intellectual thrust, the popular experience of Catholicism was a more sentimental piety, a faith bound up in ritual, often bordering on credulity and superstition. For a large part of the Catholic faithful, Neo-Scholastic rationalism remained outside their experience, external to their thinking, and never incorporated into their rituals and traditions, or the celebration and observance of their religious experience. In other words, it did not become part of their religious (and secular) culture. Bernard Connor, OP, points out,

> Both the rational approach to theology and the sentimental feeling expression of the religion were almost entirely a-social and a-historical. Rational, neo-scholastic theology was concerned with "timeless truths," while religious devotions appealed to each individual's emotions. In their own way, both sought to get away from everyday realities and especially social issues. Neither questioned the status quo in society; it is in this vacuum, especially where Catholics are in the majority and Catholicism is largely identified with the prevailing culture, that a right-wing movement could emerge. (Correspondence with the authors, June 1988)

Conservative Latin American churches in the early part of the twentieth century were heavily influenced by various strands of neo-Fascist ideologies, and they were an example of the way in which intellectual isolationism aided and abetted reactionary political and social leanings. Their geographic isolation from the intellectual heartland of Europe impeded their reaction to the influence of nineteenth-century rationalism. Latin American churches, well into the twentieth century, were extremely hierarchical, with Bishops exerting temporal power and privilege analogous to the Church in pre-revolutionary Europe. The importance of this insight will become apparent later when we discuss the influence of modern Latin American theorist Jesús Martin-Barbero on the work of Robert White.

At the other end of the ideological spectrum, the condoned conservatism pervasive in Western parts of the Church was to be challenged by the Second Vatican Council (1961–1963). When the theological paradigm did change in the 1960s, it was the theology of liberation that challenged the supremacy of the older dogmas. Since this was a movement that unabashedly opposed exploitative capitalist class structures, it was threatening to the bourgeois elements of the established Church. Despite Vatican II and the accompanying liberation theology, the sentimentality, superstition, and conservatism of the previous period was never wholly eradicated from the lived experience, the active Catholic culture, of many of the faithful. It was therefore the pre-rationalistic tradition to which Latin American fascism paid homage and Vatican II opposed. Above all, it was a tradition that felt threatened by critiques of the inequitable distribution of wealth.

Anachronistic Church Attitudes to the Media

Beginning with the French Revolution, Roman Catholicism came to be imagined by others, and constructed by itself, as being against "the modern" in at least three senses:

1. against the concept of temporal (i.e., historical) *change* and progress;

2. against the evolution of subjective individualism, that is, the notion that the private judgment and liberty of individual conscience is prior to (and superior to) communal claims; and as a corollary,

3. against the notion that religion is a private affair to be kept separate from the public sphere (O'Malley, Shultenover & Schloesser, 2007).

The enormous social upheavals of the nineteenth century increased the gulf between the Church as institution and rational, modernist society: urbanization, democratization, emergent secular nation-states, and scientific positivism all posed threats to traditional agrarian and authoritarian conceptions of organic corporatist society. The end-result was the establishment of the *Ultramonte* Catholic moment, which emphasized the authority of the Pope over both the temporal affairs of civil governments as well as the spiritual affairs of the Church, and positioned itself in opposition to the hegemonic nineteenth-century secularism of nationalism, liberalism, and self-determination. The entrenched, conservative thinking at a popular level was reflected in the official doctrine of the nineteenth-century Church, exemplified by the encyclical *Mirari Vos* (translated literally as "Wonder you," the first two words of the encyclical, but known officially in English as "On Liberalism and Religious Indifferentism"), penned by Pope Gregory XVI in 1832. The idea that individuals could be guided by their own consciences was anathema:

> This shameful font of indifferentism gives rise to that absurd and erroneous proposition which claims that liberty of conscience must be maintained for everyone. It spreads ruin in sacred and civil affairs, though some repeat over and over again with the greatest impudence that some advantage accrues to religion from it.

Particular ire was reserved for the publishing industry, purveyors of rational, secular, and, therefore, profane thought, deemed to be "harmful" and never sufficiently "denounced": "Here we must include that harmful and never sufficiently denounced freedom to publish any writings whatever and disseminate them to the people, which some dare to demand and promote with so great a clamour." The banning of "bad books" was deemed necessary in order to "exterminate the deadly poison of so many books" despite the "vehement desires" of "the shameless lovers of liberty" (*Mirari Vos*, 1832). Along with undesirable books, this document condemned press freedom, fearing that the popular media would be poisonous to the public, and railed against the press in the strongest terms:

> Here belongs that vile and never sufficiently execrated and detestable freedom of the press for the diffusion of all sorts of writings: a freedom which, with so much insistence, they dare to demand and promote. We are horrified, venerable brothers, contemplating what monstrosities of doctrine, or better, what monstrosities of error are everywhere disseminated in a great multitude of books, pamphlets, and written documents—small certainly in their size but enormous in their malice—from which goes out over the face of the earth that curse which we lament. (*Mirari Vos*, 1832)

This unease with the popular media by the Church was widespread in the nineteenth century, and elements of it continued into the early twentieth. Popular forms of expression were regarded as trivial, degrading, and opposed to romantic classical "high culture." A direct influence in discrediting the popular media as a site of evangelism was the "rationalism of neo-scholastic theology and the emphasis on an abstract, metaphysical mode of explanation" (White, 1986, p. 18). Neo-Scholastic theology identified the word of God with clear, concise, logically defined dogmatic propositions. The resulting abstraction of the language of religious faith discouraged the use of popular media for religious communication.

The immediate aftermath of the Second World War with the immense consequences of the institutional Church's alliances with the Fascist states and its passive complicity in the Holocaust were deeply unsettling for the Vatican. In a period during which the Cold War dominated the thought of much of the "developed" world, and the Church was seen to be under siege from Communist regimes in both Eastern Europe and Southeast Asia, a radical rethink was required. The result was Vatican II, front-lined by the encyclical *Dignitatis Humanae* [Human Dignity] (1962) and a number of other documents and position papers. The Second Vatican Council saw a significant change in position regarding the Church's stance on a multitude of social phenomena, including communication. The encyclical *Inter Mirifica* (1963), published in English as the *Decree on the Media of Social Communications*, called on the Church to use mass media more effectively (Vatican Archives, 1963). Catholic culture was reacting vigorously to forms of clerical authoritarian communication that had characterized the Church for the previous 150 years. More important, it questioned the principle that "divine knowledge" is above history and cultural contexts (White, 1986, p. 27).

> Among the wonderful technological discoveries which men of talent, especially in the present era, have made with God's help, the Church welcomes and promotes [are] new avenues of communicating . . . news, views and teachings of every sort. The most important of these inventions are those media such as the press, movies, radio, television and the like, which can, of their very nature, reach and influence, not only individuals, but the very masses and the whole of *human* society, and thus can rightly be called the media of social communication. The Church recognizes that these media, if properly utilized, can be of great service to mankind, since they greatly contribute to men's entertainment and instruction as well as to the spread and support of the Kingdom of God. (Vatican Archives, 1963)

Inter Mirifica is credited with revising the older Church teachings, such as those embodied in *Mirari Vos* (1832), by overturning the earlier position so critical of the liberty of the press. This Vatican II encyclical, fifty years old at the time of writing this chapter, subsequently has been augmented with a number of other important ecclesiastical documents, including *Communion et Progressio* [Communication and Progress] (Vatican Archives, 1971); *Aetatis Novae* [New Era] (1992); and John Paul II's final apostolic letter on the topic of social communications, *The Rapid Development* (Vatican Archives, 2005). As any contemporary search of the Internet will confirm, the Church has not been slow to enter the world of new media, with numerous sites devoted to proselytization, streamed and archived multimedia productions, and the enormous project of digitizing the holdings of the Vatican archive (very helpful in the preparation of this study!). Pope Benedict XVI delivered a message titled "The Priest and Pastoral Ministry in a Digital World: New Media at the Service of the Word" to mark the 44th World Communications Day (May 16, 2010). The Pontiff urged pastors to become "digital citizens" and to engage with the information society in a meaningful way, noting,

> Priests stand at the threshold of a new era: as new technologies create deeper forms of relationship across greater distances, they are called to respond pastorally by putting the media ever more effectively at the service of the Word. . . . Who better than a priest, as a man of God, can develop and put into practice, by his competence in current digital technology, a pastoral outreach capable of making God concretely present in today's world and presenting the religious wisdom of the past as a treasure which can inspire our efforts to live in the present with dignity while building a better future? (Vatican, 2010)

Robert White has written extensively on the move of the Church into the modern era of communication. As far back as 1986, he noted that the shift from Neo-Scholastic theologies of communication came about as a result of the changed perceptions toward biblical and historical studies that argued that the "exact written formulas of doctrine were not in themselves identical with divine knowledge but also reflected the literary genres, historical circumstances and cultural context of the time" (p. 28).

Religious imagination has many sources—poetry, novels, film, and television (Shea, 1980, p. 45) and owe as much to local popular cultures and popular religiosity (White, 1986, p. 29). Faith is rarely only intellectual. Neither is it a simple acceptance of authoritative teaching on the basis of supernatural signs. The communicative discourse of the Bible and religion rests on the connotative, evocative power of imagery, symbols, and myth. This mode of communication underpins much of the Church's pastoral work. The 1980s alternative weekly newspaper *New Nation*, owned and financed by the South African Catholic Bishops' Conference (SACBC) but aimed at a broad secular readership, is a case in point. The paper, now defunct, did not indulge in politics for politics' sake. It was also concerned with other areas of supportive Christian culture, not just Catholic culture. The paper

covered areas of social and cultural importance, including education, performance, cultural experience and expression of all kinds, community awareness, and offers of community support. As White states, Catholics should take as their starting point not the received theology, but their sociocultural context and to ask how the group could give witness to the gospel and reproduce the actions of Christ in this context (1986, p. 29).

Empowerment of the "poor" is the intention here. The new (Catholic) approach seeks not just to use media for the institutional purposes of the Church but also to transform media for the good of the whole society. This is most evident where the Church has developed the new communicative relationship with the larger society (White, 1986, p. 34). The Church's emphasis in the 1980s on group media occurred in response to Paulo Freire's ideas on consciousness raising where participants of group discussions are encouraged to become aware of their unthinking dependency on the cultural environment and to see themselves as active participants in the creation of culture and history (White, 1986, p. 31). Popular forms of expression were regarded as trivial, degrading, and opposed to romantic classical high culture. A direct influence in discrediting the popular media as a site of evangelism was the "rationalism of Neo-Scholastic theology and the emphasis on an abstract, metaphysical mode of explanation" (White, 1986, p. 18). Neo-Scholastic theology identified the Word of God with clear, concise, logically defined dogmatic propositions. The resulting abstraction of the language of religious faith discouraged the use of popular media for religious communication.

The importance of White's emphasis on revelation theology is that this approach is endorsed by Vatican II in *Inter Mirifica* (1963) and later *Communio et Progressio* (1971). Its manifestation in *New Nation* was not simply a whim of the SACBC, but the only direction to take in terms of the Church in the modern world. *New Nation* fulfilled its mandate for a community-oriented, theologically based people's paper, inspired by gospel values. This is the view of the Church of the future. According to White (1986):

> There is a realization that new communication technologies are not simply neutral, value-free instruments for a good cause, but come to us wrapped in an institutional organization which may or may not be consonant with Christian values. The new physical capacity for storing, transmitting or displaying information may be providential, but the institutional organization of this is a product of human society that needs to be continually questioned and evaluated. As Catholics have worked with the media, they have found ways to transform these institutional packages so that they reflect gospel values. In this way, Catholics have developed new models of radio, television, and group communication which are considered important contributions to public communications policy. (p. 24)

In attempting to build a communication of symbolic gospel witness through a free, public, secular mass communications that the Church itself does not control, the Church entered the public debate, making the paradox of its powerlessness, sim-

plicity, and commitment to the poor the basis of socio-ethical values in an affluent, consumer-oriented society (White, 1986, p. 26). *New Nation* was owned by the Church but run by the laity (a movement away from authority-directed instruction).

Vatican II, Communication for Social Justice

The thinking that informed the Second Vatican Council, and the documents that came out of that enterprise, "began the process of breaking the long alliance between Roman Catholicism and socially conservative forces" (Dorr, 1983, p. 12). As such, they marked a sea change in the relationships between Church and State. While it is a feature of papal encyclicals to invoke links with the past in order to demonstrate that they are part of a long tradition of teaching, what was significant about the documents of Vatican II was an insistence that traditional *issues* were discussed in the light of changed circumstances, particularly with respect to the role of the state in the lives of citizens (Walsh & Davies, 1984, p. 1). As part of this paradigm shift *Inter Mirifica* (1963) called on the Church to use mass media more effectively, noting that "public opinion exercises enormous influence nowadays over the lives, private or public, of all citizens" (Vatican Archives, 1963). It follows then, that

> First, a good press should be fostered. To instil a fully Christian spirit into readers, a truly Catholic press should be set up and encouraged. Such a press—whether immediately fostered and directed by ecclesiastical authorities or by Catholic laymen—should be edited with the clear purpose of forming, supporting and advancing public opinion in accord with natural law and Catholic teaching and precepts. It should disseminate and properly explain news concerning the life of the Church. Moreover, the faithful ought to be advised of the necessity both to spread and read the Catholic press to formulate Christian judgments for themselves on all events. (*Inter Mirifica*, 1963, para. 14)

Jesús Martin-Barbero and the Latin American Theology of Liberation

The *Decree* was a significant break from the past, since now Catholic culture was reacting vigorously to forms of clerical authoritarian communication that had characterised the Church for the previous 150 years. More important, it questioned the principle that "divine knowledge" was above history and cultural contexts (White, 1986, p. 27). As White (1986) explains:

> The effort to transform the media is part of the broader commitment to build a more just and human society. In Latin America, for example, Christians working in radio started with a traditional instrumentalist version of radio and gradually, with the background of a liberation theology, transformed it into a more participatory communication, the voice of the voiceless. (p. 34)

Latin America was an important arena for the development of White's epistemology. The neo-Fascist conservatism so prevalent in the entrenched Latin Ameri-

can Church structures was challenged by the Second Vatican Council, but it has never been wholly eradicated from lived experience of the active Catholic culture, of many of these countries. Just as rational theology and religious sentiment were marbled together in the consciousness of the Catholic faithful, so, too, was the process of adaptation to fresh challenges. A reorientation from regarding strict centralization of Church authority and entrenched privilege as the divinely constituted order has been unevenly intertwined with the popularization of the mode of thought that encompassed democracy and equality as Christian principles. Furthermore, when the theological paradigm did change in the 1960s, it was the *theology of liberation* that challenged the supremacy of the older observations. Since this was a movement that unabashedly engaged the exploitative class structures of capitalism, it was regarded as extremely threatening to the bourgeois elements of the established Church.

Latin America was also the home of an important intellectual influence in White's vision: the groundbreaking work of the Jesuit scholar (as Bob White is) Jesús Martin-Barbero, himself greatly influenced by the sea change of Vatican II. Martin-Barbero had the ability to synthesize the work of a number of theorists in the tradition of cultural studies, and enjoin them into a narrative that threaded its way through popular culture, hegemony, resistance, and audience appropriation. Martin-Barbero drew on the work of such widely diverse thinkers as Michel de Certeau, Pierre Bourdieu, Antonio Gramsci, Williams, Benjamin, Richard Hoggart, Edward Palmer Thompson, Mikhail Bakhtin, Umberto Eco, Jean Baudrillard, Michel Foucault, and Jurgen Habermas. As White noted, writing in 1994:

> The common thread that he draws from these theorists is a rediscovery of people's roles in producing meaning and creating their own identities through localized cultural processes that operate in spite of, or in resistance to, attempts at cultural domination through communication media. At the heart of this text is the author's passionate belief in people as active, intelligent, and tactical beings who are fully capable of disrupting, subverting, resisting, and appropriating media processes and messages. (Fox & White, p. 523).

The Latin American setting of Martin-Barbero's work alerted White to the importance of the *reception* of the message, as well as its *production* (an angle that was still rather novel in the early 1990s), but also to the multiplicity, complexity, and pervasiveness of media in Latin America. The media situation in South Africa of the 1980s was far less diverse than at the present time. The broadcast media was still under the monolithic control of the state, and newspapers were in the hands of a few monopoly corporations. There was a minor, but highly influential "alternative press" in the way of small, localized newspapers like *New Nation*, funded most frequently by nongovernmental organizations. Liberation theology shared with the Vatican social justice encyclicals a move away from the rubric of Church-as-dogma to Church-and-community. Working at the interstices of the theological and the secular, scholar-practitioners like White, Michael Traber, Pradip Thomas, and Philip Lee, among so many others, were able to meld social

justice, communication theory, and development studies into useful and norma-
tively inspired studies.

Shifting Spaces

Given South Africa's unique history of isolation and oppression we now shift gears
and write about: (1) how White helped shape the curriculum and work of our
Centre, and (2) how in his later years White actively shaped African communica-
tion studies in his own indomitable way. White's interventions, his facilitation
and popularization of other scholars' work are similarly significant, as is his expe-
rience, across a number of continents over a long period, in parts of the world in
which social justice can never be taken for granted.

The Early Days

Bob White spent a six-week sabbatical in Durban, South Africa, in 1993. Previ-
ously, he had met up with Keyan in the mid-1990s. In 1991, Keyan and the
late Arnold Shepperson produced a two-volume issue of *Communication Research
Trends* on "Popularising Semiotics" (sic). This was at a time when semiotics was
beginning to break through the primary scholars' jargon barrier in the form of
textbooks in media, literature, and linguistics, to become accessible to under-
graduate students. The volumes, which were translated into Spanish (1993), ques-
tioned the European philosophical orientation that was brought to the overview.
This orientation has remained the basis of much of our work to date (see, e.g.,
Tomaselli, 1999).

Bob's point of departure was normative theory, which as far as we could make
out, meant in everyday speak "how communication theory could be used to en-
sure that the world became a better place, a place based on strong ethical values
and integrity." Factor this into "development communication" and the project
became "how communication could be used to ensure that those who had less
material and educational capital could be privileged—rather than excluded—by
communication endeavors in a manner that was based on strong ethical values
and integrity." In this process, two strands of influence were clear—the Vatican II
values as pronounced in the encyclicals on communication for social justice; and
the writing of Jesús Martin-Barbero, particularly his affirmation of the strength
and influence on popular culture by mass communication.

The two media forms most consistently studied and commented on by
Martin-Barbero were the *telenovela* and the plethora of small community radio
stations that permeated both urban and rural areas. How different this was to
the dogma of *Mirari Vos* (1832) that eschewed popular culture as vulgar and de-
valued. In the early 1990s, South Africa boasted neither community radio nor
popular soap operas; though in time community radio would indeed become an
important medium of democratic communication, and indigenous, South Afri-
can–produced soap operas and serials would make important in-roads into both

the entertainment and *edu-entertainment* needs of the country. But that is to look forward.

Back in 1993, all this was akin to looking into a smoky glass globe and trying to discern how best to equip our students with cutting-edge media and communication theory with a strong strain of social justice, so as to provide them with the best tools for taking South African media democracy forward. In this endeavor, Bob White's contributions were seminal.

During his stay in Durban, Bob worked with Ruth Teer-Tomaselli on putting together a semester-long module for graduate students titled "Media, Development and Democracy." Ruth's long experience in the area of development studies, media studies, and broadcasting within an African context, together with Bob's insistence on the normative value of communication, proved to be a fruitful combination. The module's seminars were divided into an exploration of four macro-development paradigms: modernization; dependency-disassociation; development support communication; and participatory or "another development." In later years a fifth paradigm was added, known as the Three Ds (Dialogue, Development, and Diversity).

These paradigmatic approaches traced how conceptions of development had evolved over the past decades. The first is the modernization paradigm, dominant from approximately 1945 to 1965, which tended to support the agenda of the North Atlantic nations and their interest in transferring not only their technology but also the socio-political culture of modernity to "traditional" societies. The second paradigm is dependency-dissociation, which played an important role in the movement for a New World Information and Communication Order (NWICO) from the late 1960s to the early 1980s. It represented the goals of the new nations for political, economic, and cultural self-determination within the international community of nations. Development support communication (DSC) was designed in the early 1980s to bridge between the modernization and dependency trajectories; it is semi-participatory in approach but aimed at legitimating outside agencies' agendas and projects. The participatory or "another development" paradigm favored popular grassroots movements for greater democratization and structural change within the nonaligned countries. In this conception of development, issues of cultural identity take primacy. The Three Ds is a UNESCO-driven approach that examines the relationship between diversity and development and recognizes that the failure to deal adequately with diversity is a serious inadequacy within most development theories.

Each of these frameworks emerged as a critique of the inadequacies of the earlier paradigms, but both the practical implementations and the theoretical premises underlying the previous paradigms tend to remain operative in the culture of developing countries. Thus, in reality, we find different paradigms operating side-by-side, sometimes interlinking, sometimes not. As a prelude to the second

semester module, Communication for Social Change (CFSC) was introduced as a separate module. It places an emphasis on health communication, serves as the overarching framework drawing a link between Southern African development and social change through different mediums of interpersonal communication. The module therefore indigenizes international theory and development paradigms in terms of local contexts, culture, and knowledge.

Bob's spatial metaphor is a set of concentric circles, in which "normative theory" is the outer circle and remains the key, anchoring philosophy. Into this circle is placed the relevant "macro theory circle" (see above) and then, like a series of Russian dolls, nested a sequence of ever more specific approaches, concepts, and models—for instance, the New World Information and Communication Order (NWICO), the public sphere, public service broadcasting, or participatory media. Each is an exemplary incidence of a micro-, or even miso-, theoretical standpoint, ready to be teased out and applied to specific, concrete circumstances. The public sphere, mentioned here, is one of his favorites. White (1990a) argues the importance of public sphere consultation by powerful executives and the mass media in order to contextualize planning. A major problem with the creation of the public sphere in underdeveloped countries, he posits, was the lack of a physical communication infrastructure. He argues that the public sphere can be dominated by hegemonic influences and therefore sees the creation and/or sustainability of a central institutional structure that defines the common value for people in society as a top priority (White, 1990a, pp. 2–15). He discusses further how the use of cultural dramaturgy could construct meaning (White, 1990a, p. 27). The importance of such grassroots communication is discussed in more detail through his Latin American public service broadcasting and participatory radio papers (cf. White 1990b).

Over the years, Ruth changed, adapted, and grew the module; and in time, handed it over to other lecturers within CCMS. Development theory, public service broadcasting, and the notion of the public sphere became increasingly contextualized within African debates on development addressing problems in a uniquely South African way. The module was repositioned as "Development, Media and Culture" (2006), and again revised and reframed within a "Communication for Social Change" framework, now called "Development, Communication and Culture" (2008). It has been led by different lecturers, with different interests and emphases, and the original overhead-acetate slides have given way to sophisticated, illustrated, and even moving PowerPoint presentations.

African Communication Research

When Bob moved to Tanzania, one of his first projects was to start a *Communication Research Trends*–type of publication on African research. *African Communication Research* was the result, a journal that, unlike *Communication Research Trends* in its new and descriptive guise edited from the United States, not only

provided critical overviews of the state of research in Africa but actually pushed it along. *African Communication Review* was sorely needed to fill the vacuum left by the demise of the African Council for Communication Education in the late 1990s whose own influential journal, *Africa Media Review*, was last published in 1997. White's new publication very quickly established itself as top rated and our Centre publishes the online version under the auspices of the UNESCO Chair in Communication held by Ruth. The journal has succeeded in reuniting the East African communication scholarly community, while also taking on a pan-African role in exposing, popularizing, and assessing critical research across the continent. It cut through instrumentalist communication science assumptions imported to Africa by academics who have studied abroad, and who assumed a mechanistic, scientific approach to media and communication. This synthesizing imperative cannot be underestimated where scholars and departments often have more intense relationships with the North than they do within Africa itself (for reasons of cost, geography, access academic traveling routes, etc.). The online facility underlines the point that journals publishing from within Africa are just as important and as accessible as those publishing from the North. Even in the age of Google, African students, and especially supervisors, based in the North very often seem unaware of the easy existence of so much, often high quality, and African-generated research.

Robert White's legacy will be that unique blend of intellect and humanity. Whether expressed on old-school overhead slides, PowerPoint, or online, open access journals, his central concern remains that communication is there for a purpose—to empower people, to provide them with expressive capacity and agency, to be a force for good. All his work is premised on normative theory, and it is driven by the purpose of how communication can be used to empower people in ways that are ethical and guided by integrity.

Bibliography

Aetatis Novae. (1992). "On Social Communication on the Twentieth Anniversary of *Communio et Progressio*." Pontifical Council for Social Communication. Available at http://www.vatican.va/roman_curia/pontifical_councils/pccs/documents/re_pc_pccs_doc_22021992_aetatis_en.html

Dorr, D. (1983). *Options for the Poor*. Dublin: Gill and MacMillian/ New York: Orbis.

Fox, E., & R. White. (1994). "Review of Jesús Martin-Barbero, *Communication, Culture and Hegemony—From Media to Mediations*." *Canadian Journal of Communication*, 19(3), 521–523.

Group Media Journal. (1989). Special Issue. West Germany: Sonolux

Martin-Barbero, J. (1987). *De Los Medios a las Mediaciones*. Mexico: Gustavo Gilli, pp. 220–229.

Mirari Vos. (1832). "On Liberalism and Religious Indifferentism." Encyclical of Pope Gregory XVI, promulgated on August 15. Reproduced by the Catholic Television Network. http://www.ewtn.com/library/encyc/g16mirar.htm

Müller, K. (1989) 'Living the Grassroot Story in Lusaka'. *Group Media Journal* (Special Issue), p. 2.

O'Connell, S. (1989). "The Slow Dawn of Truth in South Africa." In *Group Media Journal*, VIII(1): 2.

O'Malley, J. W., D. G. Schultenover, & S. Schloesser. (2007). *Vatican II: Did Anything Happen?* New York: Continuum.

Shea, J. (1980). *Stories of Faith*. Chicago: Thomas More Press.

Tomaselli, K.G. (1999). *Appropriating Images*. Denmark: Intervention Press.

Tomaselli, K. G., & A. Shepperson. (1991). "Popularizing Semiotics." *Communication Research Trends*, 11(1), 1–27 & 11(2), 1–22. Reprinted in Spanish translation in *Revista de Ciencias de la Infomacion*, 8(1993), 231–257.

Tomaselli, K. G., & R. E. Teer-Tomaselli. (2003). "New Nation: Anachronistic Catholicism and Liberation Theory." In J. Curran & N. Couldry (Eds.), *Contesting Media Power: Alternative Media in a Networked World* (pp. 195–208). London: Routledge.

Vatican Archives. (2010, May 16). Message of His Holiness Pope Benedict XVI for the 44th World Communications Day. "The Priest and Pastoral Ministry in a Digital World: New Media at the Service of the Word." Available at http://www.vatican.va/holy_father/benedict_xvi/messages/communications/documents/hf_ben-xvi_mes_20100124_44[th]-world-communications-day_en.html

Vatican Archives. (1971). Pastoral Instruction *"Communio et Progressio."* On the Means of Social Communication Written by Order of the Second Vatican Council. http://www.vatican.va/roman_curia/pontifical_councils/pccs/documents/rc_pc_pccs_doc_23051971_communio_en.html

Vatican Archives. (1963, December 4). *"Inter Mirifica* [Decree on the Media of Social Communication] Solemnly Promulgated by His Holiness Pope Paul VI." Available at http://www.vatican.va/archive/hist_councils/ii_vatican_council/documents/vat-ii_decree_19631204_inter-mirifica_en.html

Vatican Archives. (2005, January 24). Apostolic Letter "The Rapid Development" His Holiness John Paul II to those responsible for Social Communications. Available at: http://www.vatican.va/holy_father/john_paul_ii/apost_letters/documents/hf_jp-ii_apl_20050124_il-rapido-sviluppo_en.html

Walsh, M.J., & Davies, B. (Eds.) (1984). *Proclaiming Justice and Peace: Documents from John XXII to John Paul II*. London: Collins Liturgical Publications

White, R. A. (SJ) (1986). "Mass Media and the Culture of Contemporary Catholism: The Significance of the Second Vatican Council" (Photostat). Centre for the Study of Communication and Culture, London. (Note that this paper builds on White's earlier article, "The New Communications Emerging in the Church", *Way Supplement*, No. 57, 1986).

White, R. A. (1989, June). "Networking and Change in Grassroots Communication." *Group Media Journal*, 17–21.

White, R.A. (1990a) 'Cultural Analysis in Communication for Development: The Role of Cultural Dramaturgy in the creation of a Public Sphere'. Article prepared for the journal (*Development*). Italy: Centre for Interdisciplinary Studies in Communications, The Gregorian University.

White, R.A. (1990b) 'Participatory Communication as a Social and Cultural Process' Chapter prepared for the book: *Participation: A Key Concept in Communication for Change and Development*. Italy: Centre for Interdisciplinary Studies in Communication, The Gregorian University.

CHAPTER SIXTEEN

Media Ecology

PAUL A. SOUKUP, SJ

Media ecology describes a general approach to communication rather than a specific theory or set of theories. Unlike more empirically derived theories, its explanatory potential lies in its ability to move from a general overarching view of communication to more specific individual behaviors. The approach itself begins with a metaphor—that of an ecosystem—and applies it in various ways to communication. That it applies the metaphor to both the physical infrastructure of communication and to the cultural or intellectual world of communication gives it added breadth. In addition, media ecology accepts broad or even polysemic definitions of "media" and "communication," including, as we shall see, language, technologies, artificial environments, human interaction, programming, and other kinds of communication content.

Media ecology rests on two defining metaphors: that of ecology and that of media (Postman, 2006/2000, p. 62). First, the ecology metaphor refers to a biological ecosystem. Such a system describes, for example, an interacting group of physical environment, plants, animals, and other factors that create a stable but changing system. First coined in 1930 by Roy Clapham "to denote the physical and biological components of an environment considered in relation to each other as a unit," the term "ecosystem" defines "a system that includes all living organisms . . . in an area as well as its physical environment . . . functioning together as a unit" (Biology Online, 2008).

The second key metaphor—"medium"—also comes from biology, though it can describe a number of other things as well, particularly relationships. Neil Postman, the founder of the graduate program in media ecology at NYU, offered a bit of background to the choice of "media ecology" as the program's name in a talk he gave at the first annual convention of the Media Ecology Association in 2000:

> You will remember from the time when you first became acquainted with a petri dish, that a medium was defined as a substance within which a culture grows. If you replace the word substance with the word technology, the definition would stand as a fundamental principle of media ecology: A medium is a technology within which a culture grows; that is to say, it gives form to a culture's politics, social organization, and habitual ways of thinking. (2006/2000, p. 62)

Though Postman does not cite it, "medium" can also apply to intervening material or agents, representatives or representation, artistic substances, or even language (Soukup, 1987). Postman did, however, later recall how multiple things could function as media: "I distinctively remember having that point of view that the school was just one medium through which a culture communicated some of its important ideas and I understood that there were other media in the culture to do it" (Lum, 2006, p. 10). All of these meanings or images of media work together to describe a rich interaction among people (communication), technologies, ideas, possibilities for growth, and possibilities of understanding.

Postman reminds us, "Human beings live in two different kinds of environments. One is the natural environment." This, of course, includes the physicality of our lives, not only nature but houses and tools and so on. "The other is the media environment, which consists of language, numbers, images, holograms, and all of the other symbols, techniques, and machinery that make us what we are" (Postman, 2006/2000, p. 62). Ecology also applies to an ideational environment. Communication generates ideas. And these ideas create the context for still more ideas. Such a process finds an apt description in the ecology model where the interaction of ideas and communication leads to the promotion or spread of some ideas and the withering of others. Those ideas picked up in the communication channels grow. New or "foreign" ideas can take over a given environment—an apt description for media fads. Ideas connected to external factors such as economic resources or political support may spread more rapidly. Communication, however defined, both constitutes an environment for ideas and participates in an environment of ideas.

Similar thinking applies to the intellectual environment. The scholars and thinkers who use the media ecology approach thus create a kind of ecology themselves:

The emergence of media ecology as a theory group and a theoretical perspective late in the 1960s can be seen as a result of the coming together of an interlocking network of an invisible college of like-minded thinkers who shared similar concerns over media technology and change within larger social, economic, political, and intellectual contexts that began at the turn of the 20th century. (Lum, 2006, p. 18)

The convergence, however, did not result from any planned development. The parts of media ecology grew independently and often unconscious of any sense of "ecology." The sense of "media" and "ecology" as an approach to communication study emerged only retrospectively.

Putting the two metaphors together into "media ecology" suggests a different way to think about communication, one in which the researcher cannot easily separate the elements. If the elements interact as a living system, then removing one or another for study changes the system itself. However, just as with the biological ecosystem, one can learn from both the parts and the interaction if one does not forget the overall system. The metaphors also scale well, since they describe both the physical environment (e.g., the technology in which a culture grows) and the "sub-environments" created by each part; they similarly describe the intellectual environment and its components.

Systems thinking of this type, while not new, does not often occur at other than the technological ("telegraph systems") or managerial ("corporate structures") levels of communication study. U.S. researchers, historically focused on communication effects or on individual behaviors, had difficulty considering these as parts of a system. The desire to know how communication works had led to a focus on what McLuhan called the "figure" rather than the ground or backdrop. As scholars more consciously began to study media as an ecosystem, they (re)claimed a number of others who seemed to do the same thing.

Antecedents and People Shaping Media Ecology

Postman played the key role in the emergence of media ecology. In his history of its beginnings, Gencarelli (2006), notes:

It is Postman who institutionalized the term when he established the PhD program in Media Ecology at New York University in 1970. The term and a definition of it first appear in print in the published version of a speech he made in 1968. . . . In sum, it is Postman whose name is most closely associated with media ecology and all that to which the term refers. (pp. 202–203)

Postman may have given the name and may have helped his graduate students to learn to recognize ecological thinking in communication, but he did not invent its practices. According to Strate,

He [Postman] told his audience [in 1968] that "the first thing to be said about media ecology is that I am not inventing it. I am only naming it" (Postman, 1970, p. 161). By not claiming the role of founder of a discipline . . . Postman left open the origins of the field, and implied that media ecology has been in existence in one form or another since antiquity. (2004, p. 4)

Postman spotted the outlines in the work of others, and he had the sensitivity to cast light on the backgrounds that often remained taken for granted.

Through his career Postman moved from a focus on education and language to a wider attention to culture. He began to think of schools as media for transmitting, sharing, nurturing, and creating culture. In this context he became sensitive to language, and in 1961 he wrote of "the ecology of the semantic environment" (Gencarelli, 2006, p. 210), expressing a concern for its pollution by trivial talk and entertainment. Since communication media so influenced that semantic environment, Postman began to look at how the media had an impact on that environment. In his prospectus for the PhD program at NYU, Postman showed a clear focus on individual communication, of people in an environment affected by media systems:

> Media ecology is the study of transactions among people, their messages, and their message systems. More particularly, media ecology studies how media of communication affect human perception, feeling, understanding, and value; and how our interaction with media facilitates or impedes our chances of survival. The word *ecology* implies the study of environments—their structure, content, and impact on people. An environment is, after all, a complex message system which regulates ways of feeling and behaving. It structures what we can see and say and, therefore, do. (quoted in Gencarelli, 2006, p. 214)

Only later did he focus his attention more specifically on the media environment and, secondary, how it shaped the culture. In probably his best known book, *Amusing Ourselves to Death* (1985), Postman examines the impact of television on public discourse. For him, scholars must examine the ecosystem in order to understand the culture growing within it.

However, by leaving the description of media ecology broadly defined, Postman accepted the fact that others could, and probably did, "do media ecology" long before he named it. The list goes on at some length, as Strate (2004) indicates in a very thorough review of the literature. For example, one could argue that the Chicago school of sociology, with its emphasis on social structures and the mass media as the nervous system of the body politic could fit into a media ecology analysis. Key members such as Robert Park, Herbert Blumer, and their students Howard Becker and Erving Goffman (as well as the theorists upon which they drew—John Dewey, Charles H. Cooley, and George Herbert Mead) (Lutters & Ackerman, 1996, p. 12)—called attention to the interaction of social systems. Even their metaphors encourage reflection not on the messages or the effects of those messages, but on the background structures that position people and reg-

ulate their behaviors. According to Lutters and Ackerman, "Ecological models were apt framing devices for the discussion of urban social relations. These social structures could be viewed as a complex web of dynamic processes, akin to components of an eco-system" (pp. 3–4).

The term "ecology" dates to biology in the 1930s. That idea of an ecology or of an interacting "system" seemed a part of the intellectual milieu of the early twentieth century, with another biologist, Ludwig von Bertalanffy, proposing a similar overarching approach in systems theory.

> [Von Bertalanffy] emphasized that real systems are open to, and interact with, their environments, and that they can acquire qualitatively new properties through emergence, resulting in continual evolution. Rather than reducing an entity (e.g., the human body) to the properties of its parts or elements (e.g., organs or cells), systems theory focuses on the arrangement of and relations between the parts which connect them into a whole. . . . This particular organization determines a system, which is independent of the concrete substance of the elements (e.g., particles, cells, transistors, people, etc.). (Heylighen & Joslyn, 1992, par. 1)

If one substitutes communication media for the various organic parts in this biological listing, one would have a fairly workable description of media ecology. The general breadth of systems theory, focusing on "concepts and principles of organization," make it and its proponents in various fields—von Bertalanffy, Ross Ashby (biology), Talcott Parsons (sociology), Niklas Luhmann (sociology), Fritjof Capra (physics), as well as others in cybernetics, business organization, or psychology—sources of ideas for media ecology itself. The very idea of a system implies communication at various levels. Even thinkers well outside of the biological sciences embraced the idea of ecology. Strate (2004) reports that in the mid-1970s, Walter Ong referred to an

> ecological concern . . . which he [Ong] describes as "a new state of consciousness, the ultimate in open-system awareness. Its thrust is the dialectical opposite of the isolating thrust of writing and print . . . not unrelated to the opening of previously isolated human groups to one another fostered by electronic communications media, telephone, radio, and ultimately television." (Ong, 1977, p. 324). (pp. 3–4)

People experience this ecology at various levels, at least, as we shall see, at a "macro-level" and a "micro-level."

Thus, following Postman's lead, media ecology tends to claim its antecedents from a broad range of thinkers, in addition to those already mentioned in connection with biology and sociology. The list includes Lewis Mumford, Edmund Carpenter, Eric Havelock, Harold Innis, Marshall McLuhan, Walter Ong, SJ, Elizabeth Eisenstein, Jacques Ellul, James Carey, Susanne Langer, and Benjamin Lee Whorf. The purpose here is not so much to argue for any of the theories proposed by these thinkers or even to describe them in great detail, but to highlight how each

takes a kind of ecological approach and how these kinds of attempts to explain human life and communication provide the background for media ecology.

Mumford, a proponent of the analysis of technology and society, called attention to how machines as organizational systems "emphasized order, control, efficiency, and power. Combining human and artificial parts, the modern megamachine also depends on communication technology to function effectively" (Strate & Lum, 2006, p. 89). Focusing on technics, Mumford refused to take a narrow view of technology or its manifestations and looked instead at the system that both made technology possible and allowed technologies themselves to grow more complex. One cannot understand technology without the larger view of "the entire technological complex" (Mumford, 1934, p. 12, qtd. in Strate & Lum, p. 78). The complex includes the city and its architecture, the human tools, the humans that use them, and the organizational systems that control human interaction.

Just as an awareness of ecology grew up in the 1930s, a different intellectual confluence occurred in the early 1960s. Havelock identifies the period from 1960 to 1964 as a time when scholars across academia paid particular attention to "the orality problem." Prompted by curiosity about how oral poets managed to remember long epic poems, about the identity of Homer, and about the organization of traditional societies, a number of scholars, working independently, probed the problem: Lévi-Strauss in *La Pensée Sauvage*, Goody and Watt in "The Consequences of Literacy," McLuhan in *The Gutenberg Galaxy*, Mayr in *Animal Species and Evolution*, and Havelock himself in *Preface to Plato* (Havelock, 1986, p. 25). Each of the works called attention to a communication-culture link manifest in how cultures without writing experienced, stored, and performed knowledge. The books and articles suggested an ecology of communication practices, cultural self-understanding, communication technologies, and knowledge management. Havelock's work on classical Greece (1963) argued that the spread of a writing system provided the affordance for a more sustained, more objective, and more critical examination of the Greek *paideia*, leading to the reorganization of Greek education and thought in the works of Plato and Aristotle.

Havelock's mentioning of McLuhan's *Gutenberg Galaxy* introduces a key figure among the forbears of media ecology. McLuhan, a Canadian literary critic who moved from the analysis of media texts (primarily advertisements, 1951) to a more comprehensive examination of the media of communication (1962, 1964), argued that communication researchers and other scholars failed to understand the impact of communication because they failed to understand its context. Using images drawn from psychology, he encouraged people to focus on the "ground" rather than the "figure." In another tack, he borrowed from philosophy to encourage people to attend to formal cause rather than the more apparent efficient cause (1976). More prosaically (and more environmentally) he compared the media

world to the water in which fish swim: each becomes an invisible environment. "His further aim was to create awareness that all human 'artefacts' . . . create a background or complex of environmental conditions and related technologies of which we are mostly unaware, because we take them as givens" (Morrison, 2006, p. 171).

McLuhan wrote initially on the impact of printing on how people organized their worlds, drawing on historical research as well as on literary criticism—since so much of the literary canon cannot be separated from its printed history. Where that effort looked to the past, his later writing on the electronic media attempted to discern the present. Here he drew on the work on "the orality problem" to seek a framework for the oral presences (in contrast to the written, printed word) in radio, film, and television. Ultimately, McLuhan wanted people to think about their environments. Insofar as he sketched out how people interacted with those environments, he proposed an ecology—or at least promoted an ecological thinking.

In framing his arguments, McLuhan drew on the work of Innis, another Canadian. Trained as an economist, Innis noticed how trade patterns and communication channels interact—the movement of goods and information. Further, he took what we now call the ecological view, following "pulp and paper through its subsequent stages—the newspaper and journalism, books, and advertising. In other words, from looking at a natural resource-based industry, he turned his attention to a cultural industry in which information, and ultimately knowledge, was a commodity that circulated, had value, and empowered those who controlled it" (Heyer, 2006, p. 147). As he continued to explore this area, Innis moved beyond one particular industry to how cultures respond to and manage information (1951). Innis recognized, and felt that he had found the evidence in history and economics for the assertion, that in Carey's phrase, "communication technology principally affect[ed] social organization and culture" (quoted in Heyer, 2006, p. 156). Like media ecologists after him, Innis tries to call attention to an often overlooked environment.

Another key figure who appears in McLuhan's *Gutenberg Galaxy* is Ong, who had first met McLuhan in the 1940s when McLuhan directed his master's thesis on the poetry of Gerard Manley Hopkins. Taking up a suggestion from McLuhan that he do his PhD work on the Renaissance educational reformer Peter Ramus, Ong completed a massive study of education in the Renaissance and the role that writing and printing played in reorienting information and education from rhetorical to logical methods. (McLuhan drew on this work in *The Gutenberg Galaxy* for evidence in support of his analysis.) With an interest in the cultural consequences of the shifting communication practices (and the traces they left in the literary sources), Ong himself took up where Havelock and others left off with "the orality problem" with a decades-long investigation into "the word." He eventually published a trilogy of studies (1967, 1977, 1982) in which he explores modes of

expression, thought, and the ways humans store and recall information; each of these things, he argues, affects how people understand and frame knowledge. In this, he attempted to bridge the gap between large-scale cultural and smaller-scale personal influences of communication practices. An indication of his thinking regarding large-scale and small-scale interaction is a chapter title from *Orality and Literacy* (1982): "Writing Restructures Consciousness." Like others claimed by media ecology, Ong maintained an interest in the communication and cultural systems; he took as his entry point educational and literary practices.

Another proto-media ecologist, Carpenter worked with McLuhan and Innis at the University of Toronto from 1948 to 1957 (Prins & Bishop, 2001–2002, p. 111). Carpenter, "an archaeologist and anthropologist . . . , impatient with traditional boundaries between disciplines, did groundbreaking work in anthropological film making and ethnomusicology and, with his friend Marshall McLuhan, laid the foundations of modern media studies" (Grimes, 2011, para. 1). That collaboration grew out of a common interest in language and culture; together Carpenter and McLuhan edited a journal, *Explorations*, which published materials from the University of Toronto Seminar on Culture and Communication, a group that discussed how various media interacted with human relationships. Carpenter's interest in the mediated world of communication and its ecology grew with his hosting of an early (1952) Canadian television program (Prins & Bishop, 2001–2002, p. 114).

The layering of media forms emerged in a number of ways in Carpenter's work, not the least in his own filmmaking. Doing anthropological fieldwork among the pre-literate Inuit peoples, Carpenter's interest in communication patterns and social organization grew, particularly as he reflected on the acoustic space of the oral culture and contrasted it with his own literacy (Prins & Bishop, 2001–2002, p. 116). "McLuhan and Carpenter were especially interested in the dialectical interplay between media technology and the social, psychological, cultural, and finally biological, condition of humanity" (p. 115). Together they built on Innis's ideas on the transformative nature of technologies on societies. Though his life's work remained in anthropology, Carpenter brought the methods and sensitivity of that discipline to focus on the larger environment of communication. This perhaps influences his metaphor for the communication media, as it interacts with preliterate people, a metaphor expressed in the title of his best known work: *Oh, What a Blow That Phantom Gave Me!* (1972). Both oral cultures and our own wrestle with what appears to our consciousness as a phantom presence (p. 130).

About the same time that the ecological thinking emerged in biology, Whorf, a part-time linguist inspired by the work of Edward Sapir, spent his summer vacations collecting data among the Amerindian populations in the southwest United States. His still controversial theories, framed as the Sapir-Whorf hypothesis, hold that a person's or a culture's language influences their perceptions of and concep-

tions about the world, that language acts as a kind of filter and force between the individual and the natural world. Whorf's theory proposes an implicit ecological view, connecting culture, language, and the individual. In Nystrom's evaluation, Whorf was

> an early media ecologist. He understood and argued persuasively that humans do not live in the objective world alone, but in symbolic environments of thought, communication, and culture built on systems of *representing* experience. The earliest and most fundamental of these systems of representation is language, and Whorf's most urgent and insistent point was that language is not a neutral container or conveyor of ideas, but an instrument of thought that has a distinctive structure of its own, and a different structure in different speech communities. (2006, p. 288)

One of the chief hallmarks of media ecology—a concern for the environment or context of communication—appears clearly in Whorf's linguistics, even though he does not address concerns regarding communication media.

The questions Whorf raised in linguistics find a complement in the philosophy of Langer. Beginning her career in the midst of philosophical debates about language and meaning, about the project of logical positivism, she developed a philosophy of mind in which she highlighted the role of symbol in understanding. Influenced by Ernst Cassirer and his work on symbolic forms, she examined how symbolic representation functions in human cognition. Rather than considering only language, she took in the arts, music, and ritual. From that starting point, she distinguished between discursive symbols (those that develop in an almost orderly fashion and lead to a stable content of meaning) and presentational symbols. The first may describe linguistic meaning, but they do not exhaust human thought. Presentational symbols attend to context; humans grasp them as wholes, which takes them beyond language and logic into other aspects of life, including emotion and the appreciation of beauty (Langer, 1942). Nystrom regards Langer as providing the philosophical ground for much of media ecology. "[Langer] argued that language is not *the* way in which humans construct reality, but *a* way, and that different systems of symbolic transformation codify different aspects of the spectrum of human experience" (2006, p. 299). Here we find media ecology writ small: not in the social structures or technologies of a culture, but in the workings of human cognition.

In addition to the largely North American cast of forebears, media ecology also looks to the analysis of the technological society provided by Ellul, a French sociologist and religious philosopher. Influenced by both Karl Marx and Roland Barthes, Ellul typically took a broad view of society. Two of his works, on propaganda (1965) and on what he terms "la technique" (1964), provide a framework for an ecological analysis since in them he examines the interaction of, on the one hand, media practices and, on the other, technological orientation with social organization. Each of the two can easily lead to a kind of "totalizing," which

drives out other kinds of human interaction. Ellul warned against the dangers of merging communication technologies with technical and scientific methodologies. "Whereas previous centuries of technique have been bound to machinations and manipulations of the material world, modern media gain entry into the inner life of the psyche, and make possible the use of the techniques of propaganda on a large scale" (Kluver, 2006, p. 105). Media ecology finds in Ellul one who understands how technology, communication, social organization, democracy, and the individual interact. Those who follow media ecology agree "when he argues that communication technologies have profound consequences for social organization and ethos" (Kluver, p. 107).

Media ecology also claims two other, more contemporary American scholars as forebears. Eisenstein, a historian of the printing press, provided detailed historical evidence for the kinds of environmental or ecological changes that occur when a new, in this case, communication technology enters a culture. Her examination of the printing press in early modern Europe (1979) looks not just at the invention itself but at the ways in which that invention interacted with the rest of society: the rediscovery and publication of classical texts; the move of manuscript preparation from monasteries into printing houses; the spread of literacy; the growth of a bookselling industry, book fairs, and trade among regions; the emergence of standardized vernacular languages and nationalism; the development of modern science; and changes in the educational system science (Ashcroft, 2006, pp. 369–370). Eisenstein's work modeled the collection and marshaling of the kinds of careful historical support necessary to demonstrate the systemic, ecological interaction of social organization and communication practices.

Finally, Carey, the former dean of the College of Communications at the University of Illinois, called attention to the cultural impact of technology. Carey's writing on the telegraph (1988c/1983), for example, anticipated the ecology label as it examined the introduction of electric communication into nineteenth-century America: interacting with everything from railroads to catalogue shopping, the technology allowed any number of other industries and practices to emerge. His aptly titled 1988 collection, *Communication as Culture*, makes the case that the physical is only one part of the ecosystem. In Wasser's words, "Carey has expanded Innis' insistence on the *physical* nature of communication in order to look broadly at all social relations" (2006, p. 259). Carey worked to move communication study and media ecology to the level of cultural critique.

On the surface, these individuals and their work may seem unrelated. However, a number did read each other's work and some, especially those around McLuhan, did collaborate at one time or another. Some like Havelock, Eisenstein, Ong, and Carey assembled manuscript and historical evidence; others like Carpenter or Whorf turned to anthropology or linguistics; others like Innis, McLuhan, and Ellul puzzled out how the various trends affected the societies

in which they appeared. Together these eleven scholars and researchers present a kind of collective ecological thought about the systemic and interrelated nature of human tools, language, culture, and communication patterns. In a kind of retrospective sense-making (Weick, 1979, pp. 194–201), Postman drew on all of them to describe media ecology.

Key Ideas

A number of repeated ideas or concepts provide a kind of loose structure for media ecology. Within the defining metaphor of the environment or ecosystem and informed by it, several themes appear: a sense of entirety, interaction and interrelationship; the macro- and micro-system as ecosystems; the unconscious impact of communication, social organization, and attention to consequences (of even seemingly small things).

Following from the environmental metaphor, media ecology tries to look at the entirety of whatever system it considers. At the very least this means that the media ecology approach does not consider communication as a single variable; rather it regards communication as embedded into a larger system. Even when one wishes to focus only on a given communication technology or behavior, the researcher must examine that technology or behavior together with everything else. For example, a mobile phone and its use makes (media ecology) sense only in terms of the history of telephony and its hardware, a governmental regulatory framework, the economics of the service provider, past usage practices of the telephone, the particular physical location of the user, the social location of the user, other communication options, and so on. This focus on the entire "big picture" characterizes media ecology perhaps more than anything else.

Other big picture ideas that run through media ecology thinking include interaction, interrelationship, and environment, with the latter defining the scope of the former two. Once researchers have identified a communication environment for study, they then examine all of the communication interactions on various levels. Media ecology takes those senses of interaction and interrelationship broadly, to encompass time, space, and ideas; physical and social interaction; cultural and technological structures; and so on, in addition to more traditional communication topics. And everything interacts. We need only to think of some contemporary changes in the communication environment to see this at work. Adding a smart phone (the mobile device that can handle voice, text, data, location finding, and a host of other applications) changes the communication ecology and affects how people talk to one another, how they use computers, how they watch video, how they spend spare time, how they find themselves on call in new ways, and even how they observe rules of etiquette. Historical examples demonstrate the same kinds of wide interrelationships among communication practices and structures. Gutenberg's introduction of printing from moveable type in the fifteenth

century took advantage of an ecology in which paper had grown more abundant, in which enough wealth existed to support a book trade, in which travel encouraged trade (and a book trade more specifically), in which rediscovered classical manuscripts and language study provided a ready supply of titles, in which some governments saw a value in circulating ideas, and in which a ready labor supply of trained clerks could edit, proofread, and correct a printed text. Media ecology studies the interrelationships, among people, among technologies, and among social practices. As McLuhan put it, "Technological environments are not merely passive containers of people but are active processes that reshape people and other technologies alike" (1962, p. 7).

Media ecology typically operates on two levels simultaneously. Gronbeck (2006) describes this in his exploration of how media ecology works with the orality-literacy theorems: "I look at the so-called macro-theory of orality-literacy, that is, theorizing about the place of dominant media in governing societies in general; . . . I narrow to focus on micro-theory, which is to say talk about how the human mind processes messages coming to us in various media, especially acoustic, literate, and visual media" (pp. 338–339). Because of the interacting nature of systems, one can separate only theoretically the macro-theory from the micro-theory, the social from the individual. And so, as media ecology tries to describe, for example, the social impact of a communication technology or practice, it also tries to describe what happens on the personal level. Whorf's linguistic studies modeled this approach since the language community shapes the individual speaker, a principle common to all contemporary linguistics since de Saussure. In a similar way, a number of key figures describe media ecology itself as an "epistemological organization" (Postman) or as an approach to understanding consciousness (Ong). In both instances, media ecology researchers recognize that using communication tools (writing, video, and so on) or practices (classroom learning or political debates) affords opportunities to think in different ways. Ong (1982) points this out in great detail, showing how something as simple as "alphabetical order" (a concept unimaginable to a nonliterate) revolutionized how individuals think about categories and groupings. Though much media ecology analysis calls attention either to the individual or to the broader picture, in reality the two levels remain linked and interacting.

Many media ecology researchers make the point that environments act on people in unconscious ways—few people think about alphabetical order or even reading. Once people have created a physical environment, say, they inhabit it without thinking more about the buildings, roads, or rooms that constrain their (communication) behaviors. The same holds true with almost any kind of communication structuring—from the nineteenth-century telegraph lines and undersea cables to the contemporary design of Facebook. These environments affect people on several levels simultaneously and in subtle enough ways that media ecology

thinkers struggle to describe them. They describe the unconscious influence as a "bias" (Innis), a "ground" (McLuhan), a "formal cause" (McLuhan, again), "technique" (Ellul), or a "restructuring of consciousness" (Ong). The consequences of the communication environments often appear more clearly in retrospect, particularly after situations have changed. The introduction of diagrams into printed textbooks in the sixteenth century, though new, seemed unremarkable at the time; only later did people realize that this innovation afforded teachers a completely new way to organize their subject matter, and students, their thoughts. At another level and in another century, due to the importance of London to the British Empire as a commercial and political hub, undersea telegraphy cables fanned out from there around the world. But these patterns persisted, hardwired into the location of cables, even into the late twentieth century, when people desiring to send a message from South America to Canada had to route it through London. People generally do not see these things, treating the communication media or patterns as transparent. Following the lead of Innis, media ecology pays attention to the economics attached to these sorts of communication: the economic impact of communication as well as the economic forces that financed the particular infrastructure (the macro-level theory). Following Ong and McLuhan, media ecology pays attention to the epistemology of thinking with the communication media (the micro-level theory).

The epistemological and physical structures, even brought to conscious awareness, only reflect a part of the media ecology interest in how communication provides a framework for human relationships. If things like roads or rooms or routers, or telegraphs or televisions or tablets, provide a physical environment, communication patterns also offer a social environment. Media ecology researchers draw on sociology and social psychology to understand people's interactions, particularly as varying forms of communication shapes them. This, too, can occur at various levels, from the corporation to the state to the general realm of culture. Citing the work of Mumford, Strate and Lum (2006) note that the machine, in this instance a clock, organizes people. "The desire and necessity for maintaining regularity, order, and regimentation was the inherent agenda of the mechanical clock. This invention of monasteries, Mumford (1934) observed, 'helped to give human enterprise the regular collective beat and rhythm of the machine'" (p. 87). Media ecologists point out that almost any communication technology serves social organization. The control over others afforded by rapid and accurate communication shapes social interaction and allows the growth of distributed corporate organizations. Carey (1988c/1983) notes something similar in his discussion of the telegraph as an agent not only of corporate growth but also of the expansion of the state and of empire. Throughout his writings, he expands the discussion from particular social arrangements to a focus on culture. According to Wasser:

> Carey writes that "[w]hen the idea of culture enters communication research, it emerges as the environment of an organism or a system to be maintained or a power over the subject" (1988b/1977, p. 65). He goes on to refine this crude notion of culture that implies that culture is separate from the human sphere. The refinement embraces the pragmatic intuition that culture is the realm of meanings created by humans, something that is implicated in the very act of being human. (2006, p. 260)

And it is something directly dependent upon communication. Based on the work of Carey, Wasser argues that media ecology focuses on "an interdisciplinary concern with culture, defining culture as a way of life rather than a hierarchy of taste"; further, it "emphasiz[es] social analysis over textual interpretation of media impact" and remains sensitive "to new formations in media audiences" (p. 256). The communication environment supports the social system that cohabits its ecosystem.

If each of these general themes of media ecology addresses the macro-level or micro-level of the environment, a last key idea calls attention to the consequences of change within the environment. Media ecology recognizes that any change to an ecosystem will affect the whole system. Rather than treating this as a conceptual idea, media ecology regards it as a methodological one. Innis, Ong, Eisenstein, Carey, and others tracked such changes in particular historical circumstances by examining evidence from periods before, during, and after communication technologies changed: the pulp/newsprint industry in nineteenth- and twentieth-century Canada, the shift from orality to literacy in the Western world, the development of the printing press in early-modern Europe, the building of the telegraph system in nineteenth-century America, and so on. Later in his career, and working with his son Eric, McLuhan tried to formalize a method to help researchers identify the consequences of introducing new communication technologies into existing ecosystems. McLuhan and McLuhan suggest four questions about any communication technology:

- What does it enhance or intensify?
- What does it render obsolete or replace?
- What does it retrieve that was previously obsolesced?
- What does it produce or become when pressed to an extreme? (1988, p. 7).

The general method they propose—one that appears in various forms in media ecology analysis—invites historical investigation (how have things changed?), cultural analysis (how do people use these media?), and technological analysis (what role does technology play?).

The combination of conceptual theories about communication and culture with methodological approaches helps to define media ecology. The combination also helps to evaluate work in media ecology.

Relationship with Broader Issues and Challenges

Because media ecology developed as a kind of retrospective sense-making, looking at previous communication and cultural research through the new lens of the ecosystem, a number of social issues shaped its outlook. Postman, for example, began by exploring public policy issues in education. As early as 1961, he worked on the "television and the teaching of English" project and authored its report for the National Council of Teachers of English (Gencarelli, 2006, p. 204). Over the next fifteen years he returned to this concern for students and their learning environments, a concern that eventually led him to a larger view of media, including not only electronic and communication media but even the school system. As he pondered the problem, Postman found persuasive McLuhan's ideas that the forms or media of communication influenced people as much as, if not more than, the media content. As he explored the systematic bias in communication, he became more and more convinced that all the factors—media, education, thinking, culture, and so on—formed an ecology and that the changes in one part of that ecology influenced the rest (Gencarelli, 2006).

Another social issue that informed media ecology came from Europe, with Ellul's concerns for democracy in the face of technology and propaganda. Ellul's understanding of media influence went far beyond the typical media effects research current in the United States in the 1960s and 1970s. He tried to understand, for example, how the media contribute to a gradual loss of human freedom. "Because the mass media (technology) have become the sole mediators between humans, the values inherent in human 'communication' have become stripped from our interactions" (Kluver, 2006, p. 102).

Such "wider perspective" thinking about social arrangements and personal values has led not only to new approaches to understand influence but also to a willingness to take ethics seriously in media ecology. Postman concluded his 2000 Media Ecology Convention address in this way, "As I understand the whole point of media ecology, it exists to further our insights into how we stand as human beings, how we are doing morally in the journey we are taking" (2006/2000, p. 69). The media and the media industries play roles in "corrupting or purifying our morality" (p. 68), an ethical task not lost on scholars who take up a media ecology perspective (see *Explorations in Media Ecology*, 2006).

Carpenter's work in anthropology offers insight into another issue important to media ecology: the role of method and the inescapable connection between researcher and participants—and even the subject matter. Carpenter had accepted a visiting professorship in New Guinea in 1969–1970, during which time he carried out visual anthropology work with stone-age tribes in the interior of the country. As part of that project, he came to understand more deeply how the media he used (film and recording devices) and what he introduced into the cultures interacted (Prins & Bishop, 2001–2002, pp. 124–130). In a sense this simply

restates the sense of interaction within ecosystems that defines media ecology, but it also serves to reinforce it in terms of methodology.

Media ecology does not find the ways in which outside events and concerns shape it unusual; this describes nothing more than its understanding of ecology. It would also accept that these external influences work in other traditions of communication research and theory. What, then, distinguishes it? Media ecology differs from some because it brings its sense of humanism and interactionism among all parts and players involved in communication. Its broad conceptualization of communication distinguishes it, but this poses its own challenges. Others ask how media ecology might produce measurable results. Is media ecology too broad in its scope, wanting to integrate every aspect of communication? How might people demonstrate the relationships it claims in ways acceptable to other research approaches? Media ecology also suffers a bit from its association with McLuhan, whose elliptical style frustrated critics and whose literary training did not lead him to put his ideas about media into testable hypotheses.

Media ecology's strongest successes have come through historical studies, but its more interesting claims seek to understand the present and the future. Those claims rest upon their own internal logic but fail, in some ways, to rule out other relationships or causal processes. As a developing area of communication study, media ecology still needs to set out some guidelines as to its methods and its measures. What does not qualify as media ecology? What counts as good media ecology? What fails the test?

Media ecology remains a strong attempt to make sense of communication practices, technologies, influences, and cultures. It challenges other traditions within communication study to look at the widest picture and it holds out a conviction that all the pieces do indeed connect.

Bibliography

Ashcroft, J. (2006). "Typography and Its Influence on Culture and Communication: Some Media Ecological Interpretations." In C. M. K. Lum (Ed.), *Perspectives on Culture, Technology, and Communication: The Media Ecology Tradition* (pp. 367–388). Cresskill, NJ: Hampton.

Biology Online. (2008). "Ecosystem. Retrieved." Available at http://www.biology-online.org/dictionary/Ecosystem

Carey, J. W. (1988a). *Communication as Culture: Essays on Media and Society*. Boston: Unwin Hyman.

Carey, J. W. (1988b/1977). "Mass Communication and Cultural Studies." In J. W. Carey, *Communication as Culture: Essays on Media and Society* (pp. 37–68). Boston: Unwin Hyman.

Carey, J. W. (1988c/1983). "Technology and Ideology: The Case of the Telegraph." In J. W. Carey, *Communication as Culture: Essays on Media and Society* (pp. 201–231). Boston: Unwin Hyman.

Carpenter, E. (1972). *Oh, What a Blow That Phantom Gave Me!* New York: Holt, Rinehart, & Winston.

Eisenstein, E. (1979). *The Printing Press as an Agent of Change: Communications and Cultural Transformations in Early Modern Europe* (2 vols.). Cambridge: Cambridge University Press.

Ellul, J. (1964). *The Technological Society*. New York: Knopf.

Ellul, J. (1965). *Propaganda: The Formation of Men's Attitudes*. New York: Knopf.

Explorations in Media Ecology. (2006). 5(4).

Gencarelli, T. F. (2006). "Neil Postman and the Rise of Media Ecology." In C. M. K. Lum (Ed.), *Perspectives on Culture, Technology, and Communication: The Media Ecology Tradition* (pp. 201–253). Cresskill, NJ: Hampton.

Grimes, W. (2011, July 7). "Edmund Carpenter, Archaeologist and Anthropologist, Dies at 88." *New York Times*. Available at http://www.nytimes.com/2011/07/08/arts/edmund-carpenter-archaeologist-and-anthropologist-dies-at-88.html?pagewanted=all

Gronbeck, B. (2006). "The Orality-Literacy Theorems and Media Ecology." In C. M. K. Lum (Ed.), *Perspectives on Culture, Technology, and Communication: The Media Ecology Tradition* (pp. 335–365). Cresskill, NJ: Hampton.

Havelock, E. A. (1986). *The Muse Learns to Write: Reflections on Orality and Literacy from Antiquity to the Present*. New Haven, CT, & London: Yale University Press.

Havelock, E. A. (1963). *Preface to Plato*. Cambridge, MA: Harvard University Press.

Heyer, P. (2006). "Harold A. Innis' Legacy in the Media Ecology Tradition." In C. M. K. Lum (Ed.), *Perspectives on Culture, Technology, and Communication: The Media Ecology Tradition* (pp. 143–161). Cresskill, NJ: Hampton.

Heylighen, F., & C. Joslyn. (1992). "What Is Systems Theory." Principia Cybernetica Web. Available at http://pespmc1.vub.ac.be/SYSTHEOR.html

Kluver, R. (2006). "Jacques Ellul: Technique, Propaganda and Modern Media." In C. M. K. Lum (Ed.), *Perspectives on Culture, Technology, and Communication: The Media Ecology Tradition* (pp. 97–116). Cresskill, NJ: Hampton.

Langer, S. K. (1942). *Philosophy in a New Key: A Study in the Symbolism of Reason, Rite, and Art*. Cambridge, MA: Harvard University Press.

Lum, C. M. K. (2006). "Notes toward an Intellectual History of Media Ecology." In C. M. K. Lum (Ed.), *Perspectives on Culture, Technology, and Communication: The Media Ecology Tradition* (pp. 1–60). Cresskill, NJ: Hampton.

Lutters, W. G., & M. S. Ackerman. (1996). "An Introduction to the Chicago School of Sociology." Available at http://userpages.umbc.edu/~lutters/pubs/1996_SWLNote96-1_Lutters,Ackerman.pdf

McLuhan, M. (1976). "Formal Causality in Chesterton." *Chesterton Review*, 2(2), 252–259.

McLuhan, M. (1964). *Understanding Media: The Extensions of Man*. New York: McGraw-Hill.

McLuhan, M. (1962). *The Gutenberg Galaxy: The Making of Typographic Man*. Toronto: University of Toronto Press.

McLuhan, M. (1951). *The Mechanical Bride: Folklore of Industrial Man*. New York: Vanguard.

McLuhan, M., & E. McLuhan. (1988). *Laws of Media: The New Science*. Toronto: University of Toronto Press.

Morrison, J. C. (2006). "Marshall McLuhan: The Modern Janus." In C. M. K. Lum (Ed.), *Perspectives on Culture, Technology, and Communication: The Media Ecology Tradition* (pp. 163–200). Cresskill, NJ: Hampton.

Mumford, L. (1934). *Technics and Civilization*. New York: Harcourt Brace.

Nystrom, C. (2006). "Symbols, Thought, and 'Reality': The Contributions of Benjamin Lee Whorf and Susanne K. Langer to Media Ecology." In C. M. K. Lum (Ed.), *Perspectives on Culture, Technology, and Communication: The Media Ecology Tradition* (pp. 275–301). Cresskill, NJ: Hampton.

Ong, W. J. (1982). *Orality and Literacy: The Technologizing of the Word*. New York & London: Methuen.

272 | Part Three: Thematic Approaches

Ong, W. J. (1977). *Interfaces of the Word: Studies in the Evolution of Consciousness and Culture*. Ithaca, NY, & London: Cornell University Press.

Ong, W. J. (1967). *The Presence of the Word: Some Prolegomena for Cultural and Religious History*. New Haven, CT: Yale University Press.

Postman, N. (2006/2000). "The Humanism of Media Ecology." In C. M. K. Lum (Ed.), *Perspectives on Culture, Technology, and Communication: The Media Ecology Tradition* (pp. 61–69). Cresskill, NJ: Hampton.

Postman, N. (1985). *Amusing Ourselves to Death: Public Discourse in the Age of Show Business*. New York: Viking.

Postman, N. (1970). "The Reformed English Curriculum." In A. C. Eurich (Ed.), *High School 1980: The Shape of the Future in American Secondary Education* (pp. 160–168). New York: Pitman.

Prins, H. E. L., & J. Bishop. (2001–2002). "Edmund Carpenter: Explorations in Media & Anthropology." *Visual Anthropology Review*, 17(2), 110–140. Available at http://www.media-generation.com/Articles/VAR.pdf

Soukup, P. A. (1987, November). "'Medium': The Middle Place and the History of Communication Studies in the United States." Paper presented at the 73rd Annual Meeting of the Speech Communication Association, Boston, MA.

Strate, L. (2004). "A Media Ecology Review." *Communication Research Trends*, 23(2), 3–48.

Strate, L., & C. M. K. Lum. (2006). "Lewis Mumford and the Ecology of Technics." In C. M. K. Lum (Ed.), *Perspectives on Culture, Technology, and Communication: The Media Ecology Tradition* (pp. 71–95). Cresskill, NJ: Hampton.

Wasser, F. (2006). "James Carey: The Search for Cultural Balance." In C. M. K. Lum (Ed.), *Perspectives on Culture, Technology, and Communication: The Media Ecology Tradition* (pp. 255–274). Cresskill, NJ: Hampton.

Weick, K. E. (1979). *The Social Psychology of Organizing* (2nd ed.). Reading, MA: Addison-Wesley.

Journalism, Multiculturalism, and the Struggle for Solidarity

THEODORE L. GLASSER AND ISABEL AWAD

Robert White happily blurs the distinction between academic and activist, between explanations of what is and arguments about what ought to be. His work, spanning nearly four decades, vivifies the value of scholarship that derives its focus—indeed, its agenda—from a clear and compelling normative framework. For White and for those of us who find inspiration in what he has said and done over the years, the study of communication always involves a critique of communication. And that critique invariably aims at developing a deeper understanding of what remains at the core of White's body of work: the conditions for the democratization of communication.

An interest in the nexus between democracy and communication leads White in precisely the direction we want to take this chapter as we examine what multiculturalism, understood normatively, means for the study and practice of journalism. With White, who more than thirty years ago, writing in the *Journal of Communication*, lamented the lack of a theoretically rich account of the "structural conditions out of which new patterns of mass communication and more critical audiences might evolve" (1983, p. 296), we worry about the persistent and still popular premise that journalism can be taught—and practiced—with little or no attention to the relationship between differences in culture and the dispersion of political power. More recently, in the chapters he contributed to *Normative Theories of the Media*, White observed that while "dialogue has emerged as a centerpiece of contemporary communication theory," too often what "appears to

be a moral consensus based on dialogue among various cultural groups is really the use of power and resources to subsume different voices under one or another hegemonic voice" (Christians, Glasser, McQuail, Nordenstreng, & White, 2009, pp. 60, 63). We, too, worry that journalism's expressed commitment to cultural diversity, manifested in newsroom policies and industry-wide initiatives, masks an indifference to the plight of subordinated cultural groups in their struggle to participate meaningfully in the larger community.

We begin our examination of multiculturalism and journalism with an account of the former, a task we take on for the purpose of being unambiguously clear about what we mean by "multiculturalism"; where we locate it in terms of political theory; and why and how we distinguish it from "pluralism," which for us represents a very different set of claims about the relationship between cultural diversity and democratic participation. We then look at what the claims of multiculturalism imply for a reconsideration of journalism's roles and responsibilities, a discussion that both critiques the traditional "trustee model" of journalism and provides an alternative to it. We conclude with an argument, rooted in the tenets of multiculturalism, in favor of equating media-press ethics with media-press accountability. This position we map out in concert with the familiar proposition—familiar, that is, to anyone familiar with White's (e.g., 1995, 2008, 2010) work in this area—that dialogue *about* journalism is as important as dialogue *in* journalism.

The Claims of Multiculturalism

Multiculturalism denotes a social and political order in which cultural differences serve as a proxy for, as Nancy Fraser (1992) once described the state of affairs in culturally diverse societies like the United States, "unequal social groups in structural relations of dominance and subordination" (p. 125). At least in the version of it that emerged in the United States in the 1980s in response to questions of race and racism, the idea of multiculturalism concerns itself with a conception of justice rooted in the proposition that the equal right of mutual influence—"giving citizens equal control over their social world," to use Thomas Christiano's (1996, p. 96) quick sketch of the most basic requirement of any democratic society—demands in general that everyone consider the plight of everyone else, and demands in particular that every group in society share an aversion to the conditions that weaken or silence any group's voice.[1] Until there exists a genuinely egalitarian society, where differences in culture no longer correspond to differences in privilege and opportunity, multiculturalism provides the theoretical resources for interrogating current arrangements (and the historical grounds for them) as well as a framework for imagining—and implementing—new and arguably better arrangements.

Among the theoretical resources at multiculturalism's disposal is a "relational" view of culture, which, in Iris Marion Young's (2000) account of it, holds that "what makes a group a group is less some set of attributes its members share than

the relations in which they stand together" (p. 90). The emphasis on relations underscores the importance of social structure, which, in turn, explains why Young prefers to refer to "structural"—as opposed to "cultural"—groups: "While they are often built upon and intersect with cultural differences, the social relations constituting gender, race, class, sexuality, and ability are best understood as structural. The social movements motivated by such group-based experience are largely attempts to politicize and protest structural inequalities that they perceive unfairly privilege some social segments and oppress others" (2000, p. 92).[2] What Young and other multiculturalists reject, then, is a static, essentialist view of culture that collapses cultural differences into an immediately recognizable but structurally meaningless taxonomy of cultures, including the familiar catalog of mutually exclusive communities of descent (African Americans, Asian Americans, etc.). This crude but bureaucratically convenient account of a culturally plural society—so politically and sociologically impoverished that Seyla Benhabib (1999) consigns it to the "prehistory of social theory"—renders culture inert and impenetrable. In effect, it reduces cultural groups, Benhabib writes, to "seamless wholes, absorbed by their members without interpretation, contestation, resistance or transformation" (p. 405).

However, thinking about culture relationally and therefore structurally—paying particular attention to, as Young (2000) suggests, "the institutionalized background which conditions much individualized action and expression, but over which individuals by themselves have little control" (p. 92)—does not imply an approach to society and culture that is altogether agnostic on the question of culture's *content*. While the very idea of multiculturalism envisions a society open to any and all cultures, no multicultural society can afford not to draw the line when it comes to cultures incapable of respecting, which is different than embracing, the interests and values of other cultures. Cultures that espouse supremacist or fundamentalist views, for example, based usually entirely on a presumption of the inferiority of other cultures, forego their place in a multicultural society, for claims of superiority contravene claims of equality. To be sure, nothing matters more in the tradition of multiculturalism than upholding the *equal* right of mutual influence, which is exactly Amy Gutmann's (1994) point when she reminds us that the "survival of many mutually exclusive and disrespecting cultures is not the moral promise of multiculturalism" (p. 21).

Cultural Diversity and Democratic Theory

The rise of multiculturalism as a "delayed antibiotic to the race trends of the 1970s and 1980s" (Gordon & Newfield, 1996, p. 3) corresponds to the rise of deliberative democracy in the early 1980s as a "critique of liberal democracy and a revival of participatory politics" (Bohman & Rehg, 1997, p. xii), and for good reason: the former requires the latter. Multiculturalism depends on a politics of

engagement that honors the central role that "collective dialogues" (Gutmann, 1994, p. 7) play in constituting and sustaining the unique and shared identities that make up a culturally diverse society. Moreover, it places a premium on these open and accessible discussions as the proper venue for dealing with the discontent that differences and disagreements might engender. As a formally articulated political theory or as a social movement aligned informally with certain presuppositions about the practice of politics, multiculturalism, simply put, seeks to substitute processes of deliberation for processes of aggregation.

Deliberation and aggregation stand as shorthand for what are widely regarded as the two dominant traditions in modern democratic thought—namely, republicanism and liberalism—and pinpoint the major differences between what multiculturalism wants and what exists in societies, the United States prominent among them, that discount the value of discussion-based democracies. In other words, deliberation and aggregation designate competing models of democracy that, to return to Young's (2000) language, differ on "the *process* of decision-making to which the idea of democracy refers" (p. 18). They differ, specifically, on what counts as a politically meaningful response to histories of "deprecating judgments, marginalization, or inequality in the wider society" (p. 103). In the deliberative or republican tradition, political participation involves a commitment to discover common goals and shared values; public debate serves as an opportunity for mutual understanding. In the aggregative or liberal tradition, in contrast, political participation involves a commitment to win support for already known goals and values; competition serves as an opportunity to determine which of these goals and values matter most.

Multiculturalism rejects liberalism and the logic of aggregation on the grounds that it conflates the *public* interest with the *public's* interest, as though there can be no sense of "us" or "our" separate from a sum of "yours" and "mine." A liberal democracy begins with individuals whose preferences exist prior to—and independent of—any openly public account of their consequences. These preferences, "conceived exogenous to the political process," as Young (2000, p. 20) sums up the limits of liberalism, become political judgments as they succeed in the marketplace, a mechanism unburdened by "criteria for distinguishing the quality of preferences by either content, origin, or motive." Thus, by locating power and authority at the level of the individual, and by viewing individuals as separate and sovereign, liberalism leaves little room for an articulation of public responsibilities and obligations beyond what is needed to secure each individual's rights and liberties. Indeed, liberalism's emphasis on unfettered *self*-interest, *self*-determination, and *self*-expression lessens the likelihood of the very sense of solidarity to which structurally disadvantaged cultural groups would appeal in their struggle for participatory parity.

Structurally disadvantaged cultural groups are further disenfranchised by liberalism's insistence on separating expression from communication. To truncate an argument developed elsewhere (Glasser, 1991, pp. 240–241; Christians et al., 2009, pp. 106–107), individual liberty in the liberal tradition protects individual expression, understood as the right to speak *in* public, but without a corollary right that protects the communication—that is, the dissemination-amplification—of expression, understood as the right to speak *to* the public. Whereas public expression exists as a public right, public communication exists as private enterprise: Unlike public expression, that is, which exists in the absence of state coercion, public communication exists as commerce, an activity "protected" only by the "laws" of market forces. This explains the liberal aversion to regulating, let alone subsidizing, (public) communication. No matter how good or important its content might be, Americans in consistently large numbers continue to regard public—as opposed to private—support for communication (e.g., public broadcasting) as illiberal and, therefore, undemocratic.

Pluralism and the Politics of Consensus

Just as republicanism and liberalism differ on the proper process for democratic decision making, they differ as well on what constitutes a democratic consensus and the role consensus plays in securing the future of a democratic society. The differences between the two conceptions of consensus become all the more pronounced in the context of the contrast between multiculturalism, as we have outlined it, and what is commonly called "pluralism," a strain of liberalism associated with the distinctive, though hardly unique, features of American democracy: "sectional rivalry, ethnic heterogeneity, religious variety, economic diversity, governmental decentralization, a dense network of voluntary associations" (Baskin, 1971, p. 1). What also becomes more pronounced—and in many ways just as important—are the differences in opportunities for change, particularly when change threatens entrenched centers of power.

A pluralist consensus distinguishes itself as a marker of stability and success. It refers to a widespread and presumably enduring agreement that existing arrangements work well—and will, with the benefit of some occasional fine-tuning, continue to work well. As a model of modern democracy, pluralism—also known as "liberal-pluralism," "interest-group democracy," or "empirical democratic theory" (e.g., Cnudde & Neubauer, 1969)—emerged in the decades following World War II as a celebration of the practice of democracy in the United States, England, and a handful of other countries aligned with American and British views of how democracy works. An "explicitly non-normative" (Cnudde & Neubauer, p. 1) theory of democracy, pluralism offers an inherently conservative account of politics; it prescribes what it describes by affirming the viability and efficacy of current structures and institutions.

Stable but not static, a pluralist consensus functions as a "process of renewal," a phrase used by Robert Dahl (1969, p. 258), one of pluralism's chief theoreticians, to explain not only how pluralism refines and refreshes the political order but why any wholesale challenge to the status quo amounts to a breach of faith in democracy itself. Dahl cites the example of the United States, where most citizens not only believe the political system is democratic "but is perhaps the most perfect expression of democracy that exists anywhere" (p. 258). Because consensus in the tradition of pluralism implies satisfaction with the basic structure of society, cultural groups exist as interest groups, not as structural groups. Cultural interests matter, as do other interests, but only as they can be expressed in ways that tacitly support, rather than disrupt or threaten, the structural assumptions of a pluralist democracy, including the priority pluralism assigns to individual initiative and private enterprise:

> Pluralism secures its celebrated consensus by discounting claims that might weaken it. By equating cultural groups with interest groups, pluralism accepts a utilitarian calibration of culture which robs groups, however disadvantaged they may be, of the grounds for whatever substantive claims they might have regarding their rights and opportunities to participate in the larger society. In other words, groups in a pluralist society compete— that is, participate—on the basis of their "private" self-interest rather than on the basis of any collective or common "public" interest, which in principle precludes any critique of the quality of political participation beyond what individuals and groups of individuals can secure by and for themselves. Remarkably, citizens in a pluralist society either consent to the consensus that legitimizes a pluralist society or they forfeit their own legitimacy. (Glasser, Awad, & Kim, 2009, p. 61)

As the popular pluralist image of a "melting pot" suggests, cultural differences in a pluralist society fade away over time—or at least become less politically charged—as the processes of assimilation emphasize the benefits of a larger culture of democracy in which all interests, including minorities' interests, receive a fair and impartial consideration. Assimilation involves learning to appreciate the logic of aggregation and coming to accept the value of market forces as a reasonably just resolution of conflicting or divergent interests. Assimilation, which, in the case of the United States, Dahl describes as "the process of 'Americanization,'" combats the "recurring fear" that "regional, ethnic, racial, religious, or economic differences might disrupt the American political system" (p. 260). Involving "vast social energies," Dahl writes, assimilation succeeds in the United States as it teaches "citizens what is expected in the way of words, beliefs, and behavior if they are to earn acceptance as Americans" (p. 259).

Journalism and Multiculturalism

Just as a long-stemmed flower suggests the existence of "an insect with an extended proboscis as its adaptive partner," James Carey writes, encouraging us to think

ecologically about the press, "journalism and politics cannot be 'thought' as two separate independent domains of activity" (1999, p. 51). Carey's metaphor underscores the constitutive relationship between a particular model of journalism and a political system, which is the point we want to make regarding the relationship between trustee journalism and liberalism. Moreover, the metaphor implies that, as liberalism's "adaptive partner," trustee journalism is necessarily ill equipped to respond to the demands of multiculturalism. We focus mainly on the United States, though trustee journalism prospers elsewhere, especially in other Western democracies (Hallin & Mancini, 2004; Christians et al., 2009).

Trustee journalism emerged in the United States at the end of the nineteenth century, a time when the broader political system was undergoing a process of "ideological decay" (Kaplan, 2002, p. 74). Marked by a move from "principled" to "pragmatic" party logics, a weakening of party allegiances, a decline in voter turnout, and an influential attack on party politics, this ideological decay elicited a radical transformation in the press's "mode and manner of facilitating democratic discussion" (Kaplan, p. 7). The U.S. press, until then a strongly partisan and elite enterprise, gained its independence from political parties. It committed itself to serving the community at large, that is, readers across social, economic, and political differences. Instead of siding with one party or the other, this new press cherished objectivity as its core value.

The shift from partisan to objective journalism became visible in, among other areas, news coverage of race. At a time when the abolition of slavery was a major issue between Democrats and Republicans, particularly in the years following the Civil War, openly racist newspaper accounts abounded. At the time, journalists "transformed the very physical body of the African-American into a charged symbolic nexus for the depiction of the nature, disorders and promises of American society" (Kaplan, 2002, p. 30). The new journalism that emerged at the turn of the century, in contrast, explicitly aimed at being impartial. While in practice it continued to rely on racial stereotypes and biases well into the twentieth century (Wilson, Gutierrez, & Chao, 2003), in principle, trustee journalism has always aspired to treat all U.S. citizens equally. As Carey (1999) explains, this kind of journalism emerged in part as "a revolt against a public sphere polluted with poisonous stereotypes and racial antagonisms" (p. 54).

The spirit of trustee journalism's revolt against racism and its equal treatment aspirations continue to be visible today in numerous and enthusiastic efforts to endorse diversity in the news media. However, these efforts are limited by the same *disability* that affects trustee journalism's other claims to public service and impartiality. Objectivity, argues Kaplan (2002, p. 194), has "disabled journalism" in the sense that it has severely reduced journalists' autonomy and capacity to contribute to public deliberation: "In their passion for rigorous objectivity, in their disavowal of any particular viewpoint, in their commitment to standing as

external observers to the deceits and diatribes of public life, reporters lost their past capacity to interject their own evaluations and judgments; provide overarching interpretations; and explore controversial or, conversely, taken-for-granted viewpoints" (p. 193).

The problem, as Kaplan views it, is that journalists became impartial even with regard to democracy itself. Similarly, Carey (1999) criticizes trustee journalism for being loyal only "to an abstract truth and an abstract public interest," where "abstract" means "procedural" (p. 56): Truth and the public interest do not derive from a commitment to certain notions of what is democratic, what is good, and what is just, but from a series of fixed procedures. A closer look at these procedures and their effects underscores the incompatibility between trustee journalism and multiculturalism.

Market Threats to Minority Journalism

Trustee journalism presumably guarantees its independence by operating within commercial enterprises and away from political institutions. It rejects, as interference from the state, any policy aimed at securing the conditions for public communication beyond what markets can offer. Although the legitimacy of markets rests largely on what is taken to be its apolitical character, which would thus secure the political neutrality of media content, market forces end up imposing a political orientation of their own (Baker, 2002). Market-based procedures also define the ways in which the news media relate to each other. In their competition for advertisers and audiences, "the best" media gain the right to speak louder and the strongest players end up having a bigger say on what is publicly relevant. Minority media are by definition marginal. They are "free" to publicize what they produce, but their limited resources severely constrain their production. As Husband (2005) explains, economic concerns commonly limit minority media's "aspirations for contributing to the cultural and political vitality of ethnic identity groups with whom they have strong affiliations" (p. 468).

The market's systematic discrimination against minority media becomes particularly evident when mainstream media implement diversity strategies that put them in direct competition with minority outlets. Mainstream and minority media compete, first, for minority journalists. One of the challenges for minority media, Husband (2005) explains, is that their most qualified staff may leave to work in mainstream outlets that recruit these professionals "in order to address their competency deficit in covering minority ethnic issues, or, more pragmatically, in order to be seen to fulfill the ethnic diversity profile of their human relations department" (p. 469). Direct competition also extends to advertisers and audiences, in which case the most significant threat for minority media comes from mainstream initiatives to produce ethnic-specific outlets. Between 1990 and 2006, for example, the number of Spanish-language newspapers in the United

States more than doubled (from 355 to 768), while the proportion of those papers owned by members of the Latina/o community decreased (Whisler, 2007).

While, for example, the mere increase of Latina/o targeted newspapers may suggest a value in competition, even laissez-faire economists acknowledge that there is no meaningful relationship between competition and diversity (e.g., Owen, 1975). At least in the case of Latina/o media, ownership does matter: "Not every medium speaking to Latinas/os is equally Latina/o" (Awad, 2008, p. 79). In fact, a case study of mainstream and minority journalism in San José, California, analyzed the coverage of a local conflict involving members of the Latina/o community in three kinds of publications: the city's mainstream newspaper, the Spanish-language weekly published by the same newspaper, and two older weeklies owned and produced by Latinas/os (Glasser, Awad, & Kim, 2009). The comparison showed striking similarities between the mainstream paper and its Spanish-language outlet, as well as a clear contrast with the two independent Latina/o papers. By reproducing its own position of "disinterested bystander" in its Spanish-language outlet, the mainstream paper reinforced the dominance of trustee journalism, denied a space for cultural differences in the production of news, and contributed little to the diversity of journalism in San José. To the extent that these kinds of initiatives constitute a threat to, rather than an incentive for, minority journalism, it is not unreasonable to call for new and better "institutional arrangements" to "accommodate forms of journalism beyond what markets sustain" (Glasser, Awad, & Kim, p. 74).

The Ironies of Combining Diversity and Objectivity

Apart from market inequalities, the comparison between mainstream and minority media also underscores significant differences in journalistic practice. In the study of mainstream and minority journalism in San José, California, reporters from the two independent Latina/o papers openly identified themselves with the Latina/o community and presented their stories as an effort to mobilize, not just inform, readers. Their coverage—which openly endorsed a specific outcome for the conflict—would be disqualified as biased or simply unprofessional by trustee journalism. Indeed, the publisher of San José's mainstream newspaper stressed the objectivity of its "ethnic" publications (not only a Spanish-, but also a Vietnamese-language one) in comparison to "the more adversarial and political form of journalism" of minority outlets. His newspaper company's effort to target minority audiences, the publisher explained, required reporters "seeped in an American journalism tradition" (Harris, 2001).

The American tradition the San José publisher referred to is the tradition of trustee journalism. Being "seeped" in this tradition means being skillful in a series of procedures that conceal journalists' cultural background and personal interests. Trustee journalists use these procedures—"strategic rituals," as Tuchman (1972)

describes them—to identify both newsworthy issues and legitimate sources. Specifically, news reporting is commonly organized according to fixed institutional locations or news beats, where newsworthy events can be "caught" in what Tuchman (1978) usefully describes as a "news net" and where journalists have easy and regular access to bureaucratically credible sources whose knowledge and authority are taken for granted (Fishman, 1980). These news-gathering procedures guarantee a regular flow of news from a limited number of beats and sources across media outlets and across individual journalists. The resulting news agenda is significantly homogenous and, since its homogeneity derives from the reliance on a community's dominant institutions and their certified representatives, it is the agenda of dominant groups in society. Like the market, then, the proclaimed neutrality of journalistic practice contributes to widening the gap between trustee journalism and minority groups. Furthermore, the sturdiness of these procedures explains the failure of efforts to overcome this gap, or what Pritchard and Stonbely (2007) call "the irony of diversity initiatives in journalism" (p. 244).

There are in fact multiple ironies in trustee journalism's efforts to diversify mainstream newsrooms and news stories. First, there are ironies in content. Benson (2005), for example, identified a decrease in "ideological diversity" in the coverage of immigration at the same time "the diversity journalism movement" gained increasing influence in the United States (p. 8). Likewise, Parisi (1998) showed how a *New York Times* series authored by an African American reporter and specifically aimed at improving a newspaper's portrayal of minority communities reinforced "modern" or implicit racism. Second, there are ironies in the experiences of minority journalists working in the mainstream media. Even those specifically hired because of their cultural background are expected to "contribute their full potential, regardless of race, ethnicity, color, age, gender, sexual orientation, physical ability or other defining characteristic," as stated in the diversity mission statement of the American Association of Newspaper Editors (n.d.). In other words, minority journalists are forced to choose between writing stories from a minority perspective or attaining professional success (Wilson, 1991). Third, there are ironies in the distrust minority readers maintain toward the mainstream media, despite the latter's numerous and explicit efforts to employ a diverse workforce and to expand and improve their coverage of minority topics and people (Adams & Cleary, 2006; Awad, 2011).

Journalism and Solidarity

Why, then, do news media persist in pursuing diversity initiatives that do so little to diversify journalism? Perhaps because managers with a sense of success, not journalists with a sense of justice, are driving these initiatives. The news media, like many other corporations in the last decades, have largely endorsed a managerial approach to cultural diversity. According to the founder of the American

Institute for Managing Diversity, a diverse organization succeeds when "it work[s] as smoothly" and "morale [is] as high, as if every person in the company was the same sex, and race and nationality" (Thomas, 1990, p. 109). The problem with this approach is not only its homogenizing force—expecting diverse workers to produce standardized outcomes—but also that it is limited by what sells in the market. As explained by Benson (2005) with respect to the news media: "If multicultural marketing is simply 'good business', then the 'cause' will be sharply limited by the needs and interests of major corporations" (p. 11; see also Awad, 2008; Glasser, Awad, & Kim, 2009).

A second, even more important, question is: What would it take for journalism to approach diversity as a matter of justice rather than a matter of market success? An answer to this question needs to be grounded on the deliberative nature of multiculturalism as well on the central role played by the media in processes of deliberation. The news media are at the core of what Husband (1998) calls the "multi-ethnic public sphere," a space where differences can become "mutually comprehensible and politically sustainable" (p. 136). Given the inequalities associated with ethnic differences in actually existing democracies, making differences comprehensible and politically sustainable is a necessary step in the pursuit of social justice. As Young (2000) explains, "If some people suffer injustices, the first step in redressing them is being able to make claims upon others in a shared public forum that together they should take action to address these problems" (p. 209). To be inclusive, such a discussion must not only convoke everyone—rich or poor, minority or not—but it should also be open to forms of expression that may be different from the traditionally sanctioned dispassionate argument.

At the core of Young's model of inclusive communication is the notion of *differentiated solidarity*. Solidarity in this sense presupposes obligations of justice among different (groups of) people without aiming at reducing the differences between them. It is based on the conviction that not everyone thinks (or should think) in the same way—also about what is true and newsworthy—but that it is possible to bridge differences, and thus to create the conditions for justice, through communication. This is precisely what White (1995) has in mind when he underscores the importance of "a public cultural truth":

> The criterion of truthfulness is not just correspondence to reality in an epistemological sense, but justice, that is, respect for the sense of human dignity and the dignity of all other forms of existence. The movements to question the truthfulness of a statement arise out of the sense of alienation, the sense that one's existence is in some way denied and destroyed. Thus, the public cultural truth is the systematic representation of the 'problems', the proposed lack of justice, that the members of a society must collectively be aware of and resolve if that society is to exist as a unity. (p. 444)

The future of multiculturalism depends in part on the emergence of solidarity as a defensible news value, an attribute of news with an overtly moral purpose.

If solidarity cannot be reduced to a ready set of routines of the kind that defines the practice of objective reporting, it can nonetheless serve as a guiding principle for journalists as they struggle, individually and collectively, to move beyond a mere "tolerance of difference," which is all that pluralism requires, and closer to a deeper "insight into difference," which is what multiculturalism demands (Ettema & Glasser, 1998, pp. 200–202). Investigative reporters already know this, at least tacitly; they know that in pursuing exposés of wrongdoing, journalists need to know not only fact from error and truth from falsehood but right from wrong. Solidarity as a news value makes explicit the sense of justice—and thus injustice— that has long been the hallmark of honorable journalism.

Journalism Ethics in a Multicultural Society

Especially in the United States but elsewhere as well, journalists, through their visceral attachment to autonomy, position themselves as adversaries of accountability (Glasser & Gunther, 2005). And this aversion to accountability, manifested in a history of disdain for any project designed to elicit from journalists a response to questions about press practices and performance—from news councils to newsroom ombudsmen—limits what it means to be an ethical journalist.

Autonomy figures prominently in what Lee Bollinger (1991) calls "the central image of the American ideal of press freedom" (p. 57), a portrait of the press that emphasizes, as does pluralism, the authority and sovereignty of the individual. It is an image of journalism as a loose confederation of individuals with no collective conscience; an institution separate and detached from the community it serves; a profession with no affinities, no loyalties, and no convictions. The folklore and mythology associated with this image—cultivated over the years in scores of plays, novels, movies, and television programs—celebrates the idea of an autonomous press by romanticizing the power of the unencumbered journalist. As journalists and their patrons canonize the success of certain styles and forms of journalism, they burnish a view of the craft, Bollinger writes, that "breathes life" into "a press conceived in the image of the artist . . . who lives (figuratively) outside of society, beyond normal conventions, and who is therefore better able to see and expose its shortcomings" (p. 55).

For the unencumbered journalist, for the journalist isolated from the larger community and insulated from outside pressures, including the pressure to publicly explain and justify what is done in the name of journalism, freedom eclipses responsibility and autonomy trumps accountability. As Bollinger makes clear, the central image of a free press confers on journalists an unfettered "freedom to make mistakes" and an unconditional "power to err"; it promotes "a posture toward the world that says, in effect, no one will tell you what to do" (p. 57). Journalists wedded to this image of a free press defer to market forces as the only legitimate framework for dealing with the propriety of press practices (e.g., if you do not

like what we do, go elsewhere), even though, as we noted earlier, the marketplace operates without explicit criteria for good and bad or right and wrong, making it—to the delight of pluralists and to the chagrin of multiculturalists—a substantively empty form of accountability.

The central image of a free press remains so strong, so compelling, so deeply embedded in the psyche of Western journalists, that efforts to re-imagine and re-invent journalism—and there have been many in the past couple of decades— seldom include any meaningful link between press ethics and press accountability, which reinforces the belief that the former can and should exist without the latter. Even as the recent and rapid computerization of communication invites new and different definitions of journalism and journalist, the central image of a free press impedes fresh thinking about how to reconcile autonomy with accountability; it instead continues to fuel what John Peters and Kenneth Cmiel (1991) describe as a curious ethic of defiance: "One feels morally justified in the act of refusing to offer a moral justification" (p. 198).

The Case of Public Journalism

Before it gradually dissolved into the inchoate phenomenon of citizen journalism, the public journalism movement of the 1990s (Glasser, 1999; Haas, 2007) offered an instructive example of the irony and hypocrisy of a commitment to increase and improve dialogue *in* journalism without a corresponding commitment to increase and improve dialogue *about* journalism. Public journalism made the case, though often obliquely, for a more deliberative democracy, calling on the press to shift from, as Carey (1987, p. 14) and others (e.g., Anderson, Dardenne, & Killenberg, 1994) had suggested, a "journalism of information" to a "journalism of conversation." Public journalism thus stood for new forms of accountability journalism (Clark, 2013), particularly as it encouraged journalists to "convene the community" (p. 5) by creating more and better opportunities for public debate and discussion. But, remarkably, public journalism's version of accountability journalism did not include journalism accountability, as though the press was not important enough—or, worse, too important—to be included in the day's conversation: While public journalism wanted "the public's business fully disclosed and thoroughly discussed, the decidedly public business of journalism, arguably the only business entitled to special Constitutional protection," remained "private, closed, and generally unexamined" (Glasser & Craft, 1996, p. 152).

Public journalism's embrace of public deliberation—its apparent enthusiasm for a "facilitative role" for a press that supports and strengthens participation in civil society (Christians et al., 2009, pp. 158–178)—stops short of reneging on its tacit promise not to let claims about what citizens need to govern themselves get in the way of claims about what the press needs to preserve its autonomy and authority. While Carey (1999) correctly detects a "republican impulse behind

public journalism" (p. 62), he also correctly detects a lingering faith in a "trustee journalism focused on the powers of the press rather than on the prerogatives of the public" (p. 57). Michael Schudson (1999) spots the same tension when he concludes that, notwithstanding a genuine interest in "convening the community" and "engaging the public," public journalism does not "empower 'the public' relative to journalists" (p. 121). Schudson hints at the source of this tension when he celebrates public journalism as variously "the best organized social movement *inside journalism* in the history of the American press" and "the most impressive critique of journalistic practice *inside journalism* in a generation" (p. 118, emphasis added).

Unlike other twentieth-century efforts to reform American journalism—in the 1940s, the privately funded Commission on Freedom of the Press, popularly known as the Hutchins Commission; in the 1960s, the publicly funded National Advisory Commission on Civil Disorders, commonly called the Kerner Commission—public journalism emerged as a grassroots effort to engage journalists in an open-ended discussion about what might be done to foster greater citizen involvement in the affairs of the community. Intentionally vague about what public journalism meant and what it wanted to achieve—and willing to accommodate divergent and even irreconcilable interpretations of its core claims—public journalism's proponents (e.g., Rosen, 1999; Merritt, 1995; Charity, 1995) made a strategic choice when they decided not to articulate a formal theory of public journalism. By letting journalists decide by themselves and for themselves how to best craft a public purpose for a private press, they by design left public journalism malleable enough to appeal to large numbers of newsrooms. Although its rapid and undisciplined diffusion across the United States and beyond only added to the confusion about what it stood for and what kind of reform it embraced, it at least became clear what public journalism was not, as Jay Rosen, an early and ardent advocate of public journalism, acknowledged a decade after the movement began:

> Public journalism is not an insurrection, or even a minor revolt against structural forces at work. It did not pose and cannot sustain a challenge to the commercial regime in which the American press operates. Precisely because it is a mainstream movement, it is the wrong place to look for a new political economy of mass media. (2000, p. 682)

Thus, public journalism succeeded in mainstream newsrooms only as it failed to advance a fundamentally new model of journalism, "one in which," to use Schudson's account of what could have made public journalism a truly public endeavor, "authority is vested not in the market, not in a party, and not in the journalist but in the public" (1999, p. 122). For all the talk about empowering the public and restoring public confidence in the press, the public in the realm of public journalism remains just as disenfranchised vis-à-vis journalism as it has

always been. If public journalism repositions the press with regard to the public, it does not reposition the public with regard to the press (Glasser, 2000; Glasser & Lee, 2002). "Nothing in public journalism," Schudson reminds us, "removes power from journalists or the corporations they work for" (p. 122). Quite simply, no plan or project under the banner of public journalism comes close to a proposal to hold the press directly accountable to the public, as Schudson recounts in his list of examples of what public journalism does not do:

> It does not propose new accountability systems. It does not offer a citizen media review board or a national news council. It does not recommend publicly elected publishers or editors. It does not suggest that the press be formally or even informally answerable to a governmental or community body. It does not borrow from Sweden the proposition that government should subsidize news organizations that enlarge the diversity of viewpoints available to the reading public. (p. 122)

In short, public journalism declined to democratize journalism, which it could have done by positioning the public as the final arbiter of newsroom norms. It instead continued to decouple ethics and accountability, which in effect reaffirmed the press's long-standing claim—more often implied than expressed—that the public has no meaningful role to play in the formulation and resolution of questions of press ethics.

Being Ethical, Being Accountable

To assure a warm welcome in American newsrooms, public journalism evaded the question of whether the topic of journalism deserves public scrutiny in the same way and for the same reason other topics deserve a full and open examination. It quietly and uncritically resorted to a view of press practices and performance as a technical-professional matter best left to the experience and expertise of practitioners rather than an ethical-political issue of legitimate concern to citizens. Public journalism, then, did little to disrupt conventional thinking about media ethics, particularly the view of journalism ethics, tied to notions of professionalism, that, as Peters and Cmiel (1991) demonstrate, "implicitly builds on the model of the few who speak and the many who listen" (p. 210).

Peters and Cmiel invite consideration of a very different model of media ethics, one that expressly rejects the idea that "the public is only a consumer and not a producer of communication" and that, therefore, moves beyond the current "preoccupation with the practices of the professional few rather than the participation of the many" (p. 210). They believe, as we do and as White (1995) does as well, that "taking the public sphere seriously would entail a broadening of 'media ethics' as a term and inquiry"; that "communication practices," in journalism or elsewhere, "are deeply political" insofar as "they are connected to a vision . . . of the public sphere"; and that, as it accommodates some notion of the public sphere, "any sensible media ethics must be explicitly political" (Peters & Cmiel,

1991, pp. 210–213). In the spirit of public deliberation and democratic participation—and true to the tenets of multiculturalism, though without reference to them—Peters and Cmiel advance an approach to media ethics that equates ethics with accountability.

By equating ethics with accountability, Peters and Cmiel anticipate Jürgen Habermas's "discourse" or "communicative" ethics, a theory of ethics designed to apply the principles of argumentation to questions concerning the validity and appropriateness of moral norms. In the tradition of Kant, Habermas (1990, 1993) emphasizes the importance of procedure in the form of an impartial and reliable process for adjudicating ethical disputes. In a departure from Kant, however, Habermas insists on a fully public process of justification, a procedure open and accessible to everyone with a stake in it. As he transforms Kant's categorical imperative from a proposition individuals can deal with on their own (*conduct is unethical if the rule that justifies it does not apply to everyone*) into a proposition individuals can deal with only in dialogue with others (*conduct is unethical if the rule that justifies it is found unacceptable in a public debate open to everyone affected by the rule*), Habermas not only shifts the mode of justification from monologic to dialogic but relocates the domain of ethics from the individual to the community. By "interpreting moral-practical reason as essentially communicative, and thus intersubjective," explains one of Habermas's translators, "discourse ethics can legitimately claim to put the Kantian project on a new footing" (Cronin, 1993, p. xxiii).

Discourse ethics depends on what Habermas describes as a "cooperative process of argumentation" (1990, p. 67), an elaborately explicated constellation of conditions intended to facilitate "the exchange and assessment of information, reasons, and terminology" (1993, p. 58). Whether at the level of principle or practice,[3] discourse ethics succeeds not as participants act strategically to advance their own interests but as they come together to find or develop common or general interests, a process that honors the value of arguments—and ultimately interests—that emerge from, rather than precede, instances of public deliberation. "The better argument prevails," to quote a handy summary of Habermas's expectations, "as it resonates with the larger community and when in the end it wins the assent of everyone affected by it":

> Not to be confused with the so-called "rational choice" that individuals might make as they calculate the consequences of supporting one argument or another, winning assent does not imply a contest among competing arguments. Rather, assent comes from, to recycle some of Habermas's language, a "rationally motivated agreement" that an argument is "equally good for everyone," which reminds us that discourse ethics does not involve a marketplace process which aggregates individual interests but a deliberative process which brings into existence common or shared interests. The better argument, which gains its authority through debate and discussion, emerges over time and evolves

in response to other arguments, counter-arguments, questions, suggestions, objections, and so on. (Glasser & Ettema, 2008, p. 529)

In its application to journalism, discourse ethics requires journalists to jettison their role as the only or final authority on questions of ethics. Dethroned but not disenfranchised, journalists learn the difference between participation and domination; they learn that in a discussion of disputed claims and contested conduct, theirs is one voice among many; they come to appreciate that in a discursive test of the norms of journalism, what counts is what is being said and how well it is said—not who is saying it: "Neither the views of the press nor the state nor the church nor even the great philosophers of our time enjoy a special standing. . . . Discourse ethics values all of these but privileges none of them. What finally matters—all that matters—is what Habermas (1993, p. 163) calls the 'unforced force of the better argument'" (Glasser & Ettema, 2008, p. 529).

Understood as a "regulative ideal to which journalists can turn to gauge the seriousness of their commitment to accountability" (Glasser & Ettema, 2008, p. 530), discourse ethics moves journalism in the same direction journalism moves a multicultural society: toward insight and solidarity. Discourse ethics accomplishes this—that is, reconciles journalism with multiculturalism—by showing that the press treats itself as it treats other democratic institutions; that journalism accountability is in fact an element of, not an exception to, accountability journalism. More than that, discourse ethics demystifies press norms by demonstrating that even journalism's most self-evident claims—and the customs and conventions associated with them—endure in history and not in nature. Even in the absence of a consensus, by excavating journalism's common sense and by interrogating journalists' moral intuitions, the process of discourse ethics empowers the press and the public and, when appropriate, sets them on a new course. If the big and enduring issues of ethics in journalism cannot be easily and quickly resolved, they can be, to use Carey's (1987) benchmark, "dissolved into a new set of practices, a new way of conceiving what journalism is and how we ought to go about it" (p. 16).

Notes

1. Citing but not quoting Onora O'Neill, Iris Marion Young (2000) puts it succinctly: "People have obligations of justice to others insofar as and on account of the fact that they assume the specific agency of others as premises for their own action" (p. 223).
2. Following Giddens (1984), Young (2000) understands "structural" in the sense of being "relatively permanent" by virtue of the processes through which "people act on the basis of their knowledge of pre-existing structures and in so acting reproduce those structures." Thus, social structures, understood in terms of "rules and resources, recursively implicated in the production of social systems," exist as processes, not as states of existence; they exist, that is, "only in the action and interaction of persons" (p. 95).

3. In recognition of the differences between principles and practices, between an "ethics of conviction" and an "ethics of responsibility," Habermas (1993) makes room for two separate and successive discourses: a "discourse of justification," which deals with the larger normative judgment "about what we ought to do" and a "discourse of justification" (p. 62), which attends to the appropriateness of the application of the normative judgment to a particular set of circumstances.

Bibliography

Adams, T., & J. Cleary. (2006). "The Parity Paradox: Reader Response to Minority Newsroom Staffing." *Mass Communication and Society*, 9(1), 45–61.

American Society of Newspaper Editors. (n.d.). "More than Three Decades of Commitment to Diversity." Retrieved from http://asne.org/content.asp?contentid=28

Anderson, R., R. Dardenne, & G. M. Killenberg. (1994). *The Conversation of Journalism: Communication, Community, and News.* Westport, CT: Praeger.

Awad, I. (2011). "Latinas/os and the Mainstream Press: The Exclusions of Professional Diversity." *Journalism*, 12(5), 515–532.

Awad, I. (2008). "What Does It Take for a Newspaper to Be Latina/o? A Participatory Definition of Ethnic Media." In N. Carpenter & B. De Cleen (Eds.), *Participation and Media Production. Critical Reflections on Content Creation* (pp. 83–96). Newcastle, UK: Cambridge Scholars.

Baker, C. E. (2002). *Media, Markets, and Democracy.* New York: Cambridge University Press.

Baskin, D. (1971). *American Pluralist Democracy: A Critique.* New York: Van Nostrand Reinhold.

Benhabib, S. (1999). "The Liberal Imagination and the Four Dogmas of Multiculturalism." *Yale Journal of Criticism*, 12(2), 401–413.

Benson, R. (2005). "American Journalism and the Politics of Diversity." *Media Culture Society*, 27(1), 5–20.

Bohman, J., & W. Rehg. (1997). *Deliberative Democracy: Essays on Reason and Politics.* Cambridge, MA: MIT Press.

Bollinger, L. C. (1991). *Images of a Free Press.* Chicago: University of Chicago Press.

Carey, J. W. (1999). "In Defense of Public Journalism." In T. L. Glasser (Ed.), *The Idea of Public Journalism* (pp. 49–66). New York: Guilford.

Carey, J. W. (1987). "Journalists Just Leave: The Ethics of an Anomalous Profession." In M.-G. Sagen (Ed.), *Ethics and the Media.* Iowa City: Iowa Humanities Board.

Charity, A. (1995). *Doing Public Journalism.* New York: Guilford.

Christiano, T. (1996). *The Rule of Many: Fundamental Issues in Democratic Theory.* Boulder, CO: Westview.

Christians, C. G., T. L. Glasser, D. McQuail, K. Nordenstreng, & R. A. White. (2009). *Normative Theories of the Media: Journalism in Democratic Societies.* Urbana: University of Illinois Press.

Clark, L. S. (2013). "Cultivating the Media Activist: How Critical Media Literacy and Critical Service Learning Can Reform Journalism Education." *Journalism*, 14(7), 885–903.

Cnudde, C. F., & D. E. Neubauer. (Eds.). (1969). *Empirical Democratic Theory.* Chicago: Markham.

Cronin, C. P. (1993). "Translators Introduction." In J. Habermas, *Justification and Application: Remarks on Discourse Ethics* (pp. xi–xxxii). Cambridge, MA: MIT Press.

Dahl, R. A. (1969). "Stability, Change and the Democratic Creed." In C. F. Cnudde & D. E. Neubauer (Eds.), *Empirical Democratic Theory* (pp. 253–267). Chicago: Markham.

Ettema, J. S., & T. L. Glasser. (1998). *Custodians of Conscience: Investigative Journalism and Public Virtue.* New York: Columbia University Press.

Fishman, M. (1980). *Manufacturing the News.* Austin: University of Texas Press.

Fraser, N. (1992). "Rethinking the Public Sphere: A Contribution to the Critique of Actually Existing Democracy." In C. Calhoun (Ed.), *Habermas and the Public Sphere* (pp. 109–142). Cambridge, MA: MIT Press.

Giddens, A. (1984). *The Constitution of Society*. Berkeley: University of California Press.

Glasser, T. L. (2000). "The Politics of Public Journalism." *Journalism Studies*, 1(4), 683–686.

Glasser, T. L. (Ed.). (1999). *The Idea of Public Journalism*. New York: Guilford.

Glasser, T. L. (1991). "Communication and the Cultivation of Citizenship." *Communication*, 12(4), 235–248.

Glasser, T. L., I. Awad, & J. W. Kim. (2009). "The Claims of Multiculturalism and Journalism's Promise of Diversity." *Journal of Communication*, 59(1), 57–78.

Glasser, T. L., & S. Craft. (1996). "Public Journalism and the Prospects for Press Accountability." *Journal of Mass Media Ethics*, 11(3), 152–158.

Glasser, T. L., & J. S. Ettema. (2008). "Ethics and Eloquence in Journalism: An Approach to Press Accountability." *Journalism Studies*, 9(4), 512–534.

Glasser, T. L., & M. Gunther. (2005). "The Legacy of Autonomy in American Journalism." In G. Overholser & K. H. Jamieson (Eds.), *Institutions of Democracy: The Press* (pp. 384–399). New York: Oxford University Press.

Glasser, T. L. & F. L. F. Lee. (2002). "Repositioning the Newsroom: The American Experience with 'Public Journalism'." In R. Kuhn & E. Neveu (Eds.), *Political Journalism: New Challenges, New Practices* (pp. 203–224). London: Routledge.

Gordon, A. F., & C. Newfield. (Eds.). (1996). *Mapping Multiculturalism*. Minneapolis: University of Minnesota Press.

Gutmann, A. (1994). "Introduction." In C. Taylor, *Multiculturalism: Examining the Politics of Recognition* (pp. 3–24). Princeton, NJ: Princeton University Press.

Haas, T. (2007). *The Pursuit of Public Journalism: Theory, Practice, and Criticism*. New York: Routledge.

Habermas, J. (1993). *Justification and Application; Remarks on Discourse Ethics* (Trans. C. Cronin). Cambridge, MA: MIT Press.

Habermas, J. (1990). *Communicative Ethics and Moral Consciousness* (Trans. C. Lenhardt & S. W. Nicholson). Cambridge, MA: MIT Press.

Hallin, D., C. & P. Mancini. (2004). *Comparing Media Systems*. Cambridge, MA: Cambridge University Press.

Harris, J. (2001). "Making the Economic Case for Diversity." Speech Given to Journalism Students at San Francisco State University. Retrieved from http://newswatch.sfsu.edu/qa/101001jharris-speech.html

Husband, C. (2005). "Minority Ethnic Media as Communities of Practice: Professionalism and Identity Politics in Interaction." *Journal of Ethnic and Migration Studies*, 31(3), 461–479.

Husband, C. (1998). "Differentiated Citizenship and the Multi-ethnic Public Sphere." *Journal of International Communication*, 5(1 & 2), 134–148.

Kaplan, R. L. (2002). *Politics and the American Press. The Rise of Objectivity, 1865–1920*. Cambridge: Cambridge University Press.

Merritt, D. (1995). *Public Journalism and Public Life: Why Telling the News Is Not Enough*. Hillsdale, NJ: Erlbaum.

Owen, B. (1975). *Economics and Freedom of Expression*. Cambridge, MA: Ballinger.

Parisi, P. (1998). "The *New York Times* Looks at One Block in Harlem: Narratives of Race in Journalism." *Critical Studies in Mass Communication*, 15(3), 236–254.

Peters, J. D., & K. Cmiel. (1991). "Media Ethics and the Public Sphere." *Communication*, 12(3), 197–215.

Pritchard, D., & S. Stonbely. (2007). "Racial Profiling in the Newsroom." *Journalism & Mass Communication Quarterly*, 84(2), 231–248.

Rosen, J. (2000). "Questions and Answers about Public Journalism." *Journalism Studies*, 1(4), 679–683.

Rosen, J. (1999). "The Action of the Idea: Public Journalism in Built Form." In T. L. Glasser (Ed.), *The Idea of Public Journalism* (pp. 21–48). New York: Guilford.

Schudson, M. (1999). "What Public Journalism Knows about Journalism but Doesn't Know about 'Public'." In T. L. Glasser (Ed.), *The Idea of Public Journalism* (pp. 118–133). New York: Guilford.

Thomas, R. R., Jr. (1990, March–April). "From Affirmative Action to Affirming Diversity." *Harvard Business Review*, 107–117.

Tuchman, G. (1978). *Making News: A Study in the Construction of Reality*. New York: Free.

Tuchman, G. (1972). "Objectivity as Strategic Ritual: An Examination of Newsmen's Notions of Objectivity." *American Journal of Sociology*, 77(4), 660–679.

Whisler, K. (2007). "Hispanic Print Continues to Show Significant Growth in 2006." *Hispanic Marketing 101*, 5(1), 2–5.

White, R. A. (2010). "The Moral Foundations of Media Ethics in Africa." *Equid Novi: African Journalism Studies*, 31(1), 42–67.

White, R. A. (2008). "Teaching Communication Ethics in the African Context: A Response to Globalization." *Equid Novi: African Journalism Studies*, 29(2), 188–209.

White, R. A. (1995). "From Codes of Ethics to Public Cultural Truth: A Systematic View of Communication Ethics." *European Journal of Communication*, 10(4), 441–459.

White, R. A. (1983). "Mass Communication and Culture: Transition to a New Paradigm." *Journal of Communication*, 33(3), 279–301.

Wilson, C. C. (1991). *Black Journalists in Paradox: Historical Perspectives and Current Dilemmas*. New York: Greenwood.

Wilson, C. C., F. Gutiérrez, & L. M. Chao. (2003). *Racism, Sexism, and the Media. The Rise of Class Communication in Multicultural America*. Thousand Oaks, CA: Sage.

Young, I. M. (2000). *Inclusion and Democracy*. New York: Oxford University Press.

Media Ethics in Transnational, Gender Inclusive, and Multicultural Terms

CLIFFORD G. CHRISTIANS

Responsible media use and appropriate journalistic conduct have been debated in Western societies since the oldest known newspaper was published in Germany in 1609. But the press's harm to society was not explicitly linked to ethical principles until the end of the nineteenth century. In her examination of journalistic standards in the United States, Hazel Dicken Garcia (1989) sees the 1890s as the transition from critiquing everyday procedures to reflection about the press based on ethical precepts. *Scribner's* magazine in April 1896 applauded a French critic for finally getting beyond "short and most immediate views" and assessing journalism "philosophically" (Gorren, 1896, p. 507). As the press develops into an industrial structure during this period, and the first forays into journalism education appear, an intellectual concern about the press's obligation takes root in a form basically unchanged until now.

Major new communication technologies between the telegraph in 1837 and wireless radio in 1899 gave birth to the modern international communication system as the twentieth century opened. The development of the submarine cable marked the zenith of the monopolistic power of the great electronic companies. Monopoly becomes a crucial issue for international communication henceforth, with regulation entangled by domestic and imperial interests.

As the media became a complex and diversified social institution, journalists identified themselves as an expert class pursuing specialized tasks. The North American press began understanding itself during the early twentieth century not

as a political forum or socializing force, but as a corporate economic structure marketing a commodity for consumers. The industrialization of the media displaced an earlier media culture that used partisan advantage as its main standard. With the commercialization of the press, media occupations, especially journalism, began to redefine themselves as middle-class professionals.

A half dozen issues were primary in these contested and volatile terrains. Sensationalism had been a staple of the entire nineteenth century, but it took institutional form in the late 1890s from the Hearst and Pulitzer circulation battles during the Spanish-American War. Invasion of privacy also entered the ethics agenda. In the United States, it spun off from Warren and Brandeis's "The Right to Privacy" in the *Harvard Law Review* (December 1890). As electronic communication systems were being established, privacy became an urgent issue as sensitive diplomatic, military and commercial information crossed multiple barriers, especially in Europe (Fortner, 1993, pp. 88–89). Freebies and junkets, scourged by media critics since 1870, were now treated more systematically in the context of big-business competition. Film censorship was initiated in the UK in 1896. And a platform was laid for the free press–fair trial debate, though with virtually no progress beyond insisting on the press's rights. Without exception, as the canon of ethical issues was being established, they were articulated in terms of utilitarian professionalism.

Writing in 1924, Lord Reith of the BBC articulated a strong ethos of public service within a professional context: "I think it will be admitted by all that to have exploited so great a scientific invention [radio] for the purpose and pursuit of entertainment alone should have been a prostitution of its powers and an insult to the character and intelligence of the people" (MacDonald & Petheram, 1998, p. 83). In C. P. Scott's famous declaration in the *Manchester Guardian* (May 6, 1921): A newspaper's "primary office is the gathering of news. The unclouded face of trust [must not] suffer wrong. Comment is free, but facts are sacred" (MacDonald & Petheram, 1998, p. 53).

In the academy, William Gibbons' *Newspaper Ethics* (1926) demonstrated a professional preoccupation with public obligation. For example, in chapters 4 ("The Newspaper and the Public"), 7 ("The Newspapers' Responsibility"), and 8 ("The Newspaper in a Democracy"), Gibbons delineated a social responsibility theory of the press, with every major doctrine the equivalent of the Hutchins Commission's two decades later. The report of the Commission on the Freedom of the Press in 1947 insisted on news in a context that gave it meaning, and this was likewise the cornerstone of Gibbons' argument when confronting the issues of confidentiality, accuracy, crime reporting, and fair trial.

Codes of ethics for professional and academic associations were seen as the conventional format for moral principles (cf. White, 1989, pp. 49–56; cf. White, 1995). Of the thirty-five states that signed the Helsinki Act in 1975, professional

media organizations in twenty-four of them had codes of ethics (Juusela, 1991). In 1995, thirty-one codes of journalism ethics existed in twenty-nine European countries (Nordenstreng, 1995, p. 85). The International Organization of Journalists produced a document called "International Principles of Professional Ethics in Journalism" at meetings in Prague and Paris in 1983, emphasizing the people's right to timely information (Nordenstreng & Topuz, 1989; Nordenstreng, 1998, pp. 124–134). The first comprehensive treatment by an international network of scholars, *Communication Ethics and Global Change*, appeared in 1989 edited by Thomas Cooper. Surveys of codes of media ethics from thirteen countries were included and integrative chapters emphasized three major areas of worldwide concern: truth, responsibility, and free expression.[1]

Professional ethics as the framework of the twentieth century carried over into the twenty-first. As the global information order emerges, applied and practical ethics dominate the academy. MacDonald and Petheram (1998, pp. 257–349) list more than 200 research centers and academic departments around the world committed to journalism, advertising, and mass media ethics. Colleges and universities are including practical ethics courses within their general education curriculum and in professional programs such as business, law, medicine, communications, and engineering. The dramatic growth in research, teaching, and interest among media professionals and academics has been unrelenting, though the methodologies of ethics scholarship are often impressionistic.

There have been intellectual gains in the middle range. We understand more sharply conflict of interest, promise keeping and contractual obligation, paternalism and client autonomy, indoctrination, reform of institutional structures, and vocation. However, the critics are generally correct—applying ethical principles to particular cases is often busywork, descriptive and functional in character, teaching students to choose from practical alternatives but often without knowing how to consider the right course of action. For mass communication ethics, important advances have been made on the ethics of privacy, confidentiality, and deception. But most of the crucial issues (social justice, diversity in popular culture, digital manipulation, and conflict of interest) are still woefully underdeveloped. Even truth telling—central to information systems as a norm—has been largely neglected.

Applied ethics is directed in principle to making actual choices in moral conflicts, without being separate from normative ethics in general. It intends to supplement the abstract structures of normative ethics by systematic attention to concrete moral decision making. It aims to draw on ethical theory in reaching or scrutinizing moral judgments. However, the overall result has been descriptive ethics of meager conceptual substance. The professional culture that took form in the 1890s remains true a century later. Robert White describes it this way: "Communication ethics has emerged out of the ethos of professionalism that character-

izes the . . . drive of upwardly mobile classes for professional status who identify with the historic myth of scientifically based progress" (1989, p. 46).

Throughout this century, in and around the formative decades in Europe and North America, communication ethics with its professional orientation benefitted little from philosophical ethics generally. As Robert White concludes in his review of the field: "Communication ethics has developed with only remote connections to systematic moral philosophy" (1989, p. 46). Where connections have occurred, communication ethics has been unable to address the complicated issues adequately. Therefore, a retrospective and new direction must be embedded in ethical theory as a whole. Rather than searching for neutral principles to which all parties can appeal, or accepting moral relativism uncritically, an entirely new model of media ethics should rest on a complex view of moral judgments as integrating facts, principles, and emotions in philosophical terms.

Dialogic Ethics

In mainstream journalism ethics, as it is taught in the classroom and worked out in the newsroom, individual professionals are the centerpiece. Practitioners are free to make choices and are accountable for doing so. Their decision making is based on the rules and principles of morality that guide professional practice.

The alternatives to this dominant approach are social rather than individualist, and these approaches insist on starting over intellectually with a media ethics that is fundamentally dialogical. Our relation to other selves carries moral obligations. Our duties to others are considered more basic to human identity than are individual rights. We are dialogic beings seeking through responsive relations a responsible fit within the life of a community (cf. White, 2000a, pp. 47–51). Moral agents need a context within which to assess what is valuable, and values are nurtured in particular settings. In dialogic ethics, the central questions are simultaneously social and moral in nature.

There are several contemporary versions of it, three of them the most noteworthy: discourse, feminist, and communitarian ethics. As representatives of the ethics of dialogue, they are an "ethics of community" where "people of different identities, cultural backgrounds, social classes, and ethnicities can meet precisely at the level of differences"; they reflect an "ethics of dialogue" that reestablishes "the public sphere as a space for the hybridization of cultures" (Christians, Glasser, McQuail, Nordenstreng, & White, 2009, p. 60).

Discourse Ethics
Habermas's discourse ethics has dominated media ethics literature since the 1990s. The translation of his *Moralbewusstsein und kommunikatives Handeln* in 1990 and the publication of *The Communicative Ethics Controversy* in the same year set the stage for the most important debates in communication ethics through the late

twentieth century, and Habermas continues to be read, taught, and debated vigorously today.[2]

Habermas (1990) replaces Kant's formal system—his universalizability criterion of non-contradiction—with a communication community representing their common interests. He develops a procedural model of moral argumentation: "justification is tied to reasoned agreement among those subject to the norms in question" (p. viii). Habermas understands language to be an agent of culture and social organization. Discourses contain in a nutshell the meaning of our theories and beliefs. Therefore, the overriding question is whether our myriad linguistic forms allow everyone's interests a representative hearing. In Habermas's perspective, competing normative claims can be fairly adjudicated in the public sphere under ideal speech conditions such as reciprocity and openness. Habermas makes a permanent contribution to ethics by recognizing that the distributive fallacy can be overcome through universal pragmatics.

Habermas's critical theory contradicts the individualistic presumptions of traditional approaches to communication ethics. Nearly all the initiatives based on classical theories take for granted the individual-society dualism of liberal democratic political philosophy. For Habermas, moral consciousness must be nurtured, not under the illusions of aggregate consensus making but instead under conditions of instrumental technocracy and institutional power that stifle autonomous action in the public arena. Cutting through our political commonplaces is a major achievement for twenty-first-century ethical theory. But there are crucial issues that the Habermasian trajectory must resolve to be intellectually viable.

First, in the well-known critique of Nancy Fraser (1992, 1997), Habermas's public sphere is an abstraction that is not deeply holistic, gender inclusive, or culturally constituted. It presumes a private-public dichotomy, with the nurturing of human intimacy constrained within the private domain.

Second, given Habermas's insistence that public discourse conform to generalizable interests, the potential ethnocentrism of his public sphere is an ongoing concern. How can he ensure that the interests of marginalized subcultures will be included in generalizable interests? Insisting in discourse ethics on full and open discussion does not itself guarantee that those without administrative power can interpret their own needs and position themselves in their own terms (Cooper, 1991, pp. 34–40). The foundational work in *Cultural Pluralism and Moral Knowledge* (Paul, Miller, & Paul, 1994) indicates how dangerous all normative theories are, whether the classical ones of the textbooks or the moral system of Habermas. Sometimes they are imperialistic, and often they provide an ethical veneer above cultural differences rather than promote ethical dialogue across cultures (cf. Fleischacker, 1994).

Third, Bauman's *Postmodern Ethics* (1993) challenges us to a revitalized notion of human agency as we face the demise of the ethical and the transition

to a new era beyond duty. Foucault (1984) opposes both the liberal democratic presumption and Habermas's critical theory by questioning the very existence of autonomous citizens who may engage in rational discourse. Thoughtful self-reflexivity is impossible for Foucault without emancipation from the prevailing regime of oppressive practices. We ought to struggle against the economic and ideological state violence that constitute us as moral subjects. In his terms, we need a critical moral philosophy in terms of today's contingency and fragmentation, and Habermas's discourse ethics is inadequate.

These three critiques are not without reproach, but they are generally salient enough to press us into looking further into dialogic ethics for theoretical models that are gender inclusive, ethnically diverse, and non-foundational in character. Antonio Pasquali (1997, pp. 17–26) calls for a new morality of intersubjectivity that accounts for multicultural relations between North and South, and for distributive justice East and West. Pasquali is compatible with the relational ethics of Nel Noddings (1984) and with the communitarian ethics of Christians, Fackler, and Ferré (1993, 2012). Intersubjectivity models situate morality in the creaturely and corporeal, and locate the conceptual more closely to the way ethical judgments actually occur in the human community. This strategy for dialogic theorizing enables us to be continually self-analytical from within rather than critical from the outside.

Feminist Ethics

Feminist ethics has made a radical break with the individual autonomy and professionalist presumptions of utilitarian rationalism. The social ethics of Agnes Heller (1988), Carol Pateman (1985, 1989), the neo-Aristotelian social ethics of Martha Nussbaum (1999, 2000, 2001, 2006), and the feminist ethics of Carol Gilligan (1982, 1988), Virginia Held (1993), Edith Wyschogrod (1974, 1990), and Seyla Benhabib (1992) have fundamentally restructured ethical theory. Agnes Heller (1988, 1990, 1996) and Edith Wyschogrod (1974, 1990, 1998) are two promising examples of ethical theory in terms of today's contingency and fragmentation. In Wyschogrod's *Saints and Postmodernism*, anti-authority struggles are possible without assuming that our choices are voluntary. She represents a social ethics of self and Other in the tradition of Emmanuel Levinas. In Heller's trilogy, moral principles are conceivable in the context of good persons (rather than in abstractions). As a star student of Georg Lukács and professor at Budapest University until her dismissal in 1973, Heller contributes to social ethics an extraordinary understanding of resistance and emancipation. Daryl Koehn (1998) challenges feminist ethics to move beyond nurturance and contribute to dialogic theory. Heller answers that challenge, with her feminist perspective reconceptualizing the theory-practice relationship and helping bring dialogic philosophy to maturity.

Feminist ethics sharpens the dialogic perspective on intersubjectivity. As Lee Wilkins puts it, "Relationships themselves, and more generally real, lived experiences rather than intellectual and theoretical constructs, are considered the genesis of philosophical feminist ethics" (2009, p. 36). In giving primacy to the relation-in-between, rather than to individual actors, feminist ethics has moved the concept of caring to the center as the most powerful way to describe our moral duty to one another. In contrast to liberalism's standard of avoiding harm to others, feminist ethics insists on empathy and nurturance in all interactions. For Nel Noddings (1984), caring is not simply a favorable disposition toward human beings in general, but, in fact, the one caring is engrossed in the needs of the Other and the needs of the Other displace self-motivation.

The ethics of care in newsgathering and dissemination means compassionate journalism. The health of the communities reported on is vital to a healthy news profession. There is other-regarding care for the audience and readers, as citizens come to mutual decisions about the most appropriate courses of action. An ethics of care is especially concerned that the political process functions constructively. Carol Gilligan, for example, is researching the role that patriarchy plays in government and social institutions. With patriarchy as deep a contradiction to democratic life as slavery, in her work "the transformation from patriarchy to a fuller realization of democracy will be one of the most important historical events of the next 50 years" (Gilligan, 2001; quoted in Wilkins, 2009, p. 38). Gilligan identifies a complicated issue in democratic renewal that requires the dialogic model of reporting.

Through an ethics of care we understand more clearly the press's purpose of civic transformation. The primary mission of journalism is not the watchdog role but facilitating civil society. As Linda Steiner summarizes it, multicultural feminism applied to the news media respects differences of all sorts by incorporating "values (such as community) and responsibilities (such as caring) that historically are associated with women, without assuming all women around the globe are permanently . . . subordinated" (2009, p. 377). In her work, feminist ethics identifies oppression and imbalance, and teaches us "to address questions about whose interests are worthy of debate" (1991, p. 158). Various social structures (family, religious organizations, schools, and government) are addressed in this framework. Dialogic ethics ensures that the public is taken seriously, and the feminist perspective emphasizes crucial dimensions of that public—gender, race, ethnicity. Seyla Benhabib of Yale University combines feminist theory with political philosophy, and enriches our understanding of the pivotal role of diversity, gender, and multiculturalism in civic transformation (Benhabib, 2002; Benhabib & Resnik, 2009). Reciprocal care—rooted in human experience and not in formal consensus—is the basis on which moral discourse is possible. A feminist eth-

ics of dialogic being is a normative model that contradicts the presumptions and principles of individualist utilitarianism.

Communitarian Media Ethics

Communitarianism is not an ethical system per se, but a social philosophy rooted in the common good rather than individual autonomy. It is identical in scope to liberalism as a philosophy of democratic society. Its success in confronting utilitarianism stems from its formal equivalence to the democratic liberalism that underlies utilitarian ethics. John Stuart Mill's *On Liberty*, written in 1858, became the bible of democratic theory and the basis for his ethics, *Utilitarianism*, written in 1861. The influential *Four Theories of the Press* is actually one theory—the media are legitimated by and will be changed by the political-economic system in which they are grounded and reflect. Similar in structure to Mill and *Four Theories*, *communitas* in its various forms is the intellectual home of the ethics model presented here.

The strategic direction for international media ethics at present appears to be the social ethics of feminism and communitarian ethics. These normative models avoid the conundrum facing Habermas, and they provide a radical alternative to utilitarian professional ethics. But communitarianism and the feminist ethics of care operate in different domains: communitarianism as a social philosophy equivalent in scope to liberalism, and feminist ethics as a moral system. Linda Steiner's work demonstrates that feminist ethics establishes a politically and morally ambitious agenda for media institutions and practice (1991, 2009; Steiner & Okrusch, 2006). When communitarianism is developed into an ethics, it echoes similar concerns. But its philosophical breadth and theoretical depth establish communitarianism as the most fundamental alternative to utilitarian professional ethics and the democratic liberalism in which utilitarianism is situated.

Communitarian media ethics has been developed in various formats, principally in two books published by Oxford University Press: *Good News: Social Ethics and the Press* in 1993 and *Ethics for Public Communication* in 2012, both by Clifford Christians, Mark Fackler, and John Ferré. Rather than grounding media ethics in the Western canon, communitarian media ethics rises conceptually from counter-Enlightenment ontology and from theories of community as a normative ideal worldwide. The breadth of these intellectual trajectories ensures that communitarian media ethics is multicultural and gender inclusive. As Robert White and his colleagues have contended in their historical account of the evolution of normative theory, the citizen participation tradition is currently being created to replace the professionalized social responsibility paradigm that has dominated the twentieth century (Christians et al., 2009, pp. 58–63). Communitarian ethics reflects that interactive, participatory, cultural-dialogue philosophy of communication. White elaborates on this historic shift in his essay in *Mediating Religion*,

showing how the growth of the multicultural worldview is a major paradigm shift away from a linear, media-centered conception of communication (White, 2003, pp. 286–289; cf. White, 1996).

Good News: Social Ethics and the Press identifies individual autonomy as the axis of Enlightenment ethics and positions itself against Rawls' procedural democracy. In *Good News*, the community is understood to be ontologically and axiologically prior to persons. Organizations in this model operate with the standard of mutuality rather than administrative efficiency. Reporting facilitates public life and represents the moral landscape within which the human community is formed. As Robert White (2008) argues regarding journalism education, courses in media ethics ought to develop a moral commitment "to build community at the local, regional, and national levels" (p. 198).

Ethics for Public Communication: Defining Moments in Media History centers the communitarian model on those critical episodes in the world media that signal a democratic "tipping point." Organized in this book around the three functions of the media in democratic societies (news, persuasion, entertainment), communitarianism is contrasted with the classical ethics of Aristotle, Mill, and Kant. When community bonds are the framework rather than individual autonomy, we define ourselves ontologically as communal and become who we are in relationships. The relations we share with others are the center of moral attention, and the way that space is changed for better or worse is how moral progress is charted. As a result, for the news media the moral task cannot be reduced to professional ethics with its focus on journalism practice. How the moral order works itself out in communities is the issue, not first of all what practitioners consider virtuous according to their own codes of ethics.

Contrary to the dichotomy between individuals and society in liberalism, we know ourselves primarily as whole beings in relation (Taylor, 1989). For communitarians, the democratic liberalism of Locke and Mill confuses an aggregate of individual pursuits with the common good. Moral agents need a context of social commitments and community ties for assessing what is valuable. What is worth preserving as a good cannot be determined in isolation, but ascertained only within specific social situations where human identity is nurtured. Public life is conceived as a mosaic of particular communities, a pluralism of ethnic identities and worldviews intersecting to form a social bond but each seriously held and competitive as well.

Not every community ought to be celebrated. Some are sexist and others have racism in their language and institutions. The Worldwide Church of the Creator is blatantly anti-Semitic and thrives on hate rhetoric. Communal values can become exclusionary and oppressive. Communities need norms beyond their own values in order to be self-critical. "Only an 'outside' lets us know that we are

limited, and defined by those limitations; only an 'outside' shapes us" and enables us to evaluate and move forward constructively (Fleischacker, 1992, p. 223).

Communitarianism turns the individual autonomy of professional ethics inside out. Individual autonomy is reversed into universal solidarity. Personal liberty is transformed into commitment to the human race. Within that domain, the sacredness of life is a catalyst for binding humans universally into an organic whole. The rationale for human action is reverence for life on earth—respect for the organic realm in which human civilization is situated. The sacredness of life, evident in the purposiveness of nature itself, enables us to avoid the divisiveness of appeals to individual interests, or community traditions, cultural practices, and national prerogatives. The veneration of human life is a protonorm similar in kind to the proto-Germanic language—*proto* in Greek meaning "underneath"—a lingual predecessor underlying the Germanic languages as we know them in history. Out of this primordial generality basic ethical principles emerge such as truth, human dignity, and nonviolence. These principles are given an explicit orientation to community life in *Ethics for Public Communication* and are summarized this way: "We offer in these chapters a vision of community that is proactive, pro-progress, pro-health, and pro-creativity. We present it as a new vision of media ethics in today's complicated world" (Christians, Fackler, & Ferré, 2012, p. vii).

When the axis of media ethics is shifted from the individual autonomy of professional utilitarian ethics to communitarianism, the press's mission is fundamentally reoriented from the unbiased reporting of neutral data. Following the communitarian worldview, the press's mission is a morally revitalized citizenship. Readers, audiences, and users of social media are not merely provided with technically correct material, but the press's goal is morally literate persons. News serves the people-groups in which it is born rather than the needs and interests of the profession and of the governing elite. The long-term issue is what citizens need to improve their society and how a common good can be vital enough to inspire social transformation. Rather than presenting the issues top-down—defined by the mayor, police chief, and CEOs—the public is considered active and socially responsible, and, therefore, the news media enable communities to come to terms with their problems themselves. To meet the communitarian challenge, journalists will need to identify representative voices and communities rather than rely on the spectacular ones that are anecdotal and idiosyncratic.

Since communities are not merely functional but knit together by an admixture of sociocultural values, the fundamental question is whether reporting, persuasion, and entertainment open windows on the moral landscape. As Herman Wasserman and colleagues (2010) demonstrate from the African continent, the popular media can contribute in local terms to democratic life, but at the same time can and ought to provide sites of resistance and critique. This prophetic role for the media requires a resonance with the community's values, and that means

professional communicators need to know ethical principles that they share with the public at large—principally truth telling, human dignity, and nonviolence. In the communitarian perspective, practitioners understand the moral dimension in interactive terms—with reporters, those in persuasion, script writers, and producers resonating critically with the same debates over authentic social existence as the people themselves. When civic transformation is the defining purpose of communitarian news, citizens can distinguish worthy communities from malevolent ones. They can help articulate community goods within everyday discourse in the age of Twitter that is often too hurried and disjointed to establish a common good on its own.

In the same way that communitarian philosophy works against the excesses of individualism in Western countries, a variety of Asian scholars are appealing to communitarianism to help remedy the drawbacks of Confucianism (Bell, 2008, ch. 9). Communitarianism's commitment to civil society, for example, opens alternatives to the Confucian focus on the family as the primary locus of moral learning. In exploring the "intermediary associations" in Confucianism, the communitarian debates in the West are suggestive (de Bary, 1998). Confucians can look to communitarian democracy for insights about the values and practices that allow ordinary citizens to make meaningful contributions to the political process.

Ubuntu is an African worldview that represents communitarian ideals (Masolo, 2004; Fackler, 2003; Christians, 2004). Mutuality and reciprocity are the fundamental values in genuine community. In *Ubuntu*, humans depend completely on one another for development, and

> the paradox of freedom-in-dependence . . . expresses an important truth about human nature. . . . In the depths of our being is the capacity and desire for freedom, and our dependence on others for its development and fulfillment. . . . The more fully I am involved in community with others, the more completely I am able to realize my own deep desires to the full. (Schutte, 1993, pp. 9, 10, 90)

Thus, *Ubuntu* emphasizes the human being's moral character. Morality is entailed by our communal personhood. Interpersonal interdependence is constitutive of human life and, therefore, the development of my own being in concert with that of the Other is obligatory. Seeing oneself as "definable only in terms of membership in a society" combines obligations with rights and the concept of a person "becomes essentially normative" (Wiredu, 2004, p. 17).

Robert White has concluded that while alternative ethical systems "are developing in non-Western political and cultural contexts, these have so far not made a significant, coherent contribution to international discussions of communication ethics" (1989, p. 65). By incorporating the ethics of Confucianism and *Ubuntu* into the social philosophy of communitarianism, and enriching it thereby, communitarian ethics can become a communication theory in a multicultural world.

Social Justice

While working on theory and ensuring the effectiveness of media ethics for the long term, a host of moral issues are obvious as global media empires take shape. Some are new moral problems, such as digital manipulation. Other long-standing issues are being transformed. Privacy, surveillance, deception, gender discrimination, and ethnic diversity are more complicated than ever. On this lengthy agenda, the issue that stands out as most demanding and complicated is social justice.

Justice is the defining norm for all social institutions, including media organizations and practices as a social institution. However, while the importance of justice has never been higher as media technologies proliferate, implementing it. Globally networked digital systems are producing unmanageable floods of data that make recognizing and evaluating relevant information difficult. For French thinker Jacques Ellul, the information explosion produces crystallized humans, not the politically informed. He uses the analogy for overwhelmed audiences of pricking a frog's muscles incessantly in the laboratory until its body freezes (1967, pp. 57–58). Information overload buries us in a world of means, of technical knowledge, or what is typically called instrumentalism. Ends become ephemeral; human values are replaced by machine imperatives.

Bernhard Debatin refers to the paradox of media complexity: "Each and every increase in complexity causes a loss of transparency" (2008, p. 259). In the profusion, anonymity, and decontextualization of digital technology, deep structures and sources are easily hidden and difficult to recover. Rather than clarity about justice and its application, the information sphere builds up "second order knowledge, that is, knowledge about knowledge. This is the birth of indexes, catalogues, retrieval systems, and information selection systems" (p. 259). For media ethics in an age committed to technical excellence, the challenge is to keep alive a moral vocabulary such as justice and its cognates, making moral distinctions meaningful in education and professional practice.

Justice means giving everyone in society their appropriate due. Retributive and distributive justice in procedural terms is the standard framework for elaborating that definition. For the ethics of justice to work productively in an international context, the meaning of justice must be given a different conceptual formulation and fundamentally new orientation, one that is compatible with communitarian social philosophy. The news media ought to base their rationale and mission on this alternative understanding, that is, on restorative justice.

The conception of justice as right order has dominated the Western intellectual tradition and utilitarian professionalism within it. Justice is considered present when members of a society receive from its institutions the goods to which they have a right. For example, Plato's version of justice, developed principally in the *Republic*, is a right-order account. Plato delineated a social order that is

"founded and built up on the right lines, and is good in the complete sense of the word" (121; 427e). He takes it as obvious that such a social order will exhibit justice. In a just society there will be rights conferred on members of the social order by the legislation, the social practices, and the speech acts of human beings. For the right-order theorist, every right is conferred by institutions. This juristic understanding of rights became "part of the medieval *jus commune*, the common law of Europe that would in turn inform the polemical works of William of Ockham and the writings of early modern philosophers and theologians—figures as diverse and seminal in their own right as John Locke and John Calvin" (Reid, 1991, pp. 39–40; quoted in Wolterstorff, 2008, p. 52), Justice as right order in democratic liberalism is typically procedural. Procedural justice requires due process and by definition concerns the fairness of decisions and administrative mechanics. Principles and procedures for justice are the outcome of rational choice. When rights and resources are distributed, and appropriate actions are taken to rectify wrongs, justice is done. Rawls' *Theory of Justice* has dominated the formal terms and categories of procedural justice in Western democracies since its publication in 1971. What constitutes a just outcome is the procedure itself. For the principles of justice to be fair, they must be developed in a situation that is itself fair. Rawls' method derives principles of justice without asserting any goal or making justice dependent on that goal. For Rawls' democratic liberalism, humans are presumed to be free, rational, and equal.

Michael Sandel (1998) challenges the individualistic biases of Rawls' theory. He disputes Rawls' theory of justice as depending on a notion of the choosing self that is unsubstantiated. For Rawls there are not overriding ends that direct the choices made. The self becomes invulnerable—it is not changed by its experiences, nor by its cooperation with others. This limited view of the self does not account for important aspects of community and self-knowledge.

Sandel's argument can be summarized this way. In Rawls' procedural democracy, the process of fairness has priority over a conception of the common good. But we can accept such a priority only by presupposing that individual identities can be established in isolation from history and culture. Liberal political theory presumes that people are distinct from their ends. Our selves are presumed to be constituted antecedently, that is, in advance of our engagement with others. Our moral obligations are not invented by individuals, but they are located within the social worlds that we enter and within which we live. The liberal concept of persons who invent their own conceptions of the good does not square with our actual moral experience.

Habermas's *Moralbewusstsein und kommunikatives Handeln* (1990) develops a procedural model of community discourse, presenting with Rawls a liberal right-order theory of justice. Though with different emphases, they agree that national sovereignty must be limited by respect for universal human rights and that dif-

fering peoples must be allowed to interpret these rights according to their own political tradition.

In his essay *The Law of Peoples* (2001), Rawls argues for mutual respect and "common sympathies" for human rights, just war principles, and economic assistance to burdened nations. But these transnational conceptions are to be organized around territorial states (cf. Nussbaum, 2006, ch. 1). In *The Inclusion of the Other* (1998) and *The Postnational Constellation* (2001), Habermas, like Rawls, insists that rights are empty apart from their unique constitutional venues. While noting the positive role played by nationalism in struggles for liberation and democracy, Habermas recognizes that nationality today has all too often justified illiberal forms of nationalism that suppress dissident minority groups and other sub-nationalities. While advocating the idea that nations represent stable units of collective agency, he concedes that this stability is being discredited by the multicultural migrations set in motion by globalization. Habermas tends to view international justice as an extension of domestic justice, whereby relationships of mutual dependency presume something like a basic structure requiring rectification vis-à-vis principles of distributive justice.

Although justice as right order has dominated the West and is the standard formulation in the media, a different definition is necessary for working out a credible global justice as the standard for the international news media today. Theories of justice of the right-order kind have generally centered on advanced, industrial democracies. Working on justice in terms that include young and developing democracies, and authoritarian systems also, moves us away from the right-order formulation (cf. Rioba, 2012, chs. 1–7).

Communitarianism points us in that different direction. It critiques the definition of the human that right order presumes, and sees primary justice as inherent in our humanness. Rights are not conferred and maintained as entities of a particular sort, but are inherent. On account of possessing certain properties, all humans have worth. And that worth is sufficient for having the rights we are owed. There does not have to be something else that confers these rights (Wolterstorff, 2008, p. 36). Receiving one's due arises from one's intrinsic worth; it is not a privilege for which one has gratitude. The universal generalization that torture of infants is unjust arises from humanity's intrinsic value, not because right order has been established in criminal law. On account of the worth we have, every human being is under obligation not to torture any human being (Wolterstorff, 2008, p. 37). Intrinsic worth as the core of the common good is ontologically prior to mechanisms of conferral.

The primary justice of communitarian democracy belongs first of all to civil society. Civil society is the human domain outside government and business, at least relatively free from the political and commercial. Robert White describes it in an African context:

The civil society is the social space between the coercive monopoly of power located in the state and the private sphere of family and business, which has no responsibility per se for the public sphere. The civil society is the area of community life where those who are citizens recognize their rights and responsibility to determine the future of the society in which they live. (2010, p. 304)

Our customs, values, life's meaning are learned and negotiated in the civil society of home, schools, religion, neighborhoods, voluntary associations, charities, civic groups such as a residents' welfare association, and NGOs. Humans are moral beings, so civil society is a moral order. It is here where morality is nurtured and the home of justice as intrinsic worth receives its understanding and application. Civil society is where restorative justice is experienced and known, and where such justice gives us ongoing orientation to the world.

When the press understands justice as the primary common good, nurtured first and foremost in civil society, it gives priority to the facilitative role of the press rather than priority to the monitorial one. The media facilitate civil society (Christians et al., 2009, ch. 7). They actively support and strengthen democratic participation in neighborhoods, churches, and organizations outside the state and market. This is a normative claim, in that the media do not simply report on civil society's activities and institutions, but seek to enrich and improve them (Christians et al., 2009, pp. 158–159). "The press is obviously most effective when it can become the voice of significant political opposition or well-organized sectors of the civil society" (White, 2010, p. 307). In the process, the media are accountable to the widely shared common good that orients the civil society in which they operate and by which they are given meaning. In the words of Martin Luther King, "The moral arc of the universe is long and it bends toward justice."

Conclusion

In communitarianism, *communitas* is understood ontologically—as a way of being in the world—and seen as an umbrella term for social philosophies worldwide that advocate *communitas* as a normative ideal. Community as a moral good is understood to exist in multiple forms historically and transnationally, and these trajectories in their own way and to varying degrees form the conceptual home of communitarian media ethics. As a social philosophy with deep roots and worldwide parameters, communitarianism yields a media ethics that is ethnically diverse, cross-cultural, and gender inclusive.

In addition, communitarianism as a social philosophy distinguishes relativism from pluralism in media ethics. For relativists, the right and valid are only known in local space and native languages; moral principles have no application outside the culture in which they are constituted. Pluralism takes culture and history seriously, but insists that different perspectives need a common core to enrich each other. Community as ontologically distinct from the atomism of classical

liberalism provides an axis around which communitarian ethics revolves. Therefore, the various concepts, histories, and problematics of *communitas* are only dialects of the same language—pluralities that feed from and into one another, held together by a body of similar ideas contra utilitarian professionalism. Communitarianism as a philosophical concept yields a media ethics that is centered on restorative justice and stretches across the continents.

Notes

1. Robert White argues that before these codified formulas can be written down, "they must exist in the ideals of outstanding professionals in the everyday practices of newsrooms and in the expectations of the public regarding the media" (2000b, p. 284). The emergence of codes at this early stage of the nineteenth century indicated that a body of professionally minded practitioners had developed in the news media.

2. Benhabib and Dallmayr (1990) reprint a major section of Habermas's *Moralbewusstsein*, plus essays by Karl-Otto Apel and two of their students, in section 1. The five chapters of part 2 are composed of recent European reflections on the relevance of discourse ethics for theories of democratic institutions—ranging from Wittgensteinian language theory to Kantian idealism. Benhabib's Afterword (pp. 330–369) clarifies the arguments in terms of Anglo-American philosophy as a whole. (For the most comprehensive analysis of the earlier Frankfurt School literature, see Benhabib, 1986.)

Bibliography

Bauman, Z. (1993). *Postmodern Ethics*. Oxford, UK: Blackwell.

Bell, D. (2008). *China's New Confucianism: Politics and Everyday Life in a Changing Society*. Princeton, NJ: Princeton University Press.

Benhabib, S. (1982). *Situating the Self: Gender, Community, and Postmodernism in Contemporay Ethics*. New York: Routledge.

Benhabib, S. (1986). *Critique, Norm and Utopia*. New York: Columbia University Press.

Benhabib, S. (1992). *Situating the Self: Gender, Community, and Postmodernism in Contemporary Ethics*. New York: Routledge.

Benhabib, S. (2002). *The Claims of Culture: Equality and Diversity in the Global Era*. Princeton, NJ: Princeton University Press.

Benhabib, S., & F. Dallmayr. (Eds.). (1990). *The Communicative Ethics Controversy*. New York: Routledge.

Benhabib, S., & J. Resnik (Eds.). (2009). *Migrations and Mobilities: Citizenship, Borders, and Gender*. New York: New York University Press.

Christians, C. (2004). "*Ubuntu* and Communitarianism in Media Ethics." *Ecquid Novi*, 25(2), 235–256.

Christians, C., M. Fackler, & J. Ferré. (2012). *Ethics for Public Communication*. New York: Oxford University Press.

Christians, C., J. Ferré, & M. Fackler. (1993). *Good News: Social Ethics and the Press*. New York: Oxford University Press.

Christians, C., T. Glasser, D. McQuail, K. Nordenstreng, & R. White (2009). *Normative Theories of the Media: Journalism in Democratic Societies*. Urbana: University of Illinois Press.

Cooper, M. (1991). "Ethical Dimensions of Political Advocacy from a Postmodern Perspective." In R. E. Denton Jr. (Ed.), *Ethical Dimensions of Political Communication* (pp. 23–47). New York: Praeger.

de Bary, W. T. (1998). *Asian Values and Human Rights: A Confucian Communitarian Perspective.* Cambridge, MA: Harvard University Press.

Debatin, B. (2008). "The Future of New Media Ethics." In T. Cooper, C. Christians, & A. Babbili (Eds.), *An Ethics Trajectory: Visions of Media, Past, Present, and Yet to Come* (pp. 257–263). Urbana: Institute of Communications Research, University of Illinois.

Dicken Garcia, H. (1989). *Journalistic Standards in Nineteenth-Century America.* Madison: University of Wisconsin Press.

Ellul, J. (1967). *The Political Illusion.* (Trans. K. Kellen). New York: Alfred A. Knopf.

Fackler, M. (2003). "Communitarian Theory with an African Flexion." In J. Mitchell & S. Marriage (Eds.), *Mediating Religion: Conversations in Media, Religion and Culture* (pp. 317–328). London: T & T Clark.

Fleischacker, S. (1992). *Integrity and Moral Relativism.* Leiden, Netherlands: E. J. Brill.

Fleischacker, S. (1994). *The Ethics of Culture.* Ithaca, NY: Cornell University Press.

Fortner, R. S. (1993). *International Communication: History, Conflict, and Control of the Global Metropolis.* Belmont, CA: Wadsworth.

Foucault, M. (1984). "On the Genealogy of Ethics: An Overview of Work in Progress"; "Politics and Ethics"; & "An Interview." In P. Rabinow (Ed.), *The Foucault Reader* (pp. 340–372, 373–389). (Trans. C. Porter). New York: Pantheon.

Fraser, N. (1997). *Justus Interruptus.* New York: Routledge.

Fraser, N. (1992). "Rethinking the Public Sphere: A Contribution to the Critique of Actually Existing Democracy." In C. Calhoun (Ed.), *Habermas and the Public Sphere* (pp. 109–142). Cambridge, MA: MIT Press.

Gibbons, W. F. (1926). *Newspaper Ethics: A Discussion of Good Practice for Journalists.* Ann Arbor, MI: Edwards Bros.

Gilligan, C. (1982). *In a Different Voice: Psychological Theory and Women's Development.* Cambridge, MA: Harvard University Press.

Gilligan, C. (2001, October 1). "From White Rats to Robots." *HBSE Harvard Graduate School of Education Newsletter.* http://www.gse.harvard.edu/news/features/gilligan.

Gilligan, C., J. V. Ward, & J. M. Taylor (1988). *Mapping the Moral Domain.* Cambridge, MA: Harvard University, Graduate School of Education.

Gorren, A. (1896). "The Ethics of Modern Journalism." *Scribner's Magazine*, April, p. 507.

Habermas, J. (2001). *The Postnational Constellation: Political Essays.* Cambridge, MA: MIT Press.

Habermas, J. (1998). *The Inclusion of the Other: Studies in Political Theory.* (Ed., C. Cronin & P. De Greiff). Cambridge, MA: MIT Press.

Habermas, J. (1990). *Moral Consciousness and Communicative Action.* (Trans. C. Lenhardt & S. W. Nicholsen). Cambridge, MA: MIT Press. (Originally published as *Moralbewusstsein und kommunikatives Handeln*, 1983).

Held, V. (1993). *Feminist Morality: Transforming Culture, Society, and Politics.* Chicago: University of Chicago Press.

Heller, A. (1988). *General Ethics.* Oxford, UK: Blackwell.

Heller, A. (1990). *A Philosophy of Morals.* Oxford, UK: Blackwell.

Heller, A. (1996). *An Ethics of Personality.* Oxford, UK: Blackwell.

Juusela, P. (1991). *Journalistic Codes of Ethics in the CSCE Countries: An Examination.* Tampere, Finland: University of Tampere Series B31.

Koehn, D. (1998). *Rethinking Feminist Ethics: Care, Trust and Empathy.* New York: Routledge.

MacDonald, B., & M. Petheram. (1998). *Keyguide to Information Sources in Media Ethics*. London: Mansell.

Masolo, D. A. (2004). "Western and African Communitarianism: A Comparison." In K. Wiredu (Ed.), *A Companion to African Philosophy* (pp. 483–498). Oxford: Blackwell.

Noddings, N. (1984). *Caring: A Feminine Approach to Ethics and Moral Education*. Berkeley: University of California Press.

Nordenstreng, K. (1998). "Professional Ethics: Between Fortress Journalism and Cosmopolitan Democracy." In K. Brants, J. Hermes, & L. Van Zooten (Eds.), *The Media in Question: Popular Cultures and Public Interests* (pp. 124–134). London: Sage.

Nordenstreng, K. (1995). *Reports on Media Ethics in Europe*. University of Tampere: Julkaisuja Sarja B41.

Nordenstreng, K., & H. Topuz. (Eds.). (1989). *Journalist: Status, Rights, and Responsibilities*. Prague: International Organization of Journalists.

Nussbaum, M. (1999). *Sex and Social Justice*. New York: Oxford University Press.

Nussbaum, M. (2000). *Women and Human Development: The Capabilities Approach*. Cambridge, UK: Cambridge University Press.

Nussbaum, M. (2001). *Upheavals of Thought: The Intelligence of Emotions*. Cambridge, UK: Cambridge University Press.

Nussbaum, M. (2006). *Frontiers of Justice: Disability, Nationality, Species Membership*. Cambridge, MA: Harvard University Press.

Pasquali, A. (1977). "The Moral Dimension of Communicating." In C. Christians & M. Traber (Eds.), *Communication Ethics and Universal Values* (pp. 46–67). Thousand Oaks, CA: Sage.

Pateman, C. (1989). *The Disorder of Women: Democracy, Feminism and Political Theory*. Stanford, CA: Stanford University Press.

Pateman, C. (1985). *The Problem of Political Obligation: A Critique of Liberal Theory*. Cambridge, UK: Cambridge University Press.

Paul, E. F., F. D. Miller, & J. Paul. (Eds.). (1994). *Cultural Pluralism and Moral Knowledge*. Cambridge, UK: Cambridge University Press.

Rawls, J. (2001). *The Law of Peoples*. Cambridge, MA: Harvard University Press.

Rawls, J. (1971). *A Theory of Justice*. Cambridge, MA: Harvard University Press.

Reid, C. J. (1991). "The Canonistic Contribution to the Western Rights Tradition: An Historical Inquiry." *Boston College Law Review*, 33(1), 37-92.

Rioba, A. (2012). *Media Accountability in Tanzania's Multiparty Democracy: Does Self-Regulation Work?* Tampere, Finland: Tampere University Press.

Sandel, M. J. (1998/1982). *Liberalism and the Limits of Justice* (2nd ed.). Cambridge: Cambridge University Press.

Schutte, A. (1993). *Philosophy for Africa*. Cape Town: University of Cape Town Press.

Steiner, L. (2009). "Feminist Media Ethics." In L. Wilkins & C. Christians (Eds.), *The Handbook for Mass Media Ethics* (pp. 366–381). New York: Routledge.

Steiner, L. (1991). "Feminist Theorizing and Communication Ethics." *Communication*, 12(3), 157–173.

Steiner, L., & C. Okrusch. (2006). "Care as a Virtue for Journalists." *Journal of Mass Media Ethics*, 21(2–3), 102–122.

Taylor, C. (1992). "Civil Society in the Western Tradition." In E. Groffier & M. Paradis (Eds.), *The Notion of Tolerance in Human Rights* (pp. 117–136). Ottawa: Carleton University Press.

Taylor, C. (1989). *Sources of the Self: The Making of the Modern Identity*. Cambridge, MA: Harvard University Press.

Wasserman, H. (Ed.). (2010). *Popular Media: Democracy and Development in Africa*. New York: Routledge.

Warren, S., & L. Brandeis (1890). "The Right to Privacy." *Harvard Law Review,* 4(5), 193–220.

White, R. A. (2010). "Foundations of Morality in Africa." In R. Fortner & M. Fackler (Eds.), *Ethics and Evil in the Public Sphere: Media, Universal Values, and Global Development* (pp. 287–310). Cresskill, NJ: Hampton.

White, R. A. (2008). "Teaching Communication Ethics in the African Context: A Response to Globalization." *Ecquid Novi: African Journalism Studies,* 29(2), 188–209.

White, R. A. (2003). "The Emerging 'Communitarian' Ethics of Public Communication." In J. Mitchell & S. Marriage (Eds.), *Mediating Religion: Conversations in Media, Religion and Culture* (pp. 285–292). London: T & T Clark.

White, R. A. (2000a). "New Approaches to Media Ethics: Moral Dialogue, Creating Normative Paradigms and Public Cultural Truth." In B. Pattyn (Ed.), *Media Ethics: Opening Social Dialogue* (pp. 47–67). Leuven, Belgium: Peters.

White, R. A. (2000b). "Seven Characteristics of the 'Ethical' Public Communicator: Protecting the Quality of Democratic Communication." In B. Pattyn (Ed.), *Media Ethics: Opening Social Dialogue* (pp. 283–304). Leuven, Belgium: Peters.

White, R. A. (1996). "A Communitarian Ethic of Communications in a Postmodern Age." *Ethical Perspectives: Journal of the European Ethics Network,* 3(4), 207–218.

White, R. A. (1995). "From Codes of Ethics to Public Cultural Truth." *European Journal of Communication,* 10, 441–460.

White, R. A. (1991). "Democratization of Communication: Normative Theory and the Sociopolitical Process." In J. Greenberg (Ed.), *Conversations on Communication Ethics* (pp. 141–161). Norwood, NJ: Ablex.

White, R. A. (1989). "Social and Political Factors in the Development of Communication Ethics." In T. W. Cooper, with C. Christians, F. F. Plude, & R. White (Eds.), *Communication Ethics and Global Change.* New York: Longman.

White, R. A. (1984). "Communication Strategies for Social Change: National Television versus Local Public Radio." In G. Gerbner & M. Siefert (Eds.), *World Communications Handbook* (pp. 279–293). New York: Longman.

Wilkins, L. (2009). "Carol Gilligan: Ethics of Care." In C. G. Christians & J. C. Merrill (Eds.), *Ethical Communication: Moral Stances in Human Dialogue* (pp. 33–39). Columbia: University of Missouri Press.

Wiredu, K. (1996). *Cultural Universals and Particulars: An African Perspective.* Bloomington: Indiana University Press.

Wiredu, K. (Ed.). (2004). *A Companion to African Philosophy.* Blackwell, UK: Oxford.

Wolterstorff, N. (2008). *Justice: Rights and Wrongs.* Princeton, NJ: Princeton University Press.

Wyschogrod, E. (1974). *Emmanuel Levinas: The Problem of Ethical Metaphysics.* The Hague: Martinus Nijhoff.

Wyschogrod, E. (1990). *Saints and Postmodernism.* Chicago: University of Chicago Press.

Wyschograd, E. (1998). *An Ethics of Remembering: History, Heterology, and the Nameless Others.* Chicago: University of Chicago Press.

CONTRIBUTORS

ISABEL AWAD is Assistant Professor in the Department of Media and Communication at the Erasmus University, Rotterdam. Awad received her PhD in communication from Stanford University. Her research pays special attention to the questions of democracy and social justice in relation to the media. Awad has addressed this topic, first, by examining the role of the news media in the inclusion/exclusion of cultural minorities in the United States and in Europe. More recently, she has been conducting research in Chile to study the relationship between journalism and neoliberalism. Her work has been published in various international journals, including *Journal of Communication, Journalism Studies, Javnost—The Public*, and *European Journal of Communication*.

DAVID BLACK (PhD, York University) is Associate Professor in the School of Communication and Culture at Royal Roads University in Victoria, British Columbia. His doctoral supervisor at York was the late Ioan Davies, a founder of cultural studies in Canada. Before coming to Royal Roads, he taught in the Department of Communication Studies at Wilfrid Laurier University in Waterloo, Ontario, where he was involved in founding a new program in cultural studies. Black is the author of the book *The Politics of Enchantment: Romanticism, Media, and Cultural Studies*, as well as articles in communication history and pedagogy. He teaches and researches in the areas of communication theory, policy, and history.

ROGER BROMLEY is Visiting Professor at Lancaster University, Emeritus Professor in Cultural Studies and Honorary Professor of Sociology at the University of Nottingham, and Associate Fellow at Rhodes University, South Africa. He held a postgraduate fellowship at the University of Illinois and then worked for forty-four years in a range of UK higher education institutions. He is the author of *Lost Narratives: Popular Fictions and Politics* (1988), *Narratives for a New Belonging: Diasporic Cultural Fictions* (2000), and four other books, as well as articles on conflict, post-conflict, and reconciliation (Rwanda, Bosnia, South Africa, and Palestine). His current research interests also include migration, diaspora, and cinematic representations of refugees and asylum seekers. In 1975, he was one of the team at Portsmouth Polytechnic that launched the first ever undergraduate program in cultural studies.

CLIFFORD G. CHRISTIANS is Research Professor of Communications Emeritus at the University of Illinois, Urbana-Champaign, where he was director of the Institute of Communications Research for sixteen years. He has been a visiting scholar in philosophical ethics at Princeton University, in social ethics at the University of Chicago, and a PEW fellow in ethics at Oxford University. He completed the third edition of Rivers and Schramm's *Responsibility in Mass Communication*, has coauthored *Jacques Ellul: Interpretive Essays* with Jay Van Hook, and has written *Teaching Ethics in Journalism Education* with Catherine Covert. He is the coauthor with Mark Fackler and John Ferré of *Good News: Social Ethics and the Press* (Oxford) and of *The Ethics for Public Communication* (Oxford). He has authored or coauthored *Communication Ethics and Universal Values, Handbook of Mass Media Ethics, Moral Engagement in Public Life, Theorists for Contemporary Ethics*, and *Ethical Communication: Moral Stances in Human Dialogue*. He was coauthor with Robert White (and Ted Glasser, Denis McQuail, and Kaarle Nordenstreng) of *Normative Theories of the Media*. The tenth edition of his coauthored book *Media Ethics: Cases and Moral Reasoning* is in press.

BRENDA L. DERVIN is Professor Emerita, School of Communication, Ohio State University, Columbus. She received her PhD from Michigan State University and holds an honorary doctorate from the University of Helsinki. She currently holds adjunct appointments in communication at Eastern Washington University, and in library-information science at the University of South Carolina. She is also director of the Sense-Making Methodology Institute, Meridian, Idaho. Her research and teaching focus on using genuinely communicative methodological frameworks for understanding users and designing systems for serving users well in myriad contexts, including mass, organizational, and interpersonal. She is fellow and past president of the International Communication Association, and longtime member of the International Association for Media and Communication Research and of the Association for Information Science and Technology.

JOSEPH OLÁDÈJO FÁNÍRAN is Senior Lecturer and the Director of the Center for the Study of African Culture and Communication, Catholic Institute of West Africa, Port Harcourt in Nigeria. He received the BDiv degree from the Pontifical Urban University, Rome through the Seminary of S. S. Peter and Paul, Bodija, Ibadan, Nigeria; Diploma in Religious Studies from the University of Ibadan; BA Honors in Communication from the University of Ottawa, Canada; MA in International Affairs from Carleton University, Ottawa; and PhD in Sociology of Communication from Pontifical Gregorian University, Rome. His research interests include African communication, communication and development, interface between communication and theology, and pastoral communication. Among his publications are *Foundations of African Communication with Examples from Yorùbá Culture*; and "The Visual Rhetoric of Yoruba Video Films," *Humanities Review Journal*, 7, 58–72.

THEODORE L. GLASSER is Professor in the Department of Communication at Stanford University. He received his PhD from the University of Iowa. His research and teaching focus on press practices and performance. In 2002–2003 he served as president of the Association for Education in Journalism and Mass Communication. He had earlier served as a vice president and chair of the Mass Communication Division of the International Communication Association. He has held visiting faculty appointments as a Senior Fulbright Scholar at the Hebrew University of Jerusalem, Israel; as the Wee Kim Wee Professor of Communication Studies at Nanyang Technological University, Singapore; and at the University of Tampere, Finland. On campus, Glasser is the chair of the board of directors of the Stanford Daily Publishing Corporation and a member of the program committee of the John S. Knight Fellowships program for mid-career journalists. For fourteen years he directed Stanford's Graduate Program in Journalism.

PETER GOLDING is Pro Vice Chancellor (Research and Innovation) at Northumbria University in Newcastle, UK since 2010. Previously he was Professor of Sociology at Loughborough University. From 1990 to 2006 he was also the head of the Department of Social Sciences there, and from 2006 to 2009 Pro Vice Chancellor (Research). He was a member of the national Research Assessment Exercise panel for his field in 1996 and 2001; a member of the HEFCE's Expert Advisory Group for the 2014 Research Excellence Framework; chair of the communications, media, and cultural studies sub-panel for 2008, and chairs the equivalent panel for REF 2014. He is an editor of the *European Journal of Communication*, Honorary Chair of the European Sociological Association Media Research Network, and was co-chair of the European Science Foundation Programme "Changing Media, Changing Europe." He was founding chair of the subject association for his field in the UK from 1993 to 1999. Since then he has been Honorary Secretary of its successor body, the Media, Communication

and Cultural Studies Association. He has been a visiting professor at universities in Switzerland, New Zealand, Japan, Estonia, and Brazil, and has lectured and taught in more than twenty countries. His research interests are in media sociology, journalism, media political economy, social inequality, international communications, new media, and media constructs of public and social policy.

CEES J. HAMELINK is Emeritus Professor of International Communication at the University of Amsterdam, Athena professor of human rights and public health at the Vrije Universiteit in Amsterdam, and professor for management of information and knowledge for sustainable development at the University of Aruba. He studied theology and psychology at the University of Amsterdam, where he received his PhD degree in 1975. He founded the People's Communication Charter, was president of the International Association for Media and Communication Research, was consultant to several intergovernmental organizations and national governments and guest-lectured in some forty countries. He is currently the editor-in-chief of the *International Communication Gazette* and has published seventeen monographs on communication and cultural issues.

STEWART M. HOOVER is Professor of Media Studies and Religious Studies at the University of Colorado-Boulder, where he directs the Center for Media, Religion and Culture. A specialist in audience studies, he has focused his work on the reconstruction of religion in the media age. He is the founding president of the International Society for Media, Religion and Culture, and has directed or co-directed more than twenty international conferences. His current research focuses on digital religion and on mediated religion in the global context. He is author or editor of nine books and numerous articles and book chapters. His most recent monograph is *Religion in the Media Age* and he has two books in progress, *Does God Make the Man?: Media and Religion in the Crisis of Masculinity* (forthcoming from NYU Press) and the edited volume *The Media and Religious Authority*.

KEVAL J. KUMAR is Adjunct Professor at Mudra Institute of Communications, Ahmedabad (MICA). He is a former reader, Department of Communication and Journalism, University of Pune, and a former director, Symbiosis Institute of Media and Communication (SIMC). He has been a Visiting Professor at Ohio State University, Siegen University, Jacobs University Bremen, and Bahrain Technical Institute. Kumar is the author of *Mass Communication in India* and coauthor of *Environmentalism and the Mass Media: The North-South Divide*. He edited a special double issue of the *Journal of Creative Communications* on "India's Many Popular Cinemas: Theoretical Perspectives." He was chair, Media Education Research Section, IAMCR, from 1998 to 2006.

JESÚS MARTIN-BARBERO received his PhD in philosophy from the University of Louvain. He founded the Department of Communication at the Universi-

dad del Valle in Cali, Colombia, in 1975. He has been president of the *Associación Latínoamericana de invesitgardores de Communicaín* (ALAIC) [Latin American Association of Researchers of Communication] and a member of the Committee for Cultural Policy of CLASCO (*Consejo Latinoamericano de Ciencias Sociales* [Latin American Council of Social Sciences]). He has published *De los medios a las mediaciones* [*From Media to Mediations*, Sage: London, 1992], Barcelona: G. Gili, 1987; *Las ejercicios del ver* [*The Exercises of Seeing*] (with G. Rey), Barcelona: Gedisa, 1990; and *Oficio de cartógrafo*, México: F.C.E., 2002.

DENIS McQUAIL is Professor Emeritus and Honorary Fellow at the Amsterdam School of Communications Research, University of Amsterdam. Educated at Oxford University (MA) and Leeds University (PhD), he taught sociology at the University of Southampton, UK, before taking the Chair in Mass Communication in Amsterdam in 1977. His publications and research have had particular reference to mass media effects and audiences, media policy, and normative theory of media. Recent publications include *Normative Theory of the Media* (with Cliff Christians, Ted Glasser, Kaarle Nordenstreng, and Robert White); *McQuail's Mass Communication Theory*; and *Journalism and Society*.

KAARLE NORDENSTRENG is Professor Emeritus of Journalism and Mass Communication at the University of Tampere (Finland). He studied psychology at the University of Helsinki (PhD in 1969) and worked as a freelance journalist in Finnish national radio since the age of fifteen, later interviewing, among others, C. G. Jung and Marshall McLuhan. He was head of research at the Finnish Broadcasting Company during its radical reform in the later 1960s. He also served as consultant to UNESCO (1969–1975), vice president of the International Association for Mass Communication Research (1972–1978), and president of the International Organization of Journalists (1976–1990). He has been Visiting Professor in the universities of California (UCSD), Maryland, Minnesota, and Texas. He has written or edited forty books (alone or with others) and published more than 400 scholarly articles (for publications, see http://www.uta.fi/cmt/en/contant/staff/kaarlenordenstreng/publications.html).

MICHAEL R. REAL (PhD, University of Illinois) is Professor of Communication and Culture at Royal Roads University in Victoria, British Columbia, Canada. His books include *Exploring Media Culture, Super Media, Mass-Mediated Culture*, and most recently *Bodies of Discourse*. He has written scores of scholarly and general publications. His research topics include sports media, popular culture, film (especially the Hollywood Oscars), television, media events both national (Super Bowl) and international (Olympics), globalization, and social change. He has also directed local and international research projects and hosted television and radio programs. His work focuses on media, culture, and social responsibility.

PETER SHIELDS is Professor of Communication at Eastern Washington University. He received his degrees in economics and communication from Ohio State University. He teaches and researches in the areas of surveillance and security, global communication, information society studies, and the political economy of information-communication technologies. His most recent publications focus on the role played by information-communication technologies in stretching borders into neighboring and distant territories, and the implications of this development for human mobility.

PAUL A. SOUKUP, SJ, has worked with media ecology for more than fifteen years and presently serves as treasurer of the Media Ecology Association. His academic interests include orality and literacy studies and the intersection of communication and theology. He and Thomas J. Farrell have edited four volumes of the collected works of Walter J. Ong, SJ, *Faith and Contexts* (1992–1999), as well as *An Ong Reader* (2002), a collection geared toward communication study. Most recently, he and Farrell have edited a collection of essays applying Ong to media ecology, *Of Ong & Media Ecology: Essays in Communication, Composition, and Literary Studies* (2012). He is a graduate of the University of Texas in Austin (PhD, 1985). Soukup teaches in the Communications Department at Santa Clara University.

RUTH E. TEER-TOMASELLI (PhD) holds the UNESCO chair in Communication, which hosts the *African Journal of Communication*, published twice a year by the East African Communication Association and edited by Professor Robert White from the editorial offices at Daystar University, Nairobi, Kenya. She has served as vice president of the International Association for Media and Communication Research, chairing the 2012 IAMCR conference held in Durban, South Africa. She has consulted for international agencies across Africa including UNESCO, UNDP, the Forum for African Women Educationists, and the World Bank. Her research interests are the political economy of global media, broadcasting and telecommunications, media memory, and research methods. Her current research focuses on the history of broadcasting in South Africa, with special emphasis on the early years.

PRADIP NINAN THOMAS is Acting Head, School of Journalism and Communication, University of Queensland. His research interests include the political economy of communications, media and religion, and communications and social change. He has written extensively in these areas. In 2012 he published the volume *Digital India: Information, Communication and Social Change*, the final installment in an authored, three-volume reading of the media in India. He is on the editorial board of two book series: The Geopolitics of Information and

the Palgrave Series on Communication and Social Change. He is currently vice president, International Association for Media and Communication Research.

KEYAN G. TOMASELLI is Director of the Center for Communication, Media and Society, University of KwaZulu-Natal, Durban. He is editor of *Critical Arts: South-North Cultural and Media Studies* and co-editor of the *Journal of African Cinemas*. He is a Fellow of the University of KwaZulu-Natal and of the International Communicology Institute, and has been a Fulbright Scholar at Michigan State University. He has been a visiting professor and external examiner at Addis Abba University, Moi and Maseno Universities in Kenya, among many others. He is the author of *Encountering Modernity: 20th Century South African Cinemas* (2006), *Cultural Tourism and Identity: Rethinking Identity* (2012), and co-editor of *Cultural Icons* (2009) and *Development and Health Communication* (2011).

THOMAS TUFTE has been a Professor of Communication at Roskilde University (Denmark) since 2004, and as of November, 2013, is also Senior Research Associate in the Faculty of Humanities at the University of Johannesburg, South Africa. He currently directs two international research projects: "People Speaking Back? Empowerment and Democracy in East Africa" (2009–2014) and "Critical Perspectives on New Media and Processes of Social Change in the Global South" (2013–2016). He is co-founder (2008) and co-director of the Danish–Swedish research center, "Orecomm Center for Communication and Global Change." He has lectured, been visiting scholar, and conducted research in more than twenty-five countries, covering topics such as media and citizenship, health communication, media and globalization, and communication for development and social change. He was UNESCO Chair of Communication at Universidad Autonoma de Barcelona (2003), member of the International Council of IAMCR (2004–2012), and co-founder of IAMCR working groups "HIV/AIDS Communication" (2002) and "Health Communication and Change" (2008). He has served as a consultant to many development organizations, including DANIDA, USAID, SIDA, UNESCO, UNICEF, World Bank, Rockefeller Foundation, CFSC Consortium, ADRA, and the Panos Institute. For publications, see http://ruc-dk.academia.edu/ThomasTufte.

JANET WASKO is the Knight Chair in Communications Research at the University of Oregon in Eugene, Oregon. She is the author, coauthor or editor of nineteen books, including *Understanding Disney: The Manufacture of Fantasy, How Hollywood Works*, and *The Handbook for the Political Economy of Communications*. Her research and teaching focus on the political economy of media, especially the political economy of film, as well as issues relating to democracy and media. She is currently the president of the International Association for Media and Communication Research (IAMCR).

ROBERT A. WHITE is Professor at the Institute of Peace Studies and International Relations at Hekima College, Nairobi, and coordinator of the PhD program at the University of Nairobi. He is also acting dean at the Institute of Social Development at Tanganza University College, Nairobi. He has a PhD in Development Sociology from Cornell University and was active on grassroots development in Honduras from 1969 to 1978. He was research director at the Center for the Study of Communication and Culture in London from 1978 to 1989 and director of the Center for Interdisciplinary Study of Communications at the Gregorian University in Rome from 1990 to 2003. He was director of Post Graduate Studies and director of Research at St. Augustine University of Tanzania from 2005 to 2010. He was a member of the Board of Management of the International Association for Media and Communication Research from 1985 to 1992 and was visiting professor at the Center for Media and Cultural Studies at the University of KwaZulu-Natal in 1995. He was the founding editor of *Communication Research Trends* and editor with Michael Traber of the Sage Publications book series Communication and Human Values. He is editor of the journals *African Communication Research* and *African Journal of Communication*. He is the author of various books and reports on educational radio, more than 100 journal articles and chapters in edited books, and coauthor of *Normative Theories of the Media*, published in 2009.

KAREN WILLIAMSON is a PhD candidate in Media Sociology, specifically focusing on the impact of the political economy of the news media in the UK on global social relations. She currently works as a research assistant for Professor Peter Golding at Northumbria University, where in 2008 she gained a first class honors degree in sociology and criminology. She has worked at the Centre for Public Policy at Northumbria University, alongside research consultancy on retention in UK higher education.

INDEX

Intersections
in Communications
and Culture

Global Approaches and Transdisciplinary Perspectives

General Editors: Cameron McCarthy & Angharad N. Valdivia

An Institute of Communications Research, University of Illinois Commemorative Series

This series aims to publish a range of new critical scholarship that seeks to engage and transcend the disciplinary isolationism and genre confinement that now characterizes so much of contemporary research in communication studies and related fields. The editors are particularly interested in manuscripts that address the broad intersections, movement, and hybrid trajectories that currently define the encounters between human groups in modern institutions and societies and the way these dynamic intersections are coded and represented in contemporary popular cultural forms and in the organization of knowledge. Works that emphasize methodological nuance, texture and dialogue across traditions and disciplines (communications, feminist studies, area and ethnic studies, arts, humanities, sciences, education, philosophy, etc.) and that engage the dynamics of variation, diversity and discontinuity in the local and international settings are strongly encouraged.

LIST OF TOPICS

- Multidisciplinary Media Studies
- Cultural Studies
- Gender, Race, & Class
- Postcolonialism
- Globalization
- Diaspora Studies
- Border Studies
- Popular Culture
- Art & Representation
- Body Politics
- Governing Practices

- Histories of the Present
- Health (Policy) Studies
- Space and Identity
- (Im)migration
- Global Ethnographies
- Public Intellectuals
- World Music
- Virtual Identity Studies
- Queer Theory
- Critical Multiculturalism

Manuscripts should be sent to:

Cameron McCarthy OR **Angharad N. Valdivia**
Institute of Communications Research
University of Illinois at Urbana-Champaign
222B Armory Bldg., 555 E. Armory Avenue
Champaign, IL 61820

To order other books in this series, please contact our Customer Service Department:
(800) 770-LANG (within the U.S.)
(212) 647-7706 (outside the U.S.)
(212) 647-7707 FAX

Or browse online by series:
www.peterlang.com